The Bayeux
Tapestry

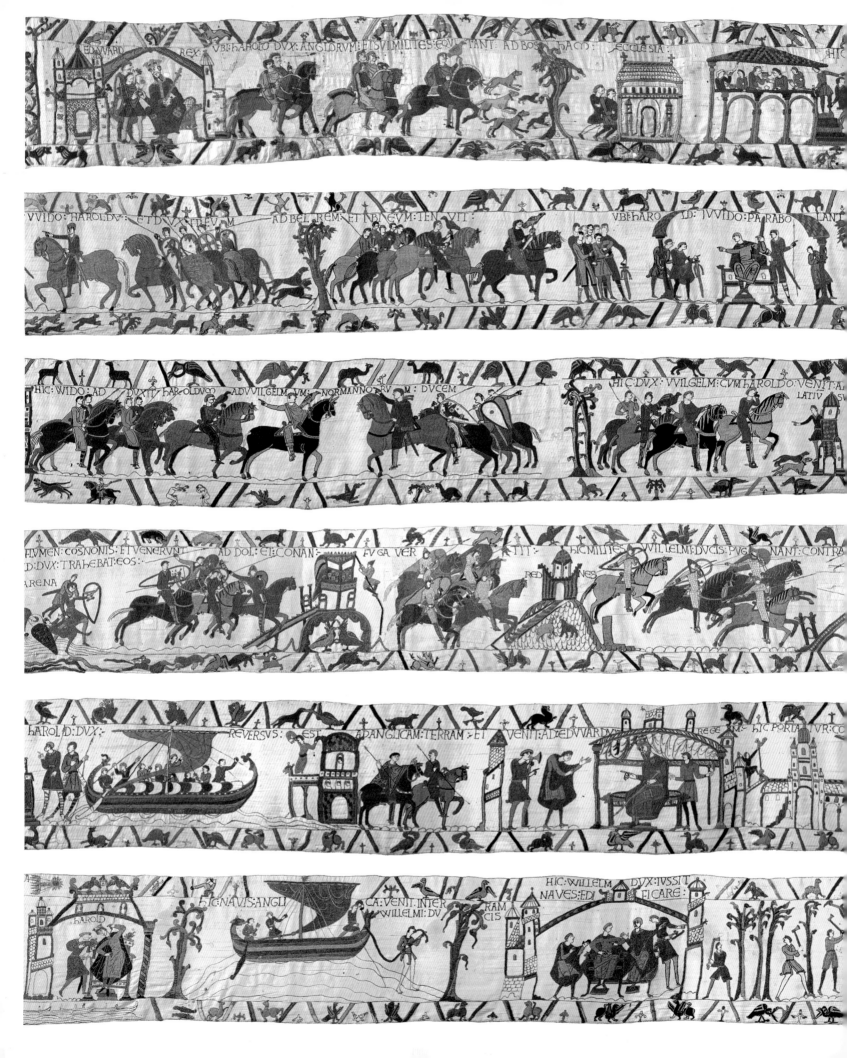

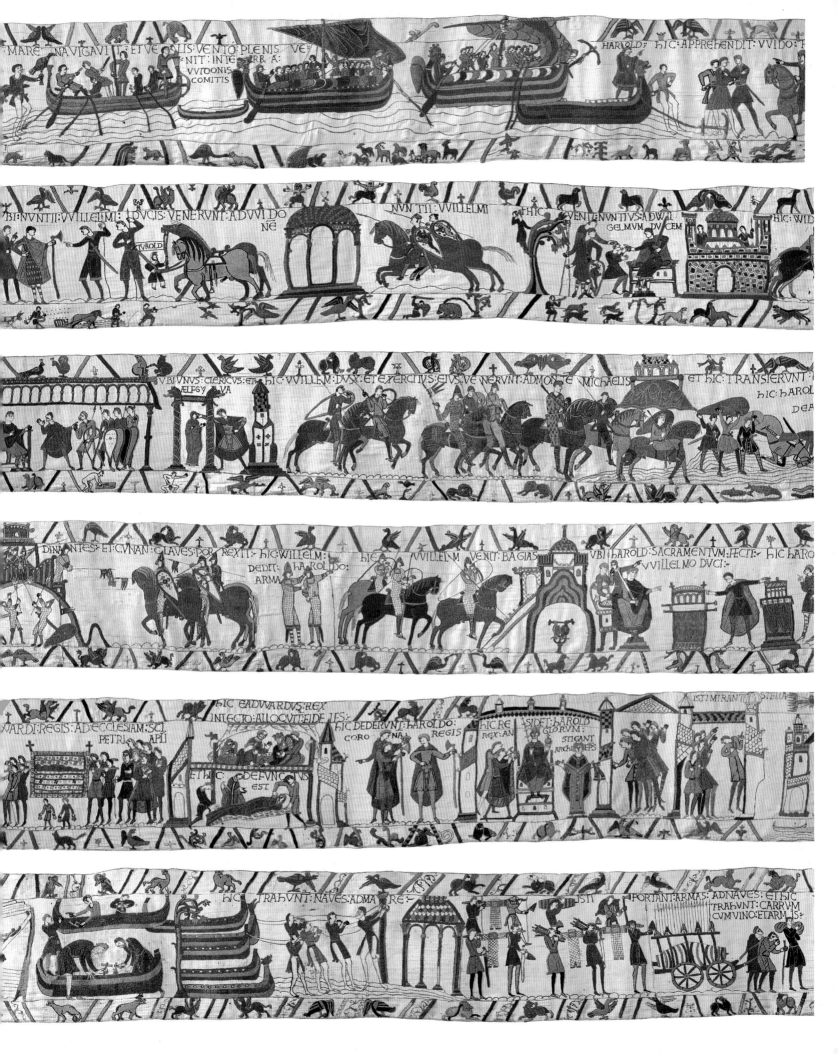

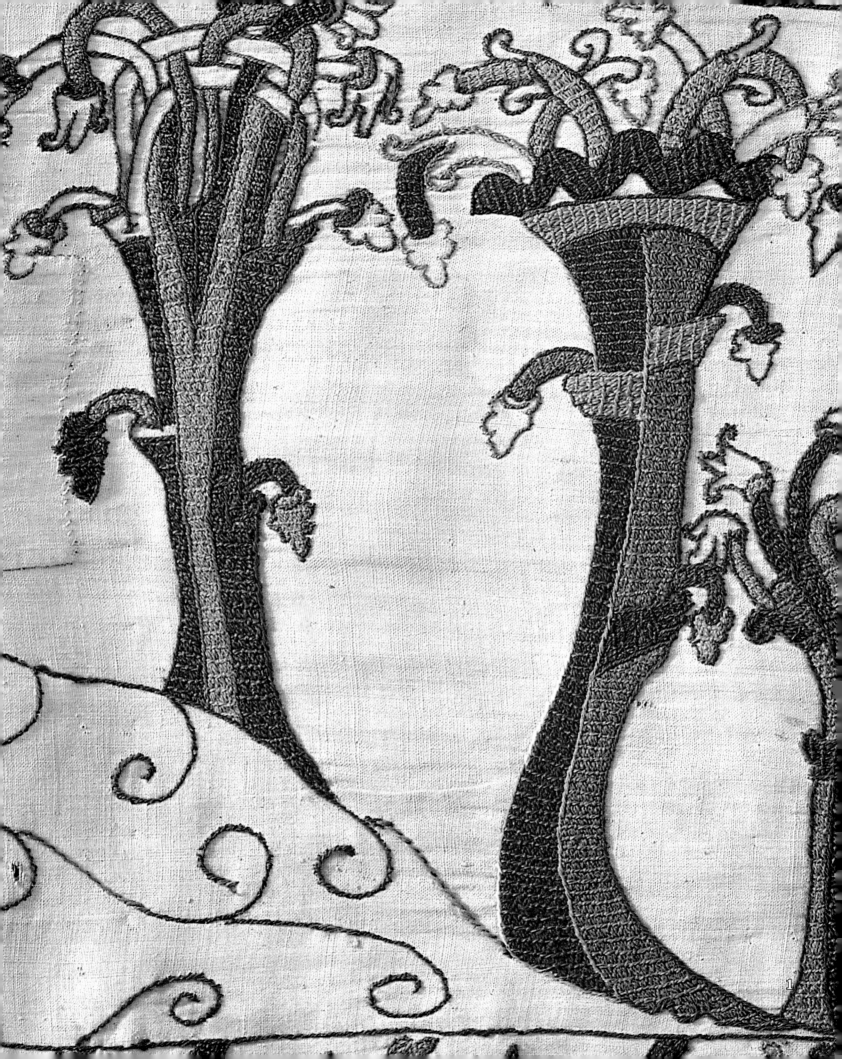

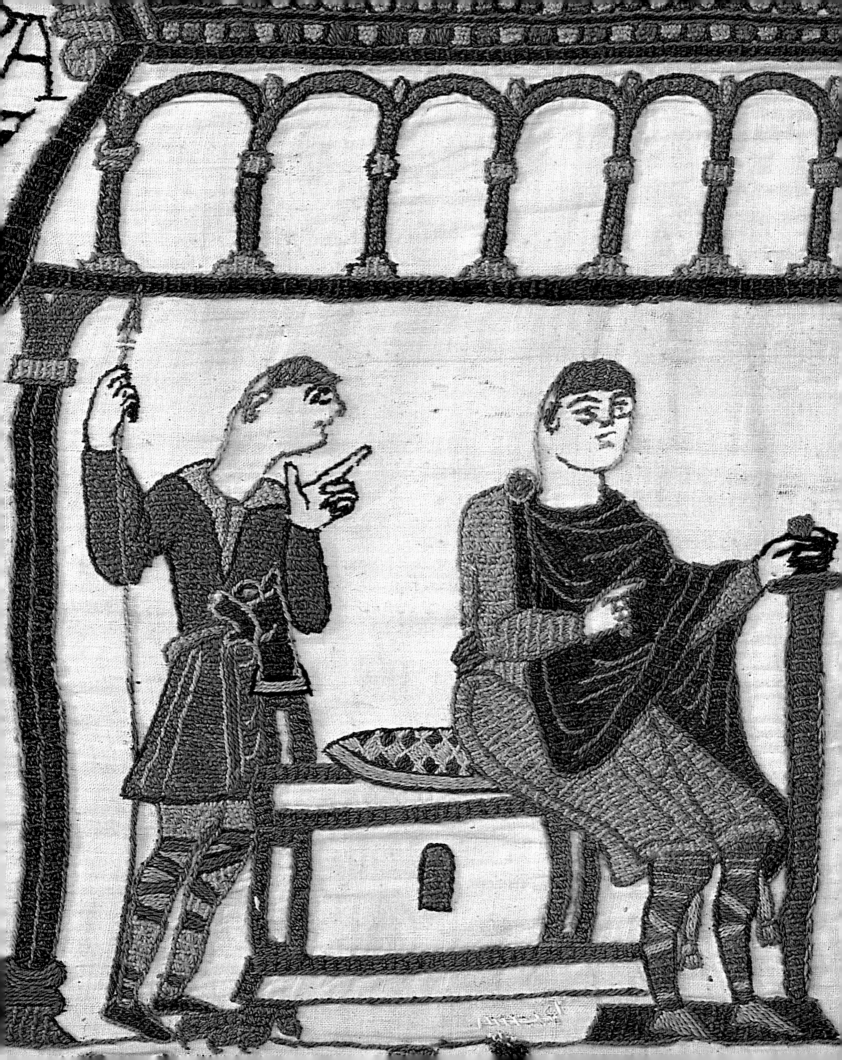

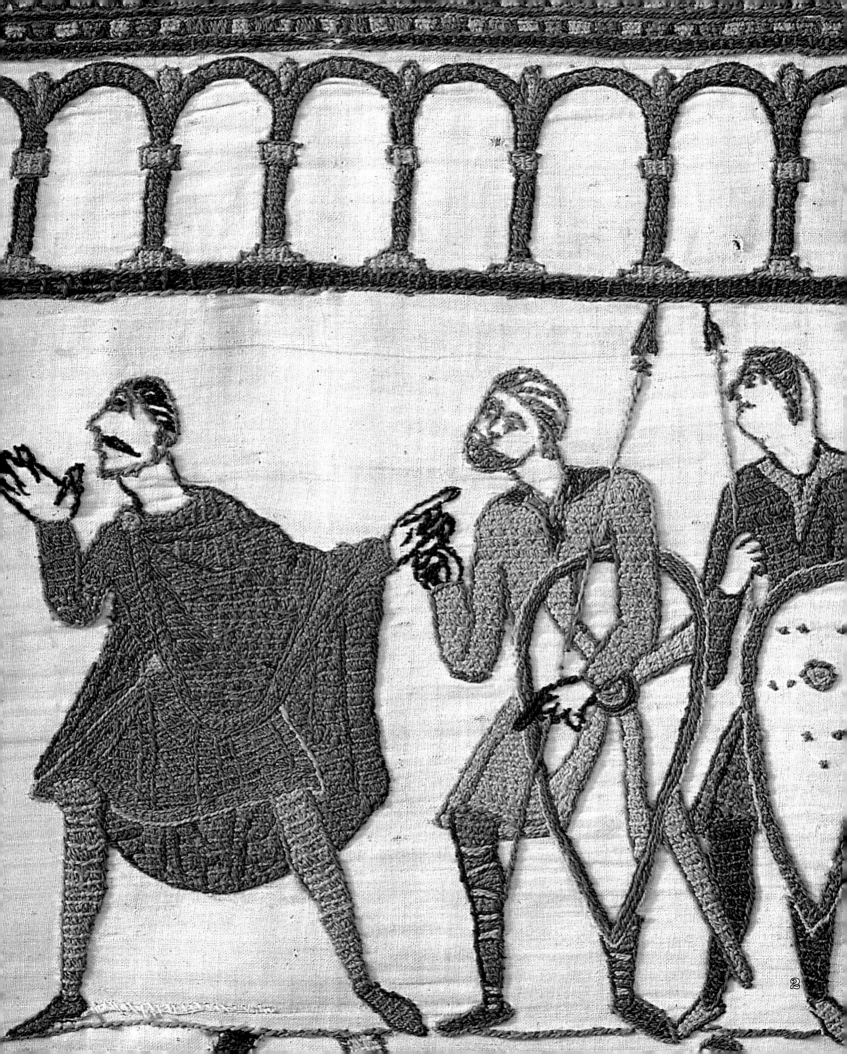

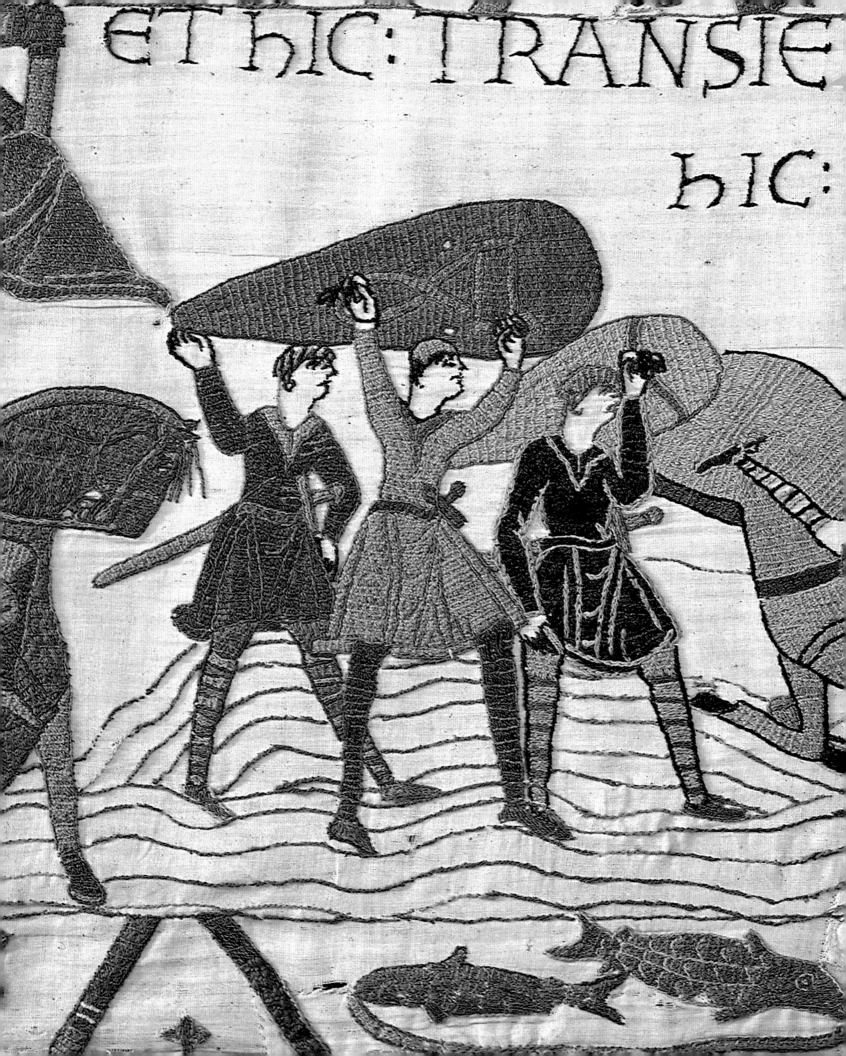

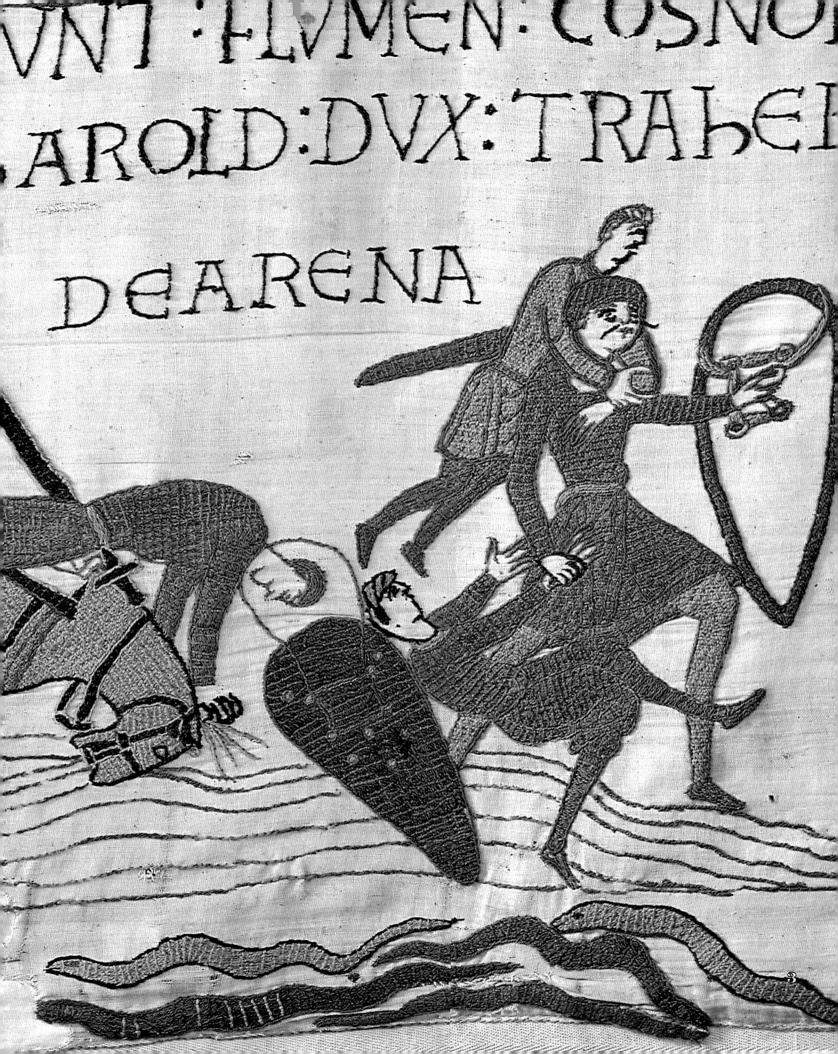

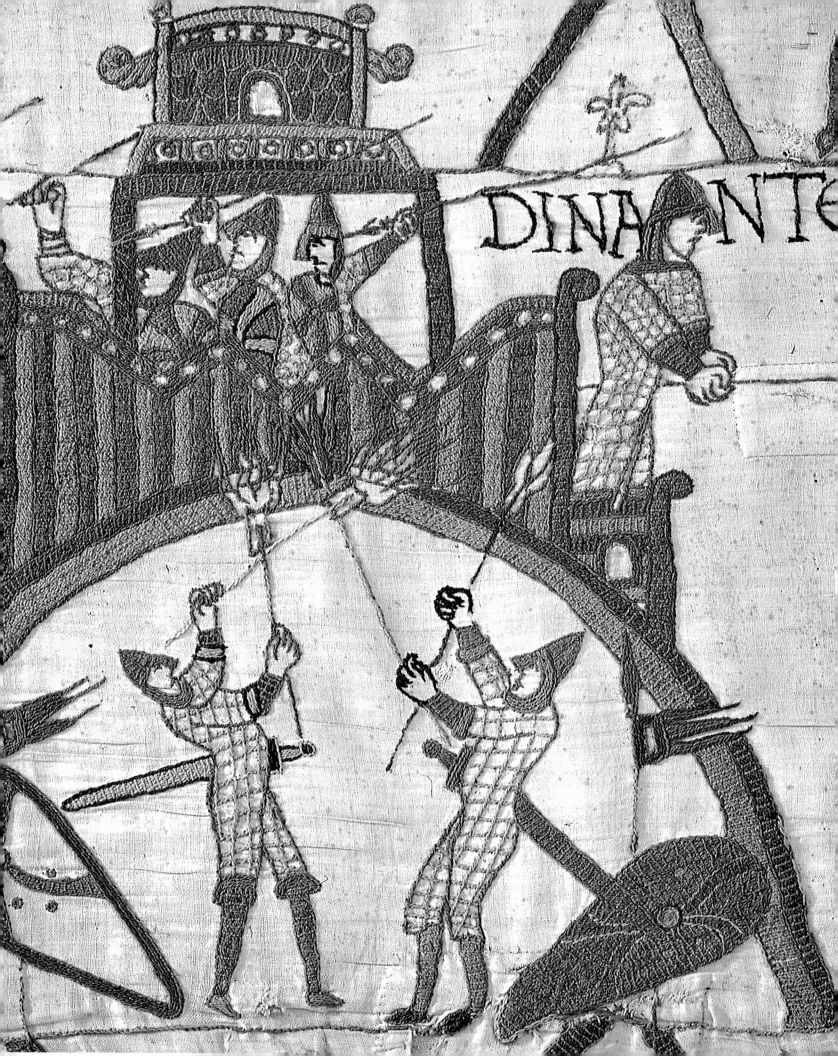

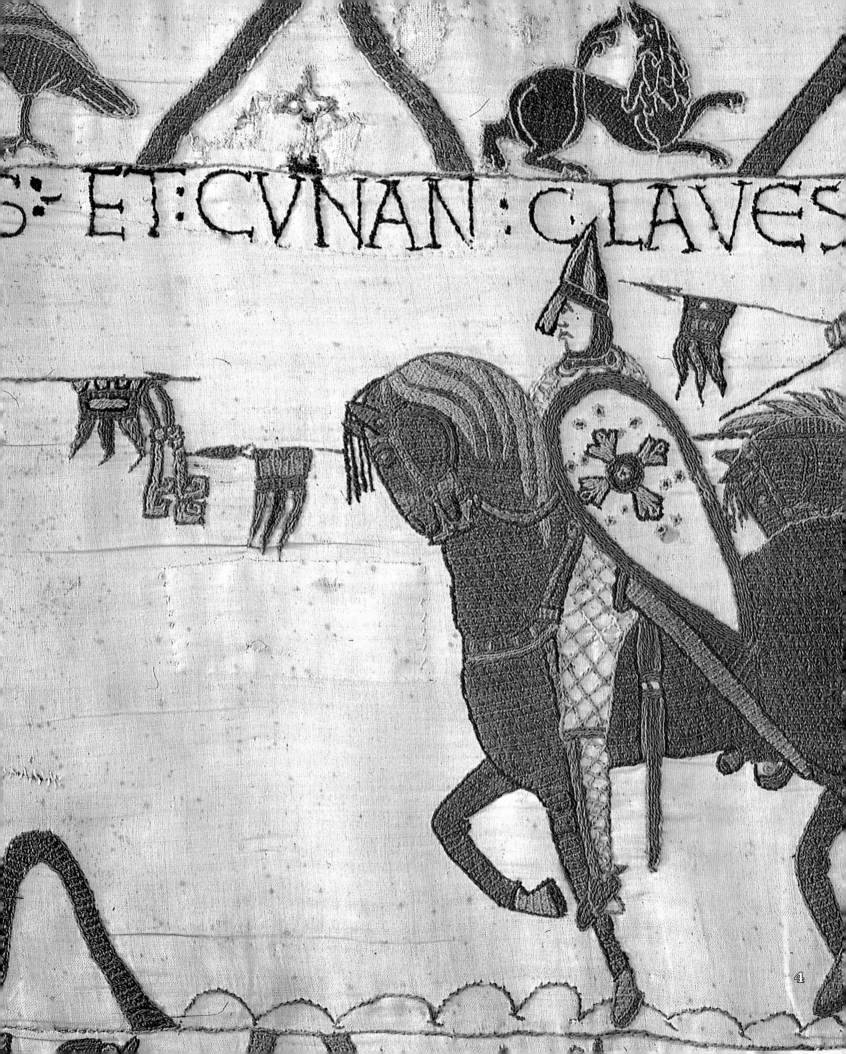

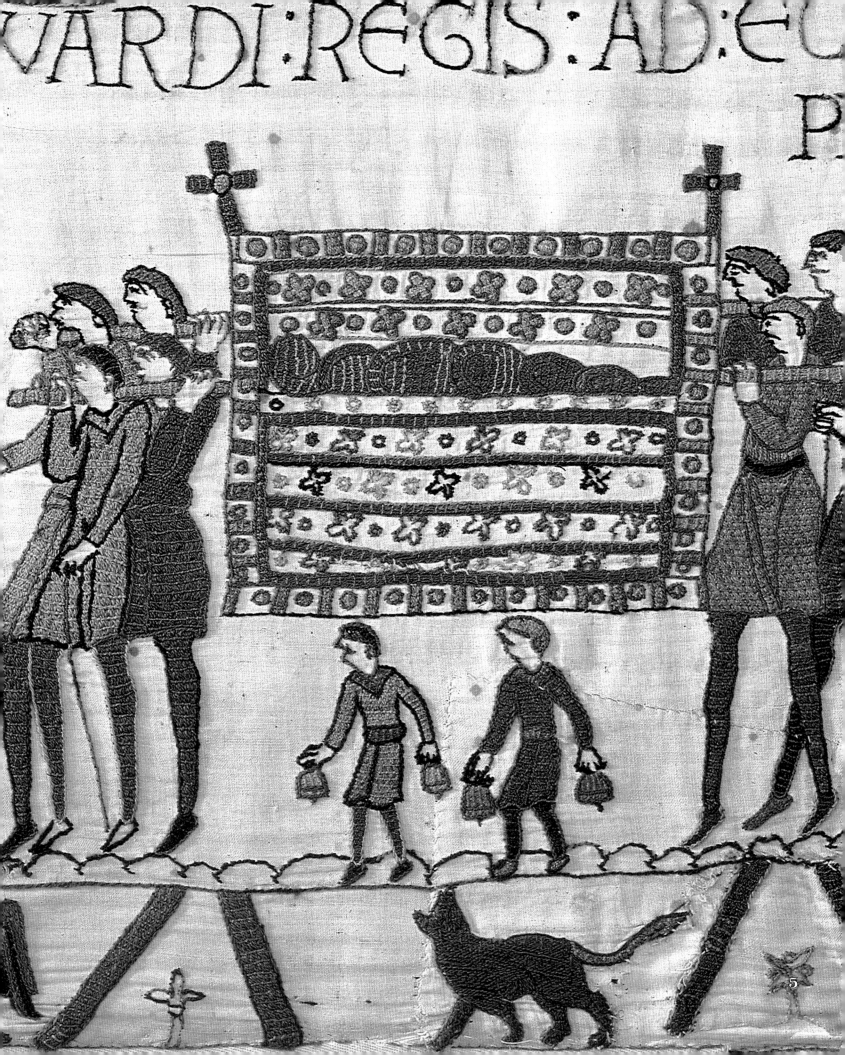

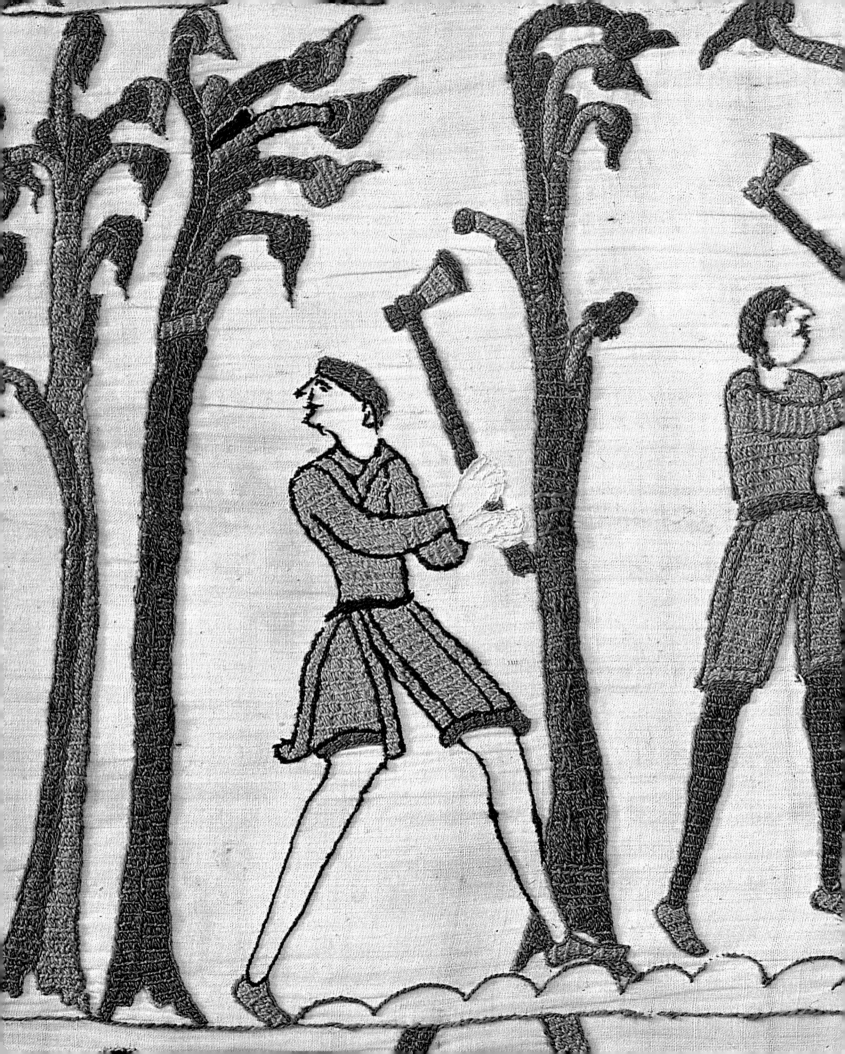

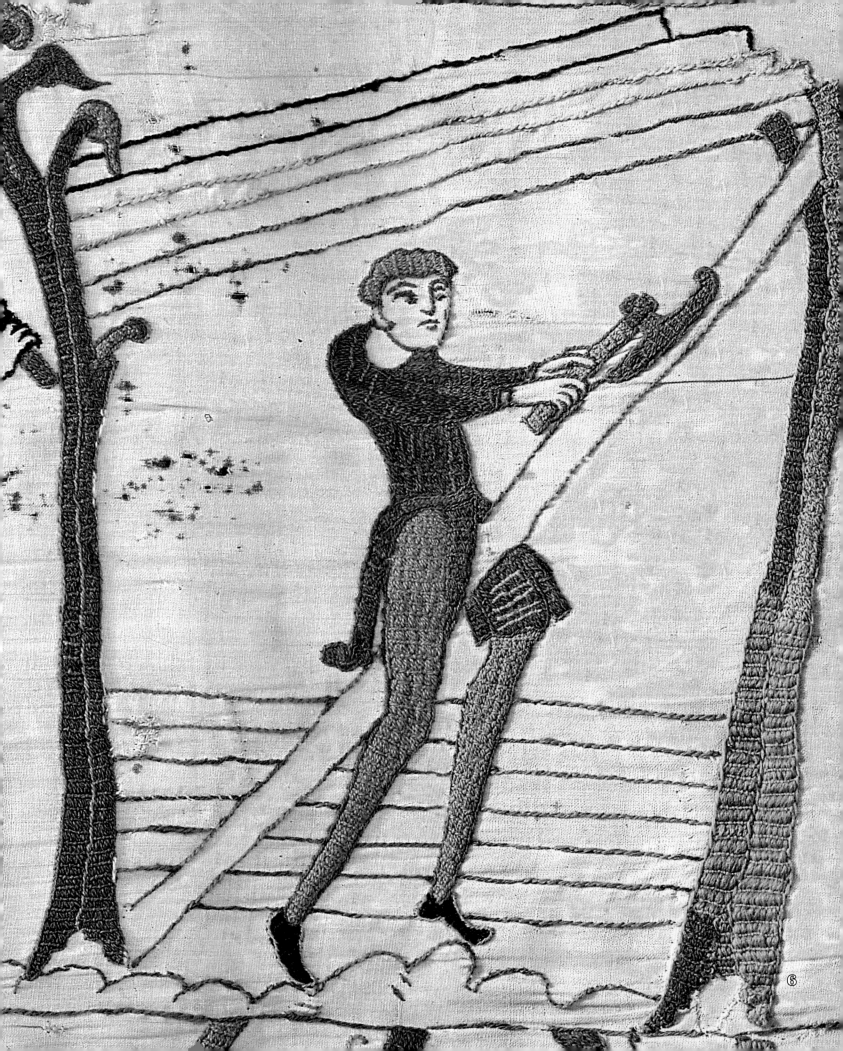

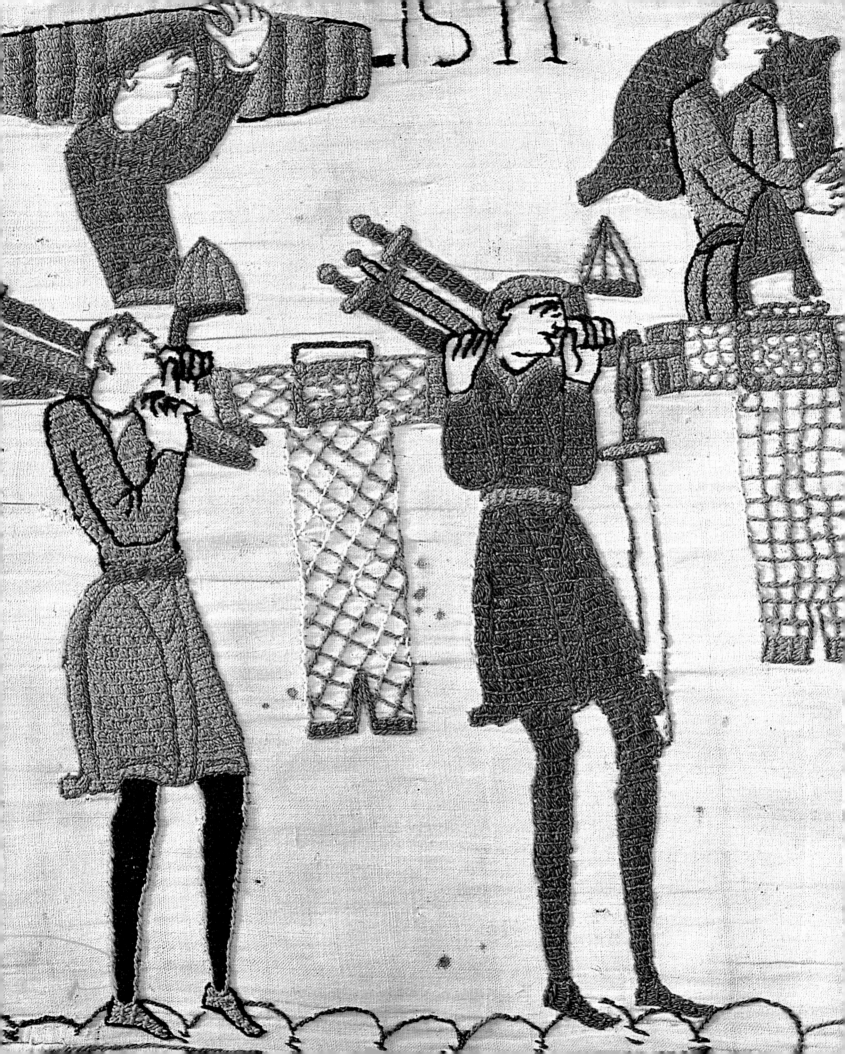

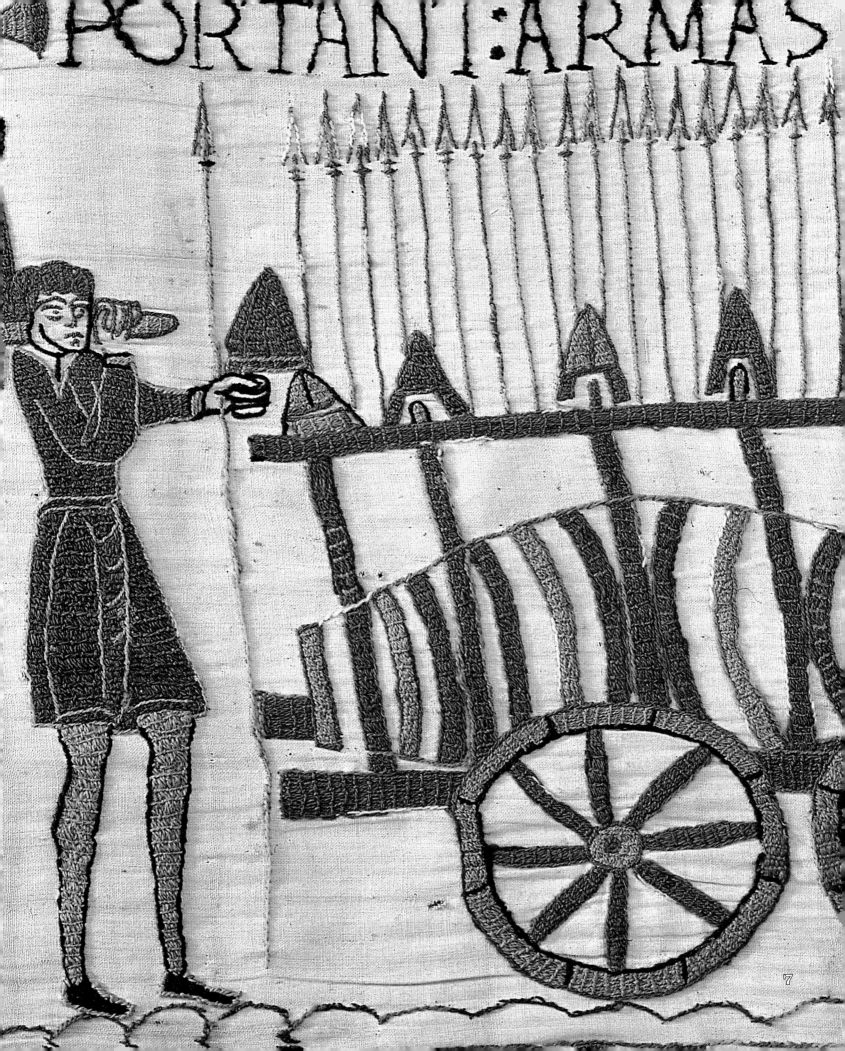

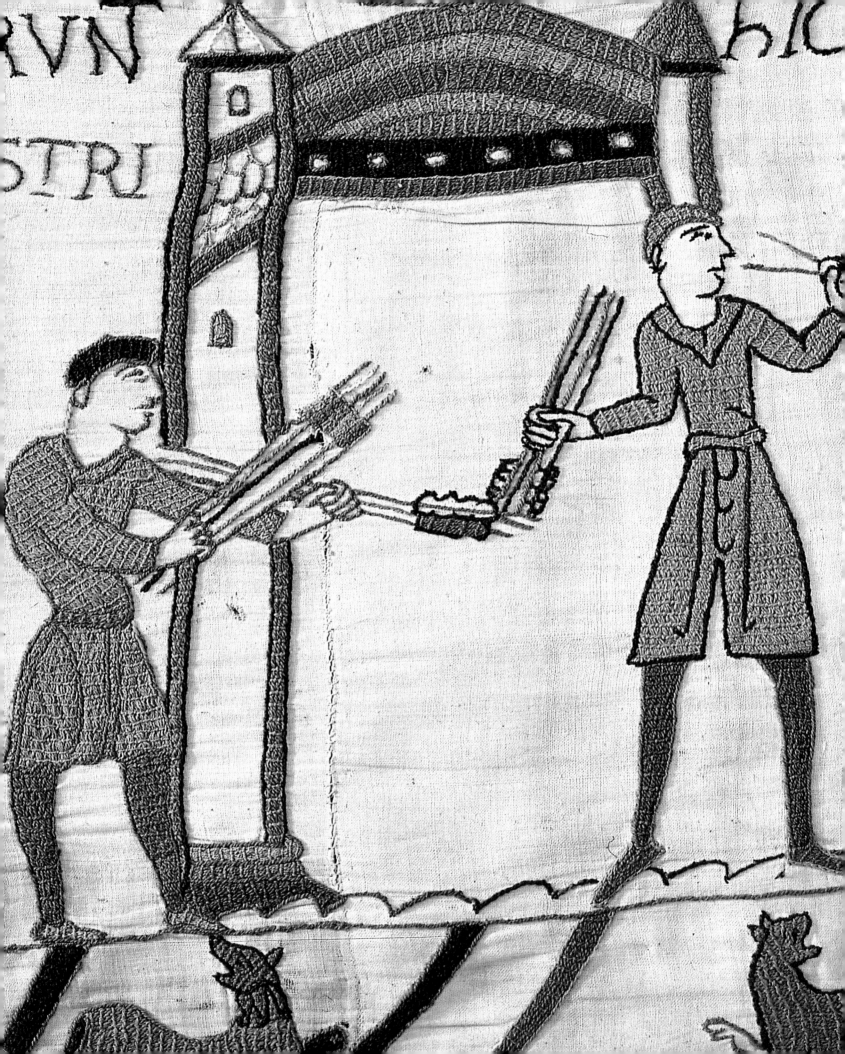

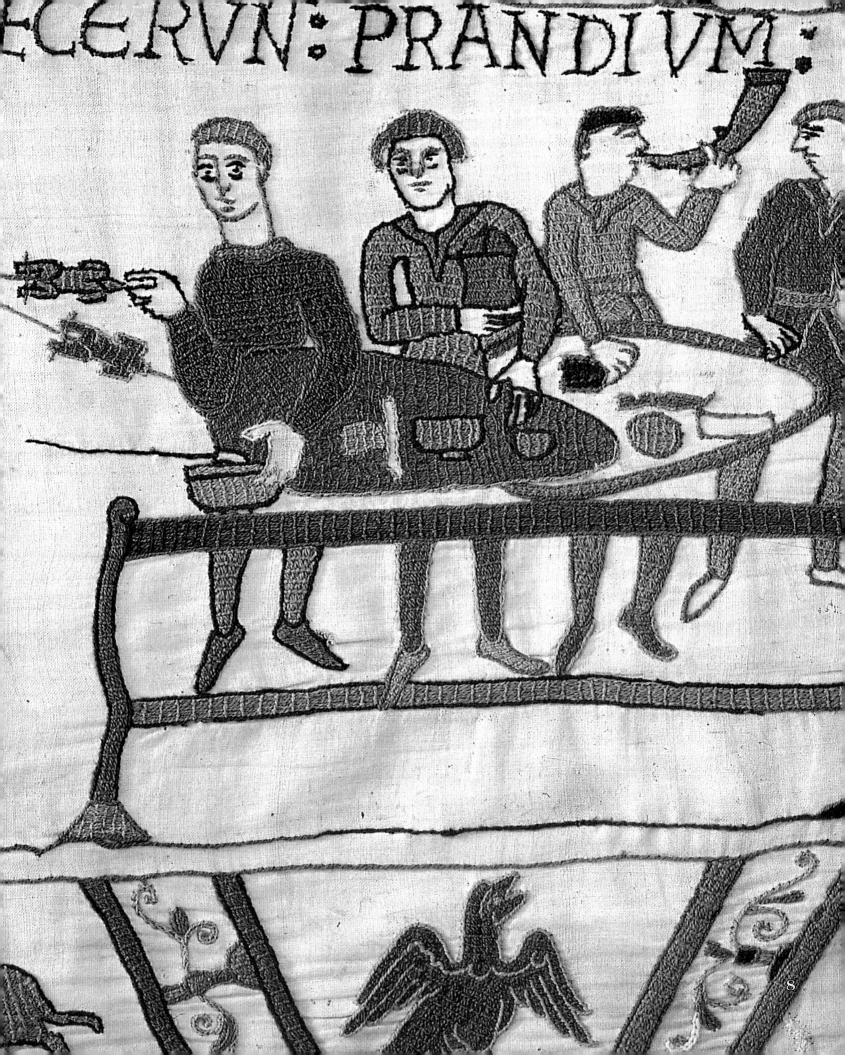

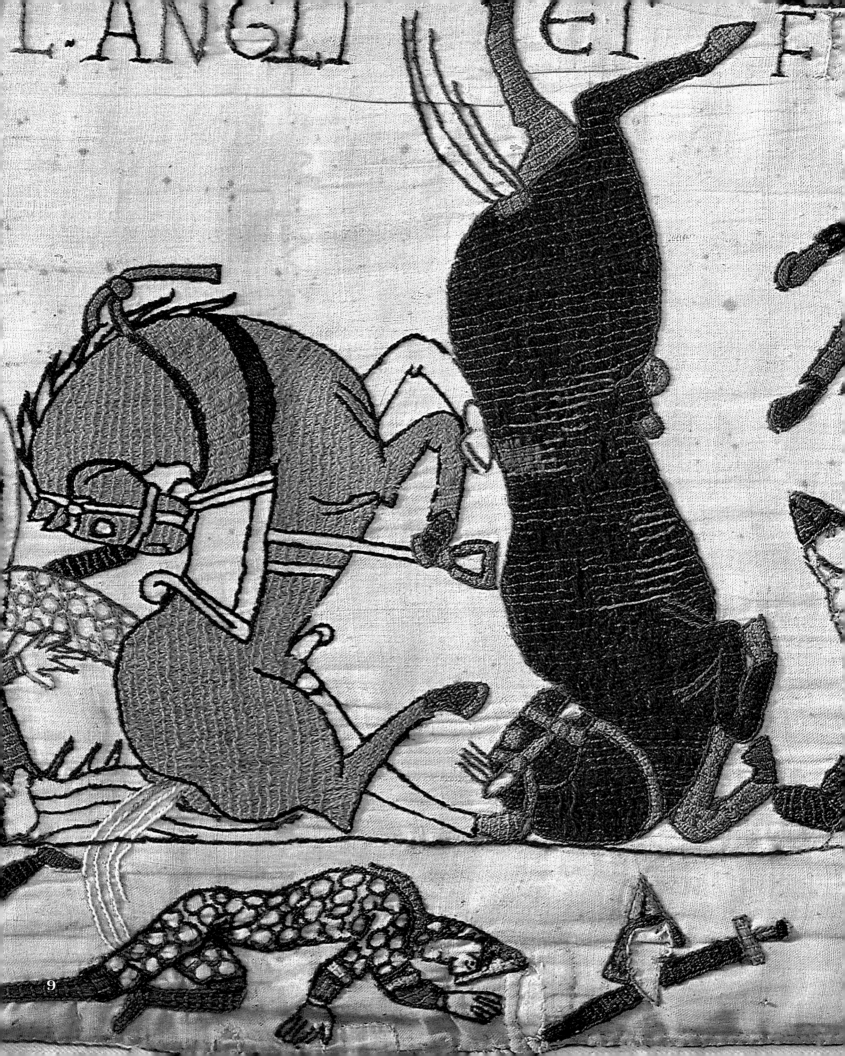

WOLFGANG GRAPE

THE BAYEUX TAPESTRY

Monument

to a

Norman Triumph

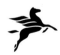

Prestel

MUNICH · NEW YORK

FOR HEIDE

The Bayeux Tapestry is reproduced
by kind permission of the City of Bayeux.
The publishers and the author are grateful for the co-operation and support
of the Centre Guillaume le Conquérant, Bayeux.
In addition, the author wishes to extend his profound thanks to David Britt
for his skilful and knowledgeable translation from the German.

CONTENTS

The Bayeux Tapestry
An Eleventh-Century Pictorial Spectacle

Publisher's Foreword

The Bayeux Tapestry: A Revolutionary New Interpretation

THE CELEBRATED BAYEUX TAPESTRY – a figured embroidery more than seventy metres long, kept in the city of Bayeux in Normandy – depicts the conquest of England by the Normans at the legendary Battle of Hastings in 1066, together with its immediate prehistory. The Tapestry is one of the most significant – and possibly the most mysterious – of early medieval works of art. The principal figures in the narrative are William the Conqueror, Duke of Normandy, his half-brother Bishop Odo of Bayeux, and his English adversary and rival for the throne, Harold of Wessex.

More urgently than previously supposed, the Tapestry demands attention as a milestone in Western art: it offers a wealth of lively artistic experiment, tapping formerly unheard-of resources for the depiction of everyday reality, external nature and contemporary history. It stands as an impressive testimony to the world as seen by eleventh-century Normans and to their sense of history and national identity.

The prevailing opinion has hitherto been that the Tapestry was made by an English workshop in conquered England. By meticulous and detailed scrutiny of the Tapestry itself, and by reassessing the entire historical and artistic context, Wolfgang Grape, a student of the famous scholars Otto Pächt and Otto Demus, has succeeded in revising this view. In a brilliantly argued exposition, as vivid as a historical novel, he establishes that the Bayeux Tapestry originated in Bayeux itself.

The Bayeux Tapestry

An Eleventh-Century Pictorial Spectacle

I

An Extraordinary Tapestry

The so-called Bayeux Tapestry – not really a tapestry at all, but a strip of linen cloth embroidered with woollen thread – now hangs in a specially converted museum in the city of Bayeux.[1] This pictorial history of the conquest of England by the Normans in the year 1066 is a unique and, in many ways, an enigmatic document, which still raises numerous questions, although more than four hundred publications have been devoted to it since the early nineteenth century.[2] The embroidery, some 50 centimetres high, and undoubtedly worked in the last third of the eleventh century, astonishes by its sheer length: 70.34 metres. Its size and technique are unparalleled in any known work of early medieval art. Such art as has survived from that period was mostly made for purposes of religious edification, but this long ribbon of cloth depicts secular events that are not myths handed down from previous ages, but the stuff of contemporary history.

The Tapestry (to call it by its traditional name) bears signs of damage, most of it repaired in the nineteenth century. The end of the strip has been missing for nearly three centuries; we thus have no idea of how the story ended. There are clues to suggest that it was commissioned by Odo of Conteville, Bishop (1049-97) of Bayeux and half-brother to William, Duke of Normandy. Odo consecrated his new cathedral in Bayeux in 1077; we do not know whether the Tapestry was made for that great ecclesiastical occasion. Nor is it known where it was made – not even in which country. Recent scholarship has favoured the south of England; this book, however, makes the case for Normandy. No source indicates how long the work took or who was its designer.

How did the Tapestry come to survive for over nine hundred years in what is by and large an astonishingly good state of preservation? There are signs that it was in the possession of Bayeux cathedral at a fairly early date. In 1420 a Burgundian court inventory mentioned a long tapestry at the cathedral, containing no gold thread and showing the conquest of England by William of Normandy. A 1476 inventory of the cathedral treasury recorded a very long and narrow strip of linen in the sacristy, embroidered with pictures and inscriptions representing that conquest.[3] It is likely that, for many years before this, the Tapestry had been housed in the cathedral, a place far more secure against rapine than the stoutest fortress. The clergy undoubtedly prized it and guarded it well.[4] The 1476 inventory tells us that the Tapestry was exhibited in the nave every year at the Feast of Relics (end of June); presumably, this was already an established tradition.[5] In 1728 the Prior of Saint-Vigor in Bayeux wrote that, for several days in every year, an ancient, long strip of tapestry was hung up in the cathedral.[6]

The most remarkable thing about the Tapestry is the way in which it presents the history of the conquest. It was usual practice in the eleventh and twelfth centuries for individual episodes within a narrative to be singled out and employed as self-contained pictorial units in decorative art, manuscript illumination, mural painting or stained glass. Yet here, a succession of scenes runs on with no hard-and-fast breaks, accompanied above and below by a narrow zoomorphic border and, with two exceptions, reading from left to right. The flow of the narrative is punctuated only by trees and by a few pieces of architectural scene-setting.

Errors in Restoration?

Unfortunately, there is still no thorough study of the exact extent and chronology of the repairs to the Tapestry.[7] Some caution is clearly called for, particularly with the borders and with some of the inscriptions along the top of the picture strip itself. The restorers always took the greatest pains to be accurate, but some of their emendations may have been influenced by historical hindsight. This means that some details may have been 'restored' in ways that distort the original designer's intentions.

There are two cases in which such details might be of considerable importance. At the height of the Battle of Hastings, when William tips back his helmet, Eustace of Boulogne rides bravely ahead of him, cheering on the soldiers who follow (p. 161). The identification of Eustace rests on the remnants of the inscription above his head: E... ΓIVS, interpreted as EVSTATIVS. This raises problems, however, if we assume that the Tapestry was commissioned soon after 1066 and made in the 1070s. For in 1067 Kent rebelled against William and his deputy Odo, Earl of Kent and Bishop of Bayeux; and Eustace and his knights took part in the revolt. As a consequence, he was in disgrace at court until 1077. Norman contemporaries spoke of him with no particular respect; why should the Tapestry give such prominence to a rebel? Was it perhaps worked after 1077? Doubtful, for Eustace's offence can hardly have been altogether forgotten, even then.

Is this really Eustace? All we know for certain is that the section of linen bearing the remnants of the name was severely damaged, and that in 1818 Charles and Anna Stothard used the few remaining needle holes to reconstruct the letters that we now see.[8] It was

they who first proposed the now generally accepted identification of the name as Eustatius. However, the gap is too wide to be filled by the letters VSTA; it would require at least one additional letter. The letter restored as E (which is smaller than the rest) might just as easily have been a B, an L or an F. We cannot, therefore, take the restoration as gospel; several Latin names would have fitted better.[9] So we must not exclude the possibility that another name originally appeared in this place.

Another piece of restoration affects the narrative in much the same way. In the scene in which Harold is killed, there stands a soldier; in his right hand he grips an arrow that seems to have penetrated his head (p. 164). The problem here is the arrow, which is another restoration by the Stothards, based on existing needle holes. The account by William of Poitiers, more or less contemporary with the Tapestry, gives no details of the way in which Harold died in battle, but later, twelfth-century English sources mention that he was struck in the eye by an arrow.[10] For this reason, a number of commentators on the Tapestry have taken the view that the soldier is Harold himself and that his death is thus shown twice over. The lettering, however, suggests rather that the name Harold applies only to the person who is being killed with a sword. The words INTERFECTVS EST, written in two lines,[11] are clearly positioned so as to draw attention to the dying man below.

Is it not possible that the legend current in England gave rise to the misapprehension that the Tapestry shows Harold struck in the eye by an arrow? The Tapestry depicts other Anglo-Saxons being struck in the head by arrows. Six or seven figures further to the left, for example, is another soldier pierced in the face by an arrow, as is the dead man who tumbles head-first behind him. In the case of the putative Harold, on the other hand, the arrow does not stick into the man's face but continues the line of the nose-guard of his helmet. If the designer meant to show an arrow hitting Harold, and thus deciding the battle once and for all, why did he not do so more clearly, as with the two soldiers just mentioned? In his posture, in the form of his upraised right hand and in the pattern on his shield, the supposed Harold resembles the second figure to his left, who holds up a spear. Might not the 'Harold' originally have wielded the same weapon, which was lost in the course of time, misinterpreted and wrongly restored by the Stothards?[12] We have no other source to turn to; it remains an open question whether the dying Harold really appears twice in the pictorial narrative.[13]

II

Reportage or Imagination?

A Single Designer?

The Tapestry cycle imprints itself on the memory through a succession of strikingly effective scenes, involving a small cast of characters. It makes the history of its own time easy to understand and follow. This particularly applies to the compositions dealing with the battle itself. Compared with the battle scenes of antique or early Renaissance art, the rendering of a cavalry charge is formulaic, but it is explicit in order and juxtaposition. The designer was evidently at pains to make history clearly legible.

And yet, succinct and lucid though it looks, the Tapestry constantly leads us to a set of linked, fundamental questions. How are we to treat this picture chronicle? Is it a reliable account of historical events, as most scholars have supposed?[14] Or is some caution called for, because the artist might well have given free rein to his imagination? How authentic is this as a representation of history? After all, in eleventh-century narrative art it was customary to borrow traditional pictorial formulas and insert them into new contexts.

Everything ultimately revolves around the nameless figure of the artist in charge. Inevitably, questions arise as to his origins, schooling, accumulated experience and aims — all inseparable from consideration of his patron's intentions. Without exception, commentators speak of *the* designer, a single artist who is always referred to as *he*. One might, however, suppose the designer to have been a woman. This is one reason among many why, lacking conclusive documentary proof, we should look for visual evidence as to whether or not the designer was familiar with the 'craft' of soldiering or was even an eyewitness to the conquest.

The composition of the Tapestry proves that the designer knew something about embroidery. Did a single artist lay out the whole of the pictorial narrative? Its relatively homogeneous style would suggest as much. Yet any precise conclusions are rendered more difficult by the fact that there is ultimately no distinguishing the designer's work from that of the executants. Many constantly repeated details suggest that, in general, the embroiderers carefully followed every line of the designer's lost cartoons: the moustaches of the Anglo-Saxons, the spurs of the horsemen, the forelocks of the galloping horses, the pointing index fingers and much else.

Occasionally, however, we encounter minor stylistic disparities, especially in the drawing of faces. The profile of William, receiving his horse at the beginning of the battle, is surprisingly sketch-like in its delicacy (p. 144). The dot for the eye, and the little dash above it, look accurate, for all their economy of line: the figure seems to look ahead. By contrast, the profile of his interlocutor, with its mask-like, oversized, sideways-looking eye close to the bridge of the nose, looks rather 'archaic'. It is hard to accept that the same artist designed both heads.

Here and there, the same sure draughtsman's hand reappears in the faces in three-quarter view: for example, the second-from-last man in the party riding down from London to Bosham and the soldier who apprehends Harold (pp. 92, 97). Here, the execution in wool has remained astonishingly faithful to what must have been the subtlety of the lost drawing: the piercing look of the eyes is almost illusionistic.[15] By and large, however, we can only speculate as to whether several assistants worked under the master, filling in portions of the design roughed out by him. Division of the work among different 'hands' would seem impossible. The

range of gradual transitions and of variations[16] is both too large and too unpredictable, and there are no clean breaks, as the narrative proceeds, to indicate a succession of different artistic personalities. We shall therefore continue to speak of one designer, although this cannot strictly be reconciled with what we know of the workshop practice of the time.

First-Hand Experience?

What other aspects might cast some light on the artist? Does the Tapestry contain any episodes or motifs that can be seen as records of personal experience? There is one scene – a moving one to us today – in which a house is burned down; before it stand a homeless mother and child (p. 143). Had the designer seen and remembered something of the kind? The context shows that this particular atrocity was committed by the Normans – but then why depict it? Was the artist distancing himself by making a gesture of protest? If so, this would be wholly exceptional, since the Tapestry consistently shows the Normans as acting justly, without a hint of criticism. Do we understand the scene aright?

Here, a glance at the Norman historical writers will help us. In the chronicle of Guy of Amiens, written in 1067,[17] we read that, after building a fortified camp at Hastings, William laid waste the surrounding country with fire and sword, burning the houses of the 'disloyal' inhabitants because the 'stupid populace' had failed to acknowledge him as King.[18] This tells us two things: firstly, that the image is not there to reflect the designer's compassionate nature, but to stand as an object lesson, a warning of condign punishment; and secondly, that the artist need not actually have seen the Normans burning down the houses (in addition to Guy's chronicle, there might well have been other written sources). Such incidents were far from uncommon in the wars of the eleventh century; even then, scorched-earth tactics were an everyday reality of war. The German annalist Lambert of Hersfeld described how, in 1070, the troops of Henry IV, King of Germany, overran the Bavarian possessions of Otto of Nordheim: 'They set to work, each to the best of his ability, to harry him with fire and sword... to plunder his lands and other possessions, to lay them waste and to commit them to the flames.'[19]

The depiction of the feast in the Norman camp (p. 140 f.), on the other hand, suggests that the designer might have been present at some of the events shown, for this highly detailed representation of a banquet and its preliminaries has no parallel in any school of art from the dawn of the Middle Ages to the thirteenth century. The artist takes visible pleasure in showing how meat was cooked, how the baker worked or what the improvised sideboard looked like. He might have had other reasons to show this event at such length, although it has no bearing on the history of the conquest. An ancient custom, lengthy banquets were especially important to the Scandinavians (including the largely Danish forbears of the Normans), as they were to the Anglo-Saxons. Feasting was one of their principal modes of social intercourse; it reinforced the morale and self-esteem of all those present. The sharing of a meal was an opportunity to exchange news, take decisions and issue orders. Accordingly, on rising from the feast blessed at table by Odo, William and his two half-brothers sit in council.

Perhaps this historic scene prompted the designer to record it at first hand. The following, no doubt wholly unimportant, episode of the two Normans hitting each other with spades is another that might well stem from personal observation. (Such professional warriors as the Norman knights would have regarded spade-work as rather beneath their dignity.)

Knowledge of Warfare and Weaponry?

The battle scenes allow us to give a more concrete definition of the artist's personality. Specialists in medieval warfare have pointed out that the designer was an expert on Norman cavalry techniques, and that there is documentary evidence to show that the handling of the lance here is authentic (horsemen could use this weapon in a variety of ways, either hand-held or thrown).[20] Although there is now a scholarly consensus to the effect that the designer was English, even the most convinced partisans of this theory have conceded that the only extant parallels for these representations are not in England, but in Continental manuscript illumination.[21] This fact is not to be explained away by the chance effects of preservation, and, if we take it more seriously than hitherto, it leads to some far-reaching conclusions. The English did not fight on horseback. In 1066 they still waged war exclusively on foot, as the Tapestry shows (when they travelled on horseback, they left their horses away from the battlefield). They were unacquainted with the evolutions of knights in battle. It would, therefore, have been very difficult for an Anglo-Saxon artist, unversed in these matters, to depict a major contemporary cavalry engagement.[22]

A number of modern authors emphasize the designer's accurate depiction of weaponry – as with the sword-belts in the scene between Harold and Count Guy at Beaurain (p. 100). In the cavalry attack on Dol these writers point to the clear indication of the way in which the soldiers carried their shields (p. 111).[23] And yet Brooks and Walker tell us that, in the depiction of hauberks or mail shirts, the artist has committed a blunder that proves his Anglo-Saxon origins:[24] fighting on foot, they say, the English wore chain-mail with trouser-like legs, and the artist has mistakenly shown Norman horsemen wearing the same. It would indeed be difficult, not to say painful, to ride in such armour, and so the argument runs that, since the designer knew only the Anglo-Saxon form of chain-mail, he must have been a native of England.

This carries little conviction. As I have said, the English rode their horses not *in* battle but *to* battle. Are we to suppose that the warriors in mail shirts put on their iron trousers only at the beginning of a battle? In the border beneath the scene of Harold's death a number of dead men are being relieved of their chain-mail, which is pulled off over their heads. This armour must have been made in two parts; otherwise it would

not have been possible to remove the chain-mail in this way. Admittedly, the English chain-mail in the Tapestry does look exactly like the Norman, and the armour worn by both William and Harold in the scene of the gift of arms resembles that worn by a warrior king in an Old English Hexateuch, illuminated c. 1030 (cf. p. 115 and fig. 1).[25] Yet, if we compare this with more detailed, early twelfth-century representations of armour, it begins to look as if the earlier images have been wrongly 'read'. It is, in fact, doubtful that there ever were suits of chain-mail with trousers. In the David and Goliath scene in a French Bible made soon after 1100[26] the giant wears a mail shirt divided like the tails of a coat, which would have made walking easier and riding a practical possibility (fig. 2). This miniature makes it clear that the eleventh-century artists were just simplifying: there was no misinterpretation on their part.

It is most likely that the English and the Normans wore the same typical form of eleventh- and twelfth-century armour, namely the ubiquitous knee-length mail shirt that was known in Norman-French as a haubergeon or hauberk, and in Anglo-Saxon as a byrnie. Only very exalted personages, such as

William of Normandy (see, for example, p. 144), also wore chain-mail leggings. For all his concern with accuracy of detail, the designer was adopting the formalized iconographic conventions in which he had been trained; only in 1100 or thereabouts did artists begin to move towards a more naturalistic rendering of mail.[27] There does not seem to have been a specific Anglo-Saxon form of infantry armour, as distinct from the mail shirts worn on the Continent. There is, therefore, no reason to draw conclusions from a supposed error as to the designer's artistic origins.

Other inconsistencies of detail in the Tapestry do not always point to a misconception on the artist's part: frequently, indeed, they prove the contrary. Mostly, these are the first emergent efforts (in the transition from early to high medieval art) to reproduce things directly seen, as reflected in a tendency to introduce subtle variations into traditional, stereotyped patterns of representation.[28] Often, both Normans and Anglo-Saxons wear swords over their mail shirts, but in the scene of William's gift of arms Harold wears his sword inside his mail, with only the hilt and tip showing – as also

does William (p. 115). Here, too, the designer has not – as one might suppose – made a mistake. According to Mann (a specialist in medieval arms and armour), 'the mail shirt often had a small slit in the left hip to accommodate the sword'.[29] Romanesque art provides convincing evidence of this. In a northern French (Norman?) miniature of c. 1150, from a manuscript of Pliny's *Naturalis historia*, the author, dressed as a twelfth-century knight, is seen presenting his manuscript to the emperor Titus (fig. 3).[30] Only the hilt and the tip of his sword are visible, as with the two men-at-arms on a roughly contemporary capital at Clermont-Ferrand (fig. 4).[31]

Uncertainty still prevails concerning the Tapestry's three depictions of an unusual garment, 'the exact nature of which is doubtful'.[32] In this, horizontal and diagonal lines create a triangular pattern in two colours. Odo, as he cheers on the Norman side in battle, wears it over his chain-mail, which can be seen at neck and wrists (p. 160). According to Nevinson, 'it is probably a military coat or rather tunic', which, 'reinforced with leather', would have 'formed quite an effective defence in battle'.[33] William is similarly

1 *Battle scene. From Old English Hexateuch, c. 1030.*
London, British Library, Ms. Cotton Claudius B. IV, fol. 24 v

2 *David and Goliath. From Bible, early 12th century.*
Dijon, Bibliothèque Municipale, Ms. 14, fol. 13

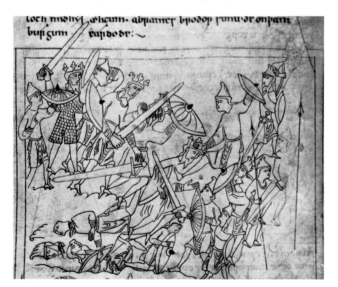

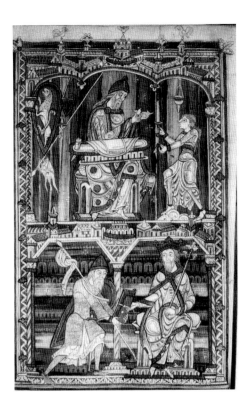

3 *Pliny before the Emperor Titus (below).*
From Pliny the Elder, Naturalis historia, *c. 1150.*
Le Mans, Bibliothèque Municipale, Ms. 263, fol. 10 v

clad on his way to Mont-Saint-Michel, although he is not wearing mail (p. 109). Count Guy, too, as he listens to William's emissaries, is wearing the same garment, with

4 *Psychomachia: The Battle of the Soul.*
Capital, c. 1150. Clermont-Ferrand, Notre-Dame-du-Port

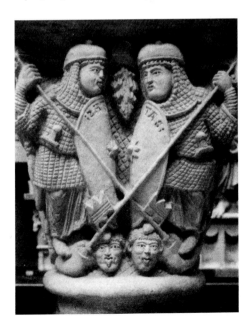

a voluminous cloak over it (p. 101). So the designer cannot have meant it to be seen as a military tunic.

We notice that Harold never appears dressed in this way. Was the artist trying to set Odo, William and Guy off from the Anglo-Saxons by a form of dress that was a figment of his own imagination? Certainly not, since we find something similar in French illuminated manuscripts of the early twelfth century. In two initials of the Bible already mentioned Solomon at his anointing and King Antiochus IV Epiphanes of Syria are shown in garments with the same small triangular pattern (fig. 5).[34] It would seem that the designer was depicting a fashion in aristocratic dress that dated from the second half of the eleventh century, worn as a mark of status by princes on the Continent but still, perhaps, unknown to the Anglo-Saxons.

Fantasy Architecture

There is, however, one department of imagery – leaving the trees on one side for the moment – in which the artistic imagination runs riot. There are numerous architectural settings, but in them, as a rule, no attempt has been made to depict anything that actually existed at the time. The cities and their gates, the castles and their halls, possess no readily comprehensible material reality. They merely symbolize the shifting scenes in which the action takes place. Often, ornate individual components of buildings are displayed in isolation or are linked by gables or slender strips of roofing – as in the scenes from the death of King Edward to the appearance of the comet (pp. 122-4).

In two cases, however, the designer may have taken pains to give a more substantial impression of what were then newly built churches. Around 1060, or shortly thereafter, the nave of the abbey church of Mont-Saint-Michel was built with a novel system of decorative arcading.[35] According to Alexander, this would seem to have so impressed the artist that he alluded to it, within the limitations of his standard repertory of forms, in his representation of the church.[36] If this were so, it would give us an indirect clue to

the designer's nationality. A Norman artist would be far more likely than an Anglo-Saxon to interest himself in a new church at this important Norman pilgrimage centre.

The Tapestry also depicts the first Norman church on English soil, that of the abbey of St Peter, Westminster, the burial place of Edward the Confessor.[37] It is shown in longitudinal section and looks relatively authentic; the individual parts are surprisingly easy to identify. We see the choir, the nave with its clerestory windows and round-arched bays,

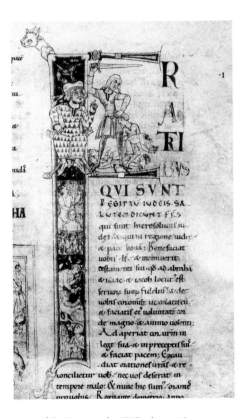

5 *Initial F: King Antiochus IV Epiphanes of Syria;*
death of the Maccabees.
From Bible, early 12th century.
Dijon, Bibliothèque Municipale, Ms. 14, fol. 191

the transept and a tall tower above. A massive crossing tower is a distinctive feature of eleventh-century Norman churches. Might not the absence of the west towers be explained by the fact that they had not yet been built when the Tapestry was made? Unfortunately, we cannot know how this no longer extant building looked in detail.

Living Detail

6 *Apollo. From Remigius of Auxerre, Commentary on Martianus Capella, late 11th century. Munich, Bayerische Staatsbibliothek, Clm. 14271, fol. 11 v*

Observation of Everyday Life

Despite the stylized system of imagery within which the designer worked, it is characteristic of him that he regarded many everyday things as worthy of depiction. In no other eleventh-century work of art do we encounter such catholic interest in the contemporary scene, such astonishing openness to the visible world. The hounds at the beginning of the Tapestry wear collars with leash-rings. When William's emissaries ride post-haste to Beaurain, their hair flies in the wind (p. 102). The horses that Turold holds have their harness precisely detailed, including a saddle with an adjustable stirrup (p. 101). One of the men who draw the cart bearing the wine barrel stoops laboriously, in marked contrast to the upright figure just ahead of him (p. 131). Even the depiction of the four-wheeled cart itself is remarkable. Two-wheeled carts are common in eleventh-century Anglo-Saxon art,[38] but there are no four-wheelers. Parallels are to be found in French manuscript illumination. In a late eleventh-century illustration to Remigius of Auxerre's commentary on Martianus Capella, Apollo sits in a four-wheeled 'peasant's cart' (fig. 6);[39] the visual source is surely contemporary rather than late antique.

Tools and Implements

A cart drawn by men and not by beasts is something that the artist might well have seen in real life, but this is not to say that carts were always manhandled in this way. The designer was used to the sight of working horses. This is indicated not only by the earliest known image of a pack pony (in the preparations for the feast in the Norman camp, p. 138 f.), but also by the diminutive scenes of rural labour in the border beneath the scene between the Norman emissaries and Count Guy (p. 100 f.). Here, a peasant has harnessed a horse to a harrow, the earliest appearance of this implement in medieval art.

To the left of this, a plough is drawn by a donkey or a mule; here, again, it is astonishing how much the designer has noticed and recorded. The mule wears the traditional breast harness, but the horse wears the more efficient collar harness. So the designer was familiar with farming techniques that were possibly unknown in England at the time: in Anglo-Saxon illustrations ploughs are invariably drawn by oxen.[40] The artist may well have intended to illustrate a novel agricultural technique. It is one that he just might have seen with his own eyes: Hodgett says that in the Paris area, for example, it was around 1200 that horses replaced the slower oxen behind the plough.[41]

Another extraordinary feature of the Tapestry is the variety of tools that it shows. In the shipbuilding scene we encounter an elongated axe with a short handle, an auger, a hammer (?), a hatchet with a T-shaped blade for trimming planks[42] and large axes for tree-felling (p. 127 f.). At Hastings the Normans build their earthen rampart with shovels or spades and a mattock (p. 142). We see shovels of two kinds, with axe-shaped and oval blades. This is another notable detail that has a bearing on the designer's origins, for, according to Wilson, shovels are 'unknown in English contexts' of the period.[43] This suggests that an Anglo-Saxon

designer might not have given such an accurate rendering of the two shovel forms.

All the scenes of working life in the Tapestry are convincingly accurate – as in the scene in which the completed ships are launched with the aid of a dolphin (p. 128 f.). This is a post fitted with rings (eyes), through which ropes are passed round the stem post of a beached vessel; the lower boat here has the ropes passed through a hole in the stem post. This method of launching halves the force required, with minimal loss through friction, and eliminates the risk of injury to the shipwrights.

Details of Combat

We constantly come upon evidence that the designer was an eyewitness to the fighting that accompanied the Norman conquest. If we survey the whole corpus of early and high medieval battle scenes that illustrate the Old Testament, the conquests of Alexander the Great, the *Chanson de Roland* and the like, it becomes clear that the artists usually applied a consistent set of basic formulas: thus, in most cases, the opposing sides are represented by two compact groups of figures in head-on collision. Not so in the Tapestry. Here, there is very much less of the customary repetition of similar episodes of combat

(though this may be said to occur in the Brittany campaign, p. 108 ff). Instead, we are presented with a marked variety of scenes and motifs. In the single combats after the death of Gyrth a sword slices through the haft of a battleaxe (p. 158). To the right of this, another axe strikes a horse on the head, and it wheels away. There follows the cavalry charge against the hilltop; here, one foot-soldier throws all his weight backward as he tugs at the girth of a horse that is taking a fall with its rider. Such self-contained groupings were new to medieval art, and they remained unique for centuries afterwards.

In this phase of the narrative we become vividly aware of the designer, and of his need to work out a new and also extremely lengthy programme for the work. This alone proves that the view that the designer of the Tapestry was nothing but 'a copyist'[44] does no justice to his artistic achievement. A number of scenes give us every right to assume that the Tapestry is a record of first-hand observation. However, this becomes intelligible only if we bear in mind the designer's principal task, which was to create as detailed and as comprehensive a pictorial chronicle of recent history as possible.[45] More was asked of him than of most eleventh- and twelfth-century artists, who were depicting Christian or secular subjects set in the distant past.

Horses and Riders

Of all the objects in the Tapestry, the horses look most consistently natural, in outline and in proportions. With a clarity uncommon in the Middle Ages, it is made evident that the chargers ridden in battle are stallions. The artist illustrates events otherwise unknown to the art of the time. Not all the soldiers sit their horses in customary style. The horseman beneath the abbey of Mont-Saint-Michel may be drawing his feet up to keep them dry (p. 109), or else he is dismounting to ford the river, as the men in front of him are doing. In either case the motif is an unusual one, presumably invented or observed by the designer, which adds to the rich variety of actions depicted in the Tapestry.

In the mêlée at Hastings two horses pitch forward on their heads; the dark one with neck bent, forelegs drawn in and hind legs pointing straight upward occupies the entire height of the strip (p. 158). This graphic battle scene is unique; its immediacy goes beyond anything in previous art. Only one explanation is possible: the artist must have precisely observed – and immediately recorded – a similar scene in the heat of battle. It is extremely probable, not to say certain, that no source image existed. No late antique painting, no sarcophagus with battle scenes, shows anything like this; even in Roman art horsemen in battle never crash in such dramatic fashion.

There are other episodes of combat that probably derive from personal observation on the designer's part. Just before the death of Harold, one horseman (facing left) is seen apparently seated on his horse's neck; this is not an oversight on the artist's part, because we can see the empty saddle behind him

(p. 163). The animal's forelegs are buckling and the rider's feet touch the ground. The designer clearly intended to show us a horse collapsing beneath its rider. In the border beneath the plunging horses (p. 159) there is a riderless horse (the hindquarters, within the outline, and neck have been carefully restored, and the image as we see it can be taken as accurate). The hind legs stretch out behind the horse, while the left foreleg, bent up, formerly rested on the lower edge of the border (the remains of the black hoof are still visible). The stirrup leathers hang or lie on either side of the beast; we seem to view the saddle from above. In other words, the designer has set out to depict not only a fallen, but a prostrate horse, as seen from directly above.

This is an utterly exceptional idea: it violates the rule – otherwise universally observed in the art of the time – that everything must be seen sideways on, and thereby anticipates some of the achievements of Trecen-

7 *Christ and the widow at Nain.*
From Gospel Book of Otto III, c. 1000.
Munich, Bayerische Staatsbibliothek,
Clm. 4453, fol. 155 v

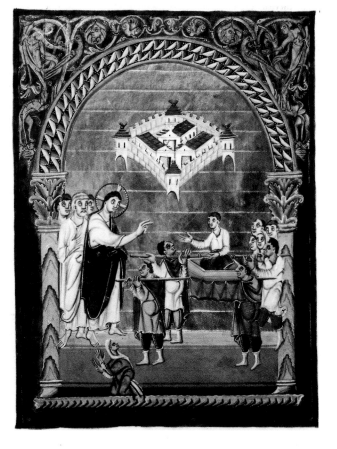

to and Quattrocento Italian painting. It is a first positive step in the direct observation of nature, performed with the aim of evoking the drama of battle (just as in the large horses that plunge and pitch in the main image above). What makes it all the more astonishing is that the artist lacked the benefit of a knowledge of perspective. The intention, however, is absolutely clear (though not followed up until many years later). This image appears in the border, already – as so often in later art – the place for forward-looking experimentation.

Nature as Landscape

Again and again, throughout the Tapestry, we encounter borderline cases between, on the one hand, traditional, premeditated, preconceived elements, and, on the other, direct observation. What induced the designer to make the individual buildings that appear at the top of the strip, above the people's heads, smaller – as with the Norman abbey church on its coastal mount or the houses of Hastings (pp. 109, 138)? The small scale used here contrasts markedly with the rendering of all the other architectural forms, which mostly stand as tall as the strip itself, punctuating the narrative or suggesting an interior scene. Diminution with distance is something that we now take for granted, but in eleventh-century art it is by no means the rule.

Tiny buildings, placed high in the image, are most common in the Christological scenes of Ottonian manuscript illumination – as, for example, in the scene of Christ and the widow at Nain in the Gospel Book of Otto III (c. 1000; fig. 7).[46] Most of the architecture in the miniatures consists of walled cities shown three-dimensionally from above. This Ottonian compositional convention derives from the background towns and villages in the landscape scenes of late antique painting.[47] Might Ottonian prototypes, similar in principle at least, have inspired the designer here? They might, but this in no way explains why the artist adopted them. What is more, his little houses are not at all antique in form.

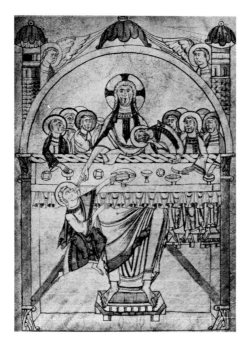

8 *Last Supper;* c. 1070.
Paris, Bibliothèque Nationale, Ms. lat. 12054, fol. 79

We learn more from the scene in which the Norman fleet crosses the Channel (pp. 132-4). There, three diminutive vessels sail along the upper edge of the strip; the placing of the word MARE alongside the first of these suggests the wide expanse of the sea. There is no parallel for this anywhere in eleventh-century art. It seems, therefore, that the designer was realizing in visual terms an everyday observation, that he was taking an impression of nature as his starting-point for depicting the vast spaces of the Channel crossing. From this it was only a small step to reduce the size of the houses of Hastings, after the Norman landing, and put them at the top in order to show that the fortified camp was on the outskirts of the town.

In all this there is a tentative search for new possibilities of design, even though the artist continues to treat his ground as a scatter pattern. These first, almost imperceptible efforts to transpose the component scenes of the work on to a new plane of 'visualization' are characteristic of the designer's three-way approach, drawing on tradition, imagination and observation. An emergent feeling for spatial depth, and an openness to the visual phenomena of nature, implicitly run counter

to the central principle whereby the narrative unfolds in a frieze-like succession of two-dimensional juxtapositions. This is just one of the contradictions in this artist's work, which never readily submits to definition in terms of a single norm.

IV

New Pictorial Inventions

The 'Last Supper' in the Norman Camp

The contradictions within the Tapestry demand our constant attention. It would be wrong, for instance, to imply that the bulk of the artistic repertory was based on study of nature. The principal source is the designer's schooling in existing art, from which he carried over compositions and motifs into the new context of his pictorial chronicle. Leaving aside direct natural observation, what of the artist's power of invention in general?

It has long been surmised that the iconography of the banquet scene, in which Odo sits in the central position, is based on that of the Last Supper,[48] with Odo himself – blessing the food and drink – in the place of Christ, and the waiter in that of Judas receiving the bread (p. 140 f.). This sounds plausible enough, but there are problems of detail. The semicircular table, common enough in Byzantine art, is rare in the Western iconography of the Last Supper before the twelfth century. Furthermore, in contemporary and earlier Byzantine versions of the Last Supper, Christ sits to one side and Judas is not in the foreground.[49] In eleventh-century art a centrally placed Christ, with Judas out in front, is a characteristically Western and Continental feature. One instance is a French drawing of the Last Supper, approximately coeval with the Tapestry (fig. 8).[50] Here, Christ sits in the centre; like Odo, he has a fish before him, while Judas, like the waiter in the Tapestry, scurries in from the left with knees bent.

This leaves us with the problem that eleventh-century Western representations of

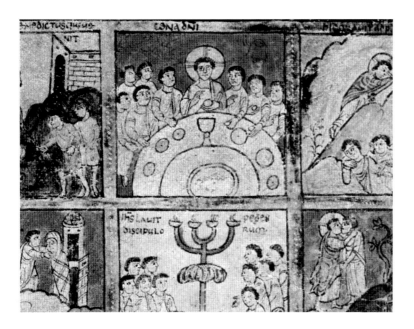

9 *Last Supper. From Gospel Book of St Augustine, late 6th century.*
Cambridge, Corpus Christi College Library, Ms. 286, fol. 125

10 *Last Supper.* Pala d'oro, *c. 1020.*
Aachen, Cathedral

the Last Supper normally show a straight, rectangular table. Incidentally – and significantly – this was not a popular theme in England: it does not exist in Anglo-Saxon art. In order to sustain the thesis that the Tapestry had an English designer, recent scholarship has pointed to a possible source image that was accessible in England at the time. This is the tiny Last Supper scene in a full-page composite miniature in the Gospel Book of St Augustine, a late sixth-century Italian manuscript that was held by St Augustine's Abbey, Canterbury, throughout the Middle Ages (fig. 9).[51] There, it is supposed, the designer saw the book and was inspired by it.[52] The hypothesis seems to be confirmed by the fact that Christ is imparting his blessing while centrally placed behind a round table.

But is this the whole answer? In the Early Christian miniature the table-top is a semi-circle, cut off by the lower edge of the picture. As in the Byzantine compositions, there is no room in the foreground for Judas, and Christ has before him not a fish, but a cup. There is no reason to suppose that Anglo-Saxon artists took any particular interest in this image, let alone that they made a 'modernized' copy of it in the eleventh century.

This would compel us to assume that the designer drew on two different versions of the theme at once – a barely credible conclusion. Furthermore – as will be shown[53] – this artist shows no interest in late antique precedents.

There are, in fact, only two possible explanations of the origin of the banquet scene in the Tapestry. The first is that there once existed one or more eleventh-century Last Supper compositions, now lost, which were identical in all essentials with the scene of the feast in the Norman camp. For this, however, there is only the scantiest of evidence. In Aachen, on the repoussé altarpiece known as the *Pala d'oro* (*c.* 1020), there is a Last Supper that follows the Byzantine iconography, with Christ seated to one side of a semicircular table, but with Judas centrally placed in the foreground (fig. 10).[54] The Ottonian goldsmith was thus already combining Eastern and Western traditions; yet the points of agreement with the Tapestry are not sufficient. The same goes for the Last Supper miniature in the Bamberg Sacramentary (*c.* 1050), a manuscript from northern France or Flanders (fig. 11).[55] In this, Christ sits in the centre behind the curved table, blessing the

meal (albeit left-handedly), but there is no Judas in the foreground. It might be conjectured that the designer had seen some innovative version of the subject that combined features of the two eleventh-century formulas, and that he based the scene in the Tapestry on this; but of this there is no conclusive evidence.

11 *Last Supper. From Bamberg Sacramentary,*
c. 1050. Bamberg, Staatsbibliothek, Ms. lit. 3, fol. 42 v

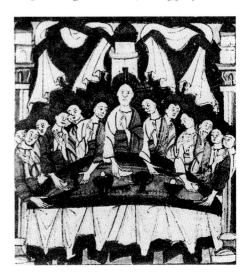

12 *Wedding at Cana.*
Tympanum relief, c. 1150.
Charlieu, Saint-Fortunat, narthex

The other possibility would be that, instead of laying hands on one of the most awesome subjects in Christian art, the designer turned to a less august precedent. He might have been inspired by the formula of the Marriage at Cana, as seen in the portal of Saint-Fortunat at Charlieu (*c.* 1150; fig. 12). Often erroneously interpreted as a Last Supper,[56] this relief shows a narrow, curved table, highly reminiscent of the horseshoe shape in the Tapestry.[57] There are other close analogies: Christ sits in the centre of an uncanonical number of diners and the table opens like a niche in the foreground to accommodate a servant. However, no earlier scene of this type has survived. We do not know precisely when the composition seen in the Charlieu relief evolved out of the iconography of the Last Supper. That it did so is highly likely; we can thus postulate the existence of a common prototype that might have influenced both the designer of the Tapestry and the sculptor of Saint-Fortunat. Yet we seem to have no way of reconstructing, with any certainty, the process whereby the designer of the Tapestry arrived at this pictorial invention.

Hunting Scenes

The designer certainly also had secular decorative motifs at his disposal. When Harold and his retinue ride down to Bosham (at the beginning of the Tapestry), they do not look like men setting out on a long journey. Their hounds, which run on ahead, apparently in pursuit of small game, and the hawk on Harold's left wrist, suggest that this is a hunting party. In all likelihood, the designer has dealt with the subject of a party travelling from London to the south coast by adapting existing images of the hunt. He would have had plenty of material to draw on, as the tiny hunting scenes in the borders suggest (below the scene where William dispatches his emissaries to Beaurain, pp. 102-4). Similar motifs appear in the calendar illustrations of eleventh-century manuscripts[58] and may very well have been painted on the walls of princely residences. Norman sculptors, too, working on new sacred buildings in the late eleventh century, favoured the same repertory: a number of capitals of the church portal at Goult, for instance, show elaborate hunting scenes with hounds, with an astonishing wealth of detail that is devoid of religious significance.[59]

In eleventh-century art the boundaries between the secular and the sacred often become blurred, and motifs frequently transfer from one realm to the other. The Tapestry designer did not by any means take his many images of animals exclusively from secular sources, even where the context of the scene would seem to suggest it. When the Norman horsemen are rounding up livestock for the camp feast at Hastings, an ox 'stands' with legs curiously bent and head turned to one side (p. 138).[60] The prototype here is unmistakably the Bull of St Luke the Evangelist, which holds a codex or a scroll between its forelegs and has its hind legs tucked up in sympathy (one example among many is the St Luke medallion in the *Majestas* miniature of the Stavelot Bible, dated 1097; fig. 13).[61]

Drolleries

At times, the designer's imagination takes wing, inventing genre details and drolleries that relax the earnest tone of some of the scenes. The hand of God appears above Westminster Abbey, conferring his blessing; but this does not deter a bird in the upper border from nibbling at the finial on top of the crossing tower (p. 121). The funeral procession of Edward the Confessor approaches the abbey, while a workman, bracing himself against one of the turrets of the royal palace, hastily installs a weathercock on the roof of the choir. The grotesque and the ordinary infiltrate the solemn and the sublime. Making the most of his evident artistic freedom, the designer delights in his own inventiveness.

Marginal notes and flourishes of this kind are the product of artistic caprice. The same may also be true of some of the animal motifs in the borders, such as the confronted pair of beasts beneath the hound scene at the very beginning of the Tapestry. Centaurs, winged beasts and mermaids were commonplace ornaments, both in the architecture and

13 *Bull of St Luke the Evangelist.*
From Stavelot Bible, 1097.
London, British Library, Ms. Add. 28107, fol. 136

in the manuscript illumination of the period; but here the artist has invented something that is all three at once. The bodies of these quadrupeds (each with its tail curled forward and one forepaw raised) are crowned with human heads; they sprout wings, not from their backs – as one might have expected – but from their necks. The result looks like a curious conflation of a dog and an angel.

The designer's range extends from the reproduction of existing iconographic forms, by way of the fruits of observation, to the presentation of the purely imaginary. We must, therefore, constantly reassess the distance between what is shown and the reality outside art. We cannot always take the artist (or the embroiderers, for that matter) literally, least of all in the local colour of objects, which is purely decorative, with no reference whatever to reality: the garments worn by individuals constantly change colour. The designer did not compose his pictorial chronicle according to any firmly defined system. Many, but not all, of the Anglo-Saxons wear moustaches; in the first half of the Tapestry, but not thereafter, the Normans can be reliably identified by the close-cropped backs of their heads (this includes William, who is later shown with a 'normal' haircut next to the burning house, p. 143). Often, a rule seems to be established, only to be subsequently flouted. Ground lines (representing the landscape) are mostly visible in outdoor scenes and not in indoor scenes; but there are also indoor scenes in which they do appear and outdoor scenes in which they do not. Tools and implements are usually shown in precise detail, but the ship in which Harold crosses from England to the Continent repeatedly changes both her stem post ornament and the pattern on her sail.

14 *Figured stone from Lärbro.*
8th century.
Bunge, Gotland, Hembygdmuseet

V

The Ships

The issue of visual accuracy carries particular weight in the seafaring scenes, because this is the fullest record of the subject anywhere in medieval art before the fifteenth century. The invasion fleet presumably consisted of both warships and transports, but the designer makes no distinction between them, except that some of the ships lack holes for the oars. Perhaps these were the cargo vessels, which normally travelled under sail. This is far from certain, however, since William's flagship, with the cross at her

masthead (her name, the *Mora*, is known from documents), also has no row-ports. The Duke certainly did not sail in a cargo vessel, but on a more manoeuvrable and prestigious warship. She will have been larger than the other ships in the fleet, since the inscription on the Tapestry tells us that he sailed IN MAGNO NAVIGIO (in a great ship).

Modern estimates of the size of the Norman army put it at seven thousand men,[62] who would have been transported in, at the most, several hundred ships.[63] Both Norman and Anglo-Saxon ships, with their tall stems and sterns, looked like the Viking longships of the tenth and eleventh centuries. Their clinker construction of overlapping planks is rendered in the Tapestry by horizontal stripes of contrasting colours. Again, this does not mean that the ships really looked like this (those under construction in the shipyard are equally brightly coloured). They were steered with a steering oar, which 'pivoted on a chock on the starboard quarter, with an athwart-ship tiller (i.e., fixed to it at right angles)'.[64] Often, the ship – like Harold's at the beginning of the Tapestry – would have a boat or boats in tow.

Shields on the Gunwale

In some of the ships under sail the shields of the crew are arrayed in a closely packed line along the gunwale. This has given rise to some controversy. A number of scholars have taken the view that this is a sign of 'insufficient knowledge of the sea' – indeed, 'a technical error on the part of the designer' – on the grounds that 'shields were only allowed to be displayed along the gunwales when in port'. 'With the limited navigational facilities of the single square sail', the crew would have had 'to man the oars… at any minute' to adjust course.[65] In answer to this, it might be said that the Normans' Viking forebears navigated successfully under sail with the steering oar alone; and Ellmers has pointed out that Viking ships were sailed with the oar-ports closed.[66] Admittedly, the experts on Viking history expressly declare: 'The shields were hung out for adornment when the ship was in port, not when she was under

way.'[67] The fact is, however, that on their coins,[68] and also on eighth- and eleventh-century Scandinavian carved stones, the Vikings repeatedly depicted their longships with shields displayed while under sail (and thus presumably at sea) (fig. 14).[69]

We must go into more detail. 'Further evidence that the designer was at fault' is, we are told, 'the arrangement of the shields *inside* the gunwale, where they could not be properly fixed: when displayed, they were always fixed outside the gunwales'.[70] Is this as certain as all that? Ellmers has observed that on a number of 'Scandinavian coins of the early ninth century... the shields are placed inside the gunwale', but that the Stone of Ledberg Kyrka[71] shows them hanging outside. It would seem from this that 'the only hard and fast rule was that the shields were arrayed along the ship's rail'.[72] Wilson, too, saw no problem in the shields on the inside of the gunwale, saying that they were 'to protect the people in the boat from spray'.[73] The opposing arguments seem to be more or less evenly matched; but how much of the evidence tells us about contemporary reality and how much derives from an iconographic tradition that was not overly concerned with detail?

Neither side in the debate has taken the shape of the shields into account. In the eleventh century Scandinavians were still using small, round shields. The shields of the Normans (also borne by some, but not all, of the Anglo-Saxons in the Tapestry) were of a narrow oval shape, tapering to a point at the bottom, and at least 1.3 metres high. The draught amidships was relatively shallow, and at sea, if these pointed shields had been hung outside the gunwale, the lower halves of them at least would undoubtedly have been soaked.

This would seem to settle one point, at least; but even this is not quite so simple. Among the miniatures in the Ebulo Codex, a south Italian manuscript of the late twelfth century,[74] there is an image that calls our hypothesis in question. This shows a ship crossing the Straits of Messina under sail, with kite-shaped shields displayed outside the gunwale (fig. 15).[75] Can we dismiss it as fantasy? Not out of hand, for the shields, like

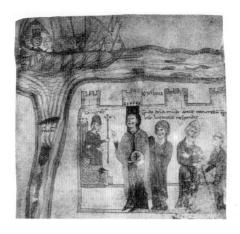

15 *Empress Constance sails to Messina. From Ebulo Codex, late 12th century. Berne, Burgerbibliothek, Ms. 120, fol. 120*

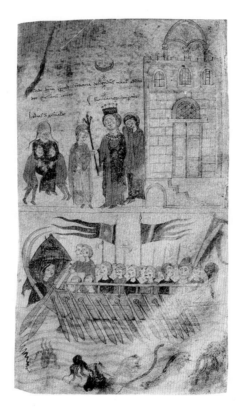

16 *Empress Constance on board a galley. From Ebulo Codex, late 12th century. Berne, Burgerbibliothek, Ms. 120, fol. 119*

those of the ships in the Tapestry, are arranged diagonally, thus diminishing their height. Even so, the shields would probably have got wet (as the illuminator seems unintentionally to suggest). So should they have been slung inside, as in the Bayeux Tapestry ships, where they could have been kept dry?

Could these very large shields have been slung at all? This is a matter for the historians of seafaring. One noteworthy piece of evidence is the diagonal placing of the shields, both in the manuscript and in the Tapestry. Since these two works belong to entirely separate artistic traditions, can we take it that this, at least, is accurate?

One fact in any case demonstrates that the designer of the Tapestry was not handicapped by 'insufficient knowledge of the sea'. Describing the excavation of the Gokstad ship, a Norwegian longship of the late ninth or early tenth century, Brøndsted wrote: 'When the ship was still inside the mound, she bore thirty-two shields along either rail... These were slung so that each half-covered the next one aft. Painted alternately black and yellow, the shields thus formed a solid row from stem to stern.'[76]

The designer of the Tapestry has shown the shields in exactly the same way, overlapping to form an unbroken sequence; and in all other depictions of Viking ships this feature is either missing or rudimentary. Since the Tapestry designer may well have had no extant pictorial tradition to rely on, he probably took the common maritime practice of the day as his source. Why, though, do the shields on the ships in the Tapestry always overlap from aft to forward? It remains unclear how they could have been fixed so as to resist the impact of wind and waves on the open sea. On a practical note, would they not have proved very awkward in a rough sea and a stiff breeze?

Shields at Stem and Stern

The arrangement of the shields gives rise to another puzzle. A few of the ships have a shield or two hanging at stem or stern or both, with heraldic-looking patterns on them. What were these shields for? The question hardly surfaces in the literature, beyond a brief reference. Wilson remarked merely that 'the shields at the stern of the ships may have had some significance'.[77] Gibbs-Smith, for his part, looked for a concrete explanation: 'The curious placing of shields (or shield-like structures) at bow and

17 *City seal of Kiel, 1365. Kiel, Stadtarchiv*

stern may be a form of the ancient *aphlaston*, or anti-ramming protection.'[78] This is scarcely convincing. Whenever these ships saw action at sea, there was no ramming, only grappling. Nor would such a protection have been sufficient — quite apart from the fact that ships would have rammed each other amidships, not head- or stern-on.

Or were the shields there only because there was no room for them anywhere else on board? This, too, would seem unlikely: two more shields would have been no great encumbrance on ships that were already carrying numerous weapons, horses and other items. Nor does it explain why the artist made such a point of them. There may be an element of psychological warfare involved: were these shields, together with those along the gunwale, intended to proclaim the strength and steadfastness of the ship's company to every side? Again, particular ships might have borne distinctive shields to make them identifiable to others in the convoy who would have seen them either head-on or stern-on.

The sceptic might well object that the designer probably intended no more than to provide his ships with an imaginary ornament. Even if so, however, the ornament in question is not unique. In the Ebulo Codex the illumination mentioned earlier is preceded by another that shows a large ship powered by oars; here, as in the Tapestry,

shields are mounted at bow and stern (fig. 16).[79] On the left, beneath an awning, sits Constance, the heiress to the Sicilian throne. Beneath her head is a shield with a light-coloured bend (a diagonal stripe), undoubtedly heraldic. On the next leaf, in the miniature of the ship under sail, the same coat-of-arms once more indicates the princess. Were shields, prominently placed on the bow and stern of a ship, used as ensigns? Caution is required in applying any such suggestion to the eleventh century, since William's flagship bears no such mark.

The depictions of ships in the Tapestry might none the less contain the germ of an evolution that was to take more definite form in the following century. Where we find ships bearing heraldic escutcheons on Hanseatic seals, these are not always in the same place. In the second seal of Wismar, *c.* 1350, the arms of the city cover the mast.[80] Yet on the Kiel seal of 1365 the arms of the feudal overlord are not only level with the prow but visibly fastened on to it (fig. 17).[81] Was this simply the seal-engraver's idea or did it stem from an iconographic tradition that went back to the age of the Bayeux Tapestry? Or did such a practice really (still?) exist in the thirteenth and fourteenth centuries?

Sails

At times, the designer's technical limitations have invited misinterpretation. The sails of the ships are mostly shown as triangular in shape; in reality they were rectangular. The artist did not know how to foreshorten in such a way as to give a recognizable rendering of a rectangle seen obliquely. (Carolingian illuminators, who were copying from late antique sources, had still possessed this ability.)[82] Yet in his first depiction of a ship at sea the designer has been at pains to indicate that the lower edge of the wind-filled sail is straight (p. 95). From here on, the rendering is simplified and stereotyped, but in a manner that emphasizes the roundness of the sail as it fills with wind. As the crossing proceeds, the apparently triangular sails become progressively more insubstantial and stocking-like.

Patterned sails, which were being made in Scandinavia by the tenth century,[83] seem to have provided a further stimulus to the designer's (and the embroiderers'?) imagination. In the Tapestry plain monochrome sails are the exception: most are striped in various colours to match the ships' sides and the rows of shields. We cannot, of course, assume that the patterns on the sails were exactly as shown; this artist was only too glad to take an opportunity of adding ornament.

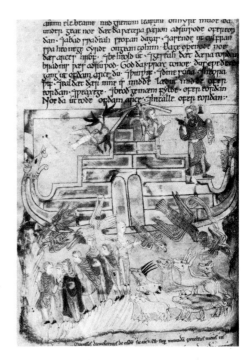

18 *Noah's Ark. From Old English Hexateuch, c. 1030. London, British Library, Ms. Cotton Claudius B. IV, fol. 15 v*

19 *Christ calms the storm. From Stuttgart Psalter, c. 830/40. Stuttgart, Württembergische Landesbibliothek, Ms. Bibl. fol. 23, fol. 124*

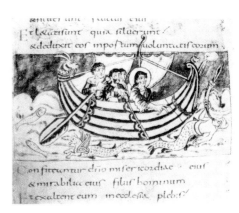

The designer seems to have taken particular pleasure in the most conspicuous ornament of the ships, the carved heads on their stem and stern posts. The Vikings – who were, after all, the Normans' ancestors – saw their ships as 'dragons'. This is in keeping with the fact that two ships in the Tapestry have a head forward and a tail aft (Harold's second ship at the beginning, and the third from last vessel in William's fleet, pp. 95 f., 133); but other ships with similar carvings are by no means so consistent. Once again, it is hard to distinguish between historical fact and artistic licence. One case of variety for its own sake seems to be the ship in which Harold sails home to England after swearing his oath: here, the stern post ends in a dragon's head and the beast's inward-curling tail is at the bow (p. 118).

The Tapestry also shows us ships with a head at each end, both facing forward. Was the designer here adopting a traditional artistic motif? The Old English Hexateuch contains a drawing of Noah's Ark as a 'dragon ship', with dragon heads on stem and stern posts, both looking forward (fig. 18).[84] Nor was this an eleventh-century innovation: in the Stuttgart Psalter, a north French manuscript of *c.* 830/40, Christ calms the storm while standing in a dragon ship that also has two figureheads facing forward (fig. 19).[85]

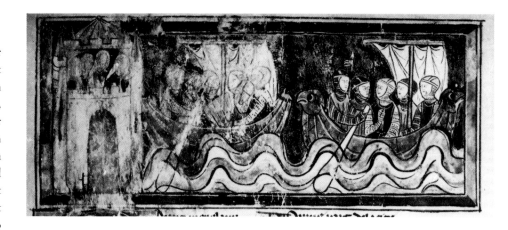

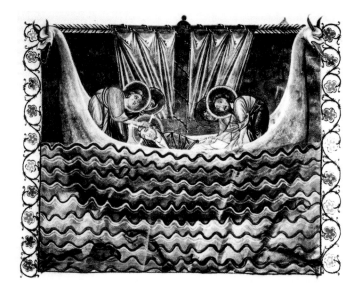

21 Aeneas leaves Carthage. From Roman d'Enéas, c. 1280. Paris, Bibliothèque Nationale, Ms. fr. 784, fol. 70

22 Storm at sea. From Salzburg Pericope Book, c. 1050. Munich, Bayerische Staatsbibliothek, Clm. 15713, fol. 22

20 Second city seal of Lübeck, c. 1250. Lübeck, Stadtarchiv

This type of ship is Scandinavian and not late antique in origin, and the Stuttgart Psalter was made at Saint-Germain-des-Prés, near Paris, in a region conquered at that time by the Vikings. It is tempting to assume, therefore, that the illuminator was responding to contemporary events by illustrating a Viking ship in this form.

For us today, iconographic tradition and historical reality are hard to tell apart. Since three such ships are shown in the Tapestry, perhaps they really existed. If there had been no substance in the tradition, it would not have survived in art as long as the thirteenth century – by which time carved stem and stern posts were anachronisms. Thus, all three versions of the city seal of Lübeck, made by order of the council *c.* 1200, *c.* 1250 and *c.* 1280, show a ship[86] with two animal heads (fig. 20).[87] Here, however, the figureheads are turned in opposite directions – as are those on the ship in which Aeneas sets sail from Carthage in a French miniature from the *Roman d'Enéas* (*c.* 1280; fig. 21).[88] These – clearly archaizing – depictions of ships with a pair of figureheads both facing outward also have their precedents in eleventh-century art (fig. 22).[89] On the whole, we should not exclude the possibility that, at the time when the Tapestry was worked, double-headed dragon ships sailed the seas and that the designer was not relying solely on existing art.

On closer inspection of the ships' figure-heads in the Tapestry, we notice that some of them (on two of Harold's ships at the beginning, and on the third from last ship in the Norman fleet) are human faces in profile (pp. 96, 133). Are these heads with stylized hair and beards, on the stem and stern posts of dragon ships, the products of artistic caprice? We are reminded of the decorative initials in twelfth-century Anglo-Norman manuscripts, such as the initial V in a Bible in Oxford, in which a similar human profile with ornamentalized head-hair grows out of the body of a dragon (fig. 23).[90] Yet in eleventh-century manuscript painting such metamorphic combinations of dragon bodies with human heads were neither widespread enough, nor consistent enough in design, to count as a possible source for the heads in the Tapestry. The likelihood is that eleventh-century ships really did have anthropomorphic figureheads. A narrative of the Battle of Nesjar (1016) mentions the longship of King Olaf of Norway, which was called the *Carl's Head*; legend has it that the monarch carved the figurehead with his own hands.[91]

23 *Initial V. From Bible, c. 1150.*
Oxford, Bodleian Library, Ms. Auct. E. inf. I., fol. 304

The equation of a dragon's head with a human head, as exemplified on one of the ships in the Norman fleet, is a product of pagan thinking. As we learn from numerous pre-Christian myths, anthropomorphic animal effigies were symbols of magical powers which affected human beings, and through which the mysterious forces of nature could be influenced.[92] In pagan belief nature and man interpenetrated and took an equal part in magic. Long since Christianized, the eleventh-century shipwrights certainly no longer thought this way, but it tells us something about the Normans that they continued to take this (presumably) ancestral custom for granted. It is a remarkable survival; for we should not forget that a figure carved in the round affected people in those days with an intensity that we cannot remotely imagine. (One notes, too, that the post-medieval practice of adorning ships with figureheads was not without precedent.)

All this rank idolatry ought to have been opposed on religious grounds, for in the eleventh century the established Norman Church was intent on avoiding any possible reproach in this direction. This is admittedly speculation, but: if the Norman clergy did not strive with all its might to eradicate these practices (and the Normans' Scandinavian forbears were by no means forgotten),[93] this does not necessarily mean that the Church liked them. There may well have been attempts to 'defuse' such images by subjecting them to a Christian interpretation (as with the dragon with a human profile that appears as a symbol of the Evil One in the Oxford initial). Is it a coincidence that the profile head on the Norman ship, with its hooked nose, centrally placed eye and cockscomb-like hair, is very similar to the Devil slain by the Archangel Michael in one late eleventh- or early twelfth-century ivory (fig. 24)? (This relief, now in the Museo Nazionale del Bargello in Florence, stems from what is now Belgium; its workmanship is presumably northern French or Flemish.)[94]

This anthropomorphic dragon's head is not the only striking piece of sculpture on

24 *St Michael. Ivory relief, c. 1100.*
Florence, Museo Nazionale del Bargello

the ships in the Tapestry. A particularly eccentric piece adorns the stern post of William's own flagship: it is a figure (no doubt in wood) of a man from the knees upwards, blowing a horn and wielding a little lance complete with pennant (p. 134). This is a unique document. Taken in conjunction with the other figureheads, it demonstrates that, in the eleventh century, figurative sculpture was valued as a purely secular decoration. Then there is the throne on which William sits at his first encounter with Harold (p. 107). Conspicuous on its left-hand side is a single, carved post with an animal's head finial;[95] such posts existed among the pre-Christian Scandinavians.[96] Evidently, traditions many generations old were still alive at the time when the Tapestry was made.

The beached ships of the invasion fleet not only have their masts unstepped, but also lack figureheads (p.136). Gibbs-Smith surmised that 'the draughtsman evidently did not feel it worth while to embellish [them] with carved stem or stern posts'.[97] Wilson, on the other hand, posed the question: 'Could it be that they [the ornamental posts] were demountable?'[98] Indeed it could. We know that the pre-Christian Vikings regarded their figureheads as the repositories of fearsome powers: in the ninth and tenth centuries they made it a rule to remove the dragon heads when a ship was beached, to avoid alarming the spirits of the shore.[99]

Once more, it looks as if Norman shipwrights in the second half of the eleventh century were still observing pagan customs. This goes to show how thin the veneer of orthodoxy could be, outside the monastery walls; it might also mean that, in certain cases, blatantly pagan observances were tolerated. If true, this would be a highly significant exception in the life of the period. For in France, England and Germany alike, the clergy possessed a monopoly of education; literacy, on the whole, was their prerogative.[100] What of the designer of the present narrative? It is doubtful whether he himself would have been a cleric; in any case, he did not shrink from illustrating a fundamentally pagan use of sculpture. It looks as if he was recording a familiar sight.

Transporting Horses

During the Channel crossing, most of the ships in the Norman fleet (in fact, all those without rows of shields) have horses looking over their gunwales. It is currently estimated that, of William's soldiers, 'some two thousand may have been mounted';[101] the fleet would thus have had that number of mounts to transport. If the Normans used cargo vessels of the same size as the Danish Skuldelev Ship No. 1, the capacity amidships would have been some 35 m³;[102] this would have been enough for several horses. When a tenth-century Danish ship from Ladby was reconstructed from its extant remains, the replica was able to put to sea with four horses on board; these embarked and disembarked by stepping over the ship's side, in the way clearly shown in the Tapestry (cf. p.136 and fig.25).[103]

The majority view among recent commentators has been that carrying horses by sea was a new departure in Normandy. Werckmeister asserts that it was borrowed from the southern Normans, those of Sicily, who had it in turn from Byzantium.[104] This opinion was first advanced by the specialists in Norman history.[105] Jäschke appealed to a documented fact: 'In 1060 or 1061 – possibly under Byzantine influence – the Normans had successfully transported warhorses on board ship.' He regarded this as a new achievement on their part. The ninth-century Danish invasion fleets might well have brought horses with them, but in his view the settled Normans of northern France had done no such thing for many years and nothing is known about the Danish attacks on England in the eleventh century.[106]

It seems, however, that the Vikings took their horses with them across the sea on many occasions in the ninth century. We know, for instance, that they sailed up the Loire to attack Angers; and there 'the use of cavalry is mentioned for the first time'.[107] Why should the descendants of the Vikings have forgotten all they knew of navigation, including the transportation of horses? (They certainly had not forgotten how to build large ships.) Was it because they had settled down? The Normans, who traded with England on a large scale from around 1000 onwards, were a maritime people with a long coastline. Tenth-century Norman coins have been found in Scotland, Denmark, Pomerania, Poland and Russia.[108] The everyday language of Normandy in the eleventh century contained a large number of Scandinavian terms relative to navigation, such as *walmanni* (whaler), *valsetae* (whalers' confederation) and *fisigarda* (fishery). Even a hundred years later, the Duke's flagship was known as his *esnèque* (a Norman-French version of the pre-Christian Viking word for ships, *snekkjur*).[109] The Danish campaigns in England in the early eleventh century would never have been as successful as they were without the mobility provided by horses. Shipping horses across the Channel was perfectly normal practice in the eleventh century: *Domesday Book* (the land register compiled in Norman England in 1086) cites the fare for a crossing via Dover for a horse as 3*d* in winter and 2*d* in summer.[110] What was extraordinary about 1066 – and this the Tapestry makes clear – was the sheer scale of the undertaking.

25 *A horse being disembarked from the replica of the Viking longship from Ladby, Denmark*

Harbour Works?

At the beginning of the Tapestry narrative we learn that ships were not always beached at the end of a voyage, but could be securely anchored. So they by no means always landed on gently sloping beaches or simply grounded themselves by waiting for the tide to ebb, as is sometimes suggested in the literature. This raises the question as to whether any harbour works existed at the time in England or in northern France, for, according to Ellmers, 'in the course of the eleventh century quays began to be used, at which ships had enough depth of water to moor while still afloat'.[111] (The draught of merchant vessels was constantly increasing.)

This seems to be confirmed by the scene in the Tapestry in which the ship bringing Harold back to England is sighted by a look-out who appears to be stationed on a pile construction that stands in the water – in other words, a man-made quay or wharf (p. 118 f.). Yet this is far from certain. The piece of scenery in question might well be a stylized representation of a coastal town or fortress, since the adjacent building has a number of windows with people looking out of them.

Soundings and a Signal Lamp

The ships in the Tapestry incorporate many details indicating that its designer knew the sea at first hand. When Harold takes ship at Bosham, two men pole the vessel out into deep water (p. 94 f.). They lean far back to push their poles: a startlingly precise piece of observation. As the ship approaches the French coast, the anchor is held out at exactly the right angle to gain an immediate hold on the bottom. On the same ship another man holds a line over the side, which drops into the water far below him. (The lookout on the English boat that brings tidings of Harold's coronation is doing the same; p. 125). It has been suggested that this may be a fishing line,[112] but at landfall no member of the ship's company would have had the leisure to go fishing, and this can hardly have been what the designer meant. Most likely, the seaman is dropping a lead, on its long line, to ascertain the depth beneath the keel.

The designer of the Bayeux Tapestry was certainly not unversed in a variety of nautical skills, though some details leave us unenlightened as to whether they actually correspond to the practice of the day. One of these is the masthead of the Norman flagship. The use of a cross as a topmark presents no problem; it appears on the ships shown on the Carolingian coins from Dorestad.[113] Beneath it, however, is a curious structure consisting of a large square divided in four by a cross. It looks like a framework of laths, but the commentators on the Tapestry, and maritime historians, almost unanimously interpret it as a signal lantern or a masthead light.[114]

It is true that, according to contemporary Norman sources,[115] William's ship did have a lantern at its masthead, which was used in the fleet's overnight crossing. Yet can the large, square construction in the Tapestry be a light? A masthead light could only have been a glass container with an oil-lamp in it – and that is just what this conspicuous detail does not look like. Torches cannot have been used, because of the danger of setting fire to the sails. Kretschmer alone rejected the lantern interpretation. He considered the object to be 'a kind of coat-of-arms', a 'personal emblem of William, as Duke and commander of the fleet',[116] intended to make the flagship identifiable from a distance. This is a highly plausible suggestion, although no one else has taken it up. We should take the whole masthead at face value: essentially a double cross, with a possible function as an ensign. The double cross, or 'True Cross of Christ', was a common emblem in the Byzantine empire, where it possessed imperial connotations: both the Empress and the Emperor bore it on their sceptres.[117] By the eleventh century this venerable symbol had reached the West, where it was used for reliquary crosses.[118]

VI

Open Questions

Turold

It begins to be evident that the Tapestry contains a number of details – and pieces of observation on the part of its designer, or 'pictorial chronicler' – to suggest that it was made within a single generation of the Norman conquest of England. The term 'chronicler' does not necessarily imply that we have before us a uniformly accurate, dispassionate piece of reporting. The artist may well have added his own emphases and made his own value judgments, particularly in the interpretation of subsidiary episodes. In these, we encounter scenes that the artist himself has probably chosen to emphasize (although it is also conceivable that his patron asked for them) and that are sometimes obscure in meaning.

To the right of the two emissaries from William, who are talking to Count Guy, stands a dwarf with the name TVROLD above his head; he is holding the reins of their two horses (p. 101). The inscription must relate to the dwarf, as personal names in the Tapestry consistently appear above the heads of those to whom they refer. What was so famous about this bearded dwarf with the back of his head shaved? If he lived at Beaurain, why was he called Thorald, a Scandinavian name that was popular in Normandy? Although Wilson ignored the Norse origin of the name (since he believed that the designer was an Anglo-Saxon), he offered a surprising, if not wholly new, interpretation: Turold is 'the artist of the Tapestry'.[119] Yet why should the designer have portrayed himself in this place, let alone shown himself engaged in an activity more proper to an ostler? With his markedly short legs, the figure clearly is a dwarf, and not to be confused with the portraits of scribes or illuminators on dedication pages, who are shown as diminutive figures in the presence of saints or princes. Other authors have supposed the name to refer not to the dwarf, but to the emissary immediately to the left of him. This

is not very helpful either: Turold was too popular a name in Normandy.

The Ælfgyva Mystery

The greatest source of puzzlement to date has been the subsidiary episode to the right of the meeting between Harold and William in the ducal palace: VBI VNVS CLERICVS ET ÆLFGYVA, 'where a cleric and Ælfgyva' have an encounter (p. 107). There have been many attempts to establish the identity of the female figure, who has been seen as, among other things, a young girl, a married woman, a widow, an abbess and a death symbol.[120] Historians have often detected a whiff of scandal, 'of overtly sexual character',[121] to which the tiny naked figure in the border, diagonally beneath the lady's feet, is held to allude. The cleric is said to be boxing her ears, stroking her cheek, or whatever. The possibilities, as Wilson remarks, are endless.[122]

Perhaps we may make some progress in the matter if we base ourselves firmly on what is there in the Tapestry. The word VBI, meaning 'where', with which the relevant inscription begins, refers to William's palace, PALATIV[M], in which the gesticulating figure of Harold seems to be pointing at the adjacent episode of the woman and the clergyman. The flanking towers suggest that the observer is to regard the two scenes as a single thematic and spatial unit. Ælfgyva is standing in an ornate doorframe, presumably part of William's palace – and are we to suppose that a clerk in holy orders abused her there, sexually or otherwise? Whatever his reasons for doing so, in terms of eleventh-century aristocratic values this would have been dishonourable to the householder, who was the Duke himself.

Now let us look at the woman's profile more closely. A salmon-pink shadow, the same colour as her headdress, falls across her forehead, nose and eyes. This unmistakably shows that she is wearing a veil and that the cleric is striding up to her and lifting the veil. This can only mean a betrothal scene (and not any form of misconduct on the clergyman's part).

Who was this promised bride? And whom was Ælfgyva supposed to marry? The Norman historian William of Poitiers tells us that a daughter of William's (unnamed) was betrothed to Harold of Wessex. In 1113 or so the account of the conquest by William of Jumièges was reworked by another Norman chronicler, Ordericus Vitalis, who stated that William had five daughters, the eldest of whom, Agatha, was engaged to be married to Harold.[123] Douglas, the English historian and one of the best-informed specialists in Norman history, considered this to be proven;[124] his colleague Butler[125] agreed, and went on to assert that the name Agatha was equivalent to the Anglo-Saxon name Ælfgyva.[126] This would mean that Harold had two reasons for visiting Normandy: to confirm Edward's promise of the throne to William and to make arrangements for his own marriage. The Ælfgyva episode would thus become an extremely important element in the pictorial chronicle. Harold would stand condemned on two counts: not only perjury, but also breach of promise.

Everything would now fall neatly into place, if it were not for one thing. Why does the Tapestry not call William's daughter Agatha, as the Norman chronicles do? Was the Anglo-Saxon name intended as a forcible reminder of Harold's breach of the marriage contract? Did she perhaps change her name at the betrothal? This leads on to the crucial question: was it possible among the Normans for one person to bear two synonymous, but different, names? This did happen. Norman documents refer to Duke Rollo (synonymous with the Norse Hrólf) as Robert. His daughter bore the alternative names of Gerloc and Adelis. The consort of Duke Richard I was called both Gunnor and Albereda, and one Turstinus (derived from the Norse Thorstein) was known in ecclesiastical circles as Richard.[127] Norse, which the eleventh-century Normans had certainly not forgotten, and Anglo-Saxon were kindred languages. Perhaps this was why the Normans had no difficulty with the name Ælfgyva.

Several prominent individuals in Normandy had names which now seem to us typically Anglo-Saxon, but which were demonstrably part of Norman cultural identity. Thus, Stigand, Archbishop of Canterbury and previously (1043-52) Bishop of Winchester,[128] is regarded as a leading figure in the ecclesiastical resistance to the Normans, but his name – which the Vikings knew as Stigandi – was also borne by the head of the Norman aristocratic family of Mézidon.[129] Curiously enough, this man's other name was Odo; we are immediately reminded of Bishop Odo of Bayeux, who ruled Kent – including Canterbury, although he did not become its archbishop – as William's deputy after 1066. His name would have been a familiar one to the inhabitants, because from 942 to 958 there had been an Archbishop Odo of Canterbury.[130] To return to Ælfgyva: Harold's mother was a Danish princess by the name of Gytha, sister to the Danish Prince Ulf.

All of which shows it to be a distinct possibility that Ælfgyva was William's daughter Agatha. Alternatively, the Tapestry might well be referring to a sister of Harold's whom he wanted to marry off to some Norman noble (a member of the Duke's family?). Harold's father, Earl Godwine, had eight children, including one daughter whose name was Ælfgifu.[131] Whatever the truth of the matter, the Tapestry narrative seems to indicate that Harold bore the responsibility for a marriage that did not take place.

To dispose of one possible objection: there would have been nothing unusual about a marriage between a Norman woman and an Englishman. King Æthelred II had married Emma, daughter of Duke Richard I of Normandy;[132] their son was Edward the Confessor.

We can safely say that this scene does not allude to any mysterious scandal: it represents a betrothal that must have played a considerable part in the lives of the principal figures in the story.

VII

The Borders

In the case of the Ælfgyva scene, the border motif of the naked figure thus turns out (previous interpretations notwithstanding)[133] to be irrelevant to the principal scene, but there remains the question of the meaning and relevance of this strip (8 centimetres high on average) for the narrative as a whole. Diagonal bars separate the borders into many sections, most of which contain animals or birds. Often, these are heraldically con-

26 *Capital, late 11th century.*
Sainte-Marie-du-Mont

27 *Relief from Canterbury Cathedral.*
Late 11th or early 12th century.
Canterbury, Heritage Museum

fronted creatures separated by a small triangular space that contains a stylized plant. (Characteristically, the designer did not stick to this formula: it is frequently interrupted and, from the shipbuilding scenes onwards, the dividing bars are often doubled, with plant tendrils in between.)

This decorative form had its origins in eleventh-century Continental textile art. In the cathedral treasury in Bamberg, Wormald discovered a number of woven borders with a similar arrangement, in which animals alternate with plants.[134] That said, we do not yet know what specific area of source material the designer drew on for his animal motifs. Confronted pairs of heraldic beasts belong to a widely current ornamental repertory that reached the West from the Byzantine empire and the East in the early Middle Ages; they are a favourite theme of eleventh- and twelfth-century architectural sculpture, as well as manuscript illumination and mural painting (figs. 26, 27).[135]

Borders as Glosses?

McNulty is more positive than most other scholars in asserting, in a recent book, that the figurative ornament of the upper and lower borders of the Tapestry is closely bound up with the content of the pictorial narrative.[136] Yet, on the whole, this attempt to interpret the borders as glosses or commentaries on the historical narrative fails to convince. It tends to substitute generalizations and contrived hypotheses for argument; the object under scrutiny in each case is ultimately fitted into a preconceived pattern.

McNulty's book begins (and this sets the pattern for what follows) with a discussion of a motif that appears beneath the advancing Norman cavalry before the battle (p. 145).[137] The author concentrates particularly on the left-hand bird, into whose compartment of the border a little star has been inserted. The bird stands on one leg, its far wing droops and its head points downwards. It forms part of the standard repertory of the upper and lower borders (the same motif, mostly paired, appears at least fifteen times in the Tapestry, with no material variation ex-

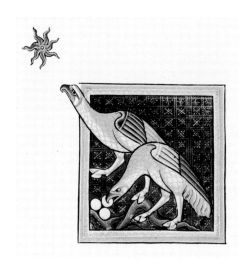

28 *The ostrich. From Bestiary, early 13th century.*
Oxford, Bodleian Library, Ms. Ashmole 1511

cept in colour). McNulty does not concern himself with the form of the bird, but only with the attribute that its pendant lacks: the star, which supposedly identifies the bird as an ostrich. We are, therefore, to assume that the designer took his depiction (directly or indirectly) from an illustrated bestiary (fig. 28). Not content with this, McNulty goes on to assert that the ostrich stands for William the Conqueror (and not for the soldiers who ride in the main panel above). This is on the strength of a legend (cited with no indication of the place and time in which it was current) that the ostrich eats iron, and even iron horseshoes.[138] *Ergo* the bird symbolizes the Conqueror's iron fortitude as he leads his troops into the Battle of Hastings.

Two obvious questions are skirted here. Firstly, if this hypothesis is true, why is the ostrich situated so far away from the Duke, who rides at the head of his troops? Secondly, why is there no star to accompany the formally identical pair of birds that does appear directly beneath William as he rides? According to McNulty, ostriches served as 'symbols of military prowess' and 'enjoyed a very respectable reputation in the Middle Ages and Renaissance'.[139] Yet the bestiary texts that were widely accepted as accurate in the Middle Ages tell us the precise opposite

about the ostrich: 'In appearance and in habits, it is a deterrent example of a multiplicity of vices. It often stretches out its wings to fly, but cannot lift itself off the ground, just like those hypocrites who give themselves the appearance of holiness but are never holy in their actions. The ostrich has wings, but its plumage is not dense enough to lift its heavy body into the air… The fact that the ostrich lays its eggs on the ground and takes no further care of them signifies that human beings often care as little for their own children as the ostrich, which lays its eggs in the desert sands.'[140]

If the designer of the Tapestry had any allegorical interpretation of this particular creature available to him, it is likely to have been the one just given. If the contemporary beholder attached any meaning to an image of the bird, this was probably it; and if the designer really intended to show an ostrich as a symbolic representation of William the Conqueror, we can picture the reaction of the patron who had commissioned him to create a Norman victory monument.

According to McNulty, female centaurs are used in the borders to satirize Harold and render him ridiculous,[141] yet at no stage in the narrative proper does the designer attempt to make fun of the English. The birds that cross their necks beneath Bosham church, at the beginning of the story (p. 93), are said by McNulty to be putting their heads together to suggest a conspiracy and to cast Harold and his companion in a bad light[142] – and this, while the two men are entering the church to pray. (Not to speak of the fact that two birds again cross their necks above William's palace when he despatches his emissaries to Count Guy; p. 103)[143] The implication would be that the two Anglo-Saxons were misusing the house of God to hatch their evil plans. This kind of arbitrary interpretation tempts one to wonder, for instance, just what might be meant by the donkey that sinks its head down to meet the word PRELIVM (battle) above the two knights who ride with pennants behind William at the head of his cavalry (p. 146).[144] One might ask numerous questions of this kind, which illuminate nothing. There is no com-

pelling basis for the view that the borders as a whole interlock thematically with the pictorial chronicle, acting as a symbolic commentary thereon.

There are, it is true, some points at which the borders allude to the narrative, but then they do so directly. Some scenes extend into the upper border (the rigging of the Norman ships and a number of individual architectural forms); in some cases inscriptions take the place of ornamental motifs. The lower border is similarly brought into the narrative. As an echo of the fateful comet above, the ground almost literally shifts beneath Harold's feet, and the lower border shows his premonitory dream of ghostly ships on the sea (p. 124). Just crowned, he converses with another man. The conversation seems to turn on the imminent danger of a Norman fleet, hinted at in the border (and the man who hurries in from the left holds in his left hand a sword that points down at the spectral fleet). During the battle, the lower border even takes an active part in the events above. Before the final sequence of fallen soldiers begins, the very last pair of birds topple over as if themselves dead (p. 153 f.) Yet even this transition holds no deep moral or allegorical message.

Fables

A number of authors have looked for encrypted messages in the fables illustrated at various points in the borders.[145] There are many of these, between the feast at Bosham and the capture of Harold, including those of the Raven and the Fox, the Wolf and the Lamb (drinking from the river), the Bitch in Pup, the Crane and the Wolf, and the Lion (Wolf) and his Subjects. Despite the effort that some commentators have lavished on the subject, none has succeeded in demonstrating any relevance to the pictorial narrative of the Tapestry; and others have confined themselves to a factual listing of the fables.[146]

The very fact that some of these tales (including the Raven and the Fox, and the Crane and the Wolf) are repeated in the borders later in the sequence, where they accom-

pany totally different historical episodes, goes to confirm Wormald's still entirely satisfactory conclusion: 'In the Bayeux Tapestry these fables serve a purely decorative purpose and cannot be related to the main scenes. Such decorative use of fables was already known in France in the ninth century.'[147] The themes of the fables are said to derive from a collection used by the French poet Marie de France (who was Norman by birth)[148] in the mid-twelfth century. She stated that it was of English origin,[149] but we do not know whether or when it reached the Continent. (Marie de France lived in England in the reign of the Plantagenet King Henry II.) We therefore cannot tell if the designer of the Tapestry used a Norman (illustrated?) version based on an earlier English prototype. What is certain is that this whole repertory of motifs was very popular and was known in several places in France.

Much the same might be said of a number of other details in the borders, such as the little scene of a farmer aiming a stone at some birds with a sling (beneath the name TVROLD, p. 101). Since Abraham does this in a drawing in the Old English Hexateuch, it has been supposed that the designer had a similar Anglo-Saxon illustration of the Old Testament before him as he worked (fig. 29).[150] This has been used as an argument for the designer's English origin. Yet such reasoning misses the mark, both by drawing over-hasty connections between the few and scattered fragments of surviving pictorial material and by ignoring some real divergences. Abraham holds his left arm close to his side and his head appears in three-quarter view. The farmer in the Tapestry, by contrast, has his face in profile and there is more of a swing to him. He slings the stone with both arms outstretched.

There is no excluding the possibility that this motif is of Insular origin, but we must not overlook the fact that many works of Anglo-Saxon art were exported across the Channel in the eleventh century. There are numerous cases in which scenic and ornamental details can be shown to have found their way into Continental art.

29 *Abraham uses a sling against birds. From Old English Hexateuch, c. 1030. London, British Library, Ms. Cotton Claudius B. IV, fol. 26 v*

Calendar Motifs, Pattern Books, Eroticism

The tiny scene of the farmer scaring off the birds that eat his seed is among the images of country life, and (in the following section of the lower border) of hunting, which Wormald ascribed to the influence of calendar illustrations.[151] (In Anglo-Saxon calendar illustrations, as mentioned above, horses do not draw harrows.) We are indebted to the same English scholar for identifying a possible source area for many of the border motifs. The strip of pictures beneath the Brittany campaign consists of 'fish, animals, a centaur and a figure with a knife'; as Wormald noticed, 'they look very like derivations from representations of the constellations'.[152]

Does this mean that the artist collected the individual images from a variety of books and altered them to suit his own ends? Surely not, for we find comparable combinations of calendrical, astronomical, fable and bestiary illustrations in the decor of floors (as in the Norman-Italian mosaic at Otranto, in southern Italy, which dates from 1163/65).[153] We find similar assortments of details in the (very rare) extant medieval pattern books, and it is perfectly possible that such a book was the source of the ornament in the borders of the Tapestry. Compilations of this kind are known to have existed in early eleventh-century French manuscript painting; Wormald drew attention to the pattern book of Adhémar of Chabannes, which contains both constellation pictures and illustrations of fables.[154]

What remains elusive is the source of the diminutive figures, generally described in the literature as erotic, that appear in the border with absolutely no relevance to the pictorial content of the Tapestry. While William and Harold converse in the hall of the palace, beneath them a naked man is at work with an axe (p. 107). Oblivious to the Norman cavalry as it sets out for the battlefield, a naked, crouching couple above stretch out their arms to each other (and here what is generally concealed becomes visible; p. 145). 'Racy' motifs of this kind have noticeably embarrassed some of the commentators on the Tapestry. A number of them simply fail to mention these unusual details;[155] others make vain attempts to interpret them as scenes from fables.[156] No one has considered that the designer may have had other motives for including them.

Why, then, did the artist opt to blend his animals and birds, his scenes of rural life, and all the rest with an erotic content that sometimes verges on the obscene (see the couple in the lower border beneath the release of Harold, p. 104)? One answer is that these, like the other motifs, are simply decorative flourishes. Of course they are; but is that all? Is this sufficient explanation for the function of the borders? If the edges of the Tapestry were literally 'meaningless', then why did the designer not content himself with geometrical ornament of the kind that we find, for instance, in the borders of Scandinavian figured textiles?[157]

Images of Nature

Juxtapositions of fabulous beasts, real creatures, human beings and plants are common in early medieval art. They form the staple repertory of Anglo-Saxon and Norman historiated initials of the eleventh and twelfth centuries, which present a world full of internecine strife. In nightmarish scenes human beings kill each other; animals bite one another, attack people and devour plants; plant tendrils, in turn, throttle and stifle animate creatures. Such depictions of aggression are noticeably rare in the borders of the Tapestry, although they would have been well suited to the battle scenes. The figure content of manuscript initials is often interpreted in terms of the constant threat that humankind will be overwhelmed and destroyed by evil; that is clearly not the theme here. What is to prevent us from taking the border motifs (along with much that is unusual in the picture narrative itself) at their legible face value? These long processions of assorted creatures, often interrupted by trees, plants, scenes from fables, loving couples, individual figures, constellations, hunting scenes, look like a catalogue with repetitions, a roster of life in the midst of nature (to eleventh-century people, even a fabulous beast was very much a thing of this world). These multitudes of living creatures stand for nature, in which — mostly two by two — they have their being.

Aside from the pleasure in crudity that viewers in those days presumably felt from time to time, the erotic motifs yield a meaning only if they are seen, in conjunction with the others, as a part of the workings of nature — as a deliberate evocation of the world in the midst of which the story of William and Harold is enacted. The borders are meant to entertain the audience, to keep alive its interest in the narrative by enlisting its curiosity as to the outward appearance of the world and of nature. The decor has a complementary, framing, contextual function.

It would, therefore, be wrong to dismiss the borders as entirely irrelevant, but we must also avoid regarding them as a symbolic interpretation. Time and again, modern writers

on medieval art tend to assume that every accessory form in painting, sculpture or decorative art either embodies a moralistic meaning or comments directly on the principal matter in hand. And yet Theophilus, author of the famous treatise *De diversis artibus* (*c.* 1100), regarded the majority of decorative work as mere 'enrichment', without immediate significance – although this experienced artist-scholar (a specialist in several branches of art) was himself a priest and, no doubt, a monk. In this category Theophilus included 'branches, flowers, leaves', also 'small animals, birds, ribbon-work' and (of particular importance to us) 'naked people'.[158]

Centuries before the emergence of modern landscape painting, the borders of the Tapestry were home to a variety of living creatures. In other words, this is a first essay in the depiction of nature, an early, tentative approach to Life and Reality, paralleled in the narrative strip by the designer's occasional forays into direct observation. All this, significantly, owes nothing to the heritage of late antiquity: these are radical new departures.

VIII

Anglo-Saxon Workmanship?

The Issue

The controversy as to whether the Tapestry was worked in England or in Normandy dates from the beginning of the twentieth century. If we accept the consensus of the recent literature, the matter seems to be more or less settled: the scholars of the past four decades have been almost unanimous in settling for England as the Tapestry's country of origin.[159] For this, however, no instantly compelling evidence has yet been produced.[160] No eleventh-century work of art has survived that bears a consistent and direct affinity to the figure style of the Tapestry. We must proceed by assessing the most

reliable indications that seem to suggest analogies; only then can we arrive at a judgment.

The main difficulty is this: in the eleventh century, Anglo-Saxon manuscript illumination influenced a great many artists in Normandy, northern France, and Flanders. As Wormald rightly pointed out: 'Any conclusion based on stylistic considerations alone is bound to be weakened unless this important fact is remembered.'[161] He went on to pronounce a verdict that decisively tilted the balance of opinion in England's favour. Cautiously sifting the evidence, but largely relying on analogies in individual forms or motifs, Wormald concluded that the Tapestry 'was produced by English workmen'.[162] His clinching argument, which has influenced all subsequent discussion of the Tapestry, was that of 'a type of English drawing which was a close survivor of the style of drawing associated with the famous ninth-century Utrecht Psalter and its English descendants made about the year 1000'. This style is found in some late eleventh-century manuscripts from Canterbury, and 'some heads in the Bayeux Tapestry have some similarity to these drawings' – although 'the transformation from pen drawing to needlework has modified the outline'.[163]

A Winchester Relief

One further, seemingly weighty argument for the 'England thesis' was adduced by Wilson. It is based on a badly damaged fragment of bas-relief found at the site of the Saxon Old Minster in Winchester (fig. 30). Roughly contemporary with the Tapestry, this sculpture was 'discarded when the church was pulled down in 1093/94 to make way for the Romanesque Cathedral'.[164] The subject has not been identified. On the left, we can still make out part of a man in armour; on the right, is the head and outstretched hand of a recumbent figure with, above it, the head of a dog or wolf, partly masking the man's left hand.[165] Wilson was convinced that this work was part of a relief frieze. In particular, the standing man's 'mail shirt with its trouser-like leg protection and short sleeves' was

'very similar to those of the warriors in the Tapestry'.[166]

Is this analogy enough to confirm that the Tapestry is of English workmanship? As has been said, there was probably never any such thing as a mail shirt with mail trousers (see p. 26). The impression of a 'trouser-like leg protection' in the relief is partly due to the fact that a section of the lower hem of the garment has broken off, on the right next to the scabbard.

The mail here covers only the top part of the thigh, whereas in the Tapestry it reaches at least as far as the knees; similarly, in the sculpture the sleeves of the mail shirt barely cover the shoulders, while those worn in the Tapestry always extend past the elbows. Nor is it easy, on stylistic grounds, to accept the proposed *terminus ante quem* of 1093/94 for the Winchester sculpture. As Zarnecki pointed out: 'Towards the end of the eleventh century… sculptural decoration of churches both in Normandy and in England was confined chiefly to capitals.'[167]

Major narrative relief friezes did not appear in architecture until the early twelfth century, and this later dating of the Winchester sculpture is supported by the comparatively

30 *Fragment of relief. Early 12th century (?). Winchester, City Museum*

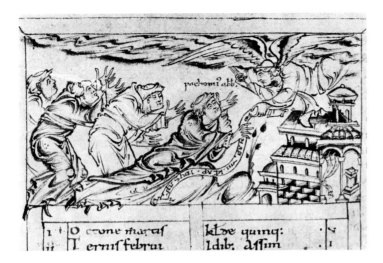

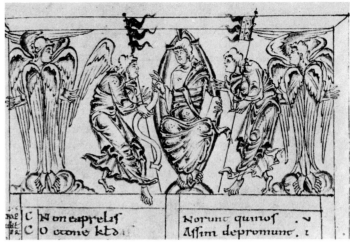

31 *St Pachomius receives the Easter Tables; c. 1073.*
London, British Library, Ms. Cotton Caligula A. XV, fol. 122 v

32 *Christ and angels; c. 1073.*
London, British Library, Ms. Cotton Caligula A. XV, fol. 123

carefully rounded forms and the elaborate patterning of the mail shirt, which approximates to 'realism' and does justice to the complex texture of the mail. This relief just does not fit into eleventh-century art, and least of all into Anglo-Saxon art.[168] Why must it have been made by an English sculptor? Norman craftsmen were employed at Winchester from the late eleventh century onwards. A comparison between the relief and the Tapestry shows no more than general similarities, of motif rather than of style, and these have no bearing on the debate over the Tapestry.

Not Anglo-Saxon Figure Drawing

What, then, was the contemporary state of painting in the south of England and, particularly, that of manuscript illumination in Canterbury? Wormald hesitated to draw any sweeping stylistic parallels, but his successors made much of the common features between the treatment of figures in the Tapestry and that in the 'Utrecht style' of Anglo-Saxon manuscript painting, which they found to be still practised in Canterbury after 1066;[169] and this brings us close to the time of the making of the Tapestry.

In confirmation they pointed to the two tinted drawings in Ms. Cotton Caligula A. XV (in the British Library, London), which were made in the scriptorium of Christ Church, Canterbury, *c.* 1073 (figs. 31, 32).[170] According to Bernstein, the Tapestry maintains 'the Utrecht style of extremely active, animated figures who make their points with dramatic gestures', stylistic features that he found to be present, in a more mannered form, in the drawings of Cotton Caligula A. XV.[171] It is true that the figures in the Tapestry and in the manuscript have similarly slender proportions, but those in the manuscript turn out to have a totally contrasting kind of liveliness, obtained through entirely different artistic means. In them, the internal modelling is marked by gradations in the width of pen and brush strokes, which denote hollows in the draperies or creases in their convex parts. The areas left blank suggest convex relief, the rounding of the body. The figures in the Tapestry, on the other hand, have virtually no volume at all. They look as if cut out of a sheet of foil.

Now comes the crucial point: the figures in the manuscript drawings seem to radiate an inner energy. The angels to the left and right of Christ appear to skip; the clerics in the previous drawing exude excitement. This impression is based on the hyperactive linear configurations within the figures, which seem to transform the blank areas. The swing of the lines is meant to be noticed, and followed by the eye; but they do not obtrude themselves like a superimposed network of busy forms. The substance of the figures appears to flow. Washed shadows soften the occasional sharp edges of the drawing, and the figures take on an almost atmospheric quality: a consistent identifying feature of Anglo-Saxon manuscript illustration from the beginning of the eleventh century onwards (which means that it is wrong to see the drawings in the Canterbury codex as a 'mannered' version of the style). The outlines, which are mostly not followed through in a single line, often lose some of their importance. The figure tends to melt away at the periphery. From the beginning of the century onwards, Anglo-Saxon figuration is characterized by the same nervous spontaneity that we find in these two drawings.

In the Tapestry, by contrast, the forms are traced by a stable outline, reduced to the essentials. Hard-and-fast lines distinguish and subdivide the figures, but individual limbs constantly make abrupt changes of direction, always strictly parallel to the ground. Liveliness here is created by surprising shifts of movement within a single plane. The restlessness of Anglo-Saxon art differs fundamentally from the tireless dynamism of the Tapestry.

The Anglo-Saxon characteristics just discussed are specific to the figure drawing of most early eleventh-century English manuscripts, whether from Canterbury or from Winchester.[172] Scholars have enlisted the two drawings in Cotton Caligula A. XV as key witnesses to the survival of the Anglo-Saxon 'Utrecht style' after 1066. A number of other stragglers can be dated as late as 'the first decade of the twelfth century'.[173] Significantly, most of these stem from Canterbury. A number of scholars have spoken, with Kauffmann, of the 'tenacious survival' of the style.[174] According to Bernstein, it is a manifest truth that the 'Utrecht style' did not disappear when the Normans arrived in Canterbury.[175]

However, once we take a comprehensive view of early post-conquest manuscript illustration in the south of England, things look very different.[176] There was no unbroken Anglo-Saxon artistic tradition. Two fundamental changes took place. The full-page dramatic scene abruptly lost favour, and the figures became hard-edged and flat (of which more later). The works of *c.* 1073 that have been cited, with their wholesale reversion to the earlier, Anglo-Saxon drawing style, are exceptional (such later throwbacks as exist always represent a compromise with the new planar style.) In other words, this was not a survival of Anglo-Saxon art, but a deliberate revival.

It was probably no coincidence that this Anglo-Saxon 'Renaissance' took place in Canterbury. There, the monks remained bitterly hostile to the new Norman hierarchy. They came out in open revolt, and there were deaths and woundings. On several occasions Archbishop Lanfranc had monks flogged; unruly townsmen had their eyes put out.[177] In *c.* 1100 monks at St Augustine's Abbey, Canterbury, wrote the manuscript known as Cotton Vitellius C. XII and adorned it with drawings in the Anglo-Saxon revival style.[178] Its Martyrology contains a provocative entry for 14 October, enjoining prayers for 'Harold, King of the English, and very many of our brethren'.[179] There are neither styl-

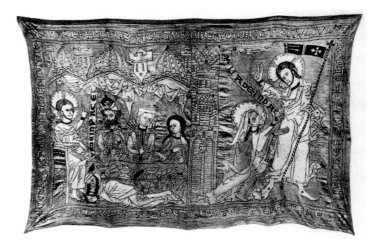

33 *Legend of St Mary Magdalene. Altar hanging, c. 1250. Wernigerode, Schlossmuseum*

istic nor historical grounds[180] for supposing Canterbury (or anywhere else in the south of England) to be the home of the Bayeux Tapestry – a monument that so resoundingly celebrates the victory of the Anglo-Saxons' enemies.

Embroidery Technique as a Factor?

The artistic verdict is decisive and must (as Wormald pointed out) address the issue of whether the technique of embroidery is responsible for the very marked formal divergences between the Tapestry and Anglo-Saxon art. How crucially did technique influence style? The line drawing of the Tapestry, in stem and outline stitch, can be directly compared with, for example, the embroidery on an altar frontal, worked *c.* 1250 in Saxony and now in the Schlossmuseum at Wernigerode (fig. 33). Although worked on linen, 'at minimum expense of materials (no gold thread, little coloured silk)', the two scenes of the life of St Mary Magdalene display a 'minute and sharp-edged style of drapery folds',[181] which exactly corresponds to that of the manuscript illumination of the same time and place. Embroidery technique in itself, therefore, does not necessarily call for any marked departure from the stylistic features of local contemporary art.

Additionally, the figures in the Tapestry incorporate some (though not many) details that are out of keeping with the overall aim

of simplifying the outlines and reducing three dimensions to two. In the gesticulating figure of Harold in William's palace (p. 107) the hem of the green tunic clings to the rounded form of the right knee (contrast the simplified curve of the clergyman's tunic in the adjacent Ælfgyva scene). Back in England, Harold stands before King Edward in a knee-length ochre tunic whose hem is represented by a restlessly undulating line (p. 120). The figure on the left of the group of men digging fortifications at Hastings wears a tunic with a hem that falls into a stepped outline, like that of the bunched folds of the cloak on the shoulder of the officer in charge (p. 142). The lining of the same cloak shows a slightly curled pattern of creases.

All this indicates that the embroiderers would have been perfectly capable of creating more subtly differentiated forms, and hence of engendering a stronger sense of volume, if they had wanted to. The point is that they did not. If the design of the Tapestry had derived from Anglo-Saxon models, much more of the fluid style of drawing would inevitably have found its way into the cartoon and thus into the needlework. Yet this is clearly not the kind of expressive statement that the embroiderers (and/or the designer) wanted to make: their work reflects a different aesthetic. The Tapestry shows virtually no clearly defined survivals of the sketchy Anglo-Saxon formal idiom and their

absence argues conclusively against the supposition that the Tapestry was worked in the first two decades after 1066 by English operatives trained in the Anglo-Saxon school.

Art at Saint-Vaast

There was a powerful Anglo-Saxon influence in the eleventh-century art of the Continental regions closest to the Channel; but there, even before 1066, a style emerged that was nearer to that of the Tapestry. In Arras, some way to the north of Normandy, there was an important scriptorium at the monastery of Saint-Vaast, and this produced a Bible (*c*.1040; Ms. 559 in the Bibliothèque Municipale, Arras) with drawings that Schulten likened to contemporary Anglo-Saxon work. He compared the scene of the Jews debating (vol. 3, fol. 70 v) with a part of the Last Judgment page (fol. 7) of Ms. Stowe 944 in the British Library, a codex from Winchester illuminated *c*.1030 in the prevalent English tradition of the 'Utrecht style' (figs. 34, 35).[182] According to Schulten, the figures, with heads craning forward and draperies bunched around the hips, demonstrate that the Arras artists were working from Anglo-Saxon models. Yet they did not merely copy or imitate their sources: they developed 'patterns' of their own. The drawing is firmer and more spare; Anglo-Saxon sketchiness gives way to more concrete and more explicit indications of form. The hardening of the line reveals a marked impulse to define objects clearly, and the whole artistic method obviously derives from a desire to pin down the elusive forms of English art. The handling of the figures in the Bible from Saint-Vaast is thus far closer to that of the seated figures in the Tapestry (made three or four decades later) than are the Anglo-Saxon works commonly adduced by way of comparison.

This can be demonstrated in detail. The striated look of the draperies in the Arras drawing, their static appearance within firm outlines, is close to the stylistic preferences of the Tapestry designer. A number of the heads on the outstretched necks of the Jews seated in the lower row do not project so

much as shoot forward, like those of Harold and his companion as they tell King Edward about their travels, or that of the scout who reports to William to the left of the blazing house (pp. 120, 143). The Arras Bible tends to a more rigorous inner contrast between hardened outline and dramatic gesture, as emphasized by the elongated arms of some of the Jews. The tendency of parts of the body (such as thighs) to move independently proclaims an approach that is alien to Anglo-Saxon art.

All this reveals tendencies which were to grow even stronger in the art of northern France and neighbouring regions in the second half of the eleventh century and which are structurally akin to the style of the Tapestry. Speaking of the manuscripts produced at the great monasteries of Saint-Vaast and Saint-Bertin in northern France, Schulten summed up accurately: 'A common approach, marked by greater stylization and greater rigidity than their English models,

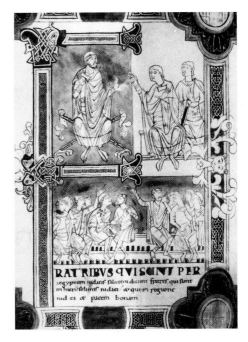

34 *Jews in debate. From* Saint-Vaast Bible, *c. 1040. Arras, Bibliothèque Municipale, Ms. 559, vol. 3, fol. 70 v*

35 *Scenes from the Last Judgment. From* Liber vitae *from New Minster Abbey, Winchester, c. 1030. London, British Library, Ms. Stowe 944, fols. 6 v – 7*

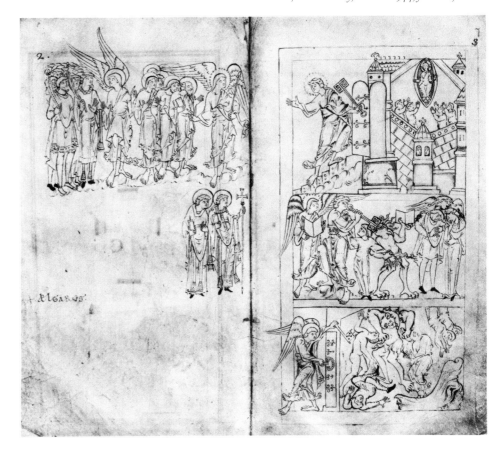

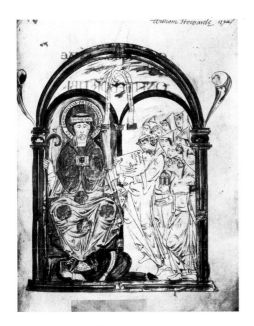

36 *St Benedict. From Eadui Psalter, 1012-23.*
London, British Library, Ms. Arundel 155, fol. 133

Commentators on the Tapestry have tended to iron out the variety of its expressions of animate life so as to fit its overall design into the framework of Anglo-Saxon art. As a result, the issue of the function of technique has barely been touched on; nor has that of the relationship between line and colour. Thus, Bernstein drew an analogy between the Tapestry and the coloured drawing of St Benedict in the Eadui Psalter (made in Canterbury between 1012 and 1023)[184] in order to make the point that, despite all the differences between drawing and embroidery, the two works shared the same balanced interaction of line and coloured plane (fig. 36).

This kind of comparison, with its excessive reliance on the interpreter's subjective impressions, misses the true character of the Tapestry style. In the Canterbury miniature, created about half a century earlier, the lower part of the draperies is coloured with a pink that looks transparent, like a watercolour (even the thin greenish-gold of the cloak over the trunk barely covers the ground). The delicate overlying linear strokes do not engender the firm definition of forms that we find in the Tapestry; the outlines hardly count at all. In the manuscript colour and line strike a fragile balance; their interaction in the Tapestry is fundamentally different. There, in the figures of the seated William and the standing Harold in the oath scene, the salmon-pink line drawing contrasts with the blue-black and ochre of the draperies and hardens the outline (an additional dark blue line separates the inside of Harold's cloak from the linen ground, p. 117). The balance is maintained, but with a sense of massive weight.[185]

Like the figures in northern French painting, those in the Tapestry display forms and motifs (certain head types, and slender overall proportions) that are borrowed from Anglo-Saxon art. The Tapestry seems, however, to extend its frame of reference to include other planar styles, which (unlike English

38 *St Michael. Mural painting,*
last third of 11th century. Le Puy, Cathedral

characterizes the northern French regional styles.'[183] New, autonomous formal qualities emerged. However generalized the parallels with the Tapestry, surely they favour the likelihood that the Tapestry was worked on the same side of the Channel and indeed in the neighbouring province of Normandy, within the wider sphere of influence of the school?

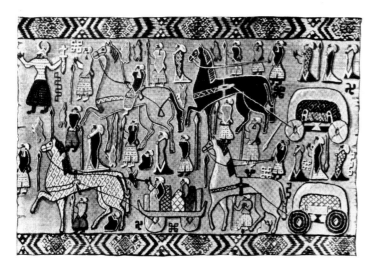

37 *Oseberg hanging (reconstruction). 9th century. Oslo, Universitetets Oldsaksamling*

art) were almost entirely out of contact with late antique art. In the ninth-century Norwegian hanging from Oseberg the figures are formed by solid areas of yellow, red, greyish-white and blue-black, all outlined in different colours (fig. 37).[186] This is not to say that the designer of the Tapestry took Viking works of this kind as direct models (although some reminiscences probably exist; see p. 63 ff.). Yet he was clearly involved in the evolution of a specifically Early Romanesque pictorial conception (that of a flattened 'space'), which was initially anti-classical in its approach and left little scope for illusionism.

In terms of stylistic history the Tapestry belongs to the mid-century transitional phase that preceded the step-by-step unfolding of the Romanesque principle of planar colour, first in France, then in Flanders, along the Meuse and the Rhine. Relatively often, the embroiderers of the Tapestry subdivided or framed compartments of green, ochre or dark blue with red lines to create the impression of compact figurative planes. This deliberate segregation of coloured lines and planes is incompatible with Anglo-Saxon art, but it appears on the Continent in mural painting as well as manuscript illumination. The great fresco of the Archangel Michael in the cathedral of Le Puy dates from the second half of the eleventh century and is therefore roughly contemporary with the Tapestry (fig. 38).[187] Michael's figure seems as if pressed flat, partly because the red areas of drapery have a firm internal drawing in blue, and the yellowish areas one in red (which agrees with the rendering of the group of William and Odo observing the fleet under construction, p. 126).

This same principle of division, of 'oppositional separatism', emerged in late Ottonian manuscript illumination c. 1050. The phrase is Tikkanen's, taken from his account of the colour in a Gospel Book now in Berlin in which he emphasizes the 'unrealistic and decorative… stylization, moving towards the Romanesque mentality', with characteristic 'lines in markedly different colours, mostly vermilion, over local hues of red-brown, blue and green'.[188]

Architecture and Pictorial Composition

In their own way the buildings seen in the course of the pictorial narrative presented by the Tapestry belong to the same stylistic phase. Take the architectural sequence that frames both the newly crowned King Harold and the crowd that gazes at the comet (p. 123 f.). Archbishop Stigand's solemn pose signals to us that Harold, in all his regalia, is enthroned in a church; but the buildings shown reveal nothing of the kind. The architectural settings in which successive groups of figures appear are not primarily intended to convey the facts of topography. By marking breaks in the rhythm of events, they clinch and focus the action itself. Within the wider of two adjacent architectural frames, the figures presenting the sword of state break in from the side upon the frontal pose of Harold and Stigand. Together with the tower at Stigand's left hand, the rigid *en face* view of the two men puts a brake on the motion and creates a focus shared by the crowd that stands in the next 'frame', on the right, to acclaim the new monarch. The third compartment marks a reversal. The dividing pier loses stability by tapering towards its foot to make room for the figures, and the crowd has turned – or, better, has wheeled round – to point at the evil omen in the skies. The juxtaposition of these two approximately equal compartments demonstrates that the populace has switched its focus of interest: enthusiasm has given way to alarm.

These buildings have more of a compositional than a representational function. Like

39 *Story of Daniel. From Great Lambeth Bible, c. 1150. London, Lambeth Palace Library, Ms. 3, fol. 285 v*

the internal contours within the figures, the architectural frames within the narrative mark a new evolutionary departure. In Romanesque painting architectural elements are used in much the same way as in the Bayeux Tapestry, to subdivide the picture area and, at the same time, to stress the successive nature of the narrative (fig. 39).[189] Here, again, a major distinction emerges between the Tapes-

40 *Christ before Pilate. Bronze doors, c. 1015. Hildesheim, Cathedral*

41 *Deposition. From Hastière Psalter, c. 1150/70. Munich, Bayerische Staatsbibliothek, Clm. 13067, fol. 17 v*

try and Anglo-Saxon art. In eleventh-century English manuscripts architectural features consistently serve to establish spatial values of projection and recession, however simplified. In the Tapestry (rare exceptions aside) this does not happen. Here, the architectural elements stand flat against the picture plane, in a succession of turrets, gables, depressed arches and square (or occasionally sloping) rooflines. Analogous forms are to be

found not in England, but on the Continent, where they date back to the beginning of the eleventh century. The reliefs on the bronze doors of Hildesheim cathedral (*c.* 1015) ring the changes on a number of stock elements, like stage flats (as, for example, in the scene of Christ before Pilate, fig. 40).[190]

In the region of so-called 'Channel art', which undeniably produced the Tapestry, Anglo-Saxon and Ottonian influences combined to engender proto-Romanesque styles at a very early date.[191] In centres further east, too, 'Channel' impulses were absorbed with alacrity and artists created versions of the human figure that are analogous, in principle at least, to those in the Tapestry. One example is the Deposition scene in a Psalter made at Hastière in the Mosan region, *c.* 1050/70 (fig. 41).[192] Its figures, with their summary, triangulated stylization, recall the triangular pattern of the draperies in the scene of Harold's capture (p. 97). This geometrical approach, with its tendency toward abstraction, is something that would never have occurred to an Anglo-Saxon artist.

Figures in Catalan Art

Stylistic phenomena of this kind can be traced from 'Channel art' right through to the manuscript illumination produced in southern France and northern Spain in the first half of the eleventh century. Thus, for example, the figures in the lengthy cycle of

illustrations in the Catalan Bible of S. Pere de Roda[193] point to the beginnings of Romanesque art and simultaneously supply a precedent of sorts for the figure style of the Tapestry. In the knee-length tunics worn by these biblical figures parallel lines separate triangular leg areas, hooked together by short curves. It is not far from this to the – mostly even more radical – schematization of the draperies in the Tapestry. At times, we even observe rather close similarities between the two, though the clothing of the Tapestry figures is even flatter in projection: compare the drawings in volume three of the Roda Bible (figs. 42, 43)[194] with the figure of the cleric in the Ælfgyva scene (p. 107), with those of the soldiers who hold their shields over their heads as they ford the river Couesnon (p. 109 f.) and with that of Harold in the scene where he is offered the crown (p. 122). The figure drawing of the Roda Bible is marked in general by simplification, consolidation, clarity, taut outlines, reduction of pictorial depth to a shallow surface layer – all attributes that reappear, greatly intensified, in the style of the Tapestry.

It might be objected that analogies of this kind spring from extrinsic factors (such as, perhaps, an equal degree of provincialism) and are insignificant in view of the vast geographical distance that separates the Catalan Bible illuminations from the Bayeux Tapestry. However, there is nothing at all fortuitous about these similarities. They emerge

42 *Story of Zechariah. From Roda Bible, first half of 11th century. Paris, Bibliothèque Nationale, Ms. lat. 6, vol. 3, fol. 45 v*

43 *Story of Daniel. From Roda Bible, first half of 11th century. Paris, Bibliothèque Nationale, Ms. lat. 6, vol. 3, fol. 64 v*

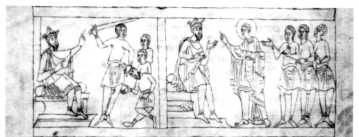

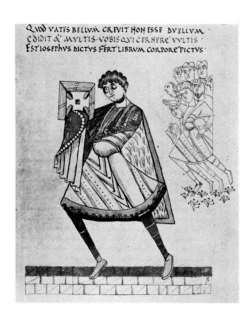

QVOD VATES BELLVM CREVIT NON ESSE DVELLVM
CODIDIT & MVLTIS VOBIS QVI CERNERE VVLTIS
EST IOSEPHVS DICTVS FERT LIBRVM CORPORE PICTVS

44 *Flavius Josephus. From Flavius Josephus,*
De bello judaico, c. 1070/80.
Paris, Bibliothèque Nationale, Ms. lat. 5058, fol. 3

from a specific historical situation: that of the revolution in eleventh-century art. In both regions artists consciously turned against a prevailing tradition that was still more or less late-antique. Anglo-Saxon artists were never so radical, which is why their work, for all its virtuosity, was fated to lead them into the dead-end of 'splendid isolation'.

And did northern artists really have such narrow horizons that they knew nothing of what was happening in the south of France and the north of Spain? Odd though we may now find it to discuss the Tapestry, and its 'Channel' origins, in the same breath as an illuminated manuscript from Catalonia, the fact is that artistic contacts did exist. In 1070 or so (at the very time when the Tapestry was worked) Norman illuminators at Mont-Saint-Michel developed new pictorial formulas derived from northern Spanish Bible illustrations.[195] It was presumably Normans, after the conquest, who brought a similar Catalan codex to England, where it influenced the iconography of biblical scenes in twelfth-century Anglo-Norman art.[196]

A number of conspicuous figures in motion in the Tapestry further confirm the designer's wide knowledge of the techniques of depicting action in the art of France or of neighbouring regions. After the building of the fort at Hastings, the scout who comes to William with news of Harold's army looks as if he is still running (p. 143). Similarly animated poses appear in the frontispiece of a late eleventh-century French manuscript of Flavius Josephus' *De bello judaico* (fig. 44).[197] In this the historian, carrying his book, is followed by a flock of readers, the first of whom makes the same eloquent gesture with his outstretched hand at head level as the messenger in the Tapestry. Josephus himself adopts a pose, a variety of the fencer's lunge, that is common in French art of the latter half of the eleventh century and the early part of the twelfth.[198] Its effect is to make the figures look like marionettes, half dangling and yet active. The legs appear to trail along the ground, parallel to each other, with the left foot far back. The figure – in a rather forced alternation of forward and backward, reading from the top – forms a kind of recti-linear S, and the energy of its motion is strictly confined within two dimensions: a maximum of haste while standing on the spot. The posture seems to reflect an incipient geometrical refraction of organic form into triangular structure.

Here, again, we have an example of a systematized, but highly specific, means of bringing figures to life, which has absolutely nothing in common with the kind of animation found in Anglo-Saxon figure drawing before and shortly after 1066. The active figures who people Anglo-Saxon art appear to move, bend and stretch far more by their own power. Even when they trip and skip, they keep their feet on the ground. Those in the French Josephus frontispiece and in the Tapestry are more radical in their denial of natural, volitional movement. They direct their energies strictly laterally, and these require – or so it seems – to be held in check by firm outlines. This principle of animation re-

45 *St Mark the Evangelist.*
From Jumièges Gospel Book,
late 11th century.
London, British Library,
Ms. Add. 17739, fol. 69

curs in many variations in the Tapestry: in, for example, Harold and his companion as they enter Bosham church or in the man who leads over from the scene of Harold's solemn oath to that of his departure for England (pp. 93, 117). Although the figures in the Josephus differ from those of the Tapestry in the design of their draperies, we find important structural parallels in the figure drawing; and these count for far more than the analogies of motif that often find their way into the debate as a mere string of instances.

Painting at Jumièges

Although works of art from the Continental seaboard do contain many motifs of Anglo-Saxon origin, they also reveal an effort to break free of English influence. The figures in the Saint-Vaast Bible, from Arras, with their craning necks and hunched shoulders, are exaggerated versions of Anglo-Saxon originals. Towards the end of the eleventh century this process was carried further in the Norman manuscript illumination of the monastery of Jumièges, near Rouen – as in the image of St Mark in the Jumièges Gospel Book now in London (fig. 45).[199] The almost horizontally extended 'bottle neck' of the angel behind the Evangelist is virtually identical with that of Harold as he reports to King Edward on his expedition to Normandy (p. 120). This is an extreme version of a posture that, in Anglo-Saxon art, had been interpreted organically. The exaggeration looks deliberate, as if the artist felt compelled to assert his own individuality. In post-conquest English art there is nothing even remotely comparable; on the other hand, Norman manuscript illumination and the Tapestry largely coincide in their *interpretation* of an originally English motif.

Dodwell's verdict on Norman manuscript illumination after 1066 is apposite here: 'In general, the Norman illuminator was less sensitive than the English one.' A number of images in manuscripts from Jumièges look, he says, like unconscious parodies of the Anglo-Saxon style.[200] In a sense, this remark might apply to some individual figures in the Tapestry, but in any case it can be accepted

46 *St Mark the Evangelist. From Gospel Book, c. 1050. Cambridge, Fitzwilliam Museum, Ms. McClean 19, fol. 41*

only with reservations. For 'unconscious' we should really read 'conscious', and the use of the term 'parody' implicitly devalues the new departure and elevates the Anglo-Saxon past to a position of superiority.

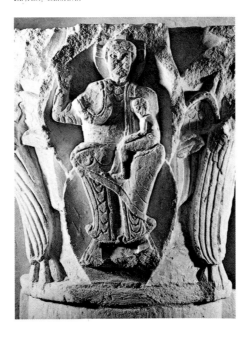

47 *Christ. Relief on capital, c. 1070. Bayeux, Cathedral*

In the mid-eleventh century the monastery of Saint-André at Le Cateau-Cambrésis (near Cambrai, again not far from the north-eastern borders of Normandy) was producing illuminated manuscripts that have a far better claim than any Anglo-Saxon work to be regarded as stylistic antecedents of the Tapestry. One characteristic example is the St Mark miniature in a Gospel Book now in Cambridge (fig. 46),[201] which reveals marked affinities with some of the seated figures in the Tapestry (although the latter are at least two decades later in date), notably with the enthroned figure of William in the scene of Harold's oath (p. 117). In both, some parts (such as the tucked-up knees) are divided into compartments. The areas occupied by the figures, wider at the bottom than at the top, are stretched flat by a firm system of internal lines that leaves no room for nuances of bodily posture or spatial location. In the Gospel Book miniature and in the Tapestry the result is a rigidly organized decorative whole, although the Evangelist's draperies retain more traces of a free relief style.

A Relief on a Capital in Bayeux

To anticipate: from this miniature it is only a step or two to the figures on the fragments of two very large capitals from the crossing of Bayeux cathedral, consecrated in 1077;[202] and, of all surviving works of eleventh-century art, these come closest, in structural terms, to the Tapestry style. Take the relief of the enthroned Christ from the south-eastern pier. Although it is possible that this has been altered by 'restoration' work in more recent times (the figure's belly looks as if it has been levelled off and the fold in the 'curtain' of drapery below the knees seems to have been made deeper; fig. 47),[203] the repertory of drapery forms, deployed with restraint, shows a kinship with that in the Tapestry. Overlapping oval notches form a pattern that fills certain panels of the figure's drapery in the relief, as it does in the figure behind Guy of Ponthieu as the latter receives William's emissaries (p. 100f.). In the garments of Christ, on the one hand, and in those of William and Odo when ordering

the building of the fleet, on the other, a ribbon-like form across the shins of the seated figure emphasizes individual compartments of the drapery, tending to give them autonomy; but, at the same time, the effect is to compress the figure as a whole, so that the implicit tension between body and clothing is resolved into two dimensions (p.126). This amounts to a considerable stylistic affinity, which carries some weight. In the sculpture – almost exactly as in the Tapestry – the outline serves as the defining limit of an emphatically unified figure.

In most of their major eleventh-century buildings the Normans remained largely indifferent to sculpture (see p.77). The figurative capitals in Bayeux form a surprising exception to the rule. Mainly because of this, it has been supposed that, in mid-century and later, Bayeux 'was the sculptural centre of Normandy. And, as the rediscovered capitals from the crossing show, the figurative art of Bayeux belongs in the first rank of the French sculpture of the period'.[204] Reason enough to regard the city as an important centre of artistic activity; and this, together with the stylistic evidence and the likelihood that Bishop Odo, for whom the cathedral was built, was also the patron of the concurrent work on the Tapestry, makes it all the more likely that this needlework monument to the Norman victory was worked in Bayeux. It is also possible that the designer had received his artistic training there (although he might well have done so elsewhere in Normandy) and that he was the head of the local workshop.

Parallels with Anglo-Norman Art

From 1066 onwards England under Norman rule was increasingly penetrated by art from the Continental seaboard. The largely unfamiliar style of the incoming works radically transformed the local tradition and ultimately formed the rootstock of a new art, that of the Anglo-Norman Romanesque. This was eventually to evolve into something stylistically closer to the Tapestry, but in the latter part of the eleventh century it was still a tentative, emergent phenomenon. Remarkably

few illuminated manuscripts were produced at this time, and the only common features between them and the Tapestry are clearly Continental in origin.

Shortly after 1072 (contemporary with that document of Anglo-Saxon resistance, Ms. Cotton Caligula A. XV, from Canterbury) a miniature of St Luke was painted in the Exeter scriptorium, based on a Flemish model of *c.*1040 (fig. 48).[205] The flattening of the figure and the stylization of the internal contours – radical by comparison with Anglo-Saxon art and scarcely less pronounced than in the Tapestry – are lifted straight from the Continental model, which already looks Romanesque.

Much the same applies to the illumination of a Psalter that was begun by an Anglo-Saxon scribe in Winchester, *c.*1060, and completed by a Norman at least twenty years later.[206] The change in the script is, by itself, eloquent testimony to the break with the English past. In 1070 Lanfranc, the victors' master theologian, brought Norman books to England; and more things changed than the reading-matter. In the Psalter from Winchester the smoothly rounded Anglo-Saxon letter-forms give way to the markedly angular script of the Normans (as happened in many English monastic scriptoria, in a direct parallel to the change in pictorial style). After the new scribe took over the Psalter in 1080 or so, it was given a Crucifixion page remotely reminiscent of the figures in the Tapestry, with bold outlines and Christ's loincloth broken up into triangles (fig. 49). Dodwell convincingly showed that the emphatic lines (which pin the figure down against the ground) were derived from a Norman model.[207]

These two books are the only English manuscripts with completed full-page miniatures known to survive from the entire period between 1066 and 1110/20. The Norman clergy may not have altogether suppressed artistic activity, but there is no doubt that, before the turn of the century, they did little to promote it. It looks as if the brakes were deliberately put on in many areas (figurative ornament was in far greater demand). Certainly in the early years after 1066

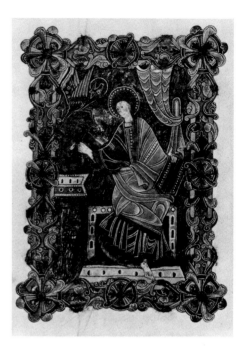

48　*St Luke the Evangelist. From Gospel Book, shortly after 1072. Paris, Bibliothèque Nationale, Ms. lat. 14782, fol. 74*

England had no major, autonomous artistic centre which could compete with the 'Channel style' of the Continent – and from which the Tapestry could have emerged.

49　*Crucifixion. From Psalter, c. 1080. London, British Library, Ms. Arundel 60, fol. 52 v*

The stylistic 'definition' of the Tapestry emerges from the foregoing remarks. Anyone still maintaining that the cartoon was of Anglo-Saxon origin must surely concede that those who executed the work did so in a style fundamentally different from, and far more advanced than, Anglo-Saxon art and that they had enjoyed something of a Continental – and probably a Norman and proto-Romanesque – visual training. This view leads to an intractable conflict. It would be necessary to suppose that the embroiderers (or embroideresses), who most probably worked in the same workshop as the designer, rejected and suppressed all the familiar features of their own Anglo-Saxon style in the interest of a thorough reworking or reinterpretation of the cartoon in front of them: an arbitrary and preposterous assumption.

Undoubtedly, as we have said, features of Anglo-Saxon art appear in many places in north-western France, Flanders and Normandy. These influences do not, however, extend beyond motivic vocabulary to encompass the grammar and syntax of art. The immediate prototypes, from circles close to the Tapestry workshop itself – that is to say, the immediate sources of the style – cannot be comprehensively identified, and seem indeed to be irretrievably lost; but what counts is the way in which we use the available facts in order to reconstruct the context in which the work was done. If we review all the analogies suggested to date, assess the historical evidence and weigh the balance of probability throughout, only one conclusion is possible. The Bayeux Tapestry is a Norman work, probably worked in the 1070s and made in Bayeux.

IX

The Iconographical Programme: A Norman Viewpoint

The Patron: Bishop Odo

In considering the question of 'how', it is first necessary to look again at 'what' was depicted in the Tapestry. Even though the common practice of art history tends to demand separate chapters, it would be a mistake to view these two aspects too much in isolation from each other: there is a risk of obscuring the specificity of the work of art.

The pictorial narrative displays a number of intentional idiosyncrasies. Bishop Odo (William's half-brother), for example, features prominently, although he did not play a decisive political role either before or during the conquest. As preparations for the invasion get under way, the Bishop stations himself at centre-stage. Like a deputy to the monarch (a role that Odo did play, as early as 1067, when William briefly returned to Normandy),[208] he sits on a lion throne beside William and hands down the order for the building of the fleet; it looks, in fact, rather as if he and not the Duke were giving the order (p.126). Odo's episcopal office is a spiritual one. Christ-like, he blesses the feast in the Norman camp – a piece of iconographic hyperbole that, no doubt unintentionally, borders on blasphemy (p.140). His power also extends into the secular realm. In the scene immediately following, the three brothers hold a council of war, and, while Robert of Mortain sits at the Duke's left hand, Odo holds the more honourable position on his right (p.141).

Clearly, the designer has looked for and discovered opportunities of effectively bringing Bishop Odo into play. 'The Bishop rallies the young men', proclaims the inscription at the height of the battle. The artist does not show us a pious servant of the Church, standing aloof from the fray; this is something for the worldly spectator to admire. The Norman cavalry has been beaten back, with one rider coming from right to left to meet him;

Odo – or so the sequence of images suggests – renews the charge, thus making a decisive contribution to the victory (p.160). The Bishop wears a helmet and a mail shirt (visible on his neck and the back of his head), plus a princely garment worn – as we have seen – otherwise only by William and by Guy of Ponthieu. Unmistakably, the Tapestry seeks to convey the image of a warlike and courageous commander in the saddle. Nor does the Bishop hold his stick (as William does) like a field-marshal's baton: it looks very much more as if he is laying about him with a cudgel or mace. BACVLVM TENENS (holding his stick), says the inscription, drawing attention to the Bishop's martial prowess. This heroic treatment of Odo, and his repeated appearances in the Tapestry as a person of high status, both ecclesiastical and temporal, make it a near-certainty that the Tapestry was worked for the Bishop of Bayeux, and that the Norman artist who designed it bore this fact very much in mind.

William's Tactical Delay

The viewpoint of the Tapestry is exclusively Norman, even though this is not always immediately obvious. It provides a pictorial record of the invasion in a long succession of episodes – embarkation, Channel crossing, landfall, and so on – but, curiously, there is no reference to the fleet's protracted wait on the French coast (six weeks in all). William is generally supposed to have planned a surprise attack. Yet this does not make sense: a military operation on such a vast scale, and so long delayed, would have been talked about. So why did he hold back for so long? The reasons cited in the literature are bad weather and adverse winds. During the nights, cloud cover is said to have obscured the Pole Star and thus made navigation impossible. This is not an adequate explanation: a month and a half of uniformly overcast nights in late summer, many miles to the south of the Dover Straits? (This was not the North Sea, after all.)

It may be, however, that William waited all those weeks on tactical grounds, since he

knew that the Norwegians, too, were planning a conquest of England. Tostig, Harold's estranged brother, joined forces with the Norwegian King, Harald Hardrada, in Northumbria and crushingly defeated an Anglo-Saxon army outside York on 8 September. This important news might have reached William's ears. It was to be expected that Harold would hastily assemble all the forces he could still muster to drive the Norwegians out. After 'riding by day and night',[209] Harold defeated the Norwegians at Stamford Bridge in Yorkshire on 25 September. For William, this decisive battle – whatever the outcome – meant that he would be confronting a weakened adversary. It was two days later, and over two weeks after the Norwegians' first successes, that the Norman fleet set sail. This timing cannot have been coincidental: it suggests that William coolly calculated his chances. If such a policy had ever become public knowledge, it would have detracted from the glory of the Norman hero's chivalrous prosecution of a just cause. Presumably, this is why the Tapestry contains no reference to the fleet's apparently unmotivated delay in port, or to Harold's hard-won victory over the Norwegians, or to the consequent fact that the Anglo-Saxon army was forced to make its way to Hastings in a renewed succession of forced marches.

Norman Chronicles

To gain a clearer idea of the content of the programme that underlies the Tapestry, we need to look in greater detail at the chronicles from which the designer might have taken his narrative. A number of authors frequently cited in the literature – Eadmer, Robert Wace, Ordericus Vitalis and William of Malmesbury – wrote in the twelfth century and therefore could not have given him any inspiration.[210] The *Vita Æduuardi Regis*,[211] written from 1065 to 1067 at the behest of the Confessor's widow, Edith, is a work of hagiography, and no reliance can be placed on it. Other Anglo-Saxon records known to us would not have greatly helped the designer, since they 'carry discretion to the point of ignoring Harold's adventures in France and

the relationship into which he had entered with Duke William'.[212]

The Norman writers, on the other hand, recount the preliminaries of the conquest in great detail. Probably in 1066/67 Bishop Guy of Amiens composed his *Carmen de Hastingae proelio* (Song of the Battle of Hastings), a description of the battle in verse; the poet certainly moved in circles close to the Duke, since he escorted William's wife, Matilda, to England for the coronation in 1068.[213] Some years later, William of Jumièges wrote his *Gesta Normannorum Ducum* (Deeds of the Norman Dukes, *c.* 1070/71); however, this much-copied text devotes only a small part of its space to the conquest.[214] The most important source, and one approximately coeval with the making of the Tapestry, is the narrative in the *Gesta Guillelmi Ducis Normannorum et Regis Anglorum* (Deeds of William, Duke of the Normans and King of the English) by William of Poitiers.[215] This chronicler was a Norman ex-soldier who had become chaplain to the Duke, so he had first-hand knowledge of soldiering and war (including, perhaps, the events of the conquest or of the Breton campaign). Perhaps the Tapestry designer's career followed a similar course?

The informative account that the Tapestry gives of the prehistory of the conquest sets the tone of the whole iconographic programme, which shows William's attack on England as a just, and indeed necessary, punishment. The Anglo-Saxon sources do not cover the events shown at the beginning of the Tapestry, but the two Williams, of Jumièges and of Poitiers, do. Their accounts make it plausible that Edward the Confessor did, in fact, send Harold to Normandy in 1064.[216] The *Carmen* clearly states that Edward wanted Harold to convey his own renewed promise of the English throne to the Duke and that Harold agreed to do so.[217] Like these three sources, though in its own different way, the 'prologue' section of the Tapestry stresses the power and renown of Duke William by depicting the release of Harold, his reception in the ducal palace,[218] the ceremony of the bestowal of arms and the key scene in which Harold swears on two holy reliquaries to recognize William as his

lord. All this is worked into a consistent and well-managed build-up to the dramatic events that ensue. We are soon left in no doubt that these, too, are presented exclusively from the Norman point of view.

The Crowning of the Usurper

The pictorial narrative comes to a climax in the depiction of the Battle of Hastings, but this sequence occupies only one-third of the length of the Tapestry and does not by any means overshadow what has gone before. Consistently, the Tapestry operates to legitimize William's claim to the English throne, with all its moral and political consequences. The group of the seated, crowned Harold and the standing Archbishop Stigand, however, looks rather out of keeping with this, especially as their rigidly frontal pose catches the beholder's eye in the midst of the surrounding flux of events (p. 123). As Stenton puts it: 'The dignity that remains to Harold throughout the Tapestry is never brought out more clearly than here.'[219] Why, then, did the designer lay so much stress on this of all scenes? Did he not see that he was undermining his own strong support for the Norman cause by lending such solemn authority to an act of state that so criminally wronged that cause?

The Tapestry conveys the impression that the archbishop who stands, robed, next to Harold is the one who performed the coronation. No one has asked why the Tapestry does not show the act of crowning itself. Commentators have generally done no more than remark that 'The Tapestry makes no attempt to show the actual coronation... but passes at once to the acclamation of the newly crowned king by the people' and that it clearly shows 'that it was Stigand who called on the assembled people to acclaim the newly crowned king'.[220] Wilson regarded this scene as 'merely a statement which recognizes him [Harold] as king', omitting any 'sacred elements'.[221] Does all this do justice to the meaning of the scene, in which Gibbs-Smith does find something Christian: 'on the right Archbishop Stigand raises his hands in a ceremonial gesture'?[222]

50 *Mass of St Clement. Mural painting, c. 1084. Rome, lower church of S. Clemente*

The content here is marked by a number of features that make the designer's approach seem wholly illogical. Stigand is neither addressing the people nor simply making a vaguely 'ceremonial' gesture. The Archbishop has half-raised his arms, symmetrically, and holds his maniple in his left hand. Pope Clement I stands in the same robes and the same attitude, with a maniple in his left hand, in a fresco in the church of S. Clemente, Rome (*c.* 1084), in which he is saying Mass (fig. 50).[223] The Tapestry does, therefore, show Stigand as engaged in a solemn liturgical act. This, in itself, endows the presentation of Harold with a meaning that goes beyond the simple statement that a coronation took place.

The pictorial scheme of Harold, enthroned with orb and sceptre, and towering above his companion figures, is clearly a deliberate borrowing from those eleventh-century German monarchical images that depict kings and emperors as the sacred representatives of Divine sovereignty in a fusion of empire and priesthood, *imperium* and *sacerdotium.* To show the king in this way emphasizes the sanctity of kingship more strongly than any depiction of the crowning could ever have done. The composition in the Tapestry is designed as a reminder of the sacred and sacramental nature – the religious and metaphysical legitimation – of monarchy and the *majestas* of kings.

The designer seems to have deliberately emphasized the contradiction inherent in this image – but why? The eleventh-century Anglo-Saxon sources are no help, since they curiously omit to mention who crowned Harold. It was Florence of Worcester, a twelfth-century compiler, who first stated that the ceremony was performed by Ealdred, Archbishop of York (surprisingly, several English historians still consider that 'the probabilities of the case are strongly in favour' of this supposition).[224]

It is the Norman writers alone who cast light on all these apparent anomalies. William of Poitiers resolves the matter. He roundly condemns the crowning of Harold by Stigand, a man who sacrilegiously styled himself an archbishop. For Stigand was not recognized by Rome: he had been excommunicated by no less than five Popes (before finally being dethroned by the Council of Winchester in 1070). Harold, violator of an oath sworn on holy relics, is seen side by side with a reprobate archbishop, a persistent offender against Canon Law. What was more, in 1052 Stigand had usurped the position of the exiled Robert of Jumièges, the Norman churchman who, in Roman and Norman eyes, was the rightful Archbishop of Canterbury. (It was one of the principal counts of the indictment against Stigand that he had worn Robert's pallium.) There is thus no contradiction in the Tapestry image; on the contrary, the designer intends to enlist the beholder's sympathies as firmly as possible for the Duke of Normandy. The rigidly frontal pose of the figures is an alienation device: it serves to unmask the perfidious collusion between the two men. The title REX, applied here to Harold, thus acquires the significance of oath-breaker, rebel and usurper, which it retains throughout the rest of the Tapestry.

The Tapestry incontestably takes the same line as the Norman historians on this matter. Both William of Jumièges and William of Poitiers denounce the unseemly haste with which Harold had himself crowned on the very day of Edward's burial; the Tapestry shows this, too (see p. 70 f.). It may be that these historians can help us to understand a number of other hitherto doubtful details in the pictorial narrative. One example is the figure of Count Guy, enthroned in the castle of Beaurain and conversing with his prisoner, Earl Harold (p. 100). Not only does the Count have a sword, but – curiously enough – his prisoner holds his own sword in his left hand. A prisoner with a sword? This is surprising, even if the captive in question was treated with the utmost respect, in the style of what we would call 'house arrest'. Gibbs-Smith conjectured that Guy had handed the weapon back to Harold, 'possibly ... as a gesture of trust'.[225] At all events, nothing in the image suggests that this is the scene of Harold's release. The *Carmen* records that King Edward gave Harold a ring and a sword to carry to William as the tokens of kingship. Would this not suit the designer's purposes very well, leading him to show Harold with Edward's sword (which Guy would not have dared to touch)? The question then arises whether at his coronation Harold really bore the true sword of state – or whether William already had it ...

Historically, the Tapestry narrative tallies best with the chronicle of William of Poitiers – as in the detailed account of Harold's journey at Edward's behest (to

confirm the promise of the throne), the encounter between Harold and Guy, the crucial importance of the oath and the crowning of Harold by Stigand.

Divergences from the Sources

In comparing the Tapestry with the Norman literary sources, scholars have mostly tended to adapt the pictorial narrative to fit the texts – that is, to interpret the individual scenes in accordance with the chronicles. The account by William of Poitiers, in particular, is much used as a guide to the interpretation of the pictures, with the result that the designer's work starts to look as if it were based on this particular source. Brown placed her reliance on the historian's statement that Harold sent spies to Normandy after his coronation and that one of them was caught and brought before William for interrogation.[226] However, the seaman who wades ashore with the anchor of the NAVIS ANGLICA (the English ship that brings news of the coronation to Normandy) has the back of his head shaved, in Norman and northern French fashion (p.125). Granted, this is not a foolproof argument, since by this stage the designer is no longer consistently using hairstyles to distinguish one nationality from the other; even so, he never shows an Englishman with a shaven back to his head. (It would no doubt be over-subtle to suppose that this is an Anglo-Saxon secret agent with his head shaved to assist his disguise.)

Since Brown regards the narrative of William of Poitiers as a reliable authority for the interpretation of the Tapestry, she reasons that the male figure in the preceding scene (to the left of the ship), to whom the enthroned Harold is listening, must be a member of the Anglo-Saxon espionage network, 'receiving last-minute instructions before heading off to the Continent' (p.124). Yet this subordinates the interpretation of the Tapestry to an idea derived from the Norman chronicle. The man who steps up to Harold is surely either an adviser or a dream-interpreter. This is suggested by the vision of the ships (whether premonitory dream or rational fear) and also by Harold's pose. He is seen frontally, but he is not sitting bolt upright, as a monarch should. Leaning to one side, with his head in three-quarter profile, the King 'lends an ear' to the man beside him. This interpretation even has an iconographic parallel to support it. In the late eleventh-century mural paintings at Saint-Savin-sur-Gartempe, Joseph is brought in from the right to interpret Pharaoh's dream (fig.51).[227] Frontally enthroned, like Harold (and with his arms identically placed), the Egyptian monarch leans across with his head similarly inclined. It may well be that the Tapestry designer adapted the scene from a Joseph cycle then in existence in France.

This episode in the Tapestry, diverging as it does from the chronicle, leads us to ask whether the designer directly followed the texts known to us today[228] or whether his narrative stems from another, lost redaction of Norman history. No extant Norman source mentions the village of Bosham, from which Harold sets out on his travels, or the episode in which he rescues some Norman soldiers caught in the quicksands of the river Couesnon (pp.93, 110). Alongside the main participants in the historical narrative, the Tapestry names – as well as Ælfgyva, otherwise unremembered in this context – three men: Turold, Wadard and Vital. It is, of course, possible that all three were in Odo's service (we know of a Vital on whom the Bishop bestowed some properties in Caen),[229] but there is no hard evidence of any connection. The point, however, is that these names do not appear in any written record of the conquest. It follows, therefore, that the Tapestry rests on a separate Norman source, now lost.

'Rewriting' History

That this now-vanished account was consulted, that it served specific ends and that it was probably seen by the designer in written form, is rendered probable by a number of features of the pictorial narrative, including possible or known misrepresentations of history. The *Gesta* of William of Poitiers, like the Tapestry, tell us of Duke William's campaign against Conan of Brittany, but there are major discrepancies between the two accounts.

According to the *Gesta*, William advanced into Brittany to give support to Rivallon, Lord of Dol. This city was under siege from Conan, who had refused to acknowledge William as his feudal overlord. As William's army approached, Conan raised the siege and withdrew. In the Tapestry the story is quite different (pp.111-14). Conan, who is occupying the city, lets himself down from the walls on a rope and flees. Then the Normans ride on to Rennes and to Dinan, which resists, but which they capture. There, Conan surrenders and hands over the keys to the city. Once again, the version given in the *Gesta* is different: without a battle, Conan took refuge with Geoffrey of Anjou, out of Wil-

51 *Joseph brought before Pharaoh. Mural painting, late 11th century. Saint-Savin-sur-Gartempe*

liam's reach; and William's adversary was never finally subdued. No written record confirms that the Normans ever appeared before the walls of Rennes. It is hard to believe that they did, since Dinan is a short distance to the west of Dol, whereas Rennes is a good way inland and to the south.

The account of events in the *Gesta* is generally accepted by historians as true. The pictorial version of the campaign in the Tapestry is thus a distortion of the facts, primarily intended to promote William's fame as an unbending warlord. It stands as an initial warning that the Norman leader will brook no rebellion. The intention is to convey a premonition of the fate of the disloyal Harold.

Unlike the *Gesta* – in which Dol is the only town mentioned at the outset of the Breton campaign – the Tapestry shows and names Mont-Saint-Michel, in the scene of the Norman cavalry fording the river Couesnon (p. 109). The abbey of Mont-Saint-Michel is entirely irrelevant to the narrative, and, although this famous place of pilgrimage was under William's protection, that does not explain why so much attention is drawn to it. The likely reason is that monks from Mont-Saint-Michel set up the abbey of Saint-Vigor, founded by Odo in his cathedral city of Bayeux (in 1066 he appointed Robert de Tombelaine, a well-known scholar and writer from Mont-Saint-Michel, as its abbot).[230] It is probable that the appearance of Mont-Saint-Michel here represents an indirect reference to the patron who commissioned the Tapestry.

William of Poitiers places the scene of Harold's oath before the Breton campaign, but the Tapestry reverses the sequence, thus stepping up the dramatic tension. The *Gesta* give a detailed account of Harold's oath, adding that it was sworn at Bonneville-sur-Touques. The Tapestry, on the other hand, unequivocally states that it was taken in Bayeux (p. 117). It all fits together. Clearly, the propaganda message of the Tapestry narrative is not only pro-Norman: it is an attempt to rewrite history in the interests of William's half-brother, the Bishop of Bayeux.

French Poetry

In a sense, the pictorial narrative of the Tapestry, with its unique interpretations of recent history, can be regarded as verging on the domain of literature. Dodwell convincingly showed extensive parallels between the Tapestry and the French epic poems known as *chansons de geste*.[231] In these works, with their marked propensity for detailed description, much space is given to accounts of battle. Treachery and the violation of treaties and oaths are also favourite themes. The oath-breakers are not mere cowards or weaklings: they are much closer to the type of Harold, who fights valiantly and has good and bad sides to his character. At times, the *chansons de geste* show startling analogies with the Tapestry, both in the presentation of the characters and in their motivation and characterization. Both narrative forms share a desire to entertain: in both, we take pleasure in empathizing with the drama as it unfolds.

These very basic analogies again suggest a designer or 'scriptwriter' schooled in a French-speaking environment. Against this, Wilson argued that heroic poems of much the same kind existed in Anglo-Saxon England and that the French reference was unnecessary.[232] However, in his eagerness to uphold the thesis of the Anglo-Saxon origin of the Tapestry, he was forced to overlook some deep-seated differences between French and Anglo-Saxon poetry. He was right to say that the *chansons de geste* are primarily a twelfth-century phenomenon, but it was in northern France in the second half of the eleventh century – the very place and time in which the Tapestry workshop was situated – that the transition took place from the more lyrical, short epic to the large-scale form of the *chanson de geste*. This represented an enormous increase in length, and we are involuntarily reminded of the exceptional length of the Tapestry.

The pleasure in extended description that we find in the Tapestry is a salient characteristic of French epic verse in the heyday of feudalism. The most highly regarded work of this kind is the *Chanson de Roland*, written (most probably by a writer named Turold)

in northern France, *c.* 1080.[233] Furthermore, both the Tapestry and the *Chanson de Roland* reveal a far more pronounced sense of national mission than do the Anglo-Saxon poems. Over and above the praise of heroic deeds, they convey an enhanced sense of shared, national identity, of contemporary belonging. However remote from each other in theme, the *Chanson de Roland* and the Tapestry eulogize conquest and thereby boost knightly self-esteem. Their supreme message is that of the splendour of feudal life. There is nothing like this in Anglo-Saxon literature.

The common features between tapestry and feudal epic all imply the need for large dimensions. In the burial scene of the Tapestry the hand of God points down from the heavens, not on the dead King Edward but on the newly built Westminster Abbey (p. 121). Begun well before 1066, Westminster marked the inception of a vast programme of church building that the Normans were vigorously carrying on, both in Normandy and in England, at just the time when the Tapestry was worked. Westminster Abbey itself had been built by Norman builders, and the Tapestry has its own unique way of showing it as pleasing unto God. Westminster and the other Norman abbeys were larger than almost anything built before.

In this connection we should remember the Saint-Vaast Bible, written and illustrated in Arras shortly before mid-century. This is the oldest illuminated 'giant bible' in medieval art (a type of manuscript that subsequently spread all over Europe). Church building, manuscript illumination, epic poetry, Tapestry: as the eleventh century progressed, it was not Anglo-Saxon England, but the aristocracy of Normandy and northern France, and its inseparable consort, the established Church, that developed a taste for impressive historical monuments calculated to enhance the status of the ruling élite within feudal society.

X

Inscriptions

Text and Image

Almost all the authors who have argued the Anglo-Saxon origins of the Tapestry designer have cited the inscriptions in confirmation of their thesis. These consist of short sentences in simple Latin, readily comprehensible even to viewers whose Latin is relatively basic. Clearly, no attempt has been made to write 'classical' Latin, and there are several errors of spelling and grammar; at times, present and past tenses are used within one inscription, as if an existing written account of past events were being transposed into the historic present of pictorial commentary.

Before we embark on specifics, one thing needs to be considered: were these inscriptions written by the designer? No sure answer can be given. All that is clear is that the lettering and the text were not laid out simultaneously. As far along as Edward the Confessor's deathbed scene (p. 122), and in most of the succeeding episodes, the inscriptions have been fitted into previously drawn compositions: the writing fills whatever space is available and, sometimes, the letters have to shrink to fit.

In a few places (as in the deathbed scene or where the order is given to build the fleet) the pictorial composition, complete in itself, has squeezed the inscription out into the upper margin and the zoomorphic frieze is interrupted – as it also is by some of the architecture and by the sails of the shipping (pp. 122, 124, 126). The pictorial narrative was conceived first, then the borders were designed and, soon afterwards, the inscriptions inserted. So was the design a collaboration involving at least two individuals? When the designer laid out his pictorial narrative, he made virtually no allowance for the insertion of written commentaries. He would then have gone on to deal with the border ornaments. Did he leave space here and there for the commentaries (and thus perhaps for a collaborator, who might have started on the inscriptions immediately after the main pictorial narrative was completed)?

There is nothing to suggest that the lettering was actually embroidered after the pictures were finished: the materials used are identical in every case. And it remains a mystery why, as the Tapestry proceeds – from the preparations for the feast onwards – the letters change colour more often (p. 139 ff.). Wormald saw this as a sign that one embroiderer had taken over from another.[234] Yet why did this supposed newcomer not continue with the black thread that had been used hitherto?

A Number of Scribes?

There is another difficulty. It looks very much as if the lettering is not all the work of one person, for there are a surprising number of inconsistencies in the writing of individual names. The very first word in the Tapestry is EDVVARD (twice V equals W);[235] when the King gives an audience to Harold on his return it is ЄDVVARDV[M] (round E); at the burial it is EADWARDI (with an added A and the W as two interlinked Vs); and in the deathbed scene it is ЄADVVARDVS (round E, added A again, W as twice V) (pp. 91, 120-2). None of these exactly matches the one before it. Surely there is more to this than one person's carelessness: it suggests a number of penmen without a norm to follow. Other names also vary: CONAN makes good his escape from Dol, but it is CVNAN who hands over the keys of Dinan (pp. 111, 114). There is no eleventh-century manuscript text in which an important name is so frequently and apparently so casually altered.

Anglo-Saxon and Norman-French Features

Some of these inconsistencies, together with features of other names in the Tapestry, supply the central argument for the 'England thesis'. The form EADWARDVS is said to be in accordance with Anglo-Saxon usage. Yet this contention is weakened by the fact that the name is twice used without the A after the E, just as it is found in a number of Norman sources. The name of William of Normandy himself varies even more frequently. If we ignore the distinction between VV and interlaced W, the versions can be classified into two groups: (a) WILGELM three times; (b) WILLELM eleven times, plus minor variants WILELM twice and WILLEM three times, making sixteen in all.

Werckmeister, who was firmly persuaded of the Anglo-Saxon origin of the Tapestry, took the view that (a) represented a Norman variant and that the (b) variants were Anglo-Saxon.[236] Bernstein confirmed that William's name was found three times in the Norman form WILGELM, with the other spellings (the WILLELM type) appearing in Anglo-Saxon texts.[237] But this is not so. The supposedly Anglo-Saxon version, Willelm, or its Latinized version, Willelmus, was in common use in Normandy. In the *Carmen de Hastingae proelio* the name is given as Willelmus.[238] In the charter of Saint-Benoît-sur-Loire, from Le Vaudreuil, dated April 1067, we read 'ego Willelmus' (I, William).[239] The epitaph on the tomb of Queen Matilda (formerly in Sainte-Trinité, Caen, and preserved in an accurate transcription) mentioned the Duke in the form 'Willelmo'.[240] The foundation charter of the Norman abbey of Lessay, promulgated c. 1080, refers to 'Signu[m] regis Will[elmi]' (the seal of King William),[241] while the seal on a charter for the abbey of Saint-Etienne, Caen, has 'Willelmum'.[242] Other noblemen who bore the name of William spelt it the same way: the seal of a Count of Ponthieu was 'Sigillum Willelmi Fili[i] Iohannis' (seal of William, son of John).[243] Any number of other instances could be cited.

And what of the Tapestry's other version of the name, WILGELM? This is exceptional. In general, the combination LG is very rare, both in Old English and in Old French.[244] The Duke's name does not appear to exist in this form in any Anglo-Saxon or Norman source. Yet in monumental inscriptions elsewhere in Europe we find a related version, with an additional I. The early twelfth-century inscriptions in Modena cathedral mention the architect, Lanfrancus,

and the sculptor, William: 'claret scultura nunc Wiligelme tua' (is now adorned by thy sculpture, Wiligelmo).[245] (Compare the inscription in the Tapestry, at the point where the captive Harold is handed over to William: AD VVILGELMVM... DVCEM, p. 104 f.) Incidentally, the Lanfranc who was the Normans' theologian came from northern Italy.

The variant spellings of the name William thus provide no compelling reason to support the 'England thesis'. However, the Tapestry does contain – apart from the two instances of EADWARDVS – a few personal names and one place name that have Anglo-Saxon connections. The first instance is GYRÐ (Gyrth), which is not actually Anglo-Saxon but an 'Old Danish personal name' (p. 157).[246] (The Ð with crossbar is the letter edh or eth, corresponding to the modern 'th' in 'the'.) Then there is the phrase AT HESTENGA CEASTRA; in Latin this would normally have been AD and CASTRA (p. 142 f.). Yet the importance of the word AT alone should not be overestimated. The Tapestry elsewhere consistently used AD (sixteen times in all), and Stigand is spelt with a D in Anglo-Saxon but as STIGANT in the Tapestry (p. 123). Brooks and Walker counselled caution: the words GYRÐ and AT HESTENGA CEASTRA have been restored and the earliest copies of the Tapestry – the drawing engraved and published by Bernard de Montfaucon in the *Monuments de la monarchie française* in 1729/30 – show different readings.[247] To which Wilson replied that 'Montfaucon would probably not have known about Anglo-Saxon scripts' and that the Ð was original.[248]

Even if Wilson was right, these details prove no more than that the person responsible knew a number of names used in Anglo-Saxon. Perhaps an Anglo-Saxon played a part in composing the inscriptions (which would not be an indication of the artistic background of the designer or of the head of the workshop). Yet, if so, why would the Anglo-Saxon name Leofwine (also written Liafwine or Liofwine) appear in the Tapestry as LEVVINE (p. 156)? Why not assume that a few names were checked against English sources (whether documents, books or personal informants) in order to convey an impression of authenticity and documentary accuracy? Might not the Anglo-Saxon names have been deliberately used because, even while the Tapestry was in preparation, its makers had a mixed public in mind, both English and Norman-French, SIMVL ANGLI ET FRANCI?

One argument in particular, not the form of a name but a convention of penmanship, has been repeatedly adduced to support the view that an Anglo-Saxon workshop made the Tapestry. This is the sigil that looks like a 7, standing for ET (and), which appears in the inscription VBI HAROLD 7 VVIDO PARABOLANT (p. 100). According to Lepelley, the 7 for ET is an Anglo-Saxon usage that first appears in France in manuscripts of the thirteenth and fourteenth centuries.[249] Wilson, too, says that this abbreviation is a 'purely English form'.[250] However, too much weight should not be attached to these things. We must always reckon with the possibility that details of penmanship, along with many artistic motifs, were exported to regions that were not Anglo-Saxon, but merely under Anglo-Saxon influence. The sign does turn up elsewhere, notably in the text of Ms. 78 in the Bibliothèque Municipale, Avranches, which was undoubtedly written by a Norman in the Mont-Saint-Michel scriptorium in or around the year 1000.[251]

In the Tapestry the inscription just discussed employs one word that is worlds away from Anglo-Saxon usage: PARABOLANT. The verb *parabolare* is Gallo-Roman in origin and belongs to the Latin used by speakers of French; in the transition from early to high Middle Ages it gave rise to the verb *parler*.[252] The Tapestry also contains a number of other words current in medieval Norman-French contexts. Take Odo, steadying his troops: CONFORTAT (p. 160). The verb *confortare*, derived from the Latin *fortis* (strong), is the immediate precursor of the French *conforter*.

The affinities between the language of the inscriptions and Anglo-Saxon thus do not amount to much. Although Wormald pronounced in favour of the 'England thesis' as long ago as 1955, in reference to the inscriptions he added a rider that seems to have been lost on subsequent scholars: 'Neither the forms of letters nor the abbreviations throw any light on the origin of the work. Only the Ð = th betrays an acquaintance with English lettering.'[253]

Normandy and England Before 1066

This – not very intimate – 'acquaintance' comes as no surprise, since in the 1040s and 1050s, as in the immediate post-conquest years, there must have been many Normans who knew Anglo-Saxon. Under Herfast, the first Chancellor to King William I of England, the Royal Chancery issued numerous documents in Anglo-Saxon between 1066 and 1070.[254] Well before 1066 the barriers between England and Normandy were highly permeable. Throughout the 1040s, and until 1052, England was heavily infiltrated by the Normans in a first, non-violent phase of the conquest. At court, Edward the Confessor favoured a pro-Norman lobby that was reinforced by an influx of clergy from Normandy. At the same time, land was granted to Norman abbeys (which led to continuing cross-Channel contacts) and Normans even built castles in England. Ralph the Timid, son of the Count of Dreux, became Earl of Herefordshire, where he founded a Norman colony.[255] As early as the reign of Æthelred II (979-1016) the inhabitants of Rouen were conducting an active trade with London.[256]

Nor must we overlook the underlying connection: Norse (which was certainly still spoken by nobles and peasants alike in early eleventh-century Normandy) and Anglo-Saxon were related languages.[257] It is probably an exaggeration rather than an untruth to say – as a thirteenth-century Icelandic manuscript does – that, before 1066, the same language was spoken in Norway and Denmark (the Normans' former home) as in England, where several contemporary sources confirm that the 'dǫnsk tunga' (Danish tongue) was in widespread use.

Today, we tend to see the events of that period in polarized terms of nationality. On close scrutiny, however, more and more historical ties emerge, including those that linked Normandy with Anglo-Saxon England (the building of Westminster Abbey is just one example among many). In 1044 Robert, Abbot of Jumièges, was enthroned as Bishop of London. In 1049 another Norman, Ulf, became Bishop of Dorchester (a diocese that stretched right across England and included Lincoln).[258] In 1051 Robert of Jumièges became Archbishop of Canterbury, and his successor in the see of London was a Norman by the name of William. Step by step, the Normans gained in influence at the English court, in administrative office and in the priesthood, until Earl Godwine (Harold's father) led an Anglo-Saxon rising and seized power in 1052. Many Normans withdrew from England for a time and contacts with Normandy suffered, though they were not broken off. It is of further interest, for present purposes, that Anglo-Saxon books found their way to Normandy long before 1066.[259] This is one more reason why the various conjunctions of Anglo-Saxon and Norman elements that appear in the Tapestry inscriptions do not add up to a corroboration of the 'England thesis'.

All this coexistence is important to our understanding of the Tapestry in another way. There is a hint of a new message in the assimilation of this foreign culture that, in 1066, became wholly – albeit only temporarily – the enemy of the Normans. While the ANGLI ET FRANCI are still in the heat of battle, the Tapestry implicitly holds up to them the mirror of a future coexistence. For it was as 'Franci' and 'Angli' that the ducal and royal chancery addressed all William's subjects at the time when the Tapestry was being made. Numerous contemporary documents refer to William's faithful subjects as 'omnibus fidelibus suis Francis et Anglis'.[260] The inscription over the first scene of the Tapestry mentions HAROLD DUX ANGLORVM, but the Earl of Wessex was not normally so styled in England, where the title *dux* (leader or duke) was not in regular use. Anglo-Saxon identity was deliberately repressed and, at the same time, absorbed, ingested. This transformation, the Anglo-Norman age, began shortly after 1066.

XI

Baudri of Bourgueil and the Tapestry

Here and there in the literature on the Tapestry we meet with the idea that it was not the only sustained pictorial narrative of the Norman conquest in the art of the day. This arises from a detailed description given by Baudri, Abbot of Bourgueil, in a Latin poem (*c.* 1100) addressed to one of William's daughters, Adela, Countess of Blois. Baudri describes an elaborate wall hanging, said to exist in the lady's bedchamber, that includes a detailed account of the Norman conquest of England.[261] He enthuses over the costly magnificence of its materials: 'The gold threads come first, followed by silver, the third strands were always of silk.'[262] A textile on such a scale made with these materials was a practical impossibility and a number of historians have accordingly dismissed the Countess's hanging as a figment of the poet's imagination. Yet do we also have to jump to the conclusion that Baudri drew no inspiration from the Bayeux Tapestry and that he pursued his flight of fancy without any reference to it?[263] To do so would conflict with an observation first made by Julius von Schlosser in 1896: 'It has been shown in a very great number of cases that the authors of rhetorical or poetical *ecphrases* [descriptions of art] of this kind had seen a real work of art, which they described more or less freely and, in most cases, probably from memory… The describer's imagination [is] such that his descriptions may be used as historical evidence.'[264]

Baudri wrote for a daughter of William the Conqueror, who would have been familiar with the Normans' then long-since completed victory monument, the Tapestry – as would the poet himself, for what else could have inspired him to describe, as he does, a seemingly endless stream of images?

To this day, the sheer length of the Tapestry is overwhelming. Although Baudri's long-winded description often diverges from what we see in the Tapestry, there are a number of points of agreement that cannot be entirely coincidental. He must have had the Tapestry in mind when he wrote that the fleet consisted of a variety of ships: ships for the infantry, others for the cavalry, others for the horses.[265] The Tapestry shows troops embarked both with and without their mounts and one vessel carries three horses between just two men (p.133). In battle, he says, the enemy left their horses behind and packed themselves into a tight wedge formation[266] – a possible reference to the Anglo-Saxon 'shield-wall', as seen in the Tapestry (p.154f.).

Nor is this all. Baudri gives a detailed account of the phase of the battle in which the Normans fell back in disarray and there was a rumour that their Duke had been killed. Thereupon, he says, William took off his helmet, showed himself to his troops, called out to them that he was alive, and exhorted them to counter-attack and put the enemy to flight.[267] This sounds like a commentary spoken in the very presence of the Tapestry; indeed, all of Baudri's interminable descriptions of combat might very well have been written under the immediate impact of seeing it. Lines 565-6 of the poem, in particular, seem positively to confirm that Baudri had studied the Tapestry. Here, he writes of the inscriptions on the hanging, which identified what was going on as well as the individuals involved: 'Littera signabat sic res et quasque figuras / ut quisquis videat, si sapit, ipsa legat' (The writing distinguished the subjects and all the figures, so that all who see, if wise, can read).[268]

'Res' and 'figuras': this can only mean that Baudri had seen the Tapestry himself and that this was what had inspired him to write his poem. It also makes it highly unlikely that the Tapestry was in England either shortly before or around the year 1100. The (admittedly unproven) uniqueness of the Tapestry would seem to have been both the source of its fame and the spur to the poet's imagination.

duction process, before late medieval times. As far as the Tapestry itself is concerned, all we know is that the linen web was made in eight sections. The first two are 13.5 metres long, and the next five range between 6.6 and 8.5 metres. The last piece is now only 5.25 metres long; a length somewhere between 1.35 and 3 metres is missing at the end. This would suggest that the Tapestry concluded with William's coronation in Westminster Abbey. The lost final section was on the outside when the Tapestry was rolled up and was consequently the part most vulnerable to damage.

We should very much like to know in which technique the artist in charge prepared his cartoon for the Tapestry and what studies were previously made.[273] Medieval embroideries were very often based on an underdrawing in charcoal; then the details were filled in with pen and ink before the charcoal was shaken out or brushed off. In a number of places in the Tapestry traces of red drawing are visible beneath green or blueblack lettering (as with the archers in the lower border at the end, p.161).[274] However, these marks were probably made by the restorers, for, according to Bertrand, the Tapestry has at some time been washed, either once or twice, and this would have removed all traces of drawing.[275]

XII

The Embroidery Technique and its Norse Antecedents

Embroiderers or Embroideresses?

Unfortunately, there is no indication anywhere of how many workers produced the Tapestry or of how long they spent on it. It would certainly have taken a team, its members working simultaneously, to complete what was – especially for its date – a gigantic project. When work started in the spring of 1885 on a copy of the whole Tapestry, thirty-five women, members of the Leek Embroidery Society, shared the task until its completion in 1886 [269] – and that was with all the advantages of improved technology. To judge by internal evidence of a thorough knowledge of numerous details of shipbuilding, seamanship and warfare, the designer was a man. This is not hard to believe: the Life of St Dunstan, composed *c*.1000, records that one great lady, surrounded by a circle of embroideresses, invited the saint (*c*.909-88) to design a stole for her to make.[270]

The size of the Tapestry, and the consistency of its design and colour, presuppose a large and experienced workshop. The assumption is generally made that the Tapestry was embroidered by women; though by no means certain, this is perfectly possible. Since we have no information on practice in the early period of the Tapestry's existence, we are forced to rely on later medieval sources,[271] which afford a glimpse, at least, of how it might have been. In 1330 Queen Philippa of England commissioned three embroidered curtains to adorn a church. The workshop, directed by two designers, employed the considerable number of 112 workers. What is more – and no one would ever have guessed this without the documentary record – men and women worked side by side. Forty-two women earned 3 ½ d per day, the men 4 ½ d. (How did the embroideresses come to earn less than their male workmates?) The highest wage was paid to the designers: one received 8 ½ d and the other 6 ¼ d.[272]

We possess no information about the division of labour, or the phases in the pro-

Yarn Colours

The embroidery was probably sewn with bronze needles. The woollen threads were dyed with vegetable dyes in a total of eight colours: a reddish yellow, an ochreous yellow, terracotta red, blue-green, sage green, a striking olive green, blue and a bluish black. Some tones that were technically possible at the time are missing here; these include a medium yellow (from crab-apple bark), a powerful red (from the madder root; already present in the Oseberg textile), intense green (as a mixture of blue and yellow), grey (using a thinned iron-gall solution), chocolate brown (a mixture of ochre, red and black) and violet (from elderberries). As all these colours occur in eleventh-century miniatures,[276] it is clear that the palette of the

Tapestry differs from that of Anglo-Saxon manuscript illumination *c.* 1050/60 (the strong olive green, for instance, was not in common use in the art of the period). Any given hue in the Tapestry will exhibit a variety of shades that may well have become more markedly differentiated in the course of time. In general, however, the wool has shown a remarkable resistance to light: the present-day beholder sees the Tapestry almost in its original state.

The embroiderers used laid and couched work, together with stem and outline stitch. The flat areas of colour were done in laid and couched work: the threads were tightly packed together on the linen and the needleworker then added a second layer at right angles to the first; the resulting areas of colour were then couched or basted down on to the linen. The outlines of the figures, and of all other objects, were established with a 'drawn' line in stem or outline stitch; the same was done with all the narrow lines in the hands, faces, lances, letters, plant tendrils and chain-mail patterns. (Outline stitch is a variant of stem stitch in which the needle comes out to the right of the thread, producing a thin line; in stem stitch proper, successive stitches slightly overlap.)

Connections with Norse Textiles

So little of the textile art of the early and high Middle Ages has survived that there is no telling for certain where this particular embroidery technique was in use, and where not. It is noticeable, nevertheless, that the only exact parallels that we do have are Scandinavian and Icelandic. A direct point of comparison is provided by a twelfth-century Norwegian textile fragment from the church at Røn (63x63 cm, Universitetets Oldsaksamling, Oslo; fig. 52).[277] This is a remnant of what looks like a scene from a chronicle, with a knight's horse on the left, then a tree, soldiers and clerics lying on the ground on the right, and plant ornament in the lower border. This fragment firmly documents the continuity of a Norse tradition to which the textiles from the ninth-century Oseberg ship burial also belong[278] and which persisted in

53 *Adam and Eve. From Old English Hexateuch, c. 1030. London, British Library, Ms. Cotton Claudius B. IV, fol. 7*

Scandinavia until the fifteenth and sixteenth centuries.[279]

Although there are no close stylistic analogies between the Tapestry and these Norwegian and Icelandic textiles, we can assume (with all due caution) that a link with Norse tradition underlies the Bayeux Tapestry somewhere. The affinities are not confined to the technique of embroidery as such: long, narrow wall hangings with a sequence of images are typical of northern Europe. Thus, the Oseberg textile (which, like the Tapestry, is a frieze) shows a procession of soldiers, horses and carts (fig. 37).[280] As we know from the Vikings themselves, these 'tjells' adorned their houses and – after Christianization – also their churches. Is it not likely that the Norse forbears of the Normans had left behind them the memory of such works (and perhaps some of the textiles themselves) and that they had brought their embroidery techniques to Normandy, thus making a vital – albeit indirect – contribution to the character of the Tapestry?

XIII

Traditions of Viking Art

Stylized Trees

The Norse artistic heritage also lurks behind the recurrent ornamentalizing tendency in the design; where this appears, it might well reflect a tendency towards decorative patterning in the specific visual source. At least, this is suggested by the varying tree configurations in the Tapestry.

Between the arrival of the English ship with the news of Harold's coronation and the building of the Norman fleet, the trees

54 *Initial D. From Psalter, c. 1020. Cambridge, University Library, Ms. Ff. I. 23, fol. 37 v*

55 *Commemorative stone. First half of 11th century.*
Vang (Valdres), Norway

look plant-like and relatively natural
(p. 126 f.). Elsewhere in the Tapestry, how-
ever, the forms are far more stylized, as in the
knotted vegetation between Count Guy's
palace and the scene of his conversation
with William's emissaries (p. 100). The outer,
S-shaped vertical stripe of the trunk curls

56 *Commemorative stone, c. 965. Jelling, Denmark*

round in an oval loop, which both frames an
elaborate interlace pattern and forms part of
it. Similar tree motifs exist in Anglo-Saxon
manuscripts: in the Old English Hexateuch
mentioned above, Adam and Eve try to hide
behind a tree with a similarly interlaced
crown (fig. 53).[281] Yet no stylistic connection
can be traced between this and the vegetation
in the Tapestry – the tree outside Bosham
church, for example (p. 93). In the Anglo-
Saxon version the interlace forms a rigid lat-
tice that does not grow out of the tree,

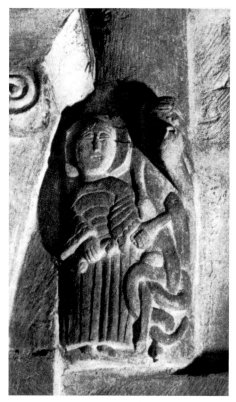

57 *Saint and a figure with a 'snake-like' body.*
Console relief, late 11th century.
Tollevast, Saint-Martin

but seems to have been mounted on top of a
stout, rounded trunk. In the cloud-like
crown of the tree the ornamental impulse has
been visibly reined back. By comparison with
the Tapestry, this looks more like an effort to
hold on to something of the natural appear-
ance of the tree; the interlace itself looks
almost handcrafted. The Bosham tree in the
Tapestry, on the other hand, undulates in
curves, and the dynamic bands of interlace

seems to be caught up in an incessant
motion.

In the whole of Anglo-Saxon art only the
initials of a few manuscripts of *c.* 1020/30 dis-
play a comparable ornamental structure: an
example is the initial D in a Psalter now in
Cambridge (fig. 54).[282] Although the trees in
the Tapestry were worked almost half a cen-
tury later, there are obvious parallels here
that point to a common origin. This source
was the Ringerike style, which was prevalent
in eleventh-century Norway, Sweden and
Denmark. A characteristic instance is the or-
nament on the stone from Vang (Valdres) in
Norway,[283] a work fundamentally related, in
the structure of its 'elastic' ornament and of
its dynamic mobility, both to the Anglo-
Saxon initial and to the stylized trees of the
Tapestry (fig. 55). Earlier forms of Viking
decorative patterning still seem to have been
familiar at the time when the Tapestry was
worked. The stern post of Harold's second
ship (on his crossing from England to
France) ends in a tight, wide ribbon inter-
lace (p. 95) reminiscent of that on the celeb-
rated Jelling Stone of *c.* 965 in Denmark
(fig. 56).[284]

Norse Reminiscences

It is well worth looking into the true sub-
stance of occasional Scandinavian reminis-
cences of this kind. They were certainly not
current across the whole spectrum of French
or German art, and we have no cause to dis-
miss them as trivial or irrelevant. It is likely
that Norse artistic forms were deliberately
adopted in the Tapestry as a reminder of the
Normans' national origins. A whole series of
clues points to this. Eleventh-century Nor-
mans were still well aware of the Norse ele-
ment – as well as the dominant French one –
in their identity. Bates has shown, from
countless place names and from the termino-
logy of seafaring (as we have seen) and of
agriculture, that Norse had by no means
vanished from the language of the common
people.[285] Furthermore, in the tenth century
numerous settlers from England found their
way to Normandy, bringing with them, quite
possibly, not only Anglo-Saxon, but also

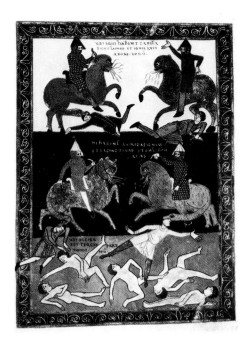

58 *Horsemen of the Apocalypse.*
From Beatus, Commentary on the Apocalypse, c. 1050.
Paris, Bibliothèque Nationale, Ms. lat. 8879, fol. 148 v

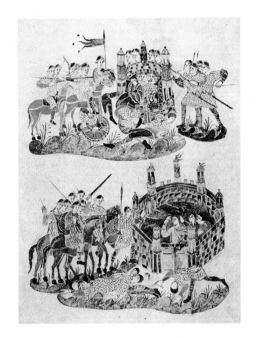

60 *Joab and his army on the march. From Golden Psalter,*
before 883. St Gallen, Stiftsbibliothek, Ms. 22, p. 140 f.

by saying that, in the eleventh century, the Norman aristocracy had not forgotten its 'Norse origins' and that the ducal house long continued to be proud of its ancestry.[289] In the last years of Duke Richard II, *c.* 1025, Sigvatr Thordharson, skald (bard) to the Norwegian King Olaf Haraldsson, was welcomed to Rouen. This shows, says Bates, that there must still have been some Norse speakers at the Norman court (not forgetting that it was a Norman archbishop, Robert of Rouen — one of Duke William's tutors — who had converted Olaf Haraldsson to Christianity).[290]

'Barbaric' Use of Colour

All the efforts that have been made to turn the Tapestry into an Anglo-Saxon artefact, and to absorb it into English art, have distracted attention from its specific qualities. Hardly one art historian has made a detailed study of the use of colour in the Tapestry. Especially in the final third of the narrative, the colour is dominated by the appearance of the horses. Whereas Wormald, for instance, left colour entirely out of account, concentrating on matters of form and motif in his discussion of the 'Style and Design' of the work, Digby stressed that 'a group of horses is worked in contrasting and quite unnaturalistic colours'.[291] In his introduction Wilson tersely remarked: 'The colours are not used naturalistically; a horse, for example, may be blue or buff'; in his section on 'Style, Art and Form' he has not one word to say about

colour.[292] Nothing but succinct descriptions: no closer studies have ever been undertaken.

The questions that suggest themselves here are the following. Is the idiosyncratic placing of colours the result of the individual 'caprice' of the members of the workshop? Or does this 'unnaturalistic' element rest on precise conventions or models, or perhaps on traditional custom and practice? The seemingly arbitrary colouring of the horses' bodies (in all the shades used in the Tapestry, yellow ochre, bluish black, dark red and the rest) is certainly not present to the same degree in late antique art. Yet neither is it unique to the Tapestry workshop. This is a markedly anti-classical, 'barbarian' characteristic that crops up in early medieval art from widely separated places. In one mid-eleventh-century miniature from south-western France — an illustration to the Apocalypse commentary of Beatus of Liébana — four horsemen sit on alternately blue and red (fire-breathing) steeds (fig. 58).[293] Horses in the same alternating colours carry a troop of Vikings on a Swedish hanging from Skog (Statens Historika Museum, Stockholm), which Salvén dated 'between the mid-eleventh and mid-twelfth centuries' (fig. 59).[294]

Danish culture and speech.[286] Immigration from Scandinavia continued until 1020.[287]

The Norman aristocracy took particular pride in its Norse origins. In 1082, or thereabouts, Roger de Montgomery boasted that he was 'ex Northmannis Northmannus'.[288] Far on into the eleventh century — so long as the Normans remained in close contact with Denmark and Norway — Norman nobles had more on their minds than their present French identity. The catalogue of the great Viking exhibition in Paris summed this up

59 *Hanging from Skog; c. 1050/1150. Stockholm, Statens Historika Museum*

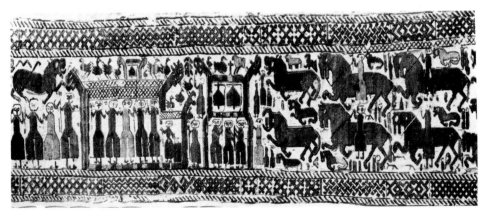

61 *Bull of St Luke the Evangelist.*
From Book of Kells, late 8th century.
Dublin, Trinity College Library, Ms. 58, fol. 3

The same happens even in a late ninth-century Carolingian manuscript illumination: the Golden Psalter of St Gallen shows us the soldiers of Joab riding on green and red chargers to do battle with the Syrians and Edomites (fig. 60).[295]

Monochromatic animals form the exception rather than the rule in the Tapestry. Here, it is unique in its radical dislocation of the relationship between colour and form. The designer has made every effort to make the animals lifelike; at the same time, the colour disrupts their organic coherence even more radically than in the manuscript examples just mentioned. Consistently in the horses — and very occasionally in human figures, too — individual parts of the body, mostly legs,[296] seem to have been coloured in as part of an abstract pattern. There are, for instance, blue horses with one yellow leg, yellow horses with one red and one black leg, green horses with two red legs, red horses with yellow, black or green legs, and so on. The hoofs and manes are often picked out in a different colour again. In contrast to the systematic design of the rhythmic and harmonic background decor, the sequence of the colours seems arbitrary. This unpredictable variation shows an unsettling readiness

to dispense with perceptual logic, and yet that same logic is still on hand to capture the animals' 'physique'. We know of no other work of the period with anything like this combination of consistency and caprice.

Just once, long before, there had been a move in the same direction. Figures with a comparably non-representational colour scheme exist in the early manuscript illumination of Ireland and Northumbria — in regions, that is to say, where Celtic tradition encountered Norse prototypes. One example is the symbol of St Luke in the Canonic Tables of the celebrated late eighth-century Book of Kells: the winged bull has a green body and one green hind leg; its other legs and its tail are blue (fig. 61).[297]

Viking Ornament

Of course, there are no grounds for supposing that the embroiderers (and / or the designer) knew and imitated centuries-old works of the Insular style. It is more likely that the unnaturalistic, highly contrasted polychromy of the beasts in the Tapestry preserves traces of an approach ultimately derived from Scandinavian art. Unfortunately, no painting to speak of has survived in Scandinavia, so it is better to rely on the metalwork, which has come down to us in some quantity. The Norse zoomorphic styles are largely dominated by disembodied forms, as in the early eighth-century bronze fibula with a horse motif that was found at Veggerslev in Jutland (Nationalmuseet, Copenhagen; fig. 62).[298] The internal divisions imi-

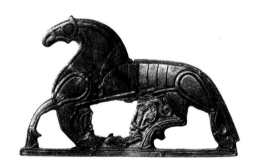

62 *Fibula from Veggerslev. Early 8th century.*
Copenhagen, Nationalmuseet

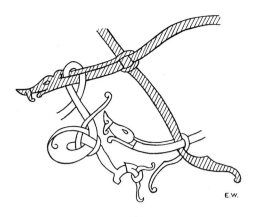

63 *Drawing of ornament on a bishop's crozier (c. 1100) in the Cathedral Treasury, Durham*

tate cloisonné — that is, goldsmith's work with coloured stone inlays.[299] The division into differently coloured areas fosters the autonomy of the individual compartments within the figure. From the sixth to the eleventh century craftsmen in south-western Scandinavia stylized natural form by overemphasizing its individual parts; the resulting compartmentalization makes the overall form hard to decipher.

Norse — and, later, Viking — artists loved to mingle the large with the small. This often went so far that parts were singled out to represent the whole. Throughout the entire early medieval period Scandinavian artists show a marked predilection for kaleidoscopic patterns. In the horse brooch from Veggerslev the broad neck and breast are more massive than the slender body. Organic coherence becomes a side-issue. The surfaces of head, neck, legs and body take on a life of their own; they seem affected by the elongated slenderness of the animal itself, which becomes more marked towards the rear. We recognize the main preoccupation of the wholly un-antique art of Scandinavia: not only does the sectional form take its lead from the overall form, but the overall form is *equally* governed by the individual form. A cognate mode of symbolic thinking is found in Scandinavian literature. The skald never described an event or a character exhaustively, but picked out individual details, episodes or features to stand for the whole.

We can thus conclude that the 'isolating' colour pattern of the horses, and the occa-

sional ornamentalization of objects (such as trees), represent – at the least – indirect connections between the Tapestry and Scandinavian art, and that this conflicted only in appearance – and not, as it might now seem, in reality – with the simultaneous tendency to capture the natural appearance of things. In their own way, through their images, the members of the Tapestry workshop furthered the national aspiration of the eleventh-century Normans: to achieve a union of disparate elements by reconciling the Scandinavian past with the French present while, at the same time, transforming Anglo-Saxondom. It was time to create something new, without allowing the past to dominate or define.[300]

There is little in Anglo-Saxon art, either shortly before or immediately after 1066, to remind us of Viking work. Four decades earlier, on the other hand, in the 1020s, the Scandinavian Ringerike style turns up in English illuminated manuscripts (such as the Cambridge Psalter already mentioned).[301] This clearly reflects the period of Danish rule under Knut the Great (Canute) and his sons (1016-42). After this, during the reign of Edward the Confessor, Anglo-Saxon artists tended to steer clear of Scandinavian motifs. However, the Normans, with whom the Confessor was on such good terms, certainly felt no such inhibitions. At all events, English art after mid-century witnessed a revival of Scandinavian ornament that has been plausibly ascribed to the invasion of the country by a nation of ex-Vikings, the Normans.[302]

The Normans long continued to hold Viking art forms in high esteem, though probably more in secular than in religious contexts. Very few major works have survived, since secular objects rarely found refuge in the relatively secure ecclesiastical treasuries.[303] Nevertheless, the occasional survivals of Scandinavian ornament in Anglo-Norman religious art serve to prove the point. At Durham – still a focus of Norman influence in England in the early twelfth century – a crozier was made c.1100, probably for Bishop Ranulph Flambard (fig.63). Designed, according to Wilson and Klindt-

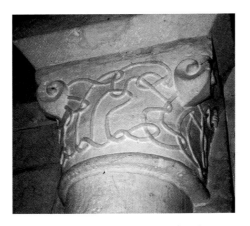

64 *Capital. Late 11th century.*
Sainte-Marie-du-Mont

65 *Fibula. Late 11th century.*
Reykjavík, Pjódminjasafn Islands

66 *Commemorative stone. Late 11th century.*
Fålebro, Denmark

Jensen, by a Norman artist who was a true successor of the Vikings, this very anti-Anglo-Saxon piece embodies the pure Urnes style of Viking art.[304]

Characterized by its loose, flowing ornament, the Urnes style evolved in Scandinavia in the later eleventh century, and it was well known to the Normans of Normandy. At the end of the century, only seven kilometres from Bayeux itself, a sculptor carved a capital for the church of Sainte-Marie-du-Mont (fig.64).[305] The bell of this typical Norman capital, with its corner volutes, is covered with a shallow ribbon interlace pattern. The sweeping, fluid curves seem to be caught up in an unending motion. Their dynamic linear alternation surely reveals a detailed knowledge of the roughly contemporary Urnes style, as exemplified by a Scandinavian fibula now in Reykjavík (fig.65; see also fig.66).[306]

We can therefore assume that, even in the period when the Tapestry was worked, the Normans had knowledge not only of the earlier, but also of the contemporary art of Scandinavia. Additionally, there are traces of Viking influence in the ornament of late eleventh-century Norman illuminated manuscripts. In the wide ornamental frame to the right of the St Mark miniature from Jumièges[307] English precedents would have led us to expect the acanthus-leaf ornament that is seen on the Evangelist pages of Anglo-Saxon manuscripts of the second quarter of the century.[308] Instead, the image is surrounded by a lively, constantly changing zoomorphic interlace of dragons and tendrils. Even the Anglo-Saxon-cum-Viking initials of the early eleventh century provide no adequate point of comparison.[309] The analogies are mostly Viking ones (as in the familiar example of the Jelling Stone). It all comes down to this: the Tapestry workshop did not owe its familiarity with a number of Scandinavian artistic conventions to Anglo-Saxon art of the second third of the eleventh century.

67 *Job's children feasting; Christ and the Apostles.*
From Floreffe Bible, *c. 1160.*
London, British Library, Ms. Add. 17738, fol. 3 v

68 *Virgins climbing the Ladder of Christ.*
From Speculum virginum, *c. 1160.*
Cologne, Historisches Archiv, W 276 a

Narrative Techniques

All that we have said, by way of observation and analysis, does not tell the whole story. However right, and indeed necessary, it may be to approach the iconographic evidence – and the attendant unresolved stylistic issues, with all their historical ramifications – primarily from a formal, aesthetic point of view, we cannot rest content with that. We fall far short of our goal unless all this leads us on to the real question: what use did the designer make of his formal repertory? By which I mean how was the work done, for what purpose and for whom? In what way does the pictorial narrative constitute a 'transposition' of the thematic content, and what is this transposed into?

Scholars in general have tended to neglect the way in which medieval art – like later art – always contains a range of different possibilities. Take twelfth-century religious manuscript illumination with its impulse to emotionalize the Christian certainty of salvation. In the mid-twelfth century, in northern France and in the Mosan region, sumptuous Bibles were illuminated in the expensive body-colour technique, with complex typological scenes (fig. 67).[310] They were intended for a restricted, lettered, visually sophisticated public, which knew its subject and delighted in intricate codes and allusions – a subtle 'language of art' that afforded the pleasure of divining and appreciating spiritual messages. At the same time, the Cistercians began to circulate works of edification such as the *Speculum virginum*;[311] books containing readily comprehensible sequences of pictures, mostly drawn in line, in which the images appealed to the mind largely as surrogates for text (fig. 68).[312]

Narrative Continuity

Clearly, the Tapestry does not belong to the emergent category of 'contemplative' art. It expounds recent history, documents the artists' relish in description and offers entertainment of an exciting kind. It was obvious-ly not conceived for some expert circle of literati, but was aimed at a wider public that wanted to see things and had to be made to see them precisely as intended by the patron and the artist. The choice of a continuous strip narrative is, in itself, significant. By contrast with eleventh- and twelfth-century Old and New Testament cycles, or lives of the saints, depicted in sequences of relatively self-contained images, the Tapestry was designed to emphasize the chronological continuity of its theme through a succession of linked phases. The resulting, tightly interlocked structure emphasizes history as process. A sequence like that shown in the Tapestry must have stimulated viewers to appreciate the salient points of a chronological progression – and to do so in the expansive context of an extended pictorial narrative. In its day, the Tapestry must have been greeted with as much fascination as the very first film newsreels.

Trees as Participants

The pictorial code of the Tapestry assigns a pivotal role to trees, which act like commas in an extended, periodic sentence-structure. Wormald (followed by others) saw them as an indication that the designer was pursuing a long-established tradition: 'Such a use of a tree to break up the scenes is very old and had been in use in classical painting. It was taken over by the Carolingian painters and had thus become part of the stock in trade of the early medieval artist.'[313] However, the antecedents cannot be traced as easily as all that. In late antique art, and in the early medieval works that followed, trees are meant to be seen primarily as part of the landscape: they accentuate the layers of spatial recession, and have nothing like the dramatic function that they possess in the Tapestry (figs. 69, 70).[314]

The plant forms in the Tapestry, which thrust themselves forward so ostentatiously to mark breaks in the narrative, also have a role in terms of content. They are involved in the action in a number of ways. Two trees flank the English ship that brings news of Harold's coronation (pp. 124-6). They seem

69 *Story of
Adam and Eve.
From Grandval Bible,
c. 840.
London, British Library,
Ms. Add. 10546, fol. 5*

the arrival of William's emissaries (p. 100). As the battle commences, a group of three trees balances the tall figure of the Norman commander, as his horse is led up to him (p. 144 f.).

At the shipyard the crown of a tree 'bows' to the right in salute to the completed ships, as if to stress the speed with which the work has been done (p. 128). Trees with this kind of dramatic function are by no means exceptional: at times, they look like actors in the drama in their own right. William orders his emissaries to ride to Beaurain (post-haste, as it would seem); a tree bows in obeisance, revealing a lookout who has climbed its trunk (p. 102 f.). As the tide of battle surges to and fro, an S-shaped tree sways elastically on the brow of the hill that the English are defending (p. 159).

Not only in their individual interlace forms, but also in their gestural participation in the story, the trees are markedly anti-traditional – that is to say, anti-classical. They have nothing in common with the legacy of late antique art, because they have a different way of intervening in the story. Before the onset of the Battle of Hastings, the Duke stands flanked by town walls and trees, almost as in a separately framed picture: here, the convention of continuous narrative is stretched to its limit. By contrast, the tree on the defended hill, which has no role in separating two episodes, is directly incorporated within the scene. The wide repertory of scene-divisions in the course of the narrative springs entirely from the artist's own delight in variety. He was clearly not tied to any preordained system, or, if there ever was one, he had outgrown it. Neither is he likely to have been constrained to use any authoritative corpus of source images; evidently, he sought and found new pictorial formulas that were intended to differ radically from those of the past.

to 'elevate' the significance of the message (the ship floats relatively high in the pictorial space), partly by marking a transition to the English and Norman palaces on either side. Whole tracts of the narrative dispense with trees as punctuation, and sometimes buildings assume the same role. Then trees reappear, to mark a powerful emphasis. The wide tree immediately to the right of Count Guy's palace at Beaurain draws attention to

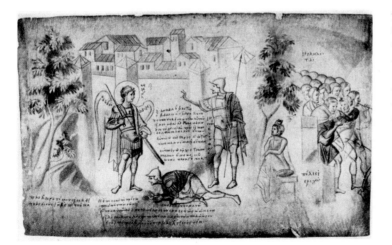

70 *Joshua and
the Archangel outside
the walls of Jericho.
From Joshua Roll,
10th century.
Rome, Biblioteca
Apostolica Vaticana,
Ms. Pal. gr. 431, sheet IV*

New Narrative Forms

The same goes for the whole narrative flow of the Tapestry, with its frequent changes of tempo. The feast at Hastings and its preparations occupy approximately the same

amount of space as the – historically far more important – processes of building the fleet and embarking the army. The frequent transition from leisurely depiction to tight narrative (a lengthy account of Harold's return to England and Edward's burial; then, in a nutshell, the coronation and the appearance of the comet; pp. 118-22, 123 f.) create a rhythmic variation in pictorial narrative such as had been unknown since late antiquity. Unmistakably, the designer was looking for new narrative techniques that would maintain the beholder's interest as never before, as he or she strolled the length of the Tapestry. Again, the Tapestry has many original ways of stimulating perceptivity by alternating between important and comparatively trivial events. Between the lines, as it were, the intention is clear: the varied sequences consistently prompt the viewer to follow and approve the actions of the Norman Duke, as well as the contributions made from time to time by Bishop Odo.

The features of the narrative itself rest on the same principles that emerged from our historical analysis of form. The Tapestry fully documents the eleventh-century Normans' desire to create an imagery and a cultural identity of their own and to distance themselves from Anglo-Saxon, Carolingian and antique precedents. This is very much the line taken by William of Poitiers in his chronicle (see p. 55). He likens the exploits of Duke William to the campaigns of the Roman emperors and leaves the reader in no doubt that the Conqueror towers above his predecessors.[315] Both before and after 1066 – as their great new churches show – the Normans faced the future with confidence. The designer of the Tapestry himself, as an innovator, no doubt felt superior to the artists who had gone before him.

Reversals of Sequence

Probably the most fundamental difference between the Tapestry and the general run of narrative cycles in late antique and early medieval art is that in two places – apparently on impulse – the designer violates the conventional chronological sequence of images. William's emissaries ride leftward on their way to rescue Harold from the clutches of Count Guy (p. 102) and the Confessor's coffin is carried leftward into Westminster Abbey (p. 121).

This feature has led to some perplexity among the commentators on the Tapestry. In 1974 Gibbs-Smith considered it inexplicable;[316] back in 1957 he had described the Confessor's burial scene as 'hard to understand'[317] and the other reversal as 'misplaced scenes'.[318] Wormald, like Stenton, was at a loss: 'It is difficult to explain the reason for this change of arrangement.'[319]

Others, however, did not give up, but looked for an explanation. Parisse interpreted the designer's course of action from the viewpoint of a modern film director: he called the violations of chronological sequence 'flashbacks'.[320] But it really will not do to transplant a modern visual convention into the eleventh century. Bernstein, in another attempt at explanation, accounted for the two cases in two different ways, thus losing credibility from the very outset. In the one instance, he claimed, Edward the Confessor's deathbed scene occupies a pivotal position between his burial and the offer of the crown to Harold in order to show that it was Edward's last wish that Harold should become king.[321] If that were so, the main point of the whole narrative – that this was a just war against a usurper – would be vitiated. In the other instance, says Bernstein, the designer had no particular motive for showing William's emissaries as he did: perhaps he wanted to emphasize the distance between the courts of William and of Guy, or perhaps the Tapestry was designed for a particular hall, the disruption of the sequence arising from this scene's position in a corner.[322]

More plausible explanations do exist. The emissaries ride from right to left to indicate that here two things happened at once. For when Count Guy captured Harold and took him to Beaurain, one member of the English party slipped away to tell William, who thereupon sent out his men (pp. 100, 103). The designer probably worked from a chronicle that dealt with Harold's capture first and went on to describe William's response. To depict this, he invented an appropriate narrative technique; his supposed blunder turns out to be a skilful device to indicate simultaneity.

The close linking of scenes in the Tapestry is actually at its height in the 'retrograde' episode in which William is briefed by the English fugitive (a form of presentation far removed from the narrative principles embodied in cycles created in the late antique tradition). Ready to leave, the two envoys swivel their heads round to the right to listen to their Duke's orders; but their bodies face forward, as if they could hardly wait to get going. Their right hands, with spears in them, already point the way forward (or back, if you will) to the lookout tree and the road to Beaurain. The man in the tree seems to be gazing after them as they ride, but there is also a subliminal suggestion that he is watching for the arrival of Harold, which then takes place to the right of the Duke's castle. This restless eagerness to carry the story forward, to heighten the tension by interlocking successive events, is characteristic of the Tapestry narrative; even the 'retrospect' (definitely not a 'flashback') prepares for what comes after. And so, in the scene of Harold's arrest, two hounds bound away from Count Guy's leftward-facing escort and towards the next episode, in which the Count takes his captive to Beaurain (p. 98).

What of the dying Confessor and his burial? Here, the narrative presents us with a subsidiary episode designed to cast light on the major events. The offer of the crown to Harold presupposes the death of the rightful King of England; and then fate takes its swift and logical course. Edward's death is not in itself part of the story of William and Harold, but it has a value as a turning-point in the narrative. If the funeral procession (which underscores the significance of the whole episode) had marched from left to right, it would have looked like a mere digression between the death of the Confessor and the crowning of his successor. The designer's intention is very much the same as in the other 'retrograde' scene. Here, too, he has set out to interlock the elements of the narrative

as tightly as possible, in preparation for an impending convergence.

All this chimes perfectly with the emphasis placed by both our Norman chroniclers, William of Jumièges and William of Poitiers, on Harold's tactlessness in having himself crowned on the very day of Edward's burial (6 January 1066). The real point of the reversal is that it emphasizes the anti-English message. The Tapestry implies that in the abbey, Edward's burial place, which terminates the scene on the left, Harold, enthroned on the far right, was crowned by Stigand, who stands next to him. The man who offers the crown to Harold points with his free hand back to the dying Edward! The designer's chronic impatience to further the narrative here becomes more than a propulsive force: the narrative technique in itself serves to unmask Harold as a law-breaker and a traitor. The use of retrograde motion interweaves a set of near-simultaneous actions in order to convey the indecent haste with which the usurper seizes power.

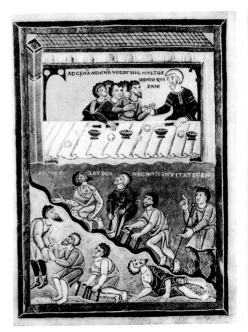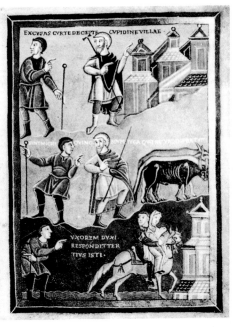

71　*Parable of the great supper. From Pericope Book of Henry III, c. 1039/43. Bremen, Universitätsbibliothek, Ms. b. 21, fols. 78 v - 79*

Gestural Exuberance

All the attempts made in the literature on the Bayeux Tapestry to reconcile, or even to link, the narrative elements of the work with the two major suites of Anglo-Saxon Old Testament illustrations – the Old English Hexateuch, mentioned above, and the Cædmon Genesis of *c.*1000, now in Oxford[323] – are flatly contradicted by the evidence. According to Bernstein, the images in these manuscripts anticipate many of the narrative techniques of the Tapestry. Yet the analogies amount to nothing more than that the Biblical illustrations sometimes include continuous sequences of scenes and that a figure sometimes appears twice within a single scene.[324] Bernstein never examined the salient characteristics of the narrative technique; if he had, this would have exposed the fundamental points of difference between the Tapestry and the miniatures. Throughout the Tapestry there are figures who make expansive gestures, either to left or right, to point to events in adjacent scenes. This never happens in the Anglo-Saxon sequences, which are

partly based on Early Christian models. Following the same principle as the illustrative cycles of late antiquity, the people in the Anglo-Saxon drawings communicate far more directly with each other. They perform in self-contained episodes and one scene follows another without any overriding connection.[325]

The narrative art of the Tapestry has nothing in common with this: it relies on a great deal of overstated gesture. After the cavalry advances at the onset of the battle, there is a long-range confrontation between the two chiefs, both on horseback, and separated by a hill and by their own scouts (pp. 147-9). William holds a mace in his right hand and points forward with his left (p. 147). The scout who rides up to him maintains the directional impulse by pointing in the same direction, although he is riding from right to left. Harold, on the other side, points to our left; the Anglo-Saxon scout runs towards him, but crooks his left arm to point back towards the Normans (p. 149). In all their different ways, the expansive, overarching gestures of the figures evoke the impending collision.

At Bosham, after (presumably) partaking of Harold's feast, one member of his entourage has risen from the table and stands on the top step, outside the house (p. 94). From there he turns back to the diners and urgently gestures with his left hand that it is time for the embarkation, which begins directly below and to the right. Enthroned in his palace at Beaurain, Guy speaks to Harold (p. 100). To the right of the throne a soldier turns to address the Count, but his left hand, in which he holds his spear, points the other way, as if he had a premonition of the arrival of William's emissaries. One man seems unable to bear the suspense: while still following the conversation in the throne room, he sidles behind a pillar and goes outside. Once the decision has been taken to build the fleet, Odo orders work to start, with a pushing gesture of his right hand to the shipwright (whose own gesture points towards the tree-felling; p. 126).

There is a long string of other instances, the most eloquent of which is the central scene of the whole Tapestry, when Harold swears his oath (p. 117). He makes the action ostentatiously in the extreme. His out-

be made primarily for the viewer's benefit. The figures in the Tapestry have modified their traditional role as actors in the drama to become embodiments of their own gestures; often, they seem to be addressing the beholder direct. In such cases the action is not propelled along by internal forces alone: the spectator is, as it were, drawn in to become a participant. The presentation of an event and the subsequent historical verdict on it tend to become one and the same thing, in a fictive simultaneity.

This is undoubtedly the most characteristic of the designer's visual devices. It has no antecedents in England, but there are some remote analogies in Continental art. The gestural 'language' of Ottonian manuscript illumination provides one possible point of departure. The Pericope Book of Henry III, illuminated *c.*1039/43, illustrates Christ's

stretched left arm echoes William's gesture and, at the same time, sweepingly indicates all that is to the right of him, in a way that seems to encompass all the events that follow. We are almost tempted to suppose that the designer makes the Earl take his oath on two reliquaries at once in order to supply a plausible excuse for the gesture.[326]

The sense of animation and vividness that we derive from the work as a whole springs from a host of specifics, whether in the indi-

vidual figure or in the description of the action: although separate and distinct in themselves, all these elements are inseparably linked as the components of a style. Of course, we encounter eloquent gestures in Anglo-Saxon painting, too; but the gestures in the Tapestry have a character all their own. They not only emphasize the rhythm of the placing of the figures, but reinforce the concision of the narrative by making long-range connections. Largely untouched by the afterglow of late antique design, the artist has vastly increased the inherent expressive content. By comparison with the figures in Anglo-Saxon art, the cast of the Tapestry consists of a corps of gesturing extras, all aligned in a single dimension. As a result, space is negated throughout. There are no groups or architectural arrangements in which one form is partly masked by another; the force of the gestures thus remains unbroken. The vehemence of the body language requires the wide open spaces of a light, neutral (linen) surface, which is far less of a background than the grounds in Anglo-Saxon art.

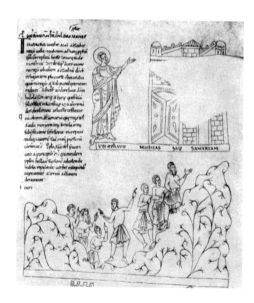

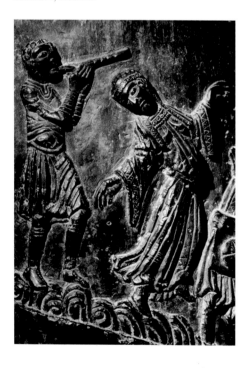

Spectator Involvement

The distinction between the art of the Bayeux Tapestry and Anglo-Saxon, Carolingian or late antique art is one of principle. There are numerous gestures that do not directly arise from the action in which the figure is engaged at the time; many conspicuous arm and hand movements seem to

parable of the Great Supper (fig. 71).[327] In the right-hand miniature, as in the narrative of Luke 14.16 - 21, the host's servant issues the invitation to the feast three times (those invited make their excuses, and the host replaces them with the poor, who are seen on the left). The servant's pointed gestural allusions and, notably, the expressive cross-over gestures of the lowest figure tie the repeated invitations

75 *Annunciation to the Shepherds.*
From Sacramentary of Mont-Saint-Michel, c. 1050/65.
New York, Pierpont Morgan Library, Ms. 641, fol. 2 v

in with the ensuing feast; at the same time – like the demurring gestures of the invitees – they are a direct address to the beholder. The servant gesticulates for our benefit, and we join in as involved onlookers. As in the Tapestry, the events narrated coincide precisely with the outsider's subsequent verdict and the action is so speeded up that the events in the two adjacent miniatures seem to be happening simultaneously.

Similar narrative features found their way westward from artistic centres in Germany. Much the same histrionic language of gesture (appealing directly to the viewer, compressing and accelerating the action) is to be found in the late eleventh-century mural paintings at Saint-Savin. The Ottonian influence is obvious here: the story of Joseph runs from left to right and even duplicates the gesture of Harold's oath (fig. 72).[328] In the scene where Potiphar's wife has Joseph cast into prison her outstretched left hand almost touches the fleeing figure of Joseph in the previous scene. With her right hand, raised to the same level, she transmits the movement onward to the overseer, who rushes in, and, through him, to Joseph, who is already locked up.[329]

This overwhelming, scene-bridging gestural energy, this oddly compressed didactic narrative, which seeks to sweep the spectator along as a direct eyewitness, is found in eleventh-century art over an area that extends from Germany through France and as far as northern Spain. In the Roda Bible, men-

tioned above,[330] one verse (Micah 4.2) is illustrated, as in the Tapestry, by a sequence of scenes directly addressed to us as beholders: 'And many nations shall come, and say, Come, and let us go up to the mountain of the Lord, and to the house of the God of Jacob; and he will teach us of his ways, and we will walk in his paths.'[331] Gesturing as they come, the nations of the Gentiles emerge from behind a hill on the left and point to the man who stands in the valley; he takes up the gestural flow with his right hand and conducts it onward with his left (fig. 74). (We are reminded of Odo, at the moment when the decision is taken to build the fleet; p. 126.) The Roda Bible figure faces the spectator like a signpost; he seems to speed the Gentiles on their way up, as they point to the summit.

In the Tapestry the horseman identified as Eustace (Eustatius) plays an analogous role (p. 161). He points back at the Duke, whose helmet is tipped back; at the same time, the horseman has raised his left hand – the standard flies to the right, as usual – to lead the eye onward and reinforce the energy of the charge. (Bear in mind that a manuscript in the style of the Roda Bible might well have been available in Normandy at the time when the Tapestry was worked.)

The gestural cross-over that we saw in the lowest of the servant figures in the Ottonian miniature from the Pericope Book of Henry III finds an echo in the gesture of the soldier who takes Harold prisoner (p. 97). He shows what he is doing by laying hold of Harold with his left hand; with the other, which crosses the left arm, he points to Count Guy (who, for his part, extends his right arm). This scene-building device was in use by the Norman illuminators of the mid-eleventh century, who undoubtedly derived it from Ottonian art. One example is the miniature of the Annunciation to the Shepherds on fol. 2v of the Sacramentary of Mont-Saint-Michel (fig. 75).[332] The central shepherd points both ways, thus heightening the already overwrought gestural intensity of the scene. Like a stage performer, he conveys the celestial message in dumb-show, while his fellow on the right is still pointing out the apparition of the angel.[333]

XV

A Pioneer Work

Anticipations of Anglo-Norman Narrative Art

The place of the Tapestry in the transition from early to high medieval art is defined by the fact that it is not dependent on Anglo-Saxon painting. However, this leaves us little the wiser if we do not at least make a start in clarifying its position in relation to English art as a whole. For one thing, a motif probably invented by the Tapestry designer, and thus a key indicator of its historical position, appears in an English illuminated manuscript of *c.* 1110/20. The horse that pitches over in the battle scene, with its head on the ground and its hindquarters vertically above (p. 158), turns up in the crosspiece of an initial T in Ms. Arundel 91 in the British Library, where the pagan, Lucian, falls with his mount from a mountaintop (fig. 76).[334]

This analogy gives us pause, and it is not an isolated case: there are others, matters of narrative technique, between the Tapestry and a number of English works produced several decades later. The Tapestry represents Norman art of the later eleventh century and,

76 *Initial T. From Passional, c. 1110/20.*
London, British Library, Ms. Arundel 91, fol. 188

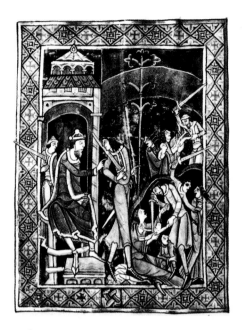

77 *Massacre of the Innocents. From St Albans Psalter, after 1123. Hildesheim, St Godehard*

in many respects, it also anticipates the Anglo-Norman art that followed. The narrative technique of the Tapestry can be summed up as follows: the themes of the action are not sacrificed to (narrative) swiftness, but

the viewer is induced to perceive all that happens as part of an interlaced web of scenes. The very same process takes place in a miniature of the Massacre of the Innocents in the celebrated 'album' of forty full-page illuminations in the St Albans Psalter, made at St Albans after 1123 (fig. 77).[335] The structure of the scene breaks with iconographical convention, which elsewhere requires two separate episodes: King Herod giving the order on the left and the soldiers killing the children on the right. In the St Albans Psalter this clear chronological distinction is abolished: an armed henchman 'ties' Herod in with the scene of slaughter. This figure looks back at Herod, in profile; while still listening to his orders, he has swung round towards the scene of the crime, which has already begun.

In the literature on the St Albans Psalter this pictorial device is explained in terms of the liturgical drama; thus, in the mystery play *Ordo Rachaelis*, it is the henchman who, to allay Herod's rage, suggests the murder of the children.[336] This may have indirectly influenced the illuminator, but it does not explain the pictorial narrative structure, which derives from a tradition shared (or partly created) by the designer of the Tapestry.

To return to the scene in which the order is given for the building of the Norman invasion fleet: Odo stretches out his hand as he passes the Duke's order on to the shipwright, who carries a tool (p. 126). The shipwright looks back, in profile, at his masters; but, at the same time, he sets off in the opposite direction and points with his left hand to the next stage in the process, which is already under way. The Tapestry thus makes the same kind of quick scene-change as the St Albans Psalter, with the same expectation that we shall mentally keep up with the pace of the action: events that happen in succession are rendered 'present', to be taken in 'at a glance'.

The designer of the Tapestry seems to have shown the way to the Anglo-Norman illuminator here; nor is this an isolated case. The Norman cleric William of St Calais took numerous books to Durham while he was Bishop there (1081-96). It was in Durham, possibly between 1083 and 1090, that the Life of St Cuthbert was provided with a first set of illustrations,[337] which was augmented by an illuminator soon after 1100 into the earliest known narrative cycle in English post-conquest art.[338] In one scene St Cuthbert appears on the left as a pilgrim before King Alfred; the monarch orders him to be given a piece of bread (fig. 78).[339] There is a fundamental analogy here with the Tapestry and its close gestural interlocking of successive events. Once more, a servant looks back in profile, 'picking up' the order with his right hand. At the same time, he strides forward, and the gesture of his left hand leads the eye on to the theoretically later moment when the bread is cut and the saint (already) grasps it.[340]

Faces in Profile

A further innovation in the Tapestry is its liberal use of profiles – another device that serves to speed up the action. Only occasionally are figures shown in full or three-quarter face; the profile unquestionably predominates. There are some early eleventh-century Anglo-Saxon illustrations – including certain scenes in the Cædmon Genesis – in

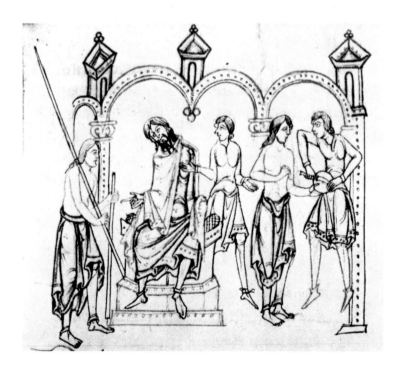

78 *St Cuthbert appears before King Alfred as a pilgrim. From Life of St Cuthbert, early 12th century. Oxford, Bodleian Library, Ms. Univ. Coll. 165, fol. 135*

which this is also the case,[341] but, on the whole, this narrative device is sparingly used in Anglo-Saxon art. It is, however, the norm in the major narrative cycles of early twelfth-century Anglo-Norman manuscript illumination, including the St Albans Psalter, the Life of St Edmund[342] and a pictorial New Testament.[343] For so extensive a use of the profile, only one precedent existed, and that was the Tapestry.

If specific features of the Tapestry anticipate some of the fundamental characteristics of Anglo-Norman art, this means that there were close artistic contacts between Normandy and Norman England after 1066. The profile faces in the manuscript cycles just mentioned, and those in the Tapestry, differ markedly from the more delicately drawn and more individualized profiles seen in An-

82 *Philosophy consoles Boethius. From Boethius,* De consolatione philosophiae, *early 11th century. Paris, Bibliothèque Nationale, Ms. lat. 6401, fol. 5 v*

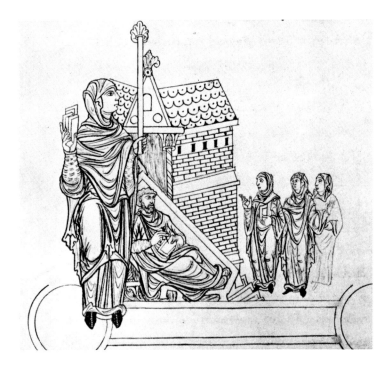

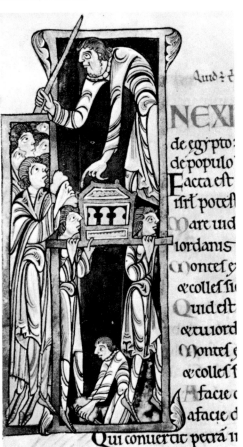

79 *Initial I. From St Albans Psalter, after 1123. Hildesheim, St Godehard*

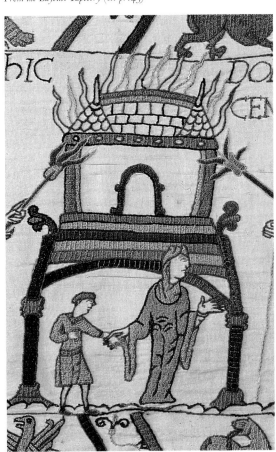

80 *Woman with a child outside a blazing house. From the Bayeux Tapestry (see p. 143)*

81 *Man pointing to the comet. From the Bayeux Tapestry (see p. 124)*

glo-Saxon manuscripts. Compare the head of the man pointing to the comet, or of the woman outside the burning house, with the faces in an initial I in the St Albans Psalter (figs. 79 - 81).[344] The straight line connecting a flat forehead with a slightly rounded nose became one of the hallmarks of early twelfth-century English art. The 'ancestors' of these characteristic profiles are found in northern French manuscripts – for example, in a miniature showing 'Philosophy Consoling Boethius' that dates back to the beginning of the eleventh century (fig. 82).[345] The Norman illuminators of Jumièges were still drawing profiles of this type in the later eleventh century and Dodwell rightly says that, in the art of Jumièges, 'the profiles, for instance, in which the nose continues the line of the forehead, are reminiscent of some in the Bayeux Tapestry'.[346]

We can therefore take it that the features in question, which are fundamental components of narrative style, were transported from Normandy to post-conquest England. At a stroke, this transforms the accepted historical status of the Tapestry. This supposed product of Anglo-Saxon art turns out to display certain central characteristics of Norman art and to have played a major part, at least indirectly, in shaping the art of the ensuing period in England (not to speak of its role as an accessory in establishing the dominance of Romanesque art at large).

XVI

The Status of Secular Art

Critics Within the Church

The Tapestry presents itself to us as the pivot of a vast artistic upheaval. Why should this position be occupied by a secular work, one whose innovations were, for quite some time, not taken up to any extent within the religious sector?

If the evidence is not wholly deceptive, there were tendencies at work in eleventh-century culture that, if taken to their logical conclusion, would have led to the abandon-

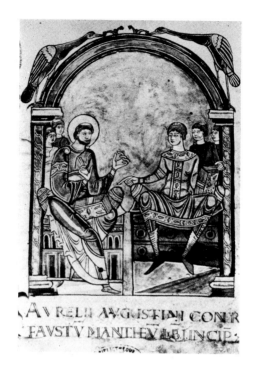

83 *St Augustine and Faustinus. From Augustine,*
Contra Faustum Manichaeum, c. 1060.
Avranches, Bibliothèque Municipale, Ms. 90, fol. 1 v

ment of Christian figurative art. To understand this, we need to be aware of the major heretical movements that threatened to

84 *St Augustine and Faustinus. From Augustine,*
Contra Faustum Manichaeum, c. 1050.
Paris, Bibliothèque Nationale, Ms. lat. 2079, fol. 1 v

encroach on Anglo-Norman territory in the second half of the eleventh century. Alongside these there were 'grassroots' initiatives from the common people to restrict the lavish use of ritual and images by the established Church. As already hinted, this had its consequences. After 1066, for several decades (and until the great religious manuscript cycles suddenly emerged at the beginning of the twelfth century), English artists, under the supervision of their Norman clergy, practised a surprising restraint in the use of Christian narrative iconography. This can be regarded as an enforced reform (part of the 'assimilation' of Anglo-Saxon culture), but it may also be interpreted as a concession.

All over northern and western France, as the eleventh century advanced, heretics arose and proclaimed that they could understand the Scriptures with the help of the Holy Spirit and without the institutionalized teaching of the Church. There were convictions for heresy in Orléans in 1022 and Reims in 1049, and unrest prevailed in all the regions bordering on Normandy. In 1025 the Council of Arras had to deal with some Manichaeans. These heretics declared the Church to be redundant and demanded that 'every man shall live by the labour of his own hands, without demanding rent or tithes from anyone'.[347] The Norman Church, which was just beginning to organize itself along strict feudalistic lines, faced a particularly strong challenge. The Council of Arras reacted: among other measures, it expressly approved the use of figured hangings in churches to teach the faith to the illiterate.[348] This was an early indication of the propaganda value attached to this publicly accessible medium.

The Church authorities were even more hard put to it to hold in check the multitude of itinerant popular preachers whose influence took hold of wide sections of the population. In official eyes these *Pauperes* often came close to heresy. They proclaimed the ideals of the *vita apostolica* (apostolic life) and of the *ecclesia primitiva* (primitive Church), and eschewed all luxury and, indeed, personal possessions, thus posing a direct threat to the whole edifice of feudal society. These preachers were unsparing in their criticism of

the established, prelatical Church. Their ascetic anti-materialism amounted to an assault on the validity of the sacraments: it was directed not only against the authority of the Church, but also against its whole apparatus of Divine Grace, based on the cult of relics and on many forms of art – including, most particularly, images of sacred history.

In Normandy, as elsewhere, the mid-eleventh century was an age of ferment. The abbeys reacted by issuing tracts against the Manichaeans. More frequently than anywhere else in Europe, books appeared with frontispieces denouncing heretical doctrines. I shall take just three examples. A codex from Mont-Saint-Michel, now in Avranches, shows a full-page image of St Augustine engaged in heated debate with the heretic Faustinus (the forceful gestures of the two debaters rightly reminding Alexander of Harold's interviews with William and with Edward in the Bayeux Tapestry; fig. 83, pp. 107, 120).[349] Another title miniature, in a codex from Fécamp written *c.* 1050, shows the saint striking down the gesticulating heretic with his staff (fig. 84); St Athanasius does the same to the heretic Arius in another codex from Fécamp.[350]

Alexander convincingly set these works in the context of the heated controversies carried on in the same period by Lanfranc.[351] His adversary was Berengar of Tours, excommunicated by Rome around 1050 for rejecting the dogma of eucharistic transubstantiation (the Real Presence of the sacraments). Lanfranc – like his successor at Canterbury, Anselm – preached the unconditional supremacy of *auctoritas* (the Bible, the Fathers and the proclaimed dogmas of the Church) and thus played a vital part in the rigid feudalization of England after 1066 and in the consolidation of Norman power. This was no easy or rapid undertaking: it took several decades to suppress all resistance for good.

Objections to Religious Figuration

What was at stake was *auctoritas*, and this was why, in the latter part of the eleventh century, the nobly born bishops and abbots, together with the secular aristocracy with which they

had so many family ties,[352] persisted with their vast church building programme all over the Norman domains. We might expect to find these works accompanied – like several great new churches of the period in central and southern France – by Christian sculpture on a large scale and in large quantities. On the contrary, however, in both portals and capitals religious figuration was avoided to an extent unparalleled elsewhere (see the relief on the capital from Sainte-Marie-du Mont, a typical work). Norman ecclesiastical ornament is unique in its predilection for geometrical patterning and profane subject-matter. The dominant forms are chevron, zigzag, reticulation, roll and billet mouldings, crocket capitals, bands of interlace, stylized plants, simple jousting scenes, masks, animal friezes and hunting scenes. This clearly accords both with the contemporary craze for ornamental initials (the 'inhabited' or 'historical scroll initial')[353] and with the concurrent inhibitions over the use of full-page figure subjects in Anglo-Norman manuscript illumination.

It looks very much as if, in their artistic practice, the Normans took account of contemporary criticisms of the Church – while maintaining a confident triumphalism in the most conspicuous symbol of their power, which was architecture. The massive figured capitals of Bayeux are exceptions to the rule: Bishop Odo seems to have been comparatively untroubled by conventional scruples. This temporary reticence towards religious figuration is made all the more conspicuous by the sudden disappearance of all such inhibitions at the beginning of the twelfth century. The lavishly illuminated St Albans Psalter contains a text that betrays a need to justify such an undertaking. In this the scribe quotes, first in Latin and then in French translation (the language of the new rulers), from Pope Gregory's famous Brief on the use of images in the Christian world.[354] This is plainly an act of self-defence.

There is much to suggest that, among the Normans in the latter part of the eleventh century, the main focus of the artistic imagination, and the desire to be entertained by images, largely switched from religious to

secular art. In non-religious art there was no need even for (ultimately) tactical restraint.[355] Yet very few major monuments of secular art have survived. This leaves us unable to reconstruct the vital processes that went on within the evolution of Norman art; its celebrated religious works tend to give us an incomplete – and often highly indirect – idea of what once existed. However fictionalized, Baudri's description of a vast wall hanging goes far to suggest that doctrinal constraints in religious art did not suppress the demand for images in general, but merely shifted it into the secular sphere.

Paradoxical though this may seem, even in the eleventh-century context, secular art may well have benefited from the detached attitude towards Christian figuration. In its capacity as precursor of the later revival of religious imagery the Tapestry documents the existence of an impulse to create narrative cycles, an impulse that undoubtedly came to fruition in the secular sphere before it broke through into the new Christian iconographical programmes of Romanesque art.

To sum up: the evolutionary role of the Tapestry as a test-bed for artistic innovation has hitherto been underestimated. Its existence proves that, in the transition from the early to the high Middle Ages, secular art was by no means automatically subservient to Christian art.

XVII

A Work of Norman Pictorial Propaganda

Palace or Church?

One crucial issue remains to be faced in any comprehensive assessment of the Tapestry. Where did it hang after it was completed? For what location was it made and for what reason? Only documentary sources would give a definitive answer, and there are none; here, as elsewhere, everything depends on the strength of the respective arguments.

By far the most important figure in this Norman victory monument is William the

Conqueror, from whom the patron of the Tapestry, Bishop Odo, derives a measure of reflected glory. As the King's deputy, Odo was disgraced and imprisoned in 1082.[356] He was released in 1087, only to be banished from England in 1088. On these grounds alone, the Tapestry must have been made at some time before 1082 and is unlikely to have been shown in England after that date.

Odo may have had several reasons for commissioning this monument from a Norman workshop. Perhaps he had William's travels in Normandy in mind. In 1067 the newly crowned King of England made a triumphal progress through Normandy;[357] in the early summer of 1069 he signed two documents at the abbey of Saint-Gabriel, ten kilometres east of Bayeux. The most appropriate occasion for the making of the Tapestry was the consecration of Bayeux cathedral by Bishop Odo in 1077, at which William was present.

Nevertheless, recent scholarship has been unanimous that the Tapestry was designed to adorn the great hall of a palace,[358] a hypothesis that takes no account of the historical fact of the consecration of the new cathedral. Bernstein reasoned that the Tapestry would have looked out of place draped along the nave piers of Bayeux cathedral, high above the heads of the congregation, and that it was more likely to have been designed for the interior of a prince's hall.[359] In reply to the frequent assertion that the Tapestry would have looked lost in the cathedral, it should be pointed out that the palace hall in question would have had to be a very large one, and it is doubtful whether the Tapestry, only 50 centimetres or so high, would have looked very much more impressive there than in the nave at Bayeux.[360]

Many authors seem concerned to refute the idea that the Tapestry was permanently on show in the cathedral; and it certainly was not, or else it would be more damaged than it is. It is known to have been shown during the Feast of Relics, otherwise being kept in store in the sacristy;[361] this was presumably the custom from the very start. It would have been necessary to use some simple form of installation that was easy to erect and remove – for example, thin wooden poles, threaded through the rings that ran along the top edge of the Tapestry. This would have enabled it to be shown at any desired height.

If the Bayeux Tapestry was designed to adorn a palace, then why was this elaborate narrative so painstakingly embroidered in the first place? Why did the patron not commission mural paintings (*al fresco*) instead? The designer would have had an easier time of it, in a number of ways, and he would have had an extant tradition to build on. Emperor Louis the Pious, for instance, had his throne room adorned with mural paintings of the victories of Charles Martel, Pepin the Short and Charlemagne. King Henry I of Germany had his victory over the Hungarians in 933 painted on the walls of his hall at Merseburg.[362] The custom of recording victories in mural paintings was still very much alive in the twelfth century: in the great hall of the ducal citadel of Carcassonne there are remnants of paintings of cavalry battles, painted *c.* 1150.[363]

It is highly unlikely that the Tapestry ever formed part of the permanent decorative programme of a hall. This narrow embroidered strip demands a close-up view. An *aula* dedicated to the memory of a famous victory would have demanded taller scenes; they would otherwise have made no impact on the space as a whole. Then there are the facts of daily life in the period. The palaces of princes were full of cloth hangings, but these had the practical purpose of taking the chill off the rooms; the Tapestry would not have helped much in this respect. Clearly, its major function was to reach as many viewers as possible and to leave them convinced by what it told them. It is utterly unlikely that ordinary subjects would have been allowed to file through the great hall of any of the princely residences of the day.

Sacred and Secular Art in Church

A number of commentators have regarded the Tapestry as inherently incompatible with an ecclesiastical setting. Here, Wilson was brief and to the point: 'the action is the heroic action recounted at a feast in hall'.[364] The sources, however, allow of other possibilities. An Anglo-Saxon widow by the name of Ælflæd presented to Ely church a hanging in memory of her husband, who had been slain in battle against the Danes in 991: *depictam in memoriam probitatis eius* (painted in memory of his valour).[365] The same practice

85 *Fictive dado curtain with horsemen in combat. Mural painting, late 12th century. Aquileia, Cathedral crypt*

existed in France. In the early eleventh century Queen Bertha presented the church of Saint-Denis with a hanging that recorded the glorious exploits of her ancestors.[366] This was certainly a textile with a 'heroic action', but it found its way into an illustrious abbey church, instead of garnering applause at 'a feast in hall'.

In the early Middle Ages the sacred and the secular were conjoined in ways that we find hard to imagine today. Not that this was always approved of: the ascetic Bernard of Clairvaux (who died in 1153) criticized the Templars for adorning their churches with battle scenes and triumphal ornaments.[367] As late as the early thirteenth century the Templars' church at Cressac-sur-Charente was painted with a decidedly warlike scheme of decoration: two superimposed registers, 15 metres long and 3 metres high, showing battle scenes and knights in single combat.[368]

In the eleventh century, in particular, the ideal of the man of God as a peacemaker had yet to win universal acceptance, and in the mêlée at Hastings – as we have seen – Odo did not exactly present himself as a devout contemplative. There were songs that praised bishops for their heroism in battle: men like Ulrich of Augsburg (923–73), who fought the Hungarians, or Benno II of Osnabrück (1067–92). There were many places where clergy could enjoy the contemplation of martial hangings as part of the decor of a church. This is demonstrated by, among other things, the late twelfth-century murals in the crypt of Aquileia cathedral, in which, in the dado zone beneath the great ceremonial images of Christology, a fictive tapestry of knights in battle 'hangs' on painted rings (fig. 85).[369]

Erotic Detail

The first scholar to question the idea that the Tapestry was housed in Bayeux cathedral was Dodwell. His idea that its erotic motifs were incompatible with the majesty of a great house of worship reflects a narrow view of medieval piety.[370] In France, alongside and in dramatic contrast to the self-contained edifice of feudal theology, the eleventh cen-

86 *Drawing of the Arch of Einhard* (c.830). 17th century. Paris, Bibliothèque Nationale, Ms. fr. 10440

tury witnessed a startling growth of erotic lyric poetry;[371] and this, remember, was copied and stored up in monasteries. In the twelfth century something very similar happened with French religious sculpture. A naked couple on a pier base in the church of Loctudy (Finistère), for example, is not there as a moralistic warning, but as 'a marginal note on the mason's part, made with obscene intent'.[372] Throughout French Romanesque sculpture there is a widespread sensual pleasure in the naked body – not expressed in prominent places, perhaps, but not concealed either. It is to be found on the periphery, as it were, on capitals and in portal friezes;[373] and, in this sense, it is analogous to the borders of the Tapestry. A delight in crude humour was a durable feature of French religious art. The marginal decoration of fourteenth-century Psalters and Books of Hours contains a welter of robustly obscene motifs.[374] In the Middle Ages the clergy was not always so stern, or so abstemious, as we mostly find it today.

A Portable Triumphal Monument

Let us not be in too much of a hurry to narrow the debate down to the simple alternative between palace and church. To do so leads to an impasse, because neither answer plausibly accounts for either the Tapestry's technique (embroidery with plain wool) or its immense length. What needs to be borne in mind is that the Tapestry showed the story of the Norman victory, in enthralling detail, to (presumably) a wide general public. It would seem natural to suppose that it was commissioned because the patron wanted the most instructive pictorial document possible, one that could be easily rolled up, transported and displayed in a number of different towns.[375] This by no means excludes the possibility that the Bishop intended all along to give the Tapestry a permanent home within the relatively safe walls of his own cathedral, and there to put it on regular exhibition – partly as an advertisement for himself – every year at the Feast of Relics. In it, Harold takes

his oath on two reliquaries that were held in Bayeux cathedral, probably those of St Rasyphus and St Ravennus.[376]

In technique and form this Norman triumphal monument was tailor-made for exhibition to the Duke's subjects both in Normandy and in England. In the late eleventh century there were far more churches than palaces with spaces big enough to show it in, and these sacred buildings were open to everyone. We can safely assume that it was put on display in a number of different places. The representatives of Norman rule (notably, William and his deputy, Bishop Odo) could not be everywhere at once to consolidate their power. In their own stead they consequently showed the public not some remote, monumental emblem of sovereignty,[377] but a transportable record in pictures that made their own valour visibly present. More than any illustrated book or fixed monument (whether mural painting or sculpture), the Tapestry was able to carry its contemporary historical message from region to region, to as many viewers as could file along the unrolled narrative. Everything in it thus combined to proclaim the triumph of the Norman monarch (and the reflected glory that accrued to Odo). What is more, it did so with a concision, comprehensiveness and detail unmatched by any previous medieval work of art known to us.

A Roman emperor's triumphal column was hardly something that could be taken on tour, yet there may have been one early medieval precedent for the idea of using a mobile monument to glorify a victorious monarch. In about 830 a miniature triumphal arch, made of silver and 37.8 centimetres high including the base, was created for Einhard, the biographer of Charlemagne (it has survived only in the form of a seventeenth-century drawing; fig. 86).[378] In his capacity as lay abbot, Einhard is said to have presented it to the monastery of St Servatius in Maastricht as a 'private monument',[379] to commemorate the Carolingian revival of the Christian Roman Empire. It is known that this *Arcus* was not a copy of any full-size triumphal arch; but why make a free imitation of an antique architectural form on such

a small scale? No adequate explanation has yet been suggested. Might not this monument, with its weighty propaganda message, have been made in a 'pocket' size in order to be displayed in a number of widely spaced centres across the Carolingian empire?

Einhard's arch embodied only a compressed programme, tied to a religious and cultic context, and with no representation of individual historical episodes; it was accessible only to a small circle of learned viewers. The length of the Tapestry narrative (which implies a large number of viewers and defines its specifically public nature) operates as a 'substantive' metaphor for the greatness of the ruling power on display. This Norman national monument, which rivalled the victory monuments of antiquity in wealth of dramatic detail, derived an unprecedented impact from its transportability. To gain an idea of its propaganda significance, we need only recall that it was more than four centuries before anything on a comparable scale was done again. This was the 'Triumphal Procession' of the Emperor Maximilian, a suite of woodcuts first printed in 1526 and comparable in overall dimensions.[380] Placed side by side, the 147 surviving woodcuts, some 38 centimetres high, produce a procession 57 metres long. They were frequently mounted on linen and hung in the council chambers of town halls, but in this case transportability was replaced by reproducibility.[381]

A 'Feudalized' Response to Art

The enthusiastic response that brings hosts of visitors to Bayeux to this day is a reminder of one essential feature of the Tapestry: the appeal to a wide public that runs like a scarlet thread through the whole of the narrative. This Tapestry was not primarily meant to be appreciated aesthetically, as an artistic masterpiece, created for its own sake by a genius. Its primary function was as an effective instrument of pictorial propaganda. At no point is display of artistic prowess the purpose of the exercise. Objectively speaking, strokes of supreme virtuosity (such as the dramatic climaxes of the battle) do exist in the work, but as means to an end. (By contrast, the reliefs

on the bronze doors in Hildesheim, for instance, set out far more to excite admiration for their formal qualities; they lay greater claim to autonomous artistic value.)

The Tapestry was intended to bring before a contemporary beholder, as something 'present', a richly eventful and, at the same time, rapidly evolving process of contemporary history. In this the inscriptions play an important role. These strips of lettering mostly ignore the requirements of a balanced pictorial composition, but they hammer home the message. They underpin the rapid identifiability of the content, which demands of the viewer no independent or complicatedly empathetic response; there is no need to take time to think. 'Artless' as they are, these inscriptions provide a direct commentary on the action, of the type that says 'Here, this and this happens.' In this respect texts and pictures form a unity. Short, to the point and memorable, they tell us how it was in (their version of) history and they embody a firm warning against any resistance to Norman rule.

This demand for unquestioning acceptance marks an advanced stage of the 'feudalization' of the beholder's response to art. The aim is not so much to subordinate as to enlist the viewer. The work firmly controls his or her subjective response to the various experiences on offer. What a contrast to Anglo-Saxon art, with its demand for empathy rather than integration! Follow and absorb the scenes depicted in the Tapestry, and you totally accept its version of history. The limits of response are laid down in advance, favouring or stimulating a kind of one-dimensional thinking, and this precisely corresponds to the function of the narrative structure and the handling of the figure style. The exemplary value of recent history is not a matter for controversy and calls for no enquiry. The experience of the pictorial narrative is so contrived as to lead to a direct assimilation of its content, as applied to the political present and future.

The confirmation of national identity within Norman society is reflected in the Tapestry as in a mirror. This casts an indirect light on the vigorous feudalizing measures

that the Normans undertook after 1066, especially in England. Langosch describes the radical changes that took place there as a shift to 'monarchic absolutism': 'William the Conqueror deprived the English nobility of its lands and made the small independent landowners and peasant freemen into feudal villeins, so that in the end the vast majority of the English people were unfree; he placed all the higher benefices of the Church in Norman hands, and imposed feudalism with a thoroughness unmatched anywhere else in Europe... And so England was incorporated into the Norman empire, and for two centuries English history was that of an alien regime.'[382]

In its own way, the Tapestry propounded both the unquestioning acceptance of Norman rule and the imposition of total control on the people (in this case, as viewers). It thus became an artistic reflection of, and a contributor to, the prevailing system of social relations.

History Through Norman Eyes

The process whereby state authority was consolidated under Norman rule was entirely in keeping with the image of history presented in the Tapestry. This embodies an attitude to time alien to us today. The chronicle of events entirely dispenses with dates. It presents, in an unbroken temporal sequence, events that undoubtedly happened at irregular intervals. The scenes preliminary to the actual war, ending with Harold's return to England, presumably took place in 1064; here, they are directly followed by the death and burial of Edward the Confessor, which took place in January 1066. The Norman fleet did not cross the Channel until September of that year. The uninitiated beholder is forced to assume, however, that all these events took place in quick succession, and predominantly on William's initiative. The pictorial narrative suggests that the Conqueror hastened the pace of events and the Tapestry itself drives the viewer onwards unflaggingly, not to say impatiently. Events seem to hang on the Norman Duke, who never wastes a moment, but fills the time

with his activities and exploits. The resulting 'image' of William defines the experience of the narrative and of the passage of time. An objectivized framework of dates, such as we customarily find in the more soberly factual historical writing of late antique and Carolingian times, would have militated against this effect.

Cracks in the Image, and a Topical Dimension

The Tapestry begins to look like a mirror of what was then the ultra-modern system of feudalism; and, by and large, it is. Not wholly so, however: to do justice to the designer's achievement, we must take a balanced view. His work tells of William and Harold contending for power in England. What counts is not simply the reporting of the events themselves, but also, once again, the question 'how': the point of view. The two protagonists confront us as free agents, entirely creatures of this world, who do battle at first side by side, then against each other. The results of their actions are seen in and for themselves – and this reveals a crack in the seemingly solid fabric of feudalism, as sustained in equal measure by the aristocracy and by the clergy.

In the latter part of the eleventh century, as I have suggested, the Church – and the Norman Church in particular – stood for the absolute primacy of supra-natural sources of knowledge. It inflexibly maintained that the only history worth the telling was *historia Dei ac hominum*, the history of God's dealings with men. Events in this world were entirely subject to the divine strategy for human salvation; so much so, that they were ultimately no more than a 'figure' of supernal truth. The Tapestry, however, renders recent history in terms of a secular, feudal reality that is valid in its own terms. It does this to an extent unsurpassed by any contemporaneous or earlier medieval work of art. Unequivocally, the Tapestry tells us that the adventure of the Norman invasion of England took place not at the behest of any supernatural power, but in pursuance of the justified will of an earthly lord. Its pictorial record of the conquest proclaims the right-

fulness of one man's self-assured intervention in the course of events. The Normans' triumph had made them all the more aware of the newness and uniqueness of their own identity.

Not that religion is entirely absent from the pictorial narrative. Odo blesses the feast; the hand of God appears over the newly built Westminster Abbey; Harold and his companion step into Bosham church to pray; and the oath in Bayeux derives additional solemnity from the fact that it is sworn on two reliquaries. Yet these aspects are not essential to the story; the battle dispenses with any sacramental sanction. This war of conquest lacks the kind of legitimization enjoyed by a Crusade – although, say, the 'false', recreant Archbishop Stigand might have supplied something of the sort. No, the feudal reality depicted in the Tapestry has hidden cracks that point, however subtly, to future developments. The Tapestry's account of the contemporary power-struggle shades into early examples of the direct observation of life and nature – that is to say, to the first inklings of an independent and less 'preordained' access to the world. The need to realize the Tapestry project, largely without pre-existent models, led to the adoption of formal and material devices keyed to the enhancement of 'secular' credibility.

The perception of still-hidden inner contradictions ultimately touches our own contemporary image of history, our endeavour to penetrate the reality of the present day. At the height of institutionalized hierarchical thinking there began an imperceptible slackening of the feudal mechanism. With its firm bias towards the representation of secular reality, the Tapestry marked a first crack in the ideological edifice of an all-powerful Church. Not, of course, that this process was a conscious, deliberate one. Nevertheless, the Tapestry enshrines a sense of national identity, a historical self-awareness and a vision of the real, surrounding world of nature that still seem topical to us today, even within a resolutely feudalistic work of propaganda that, in many ways, holds a unique position in the transition from the early to the high Middle Ages.

NOTES

1 The Centre Guillaume le Conquérant in the rue de Nesmond.

2 S. A. Brown, *The Bayeux Tapestry: History and Bibliography* (Bury St Edmunds, 1988), offers a comprehensive survey of the literature. In the present book, the text of which was completed at the end of 1992, important conclusions have often been cited in outline only, since a sustained and detailed scrutiny of the whole range of opinions already voiced would far outrun the space available.

3 Quoted in Brown (note 2), p. 2.

4 Even so, the Tapestry was nearly destroyed in 1792, amid the turmoil of the French Revolution; it was saved by the intervention of the Bayeux police commissioner.

5 According to Brown (note 2), p. 3, however, there is no telling how regularly the Tapestry was put on show.

6 Brown (note 2), p. 6.

7 Brown (note 2), p. 44, n. 7.

8 Brown (note 2), p. 40, n. 88.

9 Such as (to take two examples at random) Laurentius or Florentius.

10 N. P. Brooks and H. E. Walker, 'The Authority and Interpretation of the Bayeux Tapestry', in *Proceedings of the Battle Conference, 1978* (Ipswich, 1979), pp. 1 ff., 27 ff.

11 For which there would have been room in the top line.

12 True, there are not many stitch holes left in the continuation of the arrow, but, after all these centuries, their absence does not necessarily mean that they were never there. For the same reason, the restorers have sometimes omitted lines that must certainly once have been present: see, for instance, the incomplete outline of a dead man below and to the left of the tree in the lower border at the end of the Tapestry (p. 166).

13 D. J. Bernstein, *The Mystery of the Bayeux Tapestry* (London, 1986), p. 152 ff., interpreted the 'blinding' of Harold as a largely symbolic act, closely connected with certain passages in the Old Testament. So far-reaching a hypothesis would seem to call for discussion only if and when it can be argued, more plausibly than has so far been done, that the designer of the Tapestry actually depicted the incident in this way.

14 D. M. Wilson, *The Bayeux Tapestry* (London, 1985), p. 19, underlined the information value of the Tapestry by referring to it as a 'primary source'.

15 Such faces look almost like copies of the drawn figures in Anglo-Saxon and northern French manuscripts. Compare the arguing Jews in the Bible illuminated shortly before 1050 at Saint-Vaast, Arras (Bibliothèque Municipale, Arras, Ms. 559, vol. 3, fol. 70v; on this manuscript, see note 182).

16 There are cases where these look like deliberate distortions, although this was certainly not the intention.

17 On this chronicle, the *Carmen de Hastingae proelio*, see Section IX.

18 Quoted from K.-U. Jäschke, *Wilhelm der Eroberer: Sein doppelter Herrschaftsantritt im Jahre 1066* (Sigmaringen, 1977), p. 12.

19 Quoted from E. Erb, ed., *Geschichte der deutschen Literatur* (Berlin, 1965), vol. 1, p. 463.

20 J. Flori, 'Encore l'usage de la lance... la technique du combat chevaleresque vers l'an 1100', *Cahiers de civilisation médiévale* 31 (1988), pp. 213 ff., 217 ff.: 'La tapisserie de Bayeux et les combats à la lance: trois techniques côte à côte'.

21 Brooks and Walker (note 10), p. 19.

22 The only source images available to an Anglo-Saxon artist would have been late antique battle scenes or Carolingian copies thereof. These, however, show the mêlée as made up of overlapping figures, and thus depart radically from the convention adopted in the Tapestry.

23 Wilson (note 14), p. 181.

24 Brooks and Walker (note 10), p. 19 f.

25 London, British Library, Ms. Cotton Claudius B. IV, fol. 24v; J. Mann, 'Arms and Armour', in F. Stenton, ed., *The Bayeux Tapestry: A Comprehensive Survey* (London, 1957), p. 56 ff., fig. 30. (A second edition of Stenton's book was published in 1965.)

26 Dijon, Bibliothèque Municipale, Ms. 14, fol. 13; Y. Załuska, *L'Enluminure et le scriptorium de Cîteaux au xiiᵉ siècle* (Cîteaux, 1989), p. 193 ff., pl. 24, fig. 43.

27 This is not to deny that fairly clear depictions of chain-mail do occasionally appear in earlier images and even in Carolingian art. One example is on p. 141 of the *Psalterium Aureum* (before 883; St Gallen, Stiftsbibliothek, Ms. 22); F. Mütherich and J. E. Gaehde, *Carolingian Painting* (London, 1977), pl. 47; C. Eggenberger, *Psalterium Aureum Sancti Galli* (Sigmaringen, 1987), fig. 14.

28 The designer's ornamentalizing tendencies should, however, be borne in mind, as exemplified in his depiction of trees (see Section XIII).

29 Mann (note 25), p. 63.

30 Le Mans, Bibliothèque Municipale, Ms. 263, fol. 10v; exh. cat. *Ornamenta Ecclesiae: Kunst und Künstler der Romanik* (Cologne, 1985), vol. 1, p. 220, no. B32 (fig.).

31 R. Hamann, *Kunst und Askese: Bild und Bedeutung in der romanischen Plastik in Frankreich* (Worms, 1987), fig. 351.

32 J. L. Nevinson, 'The Costumes', in F. Stenton, ed., *The Bayeux Tapestry: A Comprehensive Survey* (London, 1957), pp. 70 ff., 72.

33 Nevinson (note 32), p. 74 f.

34 Dijon, Bibliothèque Municipale, Ms. 14, fol. 44v, 191; Załuska (note 26), pl. 31, fig. 56, and pl. 39, fig. 71.

35 R. Liess, *Der frühromanische Kirchenbau des 11. Jahrhunderts in der Normandie* (Munich, 1967), p. 252 ff.

36 J. J. G. Alexander, *Norman Illumination at Mont-Saint-Michel, 966-1100* (Oxford, 1970), p. 17: 'this system of support seems to be alluded to and to have caught the artist's attention'.

37 The earliest major Norman churches in England, most of which replaced Saxon buildings, were detested by the native English: C. Stewart, *Early Christian, Byzantine and Romanesque Architecture* (London, 1954), p. 221. On the new church in which Edward the Confessor was buried, and which was longer than any previous or contemporary church except Speyer cathedral, see E. Fernie, 'Reconstructing Edward's Abbey at Westminster', in *Romanesque and Gothic: Essays for George Zarnecki* (Woodbridge, 1987), vol. 1, p. 63 ff.

38 Bernstein (note 13), figs. 39, 40; Wilson (note 14), p. 184.

39 Munich, Bayerische Staatsbibliothek, Clm. 14271, fol. 11v; E. Panofsky, *Renaissance and Renascences in Western Art* (London, 1970), p. 85 and fig. 53.

40 One example is the calendar illustration for January in London, British Library, Ms. Cotton Julius A. VI, fol. 3; Bernstein (note 13), fig. 36. For another, see the Cædmon Genesis, Oxford, Bodleian Library, Ms. Cotton Junius II, fol. 54; *English Rural Life in the Middle Ages*, Bodleian Picture Book, no. 14 (Oxford, 1965), fig. 11a.

41 G. A. J. Hodgett, *A Social and Economic History of Medieval Europe* (London, 1972), p. 191.

42 This broad hatchet with a slightly curved blade was the tool normally used by carpenters for smoothing wood. See the miniature showing the building of the monastery of Werden (near Essen), in the late eleventh-century *Vita secunda S. Ludgeri*, Berlin, Staatsbibliothek, Ms. theol. lat. fol. 323, fol. 17.; exh. cat. *Ornamenta Ecclesiae* (note 30), vol. 1, p. 186, no. B27 (fig.).

43 Wilson (note 14), p. 188.

44 Nevinson (note 32), p. 75.

45 This was a revolutionary undertaking; in historical terms, it means that the first attempts at the study of nature in the history of medieval art were not scientific in intention.

46 Munich, Bayerische Staatsbibliothek, Clm. 4453, fol. 155v; H. Mayr-Harting, *Ottonische Buchmalerei: Liturgische Kunst im Reich der Kaiser, Bischöfe und Äbte* (Stuttgart, 1991), p. 167 ff., fig. 230.

47 Where similar architectural arrangements occur in tenth- and eleventh-century Byzantine manuscript painting, this does not at all mean that Ottonian illuminators habitually modelled themselves (as has mostly been supposed) on contemporary Byzantine work: these parallels stem from the use of the same late antique prototypes.

48 L. H. Loomis, 'The Table of the Last Supper in Religious and Secular Iconography', *Art Studies* 5 (1927), p. 71 ff.

49 O. Pächt, C. R. Dodwell and F. Wormald, eds., *The St Albans Psalter* (London, 1960), p. 58 f.

50 Paris, Bibliothèque Nationale, Ms. lat. 12054, fol. 79; H. Swarzenski, *Monuments of Romanesque Art* (London, 1974), no. 71, fig. 166. The manuscript is from Saint-Maure-des-Fosses.

51 Cambridge, Corpus Christi College Library, Ms. 286, fol. 125; K. Weitzmann, *Late Antique and Early Christian Book Illumination* (London, 1977), colour pl. 41 (reproduction of the miniature of twelve scenes of the Passion); Bernstein (note 13), fig. 17.

52 To cite only one of the concurring opinions, Bernstein stated in 1986 that this Gospel Book demonstrates that the Tapestry artist made use of manuscripts then held at Canterbury; Bernstein (note 13), p. 43 f.

53 See Section XIV.

54 E. G. Grimme, 'Der Aachener Domschatz', *Aachener Kunstblätter* 42 (1972), no. 23, pl. 19.

55 Bamberg, Staatsbibliothek, Ms. Lit. 3, fol. 42v; M. Schott, *Zwei Lütticher Sakramentare in Bamberg und Paris und ihre Verwandten*, Studien zur Deutschen Kunstgeschichte, no. 284 (Strasbourg, 1931), p. 7 ff., pl. 3, fig. 7.

56 Panofsky (note 39), p. 99, fig. 83; Hamann (note 31), fig. 201 (incorrectly captioned 'Last Supper in a Portico').

57 The narrow, incurved form of the table in the Tapestry reappears in the Last Supper miniature of the Anglo-Norman St Albans Psalter (after 1123), where it encloses the foreground figure of Judas (Pächt, Dodwell and Wormald [note 49], pl. 26b). This is just one of the many ways in which the Tapestry anticipates characteristics of twelfth-century English manuscript painting; on this, see Section XV.

58 Wilson (note 14), fig. 6.

59 Exh. cat. *Les Siècles romans en Basse-Normandie*, special issue of *Art de Basse-Normandie* 92 (1985), pp. 57 - 60 (figs.); L. Musset, *Romanische Normandie (West)* (Würzburg, 1989), figs. 118, 119.

60 Reduced and reversed left-to-right, this same creature appears in the border of the Tapestry beneath the horsemen who apprehend Harold (p. 98).

61 London, British Library, Ms. Add. 28107, fol. 136; D. H. Turner, *Romanesque Illuminated Manuscripts in the British Library* (London, 1966), colour pl. 2.

62 C. H. Gibbs-Smith, *The Bayeux Tapestry* (London, 1973), p. 13; Wilson (note 14), p. 227.

63 The early sources were certainly exaggerating when they mentioned up to three, or even eleven, thousand vessels; Wilson (note 14), p. 227, put the total no higher than 100 or 150.

64 C. H. Gibbs-Smith, 'Notes on the Plates', in F. Stenton, ed., *The Bayeux Tapestry: A Comprehensive Survey* (London, 1957), p. 170.

65 Gibbs-Smith (note 64).

66 D. Ellmers, 'Die Schiffe der Wikinger', in exh. cat. *Welt der Wikinger: Ausstellung des Statens Historika Museum Stockholm* (Vienna, 1973), p. 13.

67 J. Brøndsted, *Die Zeit der Wikinger* (Neumünster, 1964), p. 144.

68 D. Ellmers, *Frühmittelalterliche Handelsschiffahrt in Mittel- und Nordeuropa* (Neumünster, 1972), fig. 39i, k, l.

69 D. Ellmers, 'Schiffsdarstellungen auf skandinavischen Grabsteinen', in *Zum Problem der Deutung frühmittelalterlicher Bildinhalte: Akten des 1. Internationalen Kolloquiums in Marburg a. d. L. 1983* (Sigmaringen, 1986), p. 341 ff., fig. 14 (rune-stone, Ledberg Kyrka, eleventh century), fig. 17 (figured stone, Lärbro, Gotland, eighth century).

70 Gibbs-Smith (note 64).

71 Ellmers (note 69), fig. 14.

72 Letter to the author, 4 February 1992.

73 Wilson (note 14), p. 226.

74 Berne, Burgerbibliothek, Ms. 120. The drawings show episodes from the life of Constance, wife to Emperor Henry IV and heiress to the throne of Sicily.

75 Berne, Burgerbibliothek, Ms. 120, fol. 120; H. Georgen, 'Der Ebulo-Codex als Ausdruck des Konflikts zwischen Städten und staufischem Hof', in K. Clausberg, D. Kimpel, H.-J. Kunst and R. Suckale, eds., *Bauwerk und Bildwerk im Hochmittelalter* (Giessen, 1981), p. 145 ff., fig. 10.

76 Brøndsted (note 67), p. 114.

77 Wilson (note 14), p. 175.

78 Gibbs-Smith (note 64).

79 Fol. 119; Georgen (note 75), fig. 9.

80 W. Rudolph, *Das Schiff als Zeichen: Bürgerliche Selbstdarstellung in Hafenorten* (Bremerhaven, 1987), fig. 10.

81 Rudolph (note 80), fig. 12.

82 Compare the late antique galley under sail that carries St Jerome to Palestine on fol. 3v of the Vivian Bible (*c.* 845 - 46), Paris, Bibliothèque Nationale, Ms. lat. 1; Mütherich and Gaehde (note 27), colour pl. 21.

83 A. W. Brøgger and H. Shetelig, *The Viking Ships: Their Ancestry and Evolution* (Oslo, 1951), p. 94. A scrap of white textile with a red stripe, probably part of a sail, was found together with the Gokstad ship.

84 E. Temple, *Anglo-Saxon Manuscripts 900 - 1066* (London, 1976), no. 86, fig. 269.

85 Stuttgart, Württembergische Landesbibliothek, Bibl. fol. 23, fol. 124; H. Grape-Albers, *Spätantike Bilder aus der Welt des Arztes: Medizinische Bilderhandschriften der Spätantike und ihre mittelalterliche Überlieferung* (Wiesbaden, 1977), fig. 231.

86 Described by Ellmers as a cog: D. Ellmers, 'Es begann mit der Kogge', in exh. cat. *Stadt und Handel im Mittelalter* (Stade, 1980), pp. 21 ff., 24 f.

87 Exh. cat. *Die Hanse: Lebenswirklichkeit und Mythos* (Hamburg, 1989), vol. 2, p. 323, no. 15.6: 'Those animal-head stem and stern posts, in particular, are inconceivable in the thirteenth century except as atavisms.'

88 Paris, Bibliothèque Nationale, Ms. fr. 784, fol. 70; H. Buchthal, *Miniature Painting in the Latin Kingdom of Jerusalem* (Oxford, 1957), p. 78, pl. 152a.

89 Compare the miniature of the storm at sea in a Pericope Book produced in Salzburg, *c.* 1050, Munich, Bayerische Staatsbibliothek, Clm. 15713, fol. 22; H. Fillitz, *Das Mittelalter I*, Propyläen Kunstgeschichte (Berlin, 1960), no. 51 (fig.).

90 Oxford, Bodleian Library, Ms. Auct. E. inf. I., fol. 304; C. M. Kauffmann, *Romanesque Manuscripts 1066 - 1190* (London, 1975), no. 82, fig. 226. A naked human figure has become entangled in the spiral of the dragon's tail. The beast's body with a human head stands for Evil, the diabolical principle into whose toils human beings fall. This is a vivid illustration of Satan's struggle to seize the soul of Job.

91 Brøgger and Shetelig (note 83), p. 167.

92 'Theriomorphic, beast-shaped spirits and gods carry us back to the primeval depths of time, long before the Age of Migrations', as the *Geschichte der deutschen Literatur* says in its discussion of the cult of Woden among the Germanic peoples; Erb (note 19), vol. 1, p. 136.

93 See Section XIII.

94 Alexander (note 36), pl. 18c; exh. cat. *Ivory Carvings in Early Medieval England, 700 - 1200* (London, 1974), no. 47; the description 'English; middle of the twelfth century' is totally unsupported.

95 Compare the throne in the upper border, to the right of the church of Mont-Saint-Michel, or the bed on which Edward the Confessor lies dying (pp. 109, 122).

96 Compare the animal-head posts from the ship burials at Oseberg and Gokstad; exh. cat. *Les Vikings… Les Scandinaves et l'Europe 800 - 1200* (Paris, 1992), no. 166 f.

97 Gibbs-Smith (note 64), p. 171.

98 Wilson (note 14), p. 187.

99 Brøgger and Shetelig (note 83), p. 98.

100 Everywhere, the clergy fought tooth and nail against the surviving vestiges of pagan tradition: 'These ran flagrantly counter to the Church's teachings, according to which Divine Providence alone ruled the world and governed all its motions.' A. J. Gurjewitsch, *Mittelalterliche Volkskultur* (Munich, 1987), p. 131.

101 Gibbs-Smith (note 64), p. 170.

102 J. Graham-Campbell, *The Viking World* (London, 1989), p. 46 f.

103 Graham-Campbell (note 102), p. 49.

104 O. K. Werckmeister, 'The Political Ideology of the Bayeux Tapestry', *Studi medievali* 17 (1976), pp. 535 ff., 537, n. 13. 'Imported from southern Italy', affirmed F. Neveux, 'La Tapisserie de Bayeux: du récit historique à l'œuvre d'art', in *Les Siècles romans* (note 59), pp. 66 ff., 70.

105 D. C. Douglas, *William the Conqueror* (Berkeley and Los Angeles, 1967), p. 202 f.

106 Jäschke (note 18), p. 25 f.

107 I. Lindeberg, 'Kontakte zwischen dem Fränkischen Reich und Skandinavien in der Wikingerzeit', in *Welt der Wikinger* (note 66), p. 21 ff.

108 L. Musset, 'Relations et échanges d'influences dans l'Europe du Nord-Ouest (xᵉ - xiᵉ siècles)', *Cahiers de civilisation médiévale* 1 (1958), pp. 63 ff., 80.

109 A. L. Poole, *From Domesday Book to Magna Carta*, vol. 3 of *Oxford History of England* (London, 1951), p. 434.

110 J. Le Patourel, *The Norman Empire* (Oxford, 1978), p. 167, n. 6.

111 Ellmers (note 66), p. 14.

112 Wilson (note 14), p. 175.

113 Ellmers (note 68), fig. 39a - d.

114 D. Ellmers, 'Der Nachtsprung an eine hinter dem Horizont liegende Gegenküste', *Deutsches Schifffahrtsarchiv* 4 (1981), pp. 153 ff., 155; N. Denny and J. Filmer-Sankey, *The Bayeux Tapestry: The Story of the Norman Conquest, 1066* (London, 1966), unpaginated (see the description of the fleet).

115 Wilson (note 14), p. 187.

116 F. Kretschmer, 'Neue Erkenntnisse aus dem Teppich von Bayeux', *Archivium heraldicum* 1, 2 (1980), pp. 2 ff., 6.

117 Exh. cat. *Venezia e Bisanzio* (Venice, 1974), no. 51 (twelfth-century tondo of a Byzantine emperor); J. Deér, *The Dynastic Porphyry Tombs of the Norman Period in Sicily* (Cambridge, Mass., 1959), fig. 216 (solidus with the effigy of Theodora, consort of Emperor Theophilus, 829 - 42).

118 *Ornamenta Ecclesiae* (note 30), vol. 3, nos. H32, H38.

119 Wilson (note 14), p. 176. The inscription was first described as a signature by J. Salverda de Grave, 'Turoldus', *Mededeelingen der Koninklijke Akademie van Wetenschappen: Letterkunde*, series A, 57 (1924), pp. 1 ff., 7.

120 A number of articles have dealt with this topic in

isolation. To cite only two recent papers, which incorporate surveys of previous efforts at interpretation: M. W. Campbell, 'Ælfgyva: The Mysterious Lady of the Bayeux Tapestry', *Annales de Normandie* 34 (1984), p. 127 ff.; J. B. McNulty, 'The Lady Ælfgyva in the Bayeux Tapestry', *Speculum* 55 (1980), p. 659 ff. All this fruitless speculation actually led those responsible for one (otherwise complete) publication of the Tapestry to omit the scene altogether. In their preface Denny and Filmer-Sankey (note 114) wrote: 'In short, the scene is a puzzle for scholars, and since it contributes nothing to the story, except a moment of confusion, we have felt justified in leaving it out.'

121 Wilson (note 14), p. 18.
122 Wilson (note 14), p. 178.
123 Quoted from D. C. Douglas, *Wilhelm der Eroberer: Der normannische Angriff auf England* (Stuttgart, 1966), p. 399.
124 Douglas (note 123), p. 399.
125 D. Butler, *1066: The Story of a Year* (London, 1966), p. 313.
126 Butler (note 125), p. 78.
127 *Les Vikings* (note 96), p. 107.
128 Temple (note 84), p. 37.
129 *Les Vikings* (note 96), p. 107.
130 W. Levison, *England and the Continent in the Eighth Century* (Oxford, 1973), p. 182.
131 *Les Vikings* (note 96), p. 107.
132 *Les Siècles romans* (note 59), p. 83.
133 J. B. McNulty, *The Narrative Art of the Bayeux Tapestry Master* (New York, 1989), p. 55: 'The mimicking naked figure below clearly marks the scene as lewd.'
134 F. Wormald, 'Style and Design', in F. Stenton, ed., *The Bayeux Tapestry: A Comprehensive Survey* (London, 1957), pp. 25 ff., 27, figs. 2, 3.
135 Particularly impressive are the extensive late eleventh-century mural paintings of paired beasts on the piers of Saint-Savin-sur-Gartempe; H. Focillon, *Peintures romanes des églises de France* (Paris, 1950), fig. 7. Surviving early Romanesque architectural sculptures in England and Normandy include a number of remains of decorative zoomorphic friezes. D. Kahn, 'Anglo-Saxon and Early Romanesque Frieze Sculpture in England', in D. Kahn, ed., *The Romanesque Frieze and its Spectator* (London, 1992), pp. 61 ff., 71, referred to zoomorphic reliefs, found in Canterbury, which incorporate individual motifs also found in the Tapestry. The doglike quadruped that bites its own cocked tail is found in the Tapestry borders, in the architectural decoration from Canterbury (fig. 27) and in the capitals of the church of Sainte-Marie-du-Mont in Normandy (fig. 26; on which, see note 305). In my view the Canterbury sculptures were made by Norman artists shortly before 1100 (the sources tell us that even the building stone for the cathedral was imported from Caen).
136 McNulty (note 133).
137 McNulty (note 133), p. 1 ff.
138 It is possible that this legend became important only in the later Middle Ages, from the thirteenth century onwards, when there were considerable

additions to the stock of bestiary lore.
139 McNulty (note 133). p. 2.
140 Quoted from Oxford, Bodleian Library, Ms. Ashmole 1511 (early thirteenth century); F. Unterkircher, *Tiere – Glaube – Aberglaube: Die schönsten Miniaturen aus dem Bestiarium* (Graz, 1986), p. 45 f.
141 McNulty (note 133), pp. 39 ff., 85.
142 McNulty (note 133), pp. 68, 87.
143 Here, surprisingly enough, McNulty interprets the birds as an indication of harmony in William's household; McNulty (note 133), p. 95.
144 This striking single motif goes unmentioned by McNulty. According to the bestiaries, 'the ass is … a slow beast, with no intelligence'; Unterkircher (note 140), p. 24.
145 McNulty (note 133), p. 27 ff.; Bernstein (note 13), p. 128 ff.; L. Herrmann, *Les Fables antiques de la broderie de Bayeux* (Brussels, 1964); S. Bertrand, 'Etude sur les bordures de la Tapisserie de Bayeux', *Bulletin de la Société des sciences, arts et belles-lettres de Bayeux* 24 (1961), p. 115 ff.
146 M. Parisse, *The Bayeux Tapestry* (Paris, 1983), p. 126 ff.; Wilson (note 14), pp. 175 ff., 209.
147 Wormald (note 134), p. 27 f.
148 K. Langosch et al., eds., *Überlieferungsgeschichte der mittelalterlichen Literatur*, vol. 2 of *Geschichte der Textüberlieferung der antiken und mittelalterlichen Literatur* (Zurich, 1964), p. 781.
149 Wormald (note 134), p. 27 f.
150 Wormald (note 134), p. 32; Bernstein (note 13), p. 40; Wilson (note 14), p. 210.
151 Wormald (note 134), p. 28.
152 Wormald (note 134), p. 28.
153 W. Haug, *Das Mosaik von Otranto* (Wiesbaden, 1977).
154 Wormald (note 134), p. 28. Leiden, Bibliotheek der Rijksuniversiteit, Ms. Voss. lat. oct. 15; on this codex, see *Ornamenta Ecclesiae* (note 30), vol. 1, no. B87.
155 See the chapter 'The Englishness of the Tapestry: The Borders', in Bernstein (note 13), p. 82 ff., and the commentary on the borders in Wilson (note 14), p. 209 f.
156 Herrmann (note 145), pp. 31, 33, 49.
157 Compare the Norwegian textile hangings from the Oseberg burial (ninth century) and from Baldishol church (twelfth century); Bernstein (note 13), figs. 51, 52.
158 Quoted from Kauffmann (note 90), p. 26.
159 An accurate survey of the current state of research is given by Brown (note 2), p. 31 ff. Even the French scholars, almost without exception, have come to accept the 'consensus' (Brown): Neveux (note 104), p. 72, 'La tapisserie est donc vraisemblablement sortie d'un atelier anglais'; Parisse (note 146), p. 136, 'The cloth was embroidered in England.'
160 On the inscriptions, see Section X.
161 Wormald (note 134), p. 30.
162 Wormald (note 134), p. 33.
163 Wormald (note 134), p. 31.
164 Wilson (note 14), p. 206 ff.
165 Wilson (note 14), p. 206, cites one suggested interpretation according to which the relief shows a scene from the pagan Norse *Volsunga Saga*, in which the hero Sigmund 'bites a wolf's tongue

while lying bound'. An episode from the Eddas on a relief in, on or adjoining an English cathedral? Impossible. It may be that the sculpture illustrated the life of a saint. Its iconography recalls a bestiary scene in which an abducted king is freed by his faithful hounds, who attack the malefactors as they lie on the ground. This bestiary-based interpretation was put forward by J. J. G. Alexander, 'Sigmund or the King Garamantes?', in *Romanesque and Gothic* (note 37), vol. 1, p. 1 ff.; vol. 2, figs. 2 - 9.
166 Wilson (note 14), p. 208.
167 G. Zarnecki, *Romanesque Sculpture at Lincoln Cathedral* (Lincoln, 1970), p. 1.
168 Zarnecki was the first to contemplate a Romanesque dating for the relief: exh. cat. *English Romanesque Art 1066 - 1200* (London, 1984), p. 150 f. The sculpture was discovered in the rubble with which the east crypt of the Old Minster was backfilled in 1093. Its style raises the question as to whether it might not have found its way into the crypt (with the rubble) somewhat later. It is not known whether this was a piece of work that went wrong or, indeed, whether it was carved for the cathedral at all. Alexander (note 165), p. 6, considered it possible that the sculpture came from the adjacent Old Palace area.
169 Brooks and Walker (note 10), p. 13, or Bernstein (note 13), p. 64 ff.
170 On fols. 122v, 123; on these particular illustrations, see Temple (note 84), no. 106, figs. 317, 318.
171 Bernstein (note 13), p. 66.
172 For this reason I have made no attempt to draw specific comparisons with works from the Winchester scriptorium, although Wilson (note 14), considered Winchester a possible origin for the Tapestry on the strength of the relief fragment. Possible links with the 'Winchester School' were also mooted by Bernstein (note 13), pp. 67 ff., 79.
173 Wormald (note 134), p. 31.
174 Kauffmann (note 90), p. 20.
175 Bernstein (note 13), p. 66.
176 Furthermore, I believe that Norman illuminators were at work in Canterbury shortly before or *c.* 1100: see London, British Library, Ms. Royal 5. D. I, in Kauffmann (note 90), no. 6, fig. 38.
177 Bernstein (note 13), p. 58 f.
178 Kauffmann (note 90), p. 23 (colour pl.); no. 18, fig. 42.
179 Exh. cat. *The Golden Age of Anglo-Saxon Art, 966 - 1066* (London, 1984), p. 198.
180 The fact that Bishop Odo of Bayeux ruled Kent as William's vice-regent from 1066 or 1067 onwards is not enough to legitimate the 'England thesis'. The Bishop is likely to have maintained the headquarters of his artistic policy in Bayeux, where work was actively proceeding on his new cathedral (90 metres long overall).
181 Exh. cat. *Stadt im Wandel: Kunst und Kultur des Bürgertums in Norddeutschland 1150 - 1650* (Brunswick, 1985), vol. 2, no. 1020; for more on the embroidery technique, see Section XII.
182 S. Schulten, 'Die Buchmalerei des 11. Jahrhunderts im Kloster St. Vaast in Arras', *Münchner Jahrbuch für bildende Kunst* 7 (1956), p. 49 ff., figs. 14, 15; and, on

the Winchester manuscript in particular, Temple (note 84), no. 78, figs. 247, 248.

183 Schulten (note 182), p. 89, n. 40.

184 London, British Library, Ms. Arundel 155, fol. 113; Bernstein (note 13), p. 79 ff., colour pl. 45; Temple (note 84), no. 66.

185 The 'deliberate marriage between line-drawing and fully coloured painting' (Bernstein [note 13], p. 81) is no criterion in itself.

186 Graham-Campbell (note 102), p. 121; a coloured reconstruction is illustrated in *Les Vikings* (note 96), p. 47, fig. 5.

187 O. Demus, *Romanesque Mural Painting* (London, 1970), p. 130 f., colour pl. 38.

188 J. J. Tikkanen, *Studien über die Farbgebung in der mittelalterlichen Buchmalerei* (Helsinki, 1933), p. 393; on the manuscript in Berlin, Staatsbibliothek, Ms. lat. fol. 18, see exh. cat. *Zimelien: Abendländische Handschriften des Mittelalters aus den Sammlungen der Stiftung Preussischer Kulturbesitz Berlin* (Berlin, 1976), no. 36.

189 Compare, as a characteristic example, the architectural framework of the full-page illumination of the story of Daniel illustrated here as fig. 39, an Anglo-Norman work dating from *c.* 1150. Kauffmann (note 90), no. 70, fig. 36.

190 E. Panofsky, *Die deutsche Plastik des elften bis dreizehnten Jahrhunderts* (Munich, 1924), pls. 3 - 5.

191 In the context of mid-eleventh-century Norman manuscript painting at Mont-Saint-Michel, Alexander (note 36), p. 126, sums up as follows: 'It is probable that the Belgian and northern French monasteries contributed as intermediaries and transformers both of Anglo-Saxon and Ottonian styles. What is, in any case, significant is the tendency… towards the new style of the Romanesque period. From this standpoint the artists are pioneers at the start of a new movement, not feeble copiers in the decadence of an old one.'

192 Munich, Bayerische Staatsbibliothek, Clm. 13067, fol. 17v; A. von Euw, 'Zur Buchmalerei im Maasgebiet von den Anfängen bis zum 12. Jahrhundert', in exh. cat. *Rhein und Maas: Kunst und Kultur 800 - 1400* (Cologne, 1973), vol. 2, pp. 343 ff., 349, fig. 15.

193 Paris, Bibliothèque Nationale, Ms. lat. 6, vol. 3; W. Neuss, *Die katalanische Bibelillustration um die Wende des ersten Jahrtausends und die altspanische Buchmalerei* (Bonn and Leipzig, 1922), p. 10 ff.

194 Kauffmann (note 90), fig. 33; Neuss (note 193), fig. 98.

195 Alexander (note 36), pp. 190, 194.

196 Kauffmann (note 90), pp. 39, 100.

197 Paris, Bibliothèque Nationale, Ms. lat. 5058, fol. 3; exh. cat. *Byzance et la France médiévale: manuscrits à peintures du II⁰ au XVI⁰ siècle* (Paris, 1958), no. 114, pl. 31.

198 As, for instance, in the Saint-Savin murals; Demus (note 187), pl. 49 (Building of the Ark, Drunkenness of Noah).

199 London, British Library, Ms. Add. 17739, fol. 69; Temple (note 84), fig. 50; C. R. Dodwell, 'Un Manuscrit enluminé de Jumièges au British Museum', in *Jumièges: Congrès scientifique du XIII⁰ centenaire*, vol. 2 (Jumièges, 1955), p. 49 ff.

200 C. R. Dodwell, *The Canterbury School of Illumination 1066 - 1200* (Cambridge, 1954), p. 9.

201 Cambridge, Fitzwilliam Museum, Ms. McClean 19, fol. 41; J. J. G. Alexander and W. Cahn, 'An Eleventh-Century Gospel Book from Le Cateau', *Scriptorium* 20 (1966), p. 248 ff.

202 The capitals were found beneath the crossing piers in 1857; Liess (note 35), p. 147 f.; Musset (note 59), p. 285 f., figs. 104, 105, 107.

203 See the early photograph in Musset (note 59), fig. 105.

204 Liess (note 35), p. 144.

205 Paris, Bibliothèque Nationale, Ms. lat. 14782, fol. 74; Kauffmann (note 90), no. 2, fig. 5.

206 London, British Library, Ms. Arundel 60; Kauffmann (note 90), no. 1, fig. 2 (Crucifixion on fol. 52v).

207 He cited as an example the Crucifixion in Rouen, Bibliothèque Municipale, Ms. 273, fol. 36v; Dodwell (note 200), p. 118, pl. 72e.

208 Werckmeister (note 104), p. 581.

209 F. Stenton, 'The Historical Background', in F. Stenton, ed., *The Bayeux Tapestry: A Comprehensive Survey* (London, 1957), pp. 9 ff., 20.

210 This view has already been put forward by S. A. Brown, 'The Bayeux Tapestry: History or Propaganda?', in J. D. Woods and D. A. E. Pelteret, eds., *The Anglo-Saxons: Synthesis and Achievement* (Waterloo, Ont., 1985), pp. 11 ff., 14.

211 Brown (note 210), p. 14.

212 Stenton (note 209), p. 11; Brown (note 210), p. 16: 'The extant contemporary English sources make no mention of a journey to Normandy as Edward's heir.'

213 Jäschke (note 18), p. 82.

214 Brown (note 210), p. 15, n. 16.

215 Brown (note 210), p. 15, n. 17.

216 Stenton (note 209), p. 14: 'When… these writers agree with each other and with the Tapestry, they can generally be followed with reasonable assurance. Their agreement, for example, makes it probable that it was on a mission from King Edward to the Duke of Normandy that Harold left England.'

217 Jäschke (note 18), p. 76.

218 The controversial Ælfgyva episode, as a betrothal scene, may be left out of account here.

219 Stenton (note 209), p. 17.

220 Stenton (note 209), p. 17.

221 Wilson (note 14), p. 198.

222 Gibbs-Smith (note 64), p. 168.

223 Demus (note 187), colour pl. 16.

224 Stenton (note 209), p. 18.

225 Gibbs-Smith (note 64), p. 165.

226 Brown (note 210), p. 23.

227 Focillon (note 135), p. 32, pl. 30.

228 Two commentators on the Tapestry have positively asserted that the designer took the chronicle of William of Poitiers as his source: R. Drögereit, 'Bemerkungen zum Bayeux-Teppich', *Mitteilungen des Instituts für Österreichische Geschichtsforschung* 70 (1962), p. 257 ff.; H. R. Loyn, *The Norman Conquest* (London, 1982), p. 9.

229 Brooks and Walker (note 10), p. 8.

230 Alexander (note 36), p. 13.

231 C. R. Dodwell, 'The Bayeux Tapestry and the French Secular Epic', in *The Burlington Magazine* 108 (1966), p. 549 ff. Elsewhere, however, the same author repeatedly maintained that the designer was an Anglo-Saxon artist: see Brown (note 2), nos. 300, 337, 349, 355, 390.

232 Wilson (note 14), p. 203.

233 The concluding lines of the *Chanson de Roland* read as follows: 'Ci falt la geste que Turoldus declinet' (Here ends the history that Turold relates); quoted from E. R. Curtius, *Europäische Literatur und lateinisches Mittelalter* (Berne, 1963), p. 99.

234 F. Wormald, 'The Inscriptions with a Translation', in F. Stenton, ed., *The Bayeux Tapestry: A Comprehensive Survey* (London, 1957).

235 Although the name has been repaired, there is no reason to doubt that this is correctly done. The palace architecture leaves no room for an additional letter (as in EADWARDI, cited below).

236 Werckmeister (note 104), p. 576, n. 222.

237 Bernstein (note 13), p. 39.

238 Jäschke (note 18), p. 10, n. 31.

239 Jäschke (note 18), p. 21.

240 *Les Siècles romans* (note 59), p. 33 (fig.)

241 *Les Siècles romans* (note 59), p. 93.

242 *Les Siècles romans* (note 59), p. 87.

243 *Les Siècles romans* (note 59), p. 87.

244 R. Lepelley, 'Contribution à l'étude des inscriptions de la Tapisserie de Bayeux', *Annales de Normandie* 14 (1964), pp. 313 ff., 319.

245 *Ornamenta Ecclesiae* (note 30), vol. 1, p. 268.

246 Stenton (note 209), p. 24, n. 8. *Les Vikings* (note 96), p. 107, has this to say of Earl Godwine's offspring: 'Of the eight children, five were given the Norse namens of Svein, Harald, Tosti, Gyrd and Gunnhild, and the three others English names: Leofwine, Eadgyth and Ælfgifu.'

247 Brooks and Walker (note 10), p. 10; the copyist read the name as GVRD.

248 Wilson (note 14), p. 204.

249 Lepelley (note 244), p. 321.

250 Wilson (note 14), p. 204.

251 Alexander (note 36), p. 25.

252 H. Berschin, W. Berschin and R. Schmidt, 'Augsburger Passionsbild: Ein neuer romanischer Text des x. Jahrhunderts', in *Lateinische Dichtungen des x. und xi. Jahrhunderts: Festschrift für Walther Bulst zum 80. Geburtstag* (Heidelberg, 1981), pp. 251 ff., 268.

253 Wormald (note 234), p. 177.

254 Douglas (note 123), p. 298.

255 Douglas (note 123), p. 171.

256 R. A. Brown, *The Normans and the Norman Conquest* (New York, 1969), p. 51.

257 *Les Vikings* (note 96), p. 106.

258 Douglas (note 123), p. 171.

259 Alexander (note 36), p. 237 ff.

260 D. C. Douglas, 'The "Song of Roland" and the Norman Conquest of England', *French Studies* 14 (1960), pp. 99 ff., 110.

261 J. von Schlosser, *Quellenbuch zur Kunstgeschichte des abendländischen Mittelalters: Ausgewählte Texte des vierten bis fünfzehnten Jahrhunderts* (Vienna, 1896), p. 218 ff.; Brown (note 2), appendix 3, p. 167 ff.

262 Quoted from the English translation in Brown (note 2), p. 167.

263 This is the conclusion reached by Werckmeister (note 104), p. 557.

264 Von Schlosser (note 261), p. xv.

265 See lines 353-4; Brown (note 2), p. 171.

266 See line 404; Brown (note 2), p. 173.

267 See lines 427-38; Brown (note 2), p. 173 f.

268 Quoted from von Schlosser (note 261), p. 223.

269 Brown (note 2), p. 154, no. 458.

270 K. Staniland, *Medieval Craftsmen-Embroiderers* (London, 1991), p. 19.

271 With all due caution: the organization of production might have changed considerably from one century to another.

272 Staniland (note 270), p. 28.

273 Was the designer also a manuscript painter? This was the hypothesis advanced by C. R. Dodwell, 'La Miniature anglo-saxonne: un reportage sur la société contemporaine', *Dossiers de l'archéologie* 14 (1976), p. 56 ff.

274 See Wilson (note 14), colour pl. 68, right.

275 S. Bertrand, *La Tapisserie de Bayeux et la manière de vivre au onzième siècle* (La Pierre-qui-Vire, 1966), p. 38.

276 See Tikkanen (note 188).

277 Wilson (note 14), p. 204, fig. 3.

278 A. Geijer, *Ur textilkonstens historia* (Lund, 1972), p. 276 ff.

279 G. A. Piebenga, 'Een IJslands altaarkleed uit de middeleeuwen in het Rijksmuseum Twenthe te Enschede', *Antiek* 11 (1977), p. 530 ff.

280 E. Salvén, *Bonaden från Skog: Undersökning av en nordisk bildvävnad från tidig medeltid* (Stockholm, 1923), figs. 2, 3; P. Foote and D. M. Wilson, *The Viking Achievement* (London, 1980), pl. 13; Bernstein (note 13), p. 90 f., fig. 51.

281 London, British Library, Ms. Cotton Claudius B. IV, fol. 7; Swarzenski (note 50), no. 47, fig. 106.

282 Cambridge, University Library, Ms. Ff.i.23, fol. 37v; F. Wormald, 'Decorated Initials in English MSS. from A.D. 900 to 1100', *Archaeologia* 91 (1945), pp. 107 ff., 125, pl. VId. On this manuscript, see also Temple (note 84), no. 80 (there dated *c.* 1030-50, though the figure style suggests that it is somewhat earlier).

283 D. M. Wilson and O. Klindt-Jensen, *Viking Art* (Ithaca, NY, 1966), pl. 57; *Les Vikings* (note 96), p. 180, fig. 5.

284 Wilson and Klindt-Jensen (note 283), pl. 49; *Les Vikings* (note 96), p. 37, fig. 5. The dragon-tail on the ship closely resembles the bandwork interlace on a console relief in the choir of Tollevast church, near Cherbourg, which I consider to be a work of the late eleventh century (fig. 57). A different dating is given by M. Baylé, 'Remarques sur les ateliers de sculpture dans le Cotentin (1100-1150)', in *Romanesque and Gothic* (note 37), vol. 1, pp. 7 ff., 10: 'A Tollevast comme à Martinvast, l'aspect des voûtes sur croisées d'ogives ne permet guère de remonter au-delà de 1130-1140.' However, similar vaults in Normandy are known to date from *c.* 1100.

285 D. Bates, *Normandy Before 1066* (New York, 1982), p. 21.

286 Bates (note 285), p. 83 f.

287 *Les Vikings* (note 96), p. 92.

288 R. N. Sauvage, *L'Abbaye de Saint-Martin de Troarn* (Caen, 1911), p. 352.

289 *Les Vikings* (note 96), p. 93.

290 Bates (note 285), pp. 21, 37.

291 G. W. Digby, 'Technique and Production', in F. Stenton, ed., *The Bayeux Tapestry: A Comprehensive Survey* (London, 1957), pp. 37 ff., 40.

292 Wilson (note 14), pp. 11, 201 ff.

293 Paris, Bibliothèque Nationale, Ms. lat. 8879, fol. 148v; Fillitz (note 89), p. 150, pl. 20.

294 Salvén (note 280), p. 158, colour pl. 2. The uncertainty over the dating of this work need not detain us in the present context.

295 St Gallen, Stiftsbibliothek, Ms. 22, pp. 140, 141; Mütherich and Gaehde (note 27), colour pls. 46, 47; Eggenberger (note 27), colour pls. 13, 14.

296 Among the horses that charge the Anglo-Saxon shield-wall there is one with a particoloured body (p. 154).

297 Dublin, Trinity College Library, Ms. 58, fol. 3; F. Henry, *The Book of Kells* (London, 1976), colour pl. 101. This manuscript contains many other particoloured, and thus 'unnaturalistic', creatures: pls. 36, 52, 107, 111, 118, etc.

298 H. Roth, *Kunst der Völkerwanderungszeit*, Propyläen Kunstgeschichte, suppl. vol. 4 (Berlin, 1979), p. 254, fig. 191b.

299 Compare the animals in enamel and garnet inlay on the clasp of a purse found at Sutton Hoo (before 625), in the British Museum, London; Roth (note 298), p. 214, colour pl. 139.

300 Contrast with this the important influence of late antiquity on Carolingian and even on Anglo-Saxon and Ottonian art.

301 It is to be found frequently in 'Winchester School' illumination; this led Wilson and Klindt-Jensen (note 283), p. 145, to speak of a 'Winchester-Ringerike rapprochement'.

302 Wilson and Klindt-Jensen (note 283), p. 153 ff.

303 It was probably a Norman in England who wore the Pitney Brooch, a gilt fibula in the Urnes style, made in the second half of the eleventh century and now in the British Museum, London; *Les Vikings* (note 96), no. 429. The complex of tight coils, with plant-like ends that seem to be rolled up, is most frequently paralleled in eleventh-century Norman decorative initials. Compare, also, the beaded 'dragon bands' in the frame of the St Mark miniature from Jumièges (see note 199).

304 Wilson and Klindt-Jensen (note 283), p. 154, fig. 68.

305 The important carvings of the nave capitals merit a thorough art-historical study in their own right: see M. Baylé, in *Les Siècles romans* (note 59), no. 289.

306 *Les Vikings* (note 96), no. 588. Other analogies are provided by the ornament found on several rune-stones in Sweden, such as those at Skrämsta and Stav (Wilson and Klindt-Jensen [note 283], pl. 72a, b), Ala (Foote and Wilson [note 280], pl. 23b) and Fålebro (P. H. Sawyer, *The Age of the Vikings* [London, 1978], pl. 1b).

307 See note 199.

308 Compare the St Matthew miniature in New York, Pierpont Morgan Library, Ms. 709, fol. 2v; Temple (note 84), no. 93, fig. 285.

309 Compare Temple (note 84), figs. 111, 112, 118, 121, 122.

310 H. Köllner, 'Zur Datierung der Bibel von Floreffe: Bibelhandschriften als Geschichtsbücher?' in *Rhein und Maas* (note 192), vol. 2, p. 361 ff.

311 M. Strube, *Die Illustrationen des Speculum virginum* (Bonn, 1937); A. Watson, 'A Manuscript of the Speculum Virginum in the Walters Art Gallery', *The Journal of the Walters Art Gallery* 10 (1947), p. 61 ff.

312 Similar distinctions appear in early medieval work, as may be seen by comparing two Apocalypse cycles of *c.* 800 (Valenciennes, Bibliothèque Municipale, Ms. 99; Trier, Stadtbibliothek, Ms. 31) with the sumptuous codices of the contemporary Carolingian court school: Mütherich and Gaehde (note 27), p. 30 f., as against p. 32 ff.

313 Wormald (note 134), p. 26.

314 An accurate impression of the look of a late antique continuous picture strip, with trees, may be gained from the Joshua Roll (Rome, Biblioteca Apostolica Vaticana, Ms. Pal. gr. 431), which is a tenth-century Byzantine imitation. See K. Weitzmann, *The Joshua Roll: A Work of the Macedonian Renaissance* (Princeton, 1948); M. Schapiro, 'The Place of the Joshua Roll in Byzantine History', *Gazette des Beaux-Arts* 35 (1949), p. 161 ff. In this the trees have nothing remotely like the dramatic function that they perform in the Tapestry.

315 Werckmeister (note 104), p. 550.

316 Gibbs-Smith (note 62), p. 9.

317 Gibbs-Smith (note 64), p. 168.

318 Gibbs-Smith (note 64), p. 165.

319 Wormald (note 134), p. 26. Stenton (note 209), p. 17: 'It is perhaps unlikely that the true reason for this aberration will ever be discovered.'

320 Parisse (note 146), p. 74 f.

321 Bernstein (note 13), p. 121.

322 Bernstein (note 13), p. 199, n. 16.

323 Oxford, Bodleian Library, Ms. Cotton Junius II; Temple (note 84), no. 58.

324 Bernstein (note 13), p. 92 f.

325 This is why I remain unconvinced by all the attempts in the literature to derive the continuous narrative principle of the Tapestry from the Roman triumphal columns (see Werckmeister [note 104], p. 1 ff.; Bernstein [note 13], p. 94 f.). The Tapestry tells its story in a way that has little to do with late antiquity. At most, the designer absorbed a set of widespread and highly generalized ideas that had been tempered and transformed in their passage through tenth- and eleventh-century art. His continuous narrative style is better described as an innovation: it was an autonomous creation, a spirited assertion of Norman identity. (A close connection with late antique art can be constructed only at the expense of misreading the true artistic achievement involved.) In early medieval times, rolls illustrated in a consistently cyclical manner existed in Byzantine art, but only as exceptions; there were virtually none in the West. Mural painters invariably employed an articulating framework to keep the scenes distinct on the walls. Even in late antique times manuscript painters had largely given up the technique of strip composition, which is very hard to reconcile with the codex

form: narrative images were removed from their immediate textual contexts and separately framed, with the result that the overall pictorial content was considerably reduced.

326 The use of two shrines at once was by no means common practice in the Middle Ages. In the illustrations of the *Sachsenspiegel*, one of the most important law books of the high medieval period, oaths are invariably sworn on a single shrine: C. Schrott, ed., *Eicke von Repgow, Der Sachsenspiegel* (Zurich, 1984), pp. 80, 288, 304, 337 (colour pls.); 351 (fig.), etc.

327 Bremen, Universitätsbibliothek, Ms. b. 21, fols. 78v–79; A. Goldschmidt, *Die deutsche Buchmalerei* (Leipzig, 1928), vol. 2, pl. 55. On this manuscript, see J. Plotzek, *Das Perikopenbuch Heinrichs III. in Bremen und seine Stellung innerhalb der Echternacher Buchmalerei* (Cologne, 1970).

328 Focillon (note 135), pl. 29. It is likely that Ottonian mural paintings included some extensive Joseph cycles, as recorded in Ekkehard IV's *tituli* for Mainz cathedral (before 1031); von Schlosser (note 261), p. 163 ff.

329 Compare the attitude, gesture and lunging posture of the gaoler with those of Harold as he converses with William to the left of the Ælfgyva scene (p. 107). Potiphar's wife wears long, trailing sleeves, like those of the mother who leaves the blazing house in the Tapestry (p. 143). This refutes Nevinson (note 32), p. 74, who says: 'Sleeves of this type are unusual before the twelfth century and first appear in manuscripts such as the *Historia Eliensis* (Corpus, Cambr. 393), in which there is an initial of St Withburga, fol. 59a.' This fashion point therefore does not compel us to date the Tapestry to the twelfth century. The dancing figure of Salome on the bronze column in Hildesheim cathedral (*c.* 1015; fig. 73) wears a dress with 'trailing, wide-cut sleeves': H. J. Adamski, *Die Christussäule im Dom zu Hildesheim* (Hildesheim, 1990), pp. 46, 47 (fig.). This seems to have been a fashion worn by women of exalted rank, which only gradually found its way into art.

330 See note 193.

331 Paris, Bibliothèque Nationale, Ms. lat. 6, vol. 3, fol. 84; Neuss (note 193), p. 96, pl. 36, fig. 109.

332 New York, Pierpont Morgan Library, Ms. 641, fol. 2v; Alexander (note 36), p. 127 ff., pl. 31a.

333 For the part played by Ottonian art in the evolution of Norman manuscript painting, see note 191.

334 London, British Library, Ms. Arundel 91, fol. 188; Kauffmann (note 90), no. 17, fig. 44. Bernstein (note 13), fig. 22, illustrated this initial as evidence of the survival of the 'active, animated' narrative style (see ibid., p. 52), but paid no particular attention to the motivic analogy. In the bottom medallion of the initial, Caesarius is cast overboard into the sea; the heads on the stem and stern posts of the dragon ship both face forward, as on two of the ships in the Tapestry (see Section V).

335 Pächt, Dodwell and Wormald (note 49), pl. 21a. For the later dating, see exh. cat. *Der Schatz von St. Godehard* (Hildesheim, 1988), no. 69.

336 Pächt, Dodwell and Wormald (note 49), p. 85.

337 J. J. G. Alexander, *Medieval Illuminators and Their Methods of Work* (New Haven and London, 1992), p. 85.

338 Oxford, Bodleian Library, Ms. Univ. Coll. 165; Kauffmann (note 90), no. 26.

339 Fol. 135; T. S. R. Boase, *English Romanesque Illumination*, Bodleian Picture Book, no. 1 (Oxford, 1951), fig. 6a.

340 O. Pächt, *The Rise of Pictorial Narrative in Twelfth-Century England* (Oxford, 1962), p. 15 f., associated the overlapping scene changes in the illustrations of the Life of St Cuthbert with a late eleventh-century Life of St Benedict, illuminated at Monte Cassino (Rome, Biblioteca Apostolica Vaticana, Ms. lat. 1202). In Pächt's view it was quite possible that a prototype of this kind of illustration had existed in early Christian times and had reached England at an early date. His argument is weakened, however, by the essentially medieval nature of this narrative technique: it is uncharacteristic of late antiquity. In addition, Pächt did not enlarge on the analogy with the St Albans Psalter miniature, which he himself explained in terms of the contextual influence of mystery plays. It is more likely that pictorial narratives of this kind did not become current until the eleventh century (as generalized parallels to the Tapestry cycle). W. Sauerländer, 'Romanesque Sculpture in its Architectural Context', in D. Kahn, ed., *The Romanesque Frieze and its Spectator* (London, 1992), pp. 17 ff., 42, put it as follows: 'Illustrating the lives of saints was itself a novelty in the Romanesque period. There was an enthusiasm for more stories, more details and illustrations turning these stories into images that could be read by the illiterate.'

341 T. H. Ohlgren, *Anglo-Saxon Textual Illustration* (Kalamazoo, Mich., 1992), no. 16 (all illustrations reproduced).

342 New York, Pierpont Morgan Library, Ms. 736; Kauffmann (note 90), no. 34.

343 Cambridge, Pembroke College Library, Ms. 120; Kauffmann (note 90), no. 35.

344 Pächt, Dodwell and Wormald (note 49), p. 304; Kauffmann (note 90), fig. 73.

345 Paris, Bibliothèque Nationale, Ms. lat. 6401, fol. 5v; Swarzenski (note 50), no. 70, fig. 164.

346 Dodwell (note 199).

347 Quoted from Erb (note 19), vol. 1, p. 960.

348 Digby (note 291), p. 45.

349 Avranches, Bibliothèque Municipale, Ms. 90, fol. 1v; Alexander (note 36), p. 101, pl. 24a.

350 Paris, Bibliothèque Nationale, Ms. lat. 2079, fol. 1v, and Ms. lat. 1684, fol. 1; exh. cat. *Manuscrits normands: XI^e–XII^e siècles* (Rouen, 1975), no. 11 f.

351 J. J. G. Alexander, 'Manuscrits enluminés du XI^e siècle provenant du Mont-Saint-Michel', *Art de Basse-Normandie* 11 (1966), pp. 27 ff., 32.

352 Many eleventh-century bishops were members of the ducal family or close relatives.

353 Alexander (note 36), p. 211: 'a Norman development'.

354 Pächt, Dodwell and Wormald (note 49), p. 137 f. On the Old French texts in the St Albans Psalter, 'in the Norman Geoffrey's mother tongue', see also *Der Schatz von St. Godehard* (note 335), p. 164.

no. 69. Geoffrey de Gorran succeeded another Norman, Richard, as Abbot in 1119.

355 Even the Byzantine imperial court – which, from 730 until 843, was the focus of the most virulent outbreak of early medieval iconoclasm – valued figuration in secular art.

356 We have no reliable contemporary explanation of the grounds for his imprisonment.

357 Jäschke (note 18), p. 232.

358 This is the view taken, for instance, by M. Parisse in his review of Brown (note 2), in *Cahiers de civilisation médiévale* 33 (1990), p. 285 ff.

359 Bernstein (note 13), p. 105.

360 Bernstein (note 13), fig. 65, publishes a conjectural drawing of a hall with the walls hung in this way; the Tapestry would have looked like an interminable dado strip.

361 Brown (note 2), p. 2: 'the Tapestry apparently was kept in the vestry of the cathedral when not on public display'.

362 Digby (note 291), p. 46.

363 M. Durliat, 'Les Peintures murales romanes dans le Midi de la France, de Toulouse et Narbonne aux Pyrénées', *Cahiers de civilisation médiévale* 26 (1983), p. 135.

364 Wilson (note 14), p. 203.

365 Digby (note 291), p. 48.

366 Bertrand (note 275), p. 46.

367 Demus (note 187), p. 147.

368 Demus (note 187), p. 147.

369 Demus (note 187), p. 123, ill. 9, pl. 61.

370 Dodwell (note 231), p. 549.

371 Erb (note 19), vol. 2, p. 660.

372 R. Hamann-MacLean, 'Künstlerlaunen im Mittelalter', in F. Möbius und E. Schubert, eds., *Skulptur des Mittelalters: Funktion und Gestalt* (Weimar, 1987), pp. 385 ff., 424.

373 Hamann (note 31), ch. 7, 'Das Nackte', p. 163 ff.

374 See L. M. C. Randall, *Images in the Margins of Gothic Manuscripts* (Berkeley and Los Angeles, 1966), nos. 525–43.

375 Although Bernstein (note 13), p. 107, was convinced that the embroidery was done for a hall, he too voiced the conjecture that Odo might have taken it with him on his travels.

376 Gibbs-Smith (note 64), p. 167.

377 Such as the celebrated statue of the Magdeburg Horseman or the Brunswick Lion.

378 H. Belting, 'Der Einhardsbogen', *Zeitschrift für Kunstgeschichte* 36 (1973), p. 93 ff.

379 Belting (note 378), p. 110.

380 Exh. cat. *Kunst der Reformationszeit* (Berlin, 1983), no. C2.

381 All this is not to be confused with the triumphal processions of Italian Renaissance art, which were sculptured or painted, and thus restricted to a single location.

382 K. Langosch, *Profile des lateinischen Mittelalters* (Darmstadt, 1965), p. 231.

PLATES

The Tapestry Sequence

Inscriptions
and
Commentaries

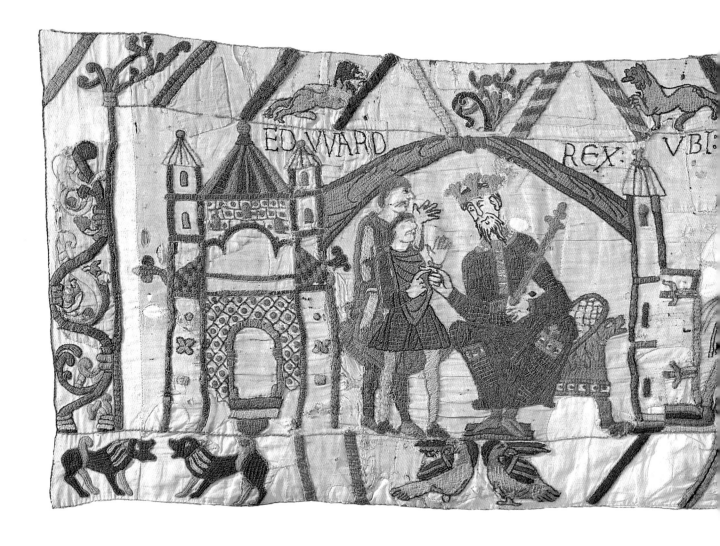

EDVVARD REX:

King Edward.

The narrative of the Norman conquest of England begins with its prehistory. In the year 1064 Edward the Confessor, King of England, sits in his Palace of Westminster and commands Harold, Earl of Wessex, to travel to Normandy. The elderly, bearded monarch (the letters of his name have been restored from the stitch holes in the linen) is seated on a lion throne; the architecture – like most of the buildings shown in the Tapestry – is a product of the designer's imagination.

Since the reason for Harold's journey is not given – and no remotely contemporary English source explains it – we have only the eleventh-century Norman chronicles to rely on. These tell us that the childless King Edward desired to renew a promise of his that William, Duke of Normandy, should be his successor. Harold was sent as his envoy to carry this message.

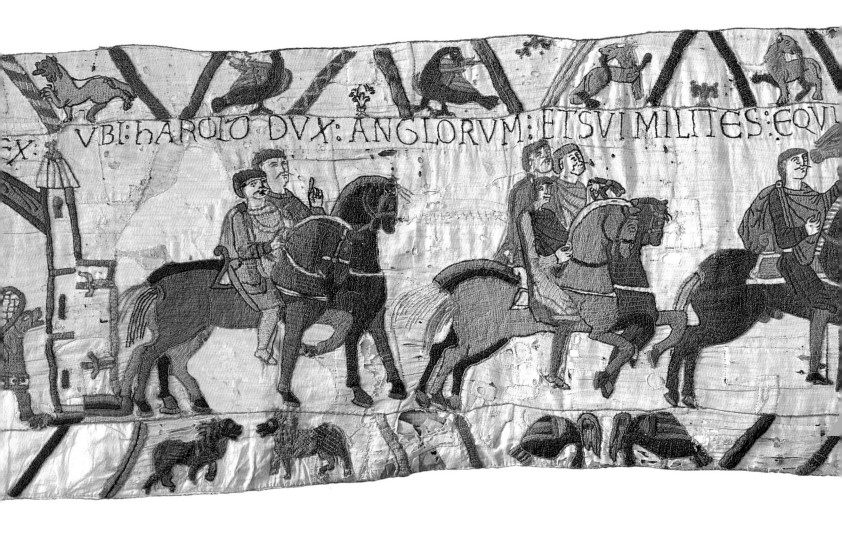

VBI ⋮ hAROLd DVX ⋮ ANGLORVM ⋮ ET SVI MILITES ⋮
EQVITANT ⋮ AD BOShAm ⋮

Where Harold, Duke of the English, and his soldiers ride to Bosham.

We see Harold and his retinue on the first stage of their journey. The Earl (who is given the title of Duke) carries a hawk on his left wrist. He is preceded by three hounds, which are chasing small animals (possibly hares). Clad in tunics and cloaks, the horsemen are unarmed: it is a scene that seems intended to underline the peaceful purpose of the expedition.

Here, for the first time, a distinguishing mark of nationality becomes evident: the Anglo-Saxons wear moustaches, unlike the Normans and Bretons in subsequent scenes (who, in addition, have the backs of their heads shaven).

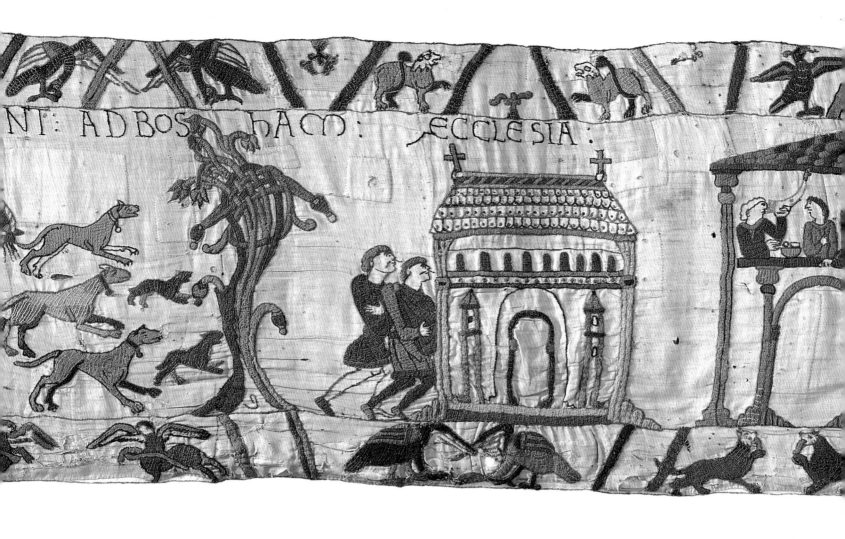

ȨCCLESIA :

The church.

Harold and a companion step into Bosham church, with the apparent intention of praying for a safe journey. Only the crosses on the roof and the long row of windows identify the religious purpose of the building, which otherwise looks more like an elaborate gateway.

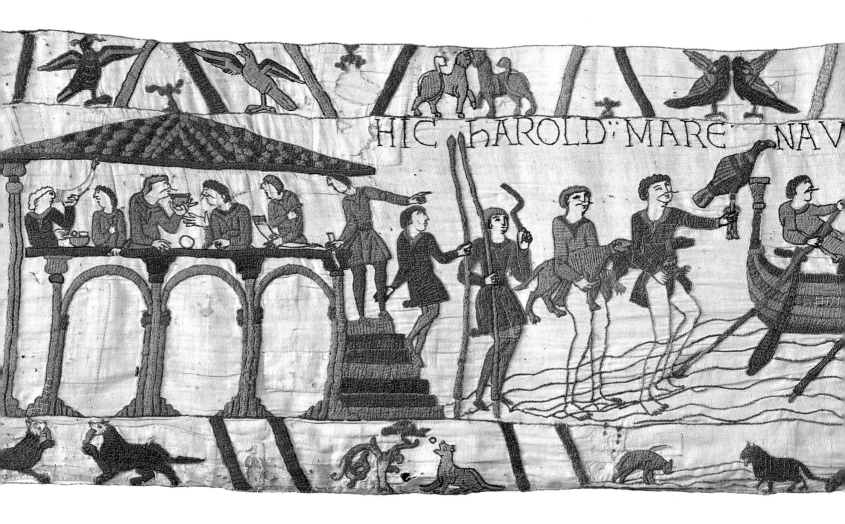

HIC HAROLD MARE NAV

Next, a meal is in progress on the upper storey of a house, above a ground-floor arcade. One of the men drinks from a horn, another from a bowl; meanwhile, a third stands on the top step of the staircase at the end of the room and clearly signals that it is time to leave.

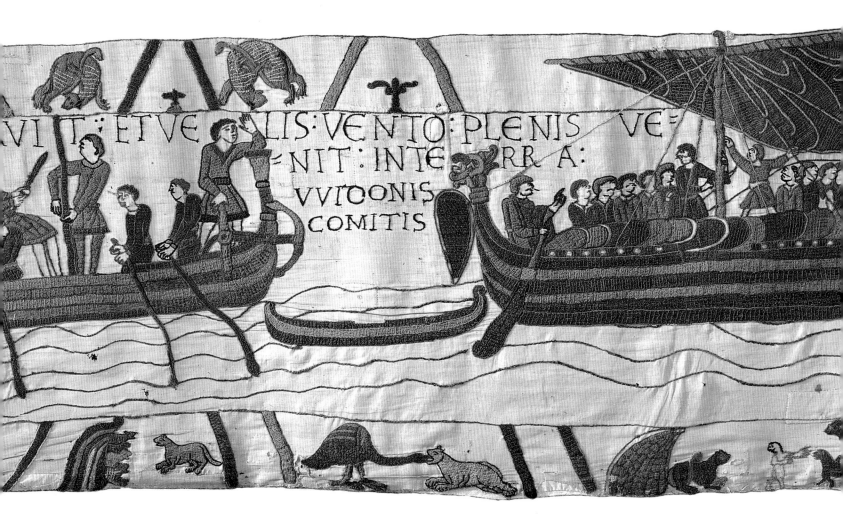

HIC hAROLD ·.· MARE NAVIGAVIT ·.· ET VELIS : VENTO :
PLENIS VE =/= NIT : IN TERRA : / VVIdONIS / COMITIS

Here Harold sailed the sea, and, with the wind full in his sails, he came to the land of Count Guy.

Two men with long poles (or oars) are on their way to the ship; one holds an angled object of uncertain function. Ahead of them, two other members of the party are wading in the sea, carrying hounds and a hawk. Although only one ship crosses the Channel, the Tapestry shows her several times. Like those of the invasion fleet (shown later, p. 132 ff.), she is identical in shape to the seaworthy Viking craft of the tenth and eleventh centuries, which could be propelled by oars as well as by their rectangular sails.

When the ship makes landfall on the French coast (at a location thought to be near Saint-Valéry, at the mouth of the Somme), the anchor is dropped and the mast unstepped. This is the land of Count Guy of Ponthieu, a vassal of Duke William of Normandy.

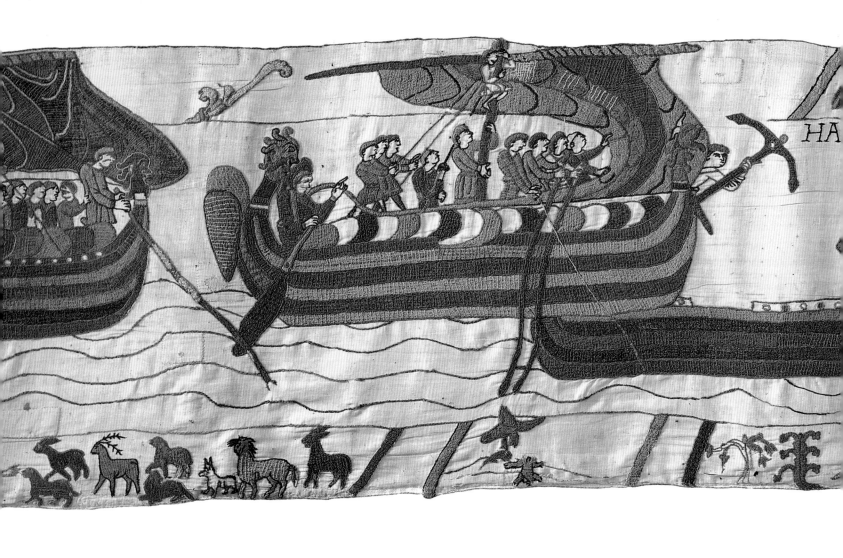

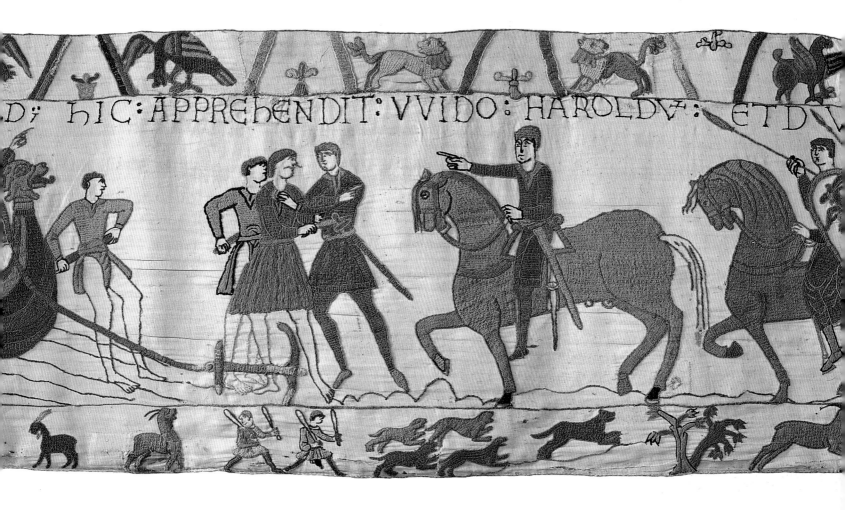

HAROLD ✝ hIC : APPREhENDIT : VVIDO : HAROLDV̄ [Haroldum] :

Harold. Here Guy captures Harold.

At the head of his armed and mounted escort, Guy orders the detention of Harold, who seems to have a mind to defend himself, as he has a large knife in his right hand.

Again, only the Norman sources mention Harold's captivity. Why did he not sail straight across the Channel to Normandy? The question has aroused controversy. Some historians argue a navigational error; others conjecture that Harold was driven to shelter from bad weather. The idea that a storm drove the ship off course is not reconcilable with the inscription on the Tapestry, which speaks of 'the wind full in his sails': a fair wind.

Perhaps, however, this overcomplicates the matter. Would not the safest possible course have been set? If so, after putting out from Bosham in Wessex, Harold might well have hugged the coast eastward to Kent before sailing over to the Continent. This would have made for a shorter Channel crossing. It was probably no coincidence that, in 1066, William's invasion fleet sailed for England from the mouth of the Somme, close to the point where Harold had landed.

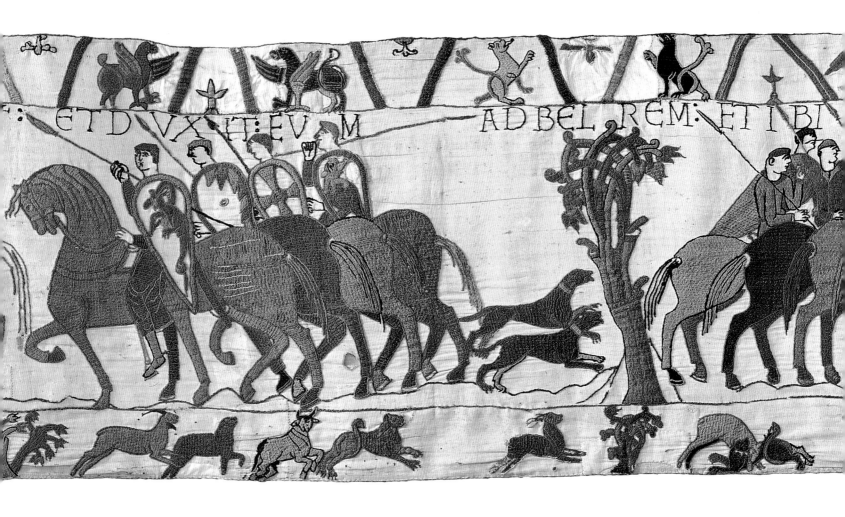

ET DVXIT : EVM AD BELREM : ET IBI EVM : TENVIT :

And he took him to Beaurain and held him there.

The inscription makes it clear that Harold was held prisoner. This act of violence was, of course, a grave insult. The designer of the Tapestry seems to have tried to take the sting out of the given fact of Harold's detention: the images, although not the text, make it all seem entirely painless. Harold and Guy (followed by the latter's troop of horse) look like peaceable companions, each with a hawk on his wrist. One would expect the leading rider to be the Count of Ponthieu, but this figure wears a moustache, so he must be Harold. As he is riding at the head of the party, it looks as if he is there of his own free will. The next scene, too, is shown in such a way as to extenuate the crime of William's feudal vassal, for which the ultimate responsibility would have lain with the overlord himself.

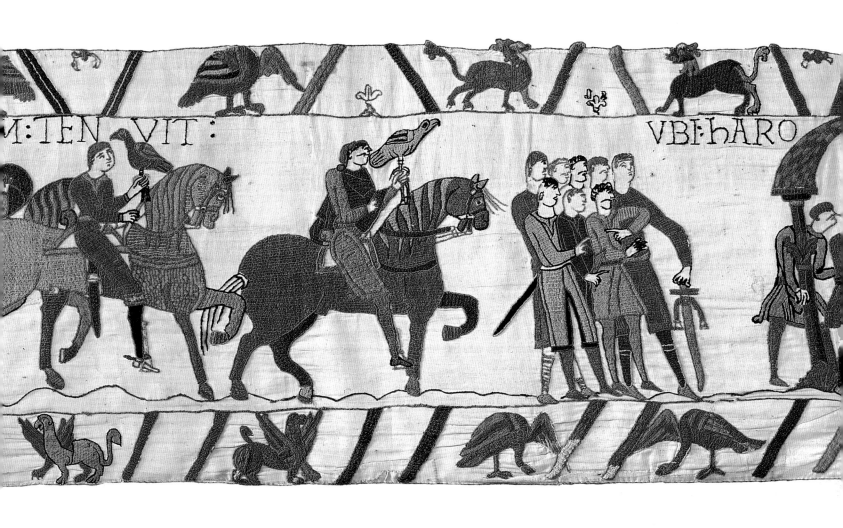

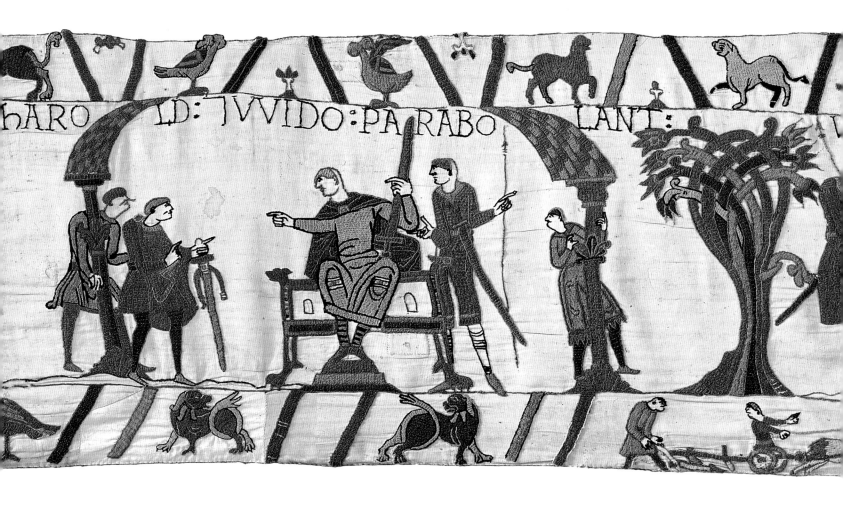

VBI : hAROLD : 7 [et] VVIDO : PARABOLANT :

Where Harold and Guy converse.

Two pillars supporting a roof indicate that the scene takes place inside the castle of Beaurain. A group of men wait outside. Harold has just entered, with a single escort – the constantly changing colours of the garments are no help with identification. Seated on his throne, Guy holds in his left hand a sword that stands propped on his knee and, as he speaks, he points to Harold; the prisoner, too, holds a sword as he steps in to meet the lord of Beaurain. This would seem to dispose of the embarrassment (to the Norman side) of the wrong done to Harold. To the right of the throne, two of the Count's retainers lead over into the following scene.

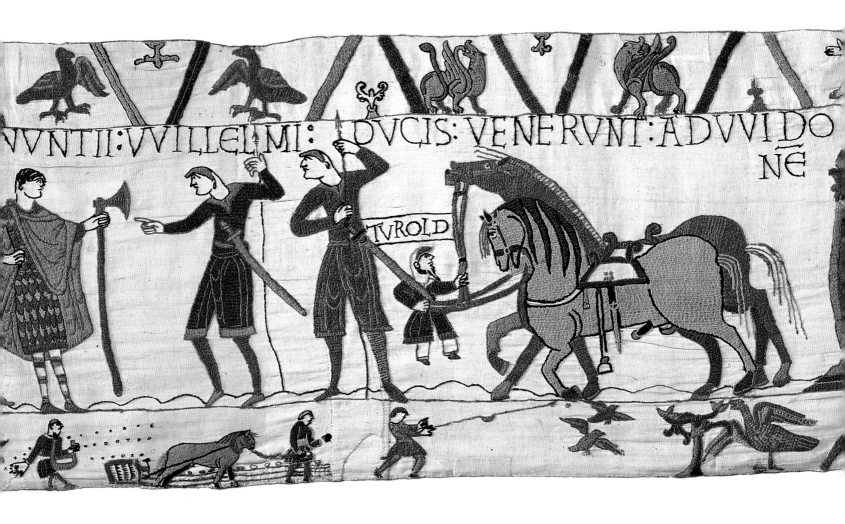

NVNTII:VVILLELMI : DVCIS:VENERVNT:ADVVIDO NĒ

TVROLD

VBI : NVNTII : VVILLELMI : DVCIS : VENERVNT :
AD VVIDO/NĒ [Widonem]/TVROLD

Where Duke William's messengers came to Guy. Turold.

Once more a tree marks the change of scene. There follow three episodes that require to be read chronologically from right to left. Two messengers from William have just dismounted and are calling on Guy (who carries a battleaxe) to release Harold. A dwarf holds their horses' reins. In the lower border we notice that animals and birds are replaced by countryfolk tilling the soil, who are followed by little hunting scenes.

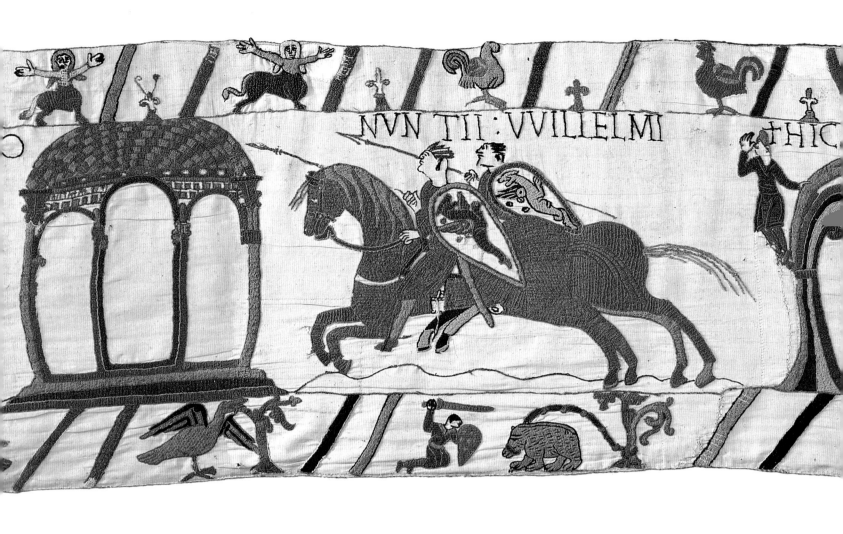

NVN TII : VVILLELMI THIC

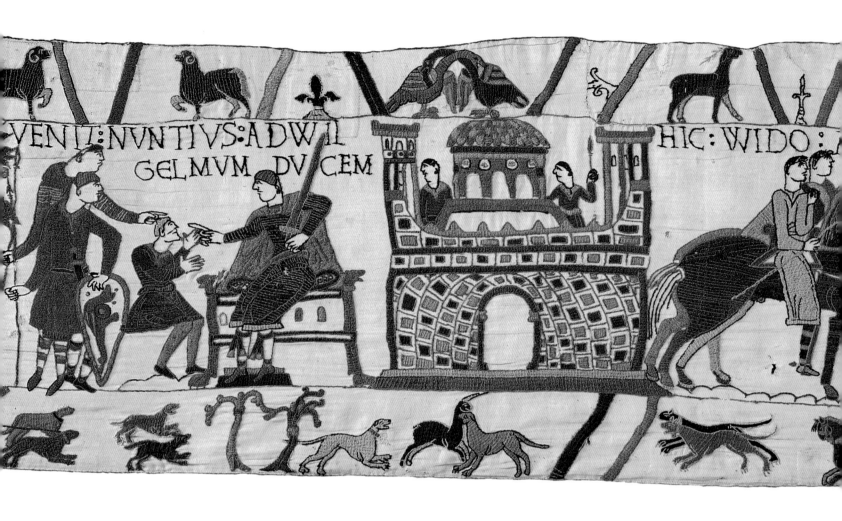

VENIT:NVNTIVS:ADWIL GELMVM DVCEM · · · HIC:WIDO:

NVNTII : VVILLELMI + HIC VENIT : NVNTIVS :
AD WIL / GELMVM DVCEM

William's messengers. Here the messengers came to Duke William.

On the right, William sits enthroned; behind him stands a castle-like structure that may stand for Rouen, the capital of Normandy. An Anglo-Saxon brings news of Harold's detention. The Duke immediately dispatches two messengers, who have been standing by. They ride full-tilt leftward to Guy (the horses' legs are outstretched).

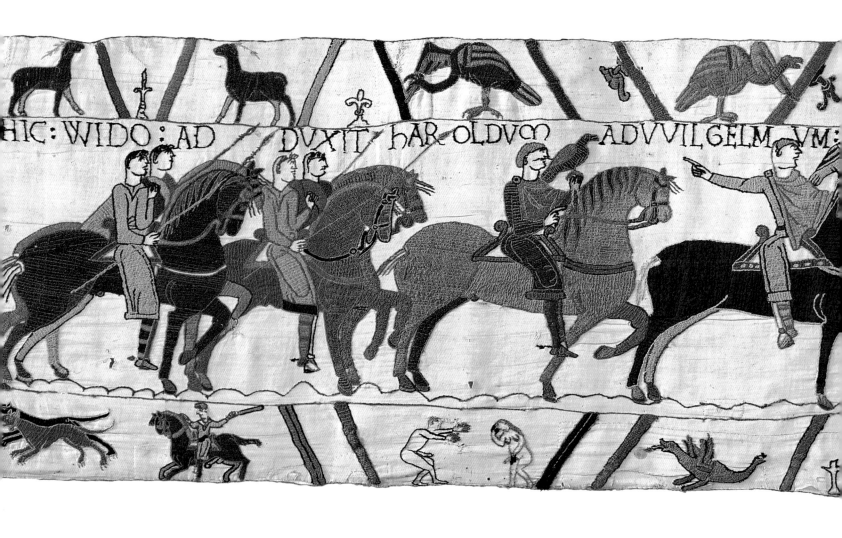

HIC: WIDO: AD DVXIT: HAROLDVM ADVVILGELMVM:

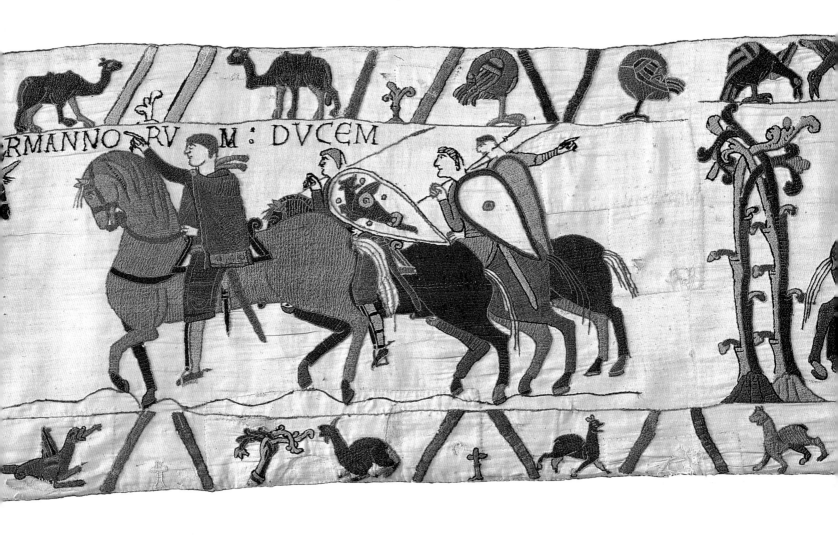

HIC : WIDO : ADDVXIT hAROLDVm AD VVILGELMVM :
NORMANNORVM : DVCEM

Here Guy brought Harold to William, Duke of the Normans.

Now the scenes run from left to right once more. Guy points back towards Harold; both ride towards William with their hawks on their wrists. Guy's prick-eared black horse is notably slender in build; unlike the stallions ridden else-where in the Tapestry, this is presumably not a warhorse.

In the lower border we see a little naked couple, one of the erotic motifs that appear here and there in the margins of the Tapestry.

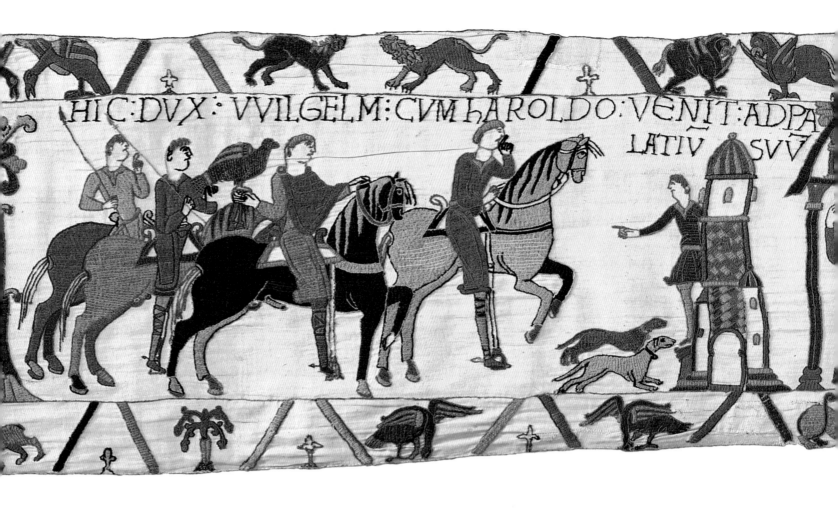

HIC : DVX ⠿ VVILGELM ⠿ CVM hAROLDO : VENIT :
AD PA / LATIV̄ SVV̄ [palatium suum]

Here Duke William comes to his palace with Harold.

Harold rides at the head of the party.
William carries a hawk (on his right
wrist, this time); this is perhaps Harold's
gift to his host. Emerging from behind a
tower-like structure, a guard hails the new
arrivals. Next, William holds court in his
palace hall (probably in Rouen), which is
adorned with an upper arcade. Standing,
Harold gesticulates forcefully; he is
clearly pointing with his left hand at the
scene that follows.

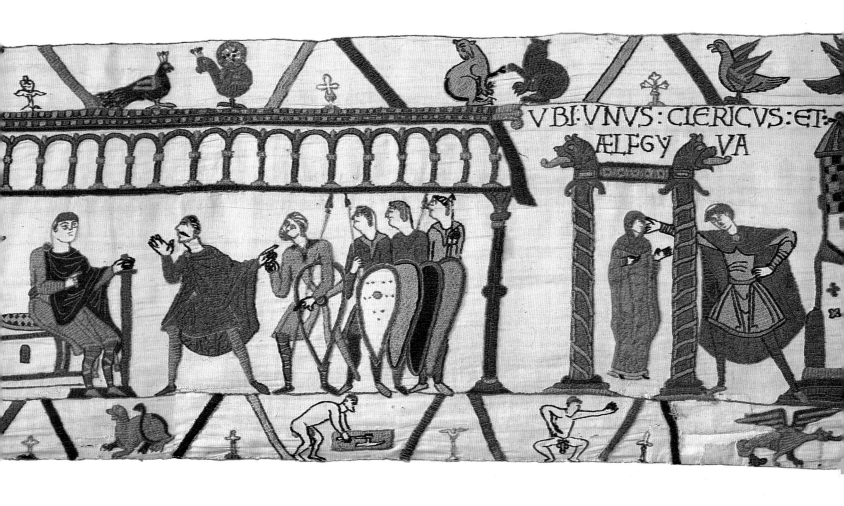

VBI : VNVS : CLERICVS : ET :– / ÆLFGYVA

Where a Cleric and Ælfgyva.

The 'where' in the inscription refers to the location of the conversation just seen. A cleric strides in and touches with his right hand the face of Ælfgyva, who stands in an ornate (wooden?) doorway, presumably that of the palace hall. No one has yet succeeded in identifying this figure, who has an Anglo-Saxon name. There is no mention of her in any of the surviving chronicles of the immediate pre-conquest period. Yet it would seem, from the brevity of the inscription, that contemporaries could be expected to find the scene perfectly intelligible; the use of an incomplete sentence implies that Ælfgyva was a well-known person. This is the first indication in the Tapestry that it must have been made soon after 1066.

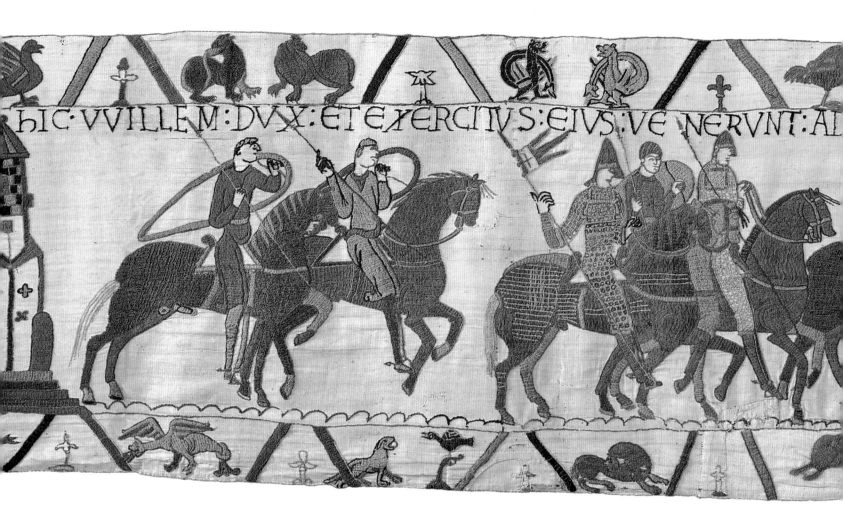

hIC · VVILLEM : DVX : ET EXERCITVS : EIVS :
VENERVNT : AD MONTĒ [montem] MIChAELIS

Here Duke William and his army came to Mont-Saint-Michel.

This image and the following scenes show William's war in Brittany. Harold has attached himself to the Norman army; he is identified by his moustache, as he rides in the van. The purpose of the expedition was to capture Conan, the disaffected Duke of Brittany. As the army approaches the abbey of Mont-Saint-Michel on its coastal peak, William wears a resplendent coat (like that worn by Count Guy, with battleaxe, at the arrival of the Norman messengers, p. 101). In his right hand the Duke carries a mace – possibly as a token of his exalted rank, like a marshal's baton. In the group of figures that stands for the army we see, for the first time, horsemen wearing mail shirts and conical helmets.

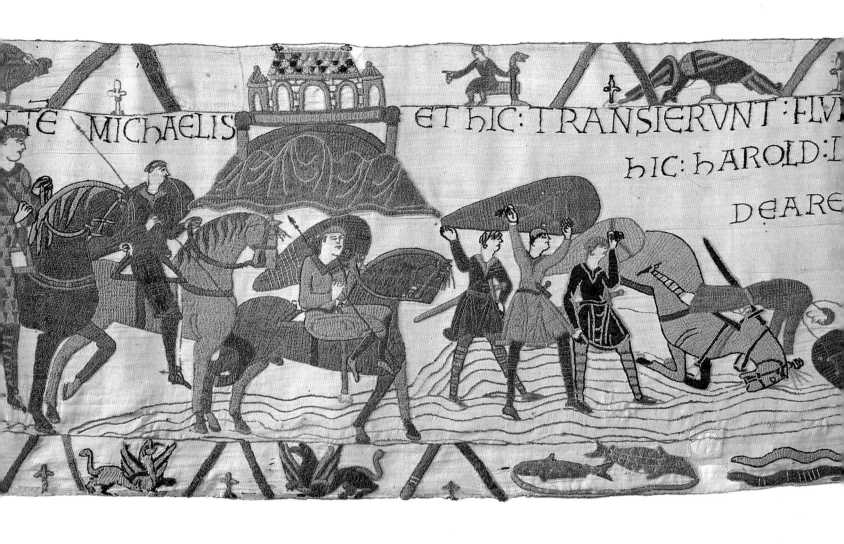

...TE MICHAELIS ET HIC:TRANSIERVNT:FLV...

hIC:hAROLD:L...

DEARE...

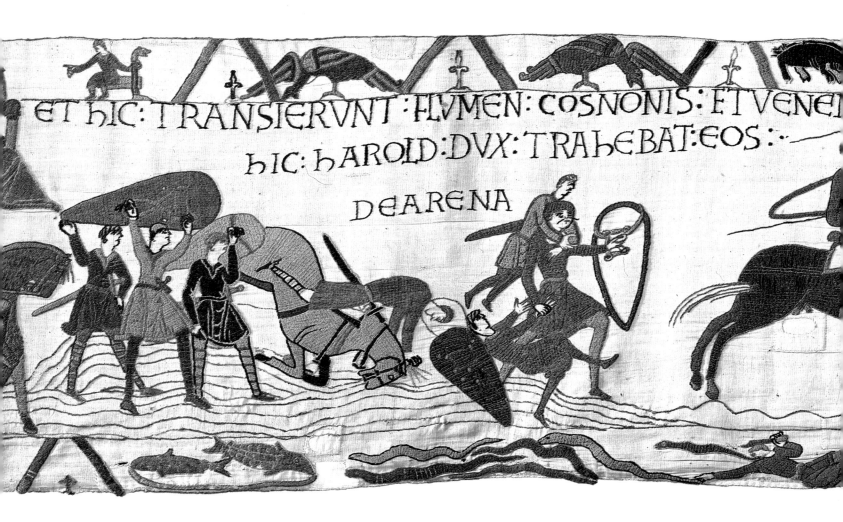

ET hIC : TRANSIERVNT : FLVMEN : COSNONIS : /
hIC : hAROLD : DVX : TRAhEBAT : EOS :· / DE ARENA

And here they crossed the river Couesnon.
Here Duke Harold pulled them out of the sand.

The troops ford the river on foot and hold their shields over their heads; one horseman takes a fall. Harold gives proof of his courage and strength by rescuing two Normans from some quicksand; he carries one on his back and drags the other to safety with his right hand.

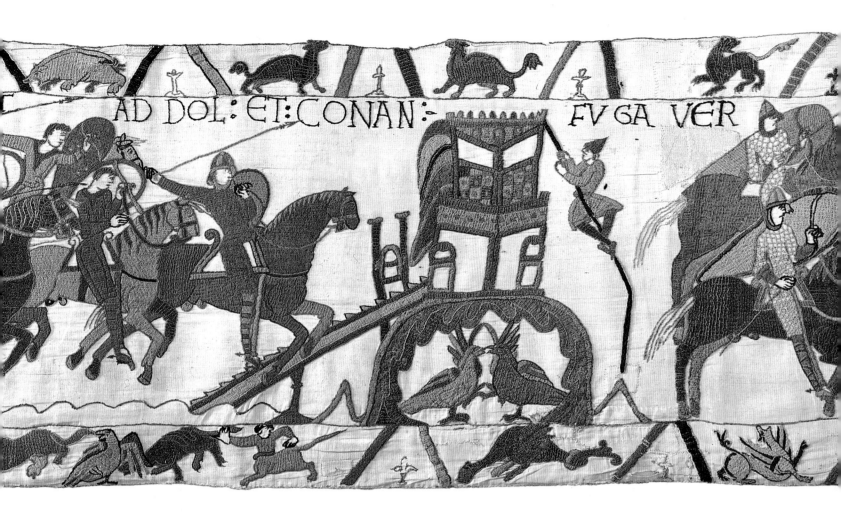

AD DOL : ET : CONAN :· FVGA VER

ET VENERVNT AD DOL : ET : CONAN :– FVGA VERTIT :–
REDNES

And they came to Dol, and Conan fled. Rennes.

When the Normans attack the town of
Dol, the Duke of Brittany makes his
escape by rope – or so the Tapestry would
have us believe. (The historical facts are
otherwise; see p. 57 f.) Then the Norman
army proceeds to Rennes.

Perhaps the building depicted stands
for the citadel of Dol, with a drawbridge
on the left. The hill on which it is
situated encloses a brace of outsize
decorative birds.

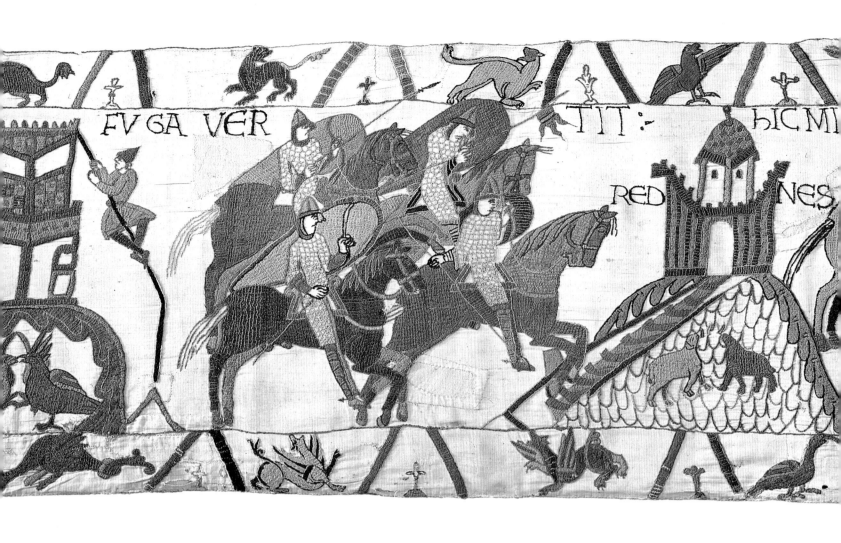

FVGA VER TIT: hIC MI RED NES

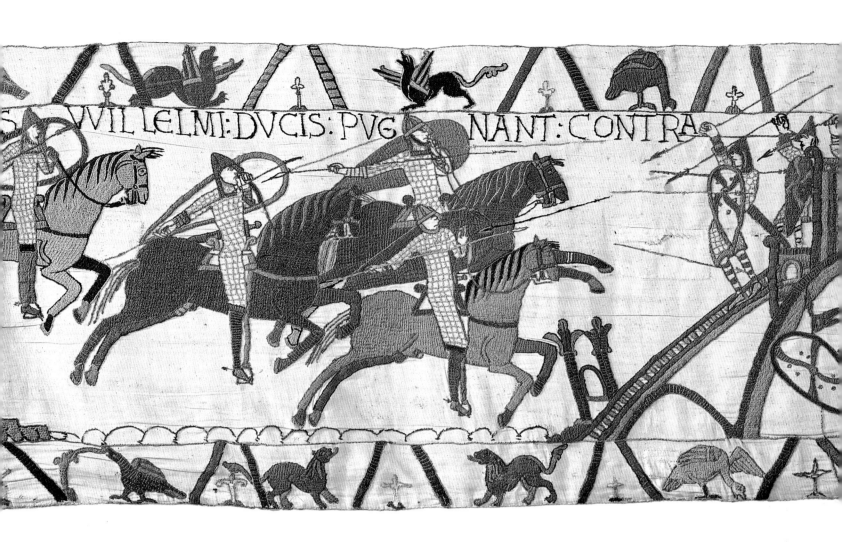

hIC MILITES VVILLELMI : DVCIS : PVGNANT : CONTRA
DINANTES :– ET : CVNAN : CLAVES : PORREXIT :–

Here Duke William's soldiers do battle with the men of Dinan.
And Conan surrendered the keys.

The campaign is brought to a triumphant end by Conan's capitulation (but see p. 57 f.). The Tapestry illustrates a hard-fought battle for the citadel (or city) of Dinan, which is protected by a wooden palisade.

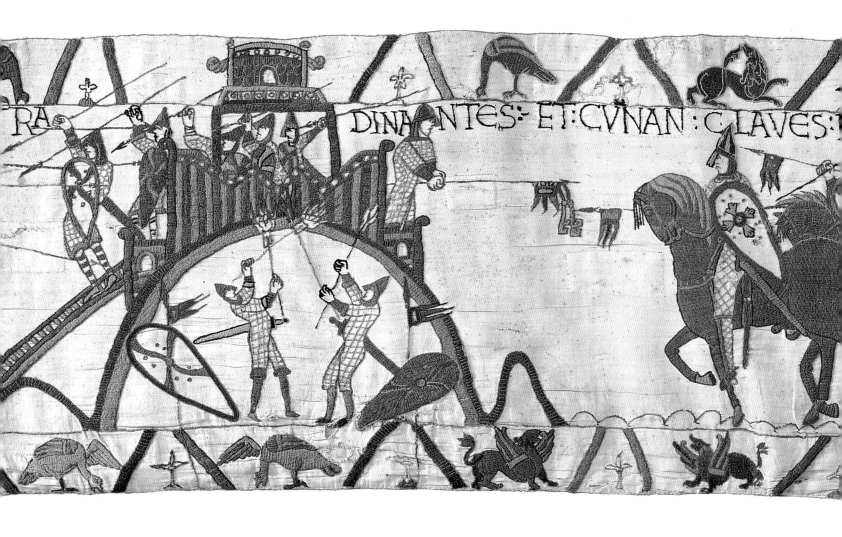

Two soldiers with torches are trying to set fire to the fortress. Above right is Conan; on the tip of his lance hang the keys, which William receives on the tip of his own weapon.

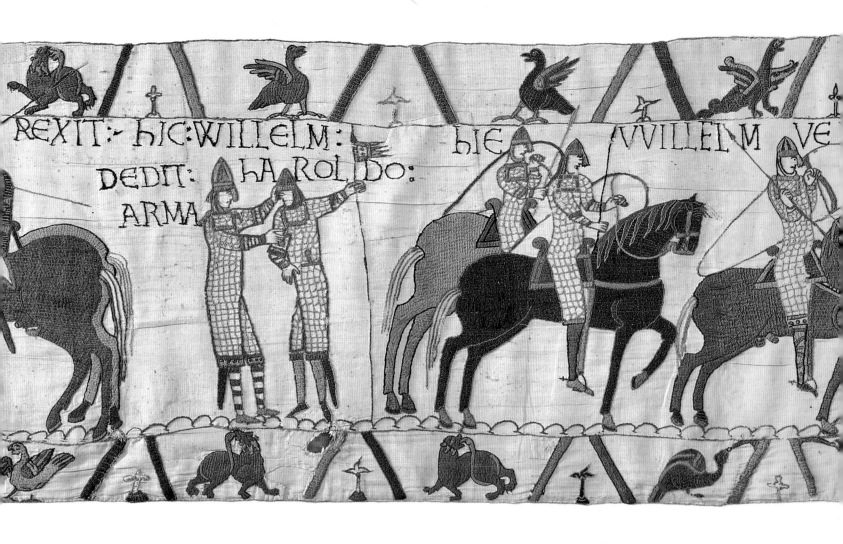

hIC WILLELM : / DEDIT : hAROLDO : / ARMA

Here William gave arms to Harold.

William and Harold are both in full armour. The Duke is clearly bestowing arms on Harold with his own hands: his left hand grasps the Englishman's helmet and his right seems to touch his mail shirt. This investiture with arms gave the Earl the status of a vassal – or so contemporary observers would have assumed.

This event, of crucial importance to Harold, gains additional narrative weight from its position as a preamble to the following scene, on which the whole story turns.

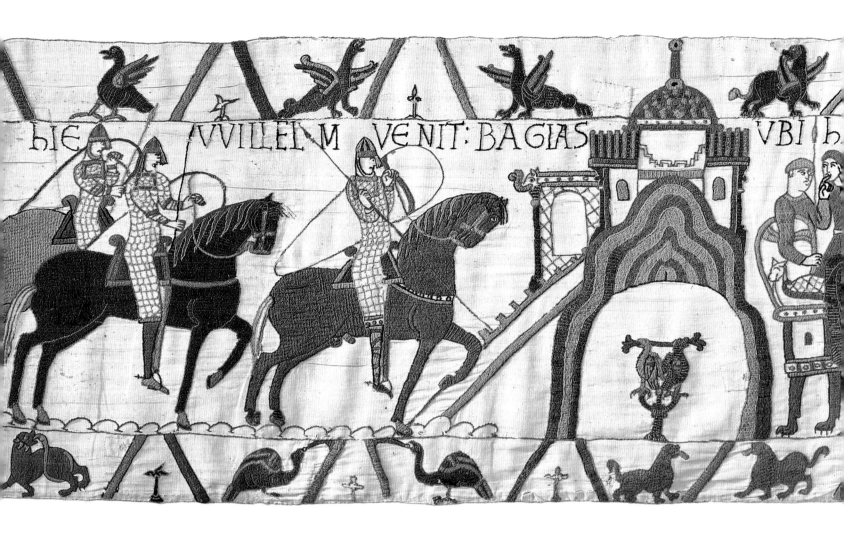

hIC :VVILLEL M VENIT:BAGIAS VBI h

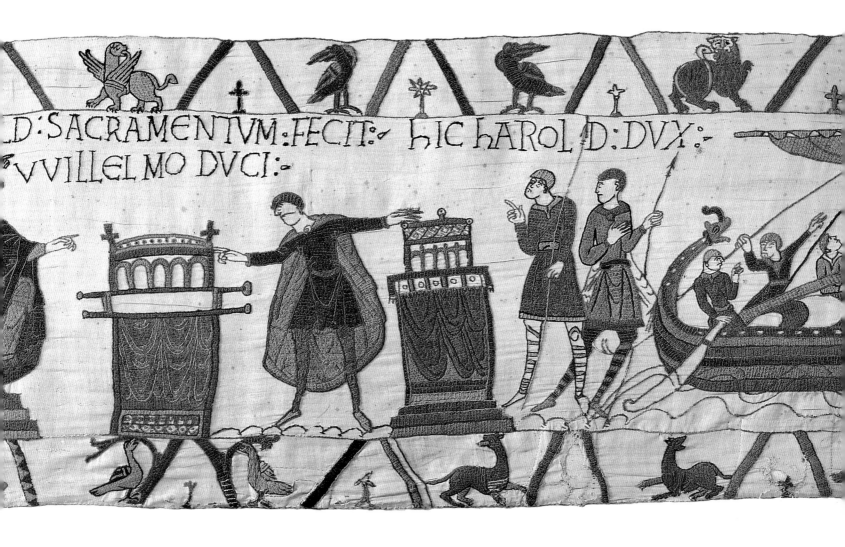

hIE [hic] VVILLELM VENIT : BAGIAS VBI hAROLD :
SACRAMENTVM : FECIT :– / VVILLELMO DVCI :–

Here William came to Bayeux, where Harold swore a sacred oath to Duke William.

William rides to Bayeux, and there – the Tapestry leaves us in no doubt on this score – Harold swears an oath of fealty to him. This is the first climax of the narrative. King Edward's promise, the gift of arms and, above all, this oath – later broken – together provide the justification for William's conquest of England. The oath is not presented as a private agreement, but as a solemn ceremony. William sits on a throne, in a frontal pose, resting his drawn sword against his right shoulder. Harold swears with outstretched arms on two reliquary shrines; these certainly belong to the cathedral that Bishop Odo is in the process of building. The momentous consequences of the breaking of the oath loom ahead.

None of the Anglo-Saxon sources mentions this event, but the Norman historians certainly do. William of Poitiers gives us some of the details (see p. 55). According to him, Harold undertook to represent William's interests at Edward's court and to do everything in his power to safeguard the Norman succession. Again according to William of Poitiers, Harold was under no duress when he swore his oath; he became Duke William's vassal of his own free will.

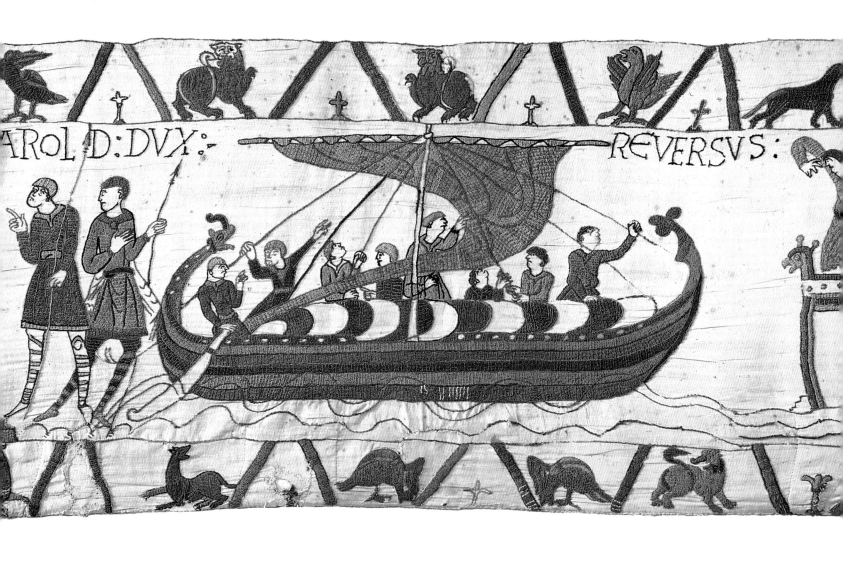

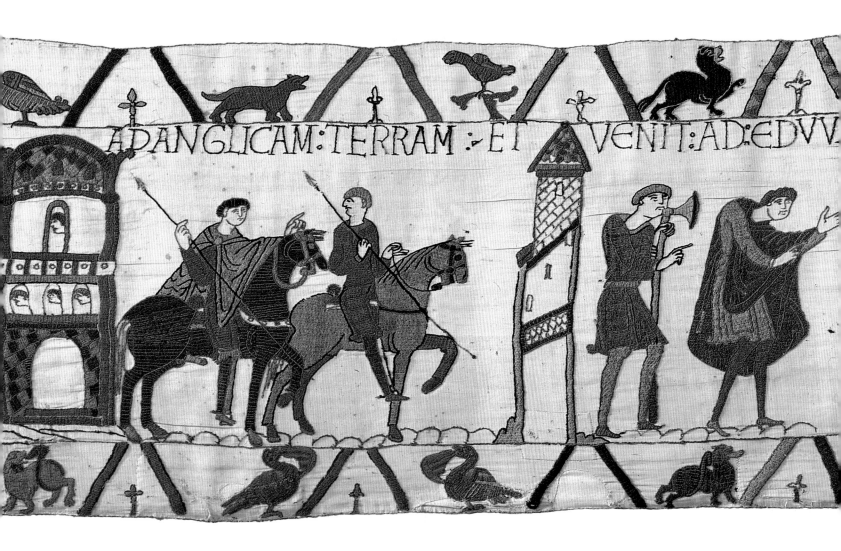

AÐ ANGLICAM : TERRAM : ET VENIT : AD : EÐVV

hIC hAROLD : DVX :– REVERSVS : EST AD ANGLICAM :
TERRAM :– ET VENIT : AD : EDVVARDV̄ [Edwardum] :–
REGEM :–

Here Duke Harold returned to English soil and came to King Edward.

A coastguard sights the ship that brings Harold back to England; other people watch her approach from the windows of the same building. No one on board wears a moustache; from this point onwards the Tapestry often neglects its rule of identifying the Anglo-Saxons in this way.

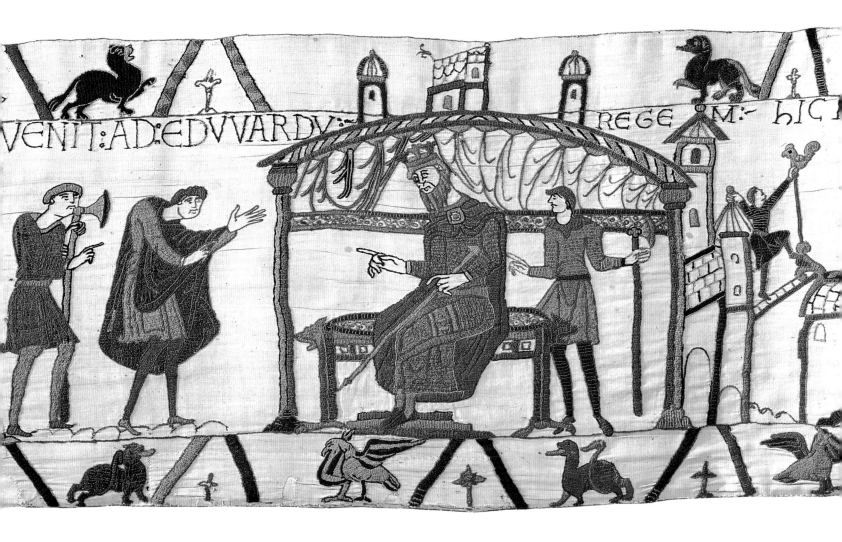

VENIT:AD:EDVVARDV: ... REGE M:~ hIC

Then Harold rides to London, where King Edward receives him, presumably in the Palace of Westminster. The Earl seems to be giving a lively account of his travels. The scene is flanked by two men armed with battleaxes. A curtain hangs from the arched roof of the palace. As at the beginning of the Tapestry, the King wears his crown and holds his sceptre; the conversation thus takes on the character of a formal audience.

There now follow two scenes that cover a considerable span of time and again seem to be in reverse order: that is, they are intended to be read from right to left.

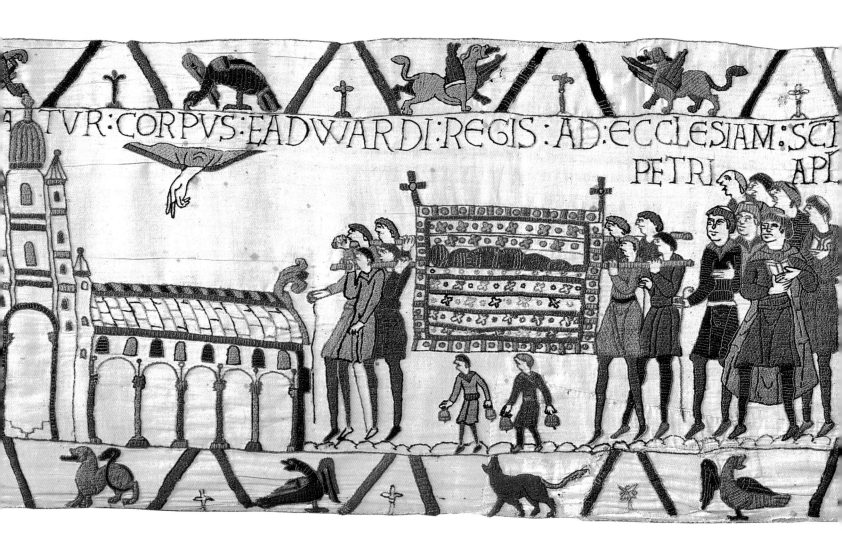

hIC PORTATVR : CORPVS : EADWARDI : REGIS :
AD : ECCLESIAM : SC̄I / PETRI APL̄I [Sancti Petri Apostoli]

Here King Edward's corpse is borne to the church of St Peter the Apostle.

A workman sets up a weathercock on the roof of Westminster Abbey. This conveys to us that the King died only a few days after the consecration of the new church, which took place on 28 December 1065. (He died, in fact, on 5 January 1066.) The hand of God emerges from a segment of heaven above the church.

Edward was interred on the day after his death, 6 January. In the Tapestry his bier is covered with a richly embroidered pall. Two of the clerics in the funeral procession carry open books and one holds a bishop's crozier. The clergymen behind him are singing.

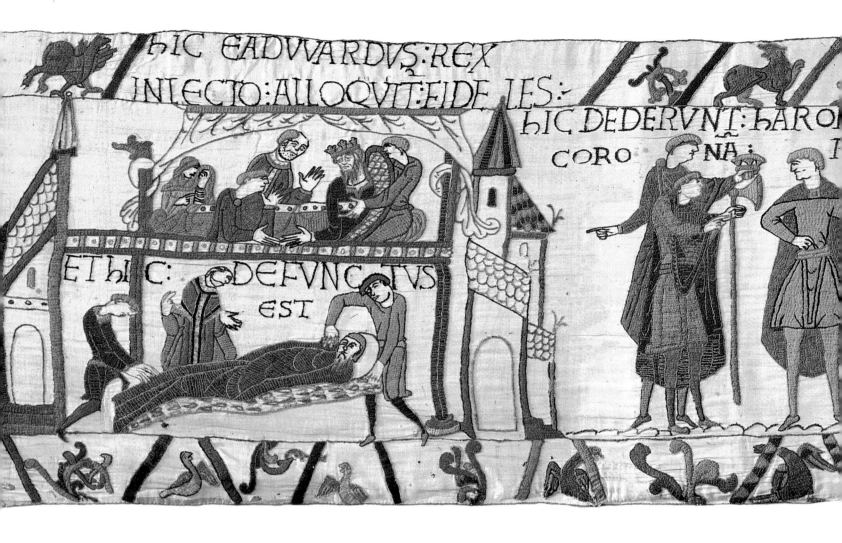

hIC EADVVARDVS : REX / IN LECTO ∶ ALLOQVIT̄

[alloquitur] : FIDELES :– / ET hIC : DEFVNCTVS / EST

Here King Edward, in his bed, addresses his faithful followers; and here he has died.

Two scenes are superimposed. Above, the dying King lies in bed. His loyal friends have assembled around him, including a woman who may well be Queen Edith (otherwise known as Eadgyth, she was one of Harold's three sisters). One bedpost is adorned with a carved animal-head. In the scene below, the dead King is prepared for burial in the presence of a clergyman.

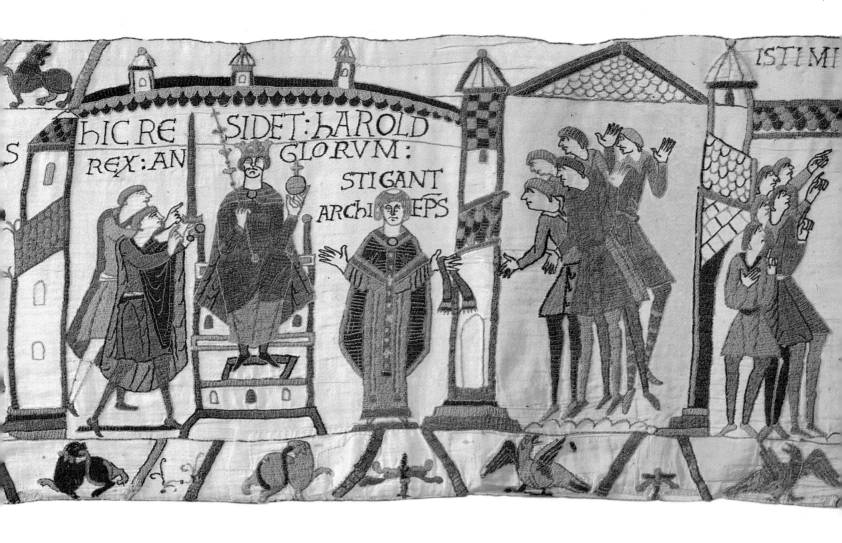

hIC DEDERVNT : hAROLDO : / CORONĀ [coronam] : REGIS
hIC RESIDET : hAROLD /REX : ANGLORVM : / STIGANT /
ARChIEP̄S [archiepiscopus]

Here they gave Harold the King's crown.
Here sits [enthroned] Harold, King of the English. Archbishop Stigand.

Harold had himself crowned on the very day of Edward's burial. One of the two men who stand before him is handing him the crown. Next, the new King sits on the throne, with orb and sceptre. On the King's right, the sword of state is held out to him. On the other side, Arch-bishop Stigand of Canterbury, robed, holds his maniple and uplifts his hands. The Tapestry thus indicates that it was Stigand who performed the ceremony of coronation. Further to our right, a group of Anglo-Saxons acclaims the King.

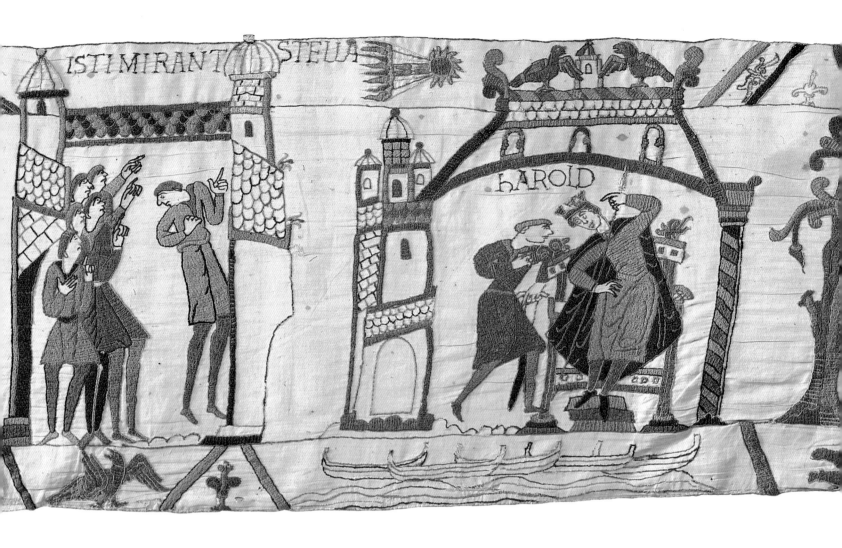

ISTI MIRANT STELLĀ [stellam] / hAROLD

These men wonder at the star. Harold.

The appearance of Halley's Comet (in the upper border) causes great consternation among all who see it. It was visible in England from February 1066 onwards, reaching its maximum brightness at the end of April. This comet was regarded as an ill omen and it inspired terror. The presentation of Harold to his people is thus directly followed by the suggestion that his coronation took place beneath an 'evil star'.

The new King is clearly also perturbed by the comet. Harold sits listening, head to one side, as a man addresses him. The Tapestry seems to imply that they are talking about the impending invasion by a Norman fleet, for beneath the King's feet we see ghostly ships in skeletal outline.

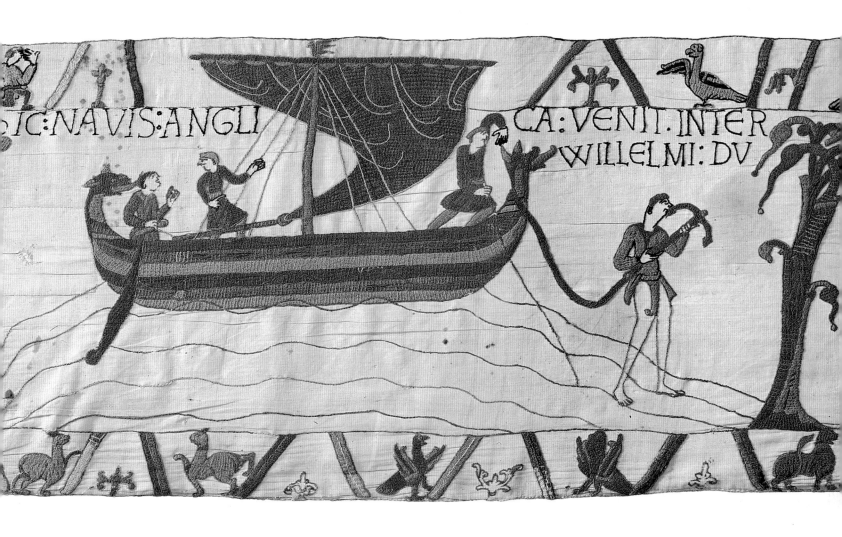

hIC : NAVIS : ANGLICA :
VENIT . IN TERRAM /
WILLELMI : DVCIS

*Here an English ship came
to Duke William's country.*

A ship's company brings news of Harold's
coronation to Normandy.

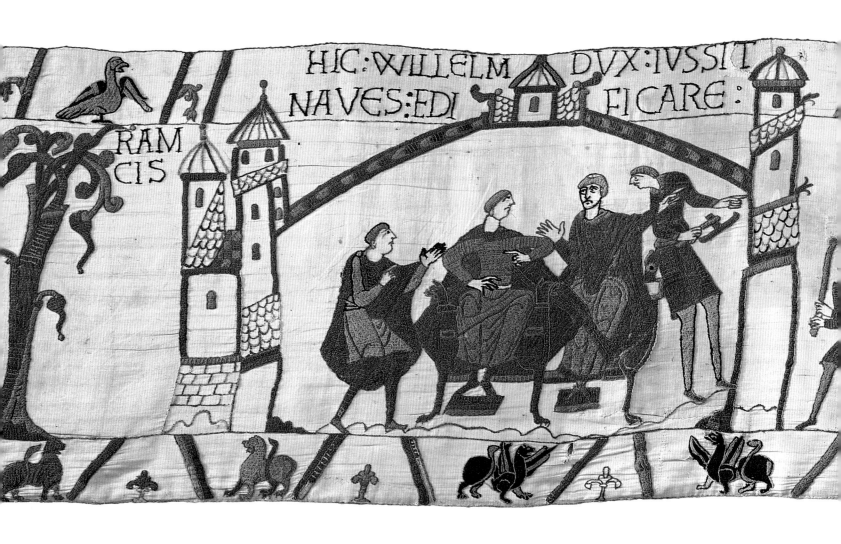

HIC:WILLELM DVX:IVSSIT
NAVES:EDI FICARE:

RAM
CIS

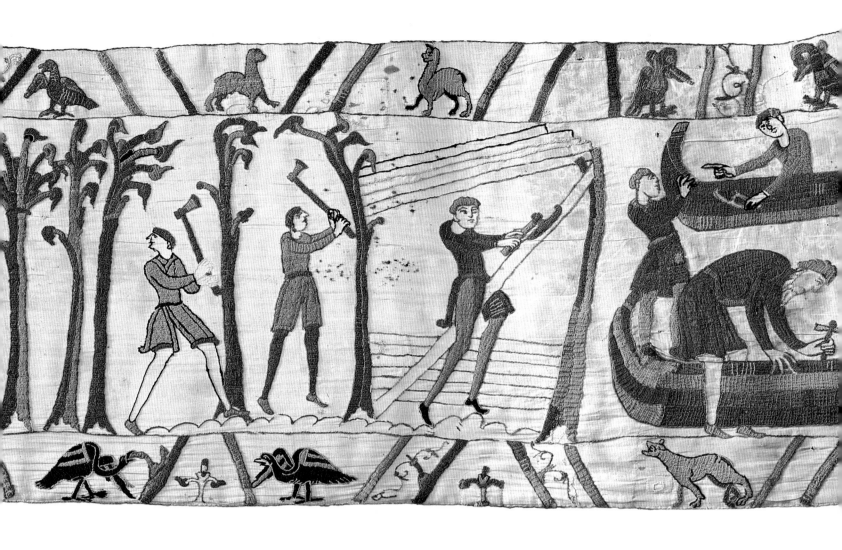

HIC : WILLELM DVX : IVSSIT / NAVES : EDIFICARE :

Here Duke William ordered ships to be built.

The scene is, presumably, Rouen castle. William and his half-brother Bishop Odo (with tonsure) sit side by side. While the Duke's informant is still speaking, the two men on the throne give orders for the building of the invasion fleet. A man with an axe in his hand hastens to start work. Trees are felled and the trunks are cut into planks and smoothed with axes.

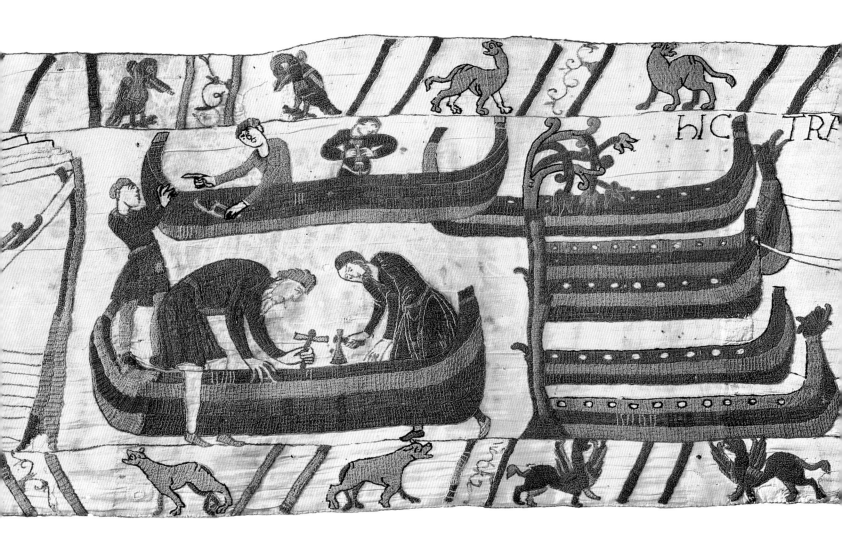

There follows the actual building of the vessels. In the upper ship two men are working with an axe and a drill; in the lower, two others are using a smaller hatchet and a hammer-like implement. Between the two hulls stands the man who is supervising the work.

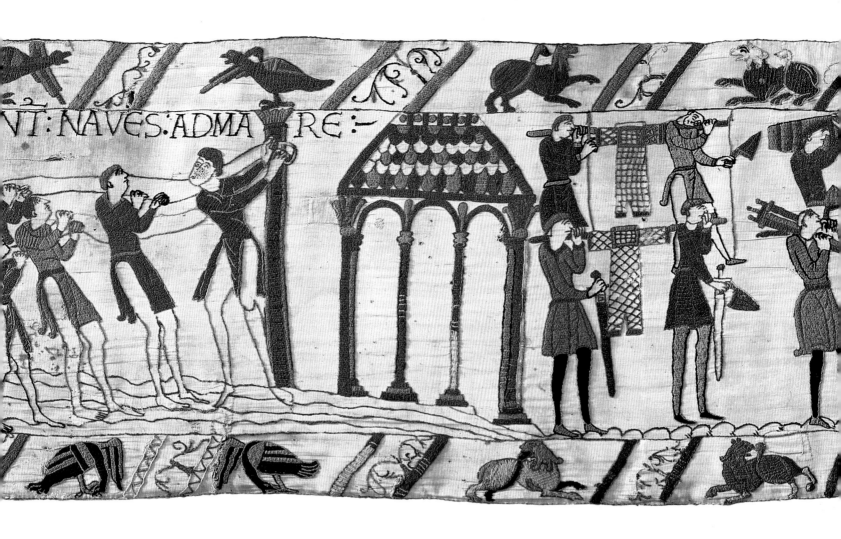

hIC TRAhVNT̄ [trahuntur] : NAVES : AD MARE :–
ISTI PORTANT : ARMAS : AD NAVES : ET hIC / TRAhVNT :
CARRV · M / CVM VINO : ET ARMIS :–

Here the ships are hauled down to the sea.
These men carry arms to the ships; and here they drag a cart laden with wine and arms.

With a rope passed through a ring on a post, the shipwrights haul the completed ships into the water. From this point onwards the Normans, too, mostly lose their distinctive hairstyle. The sources tell us that the fleet mustered at the mouth of the river Dives, so the shipyard may well have been at the nearby village of Dives-sur-Mer.

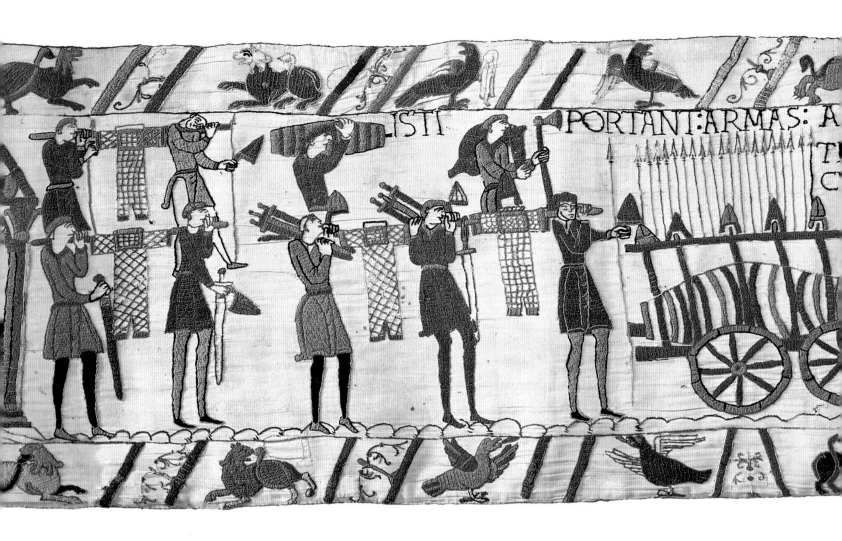

In the following scene the ships are
loaded with victuals, hauberks (which look
less trouser-like than those worn by the
mounted Normans in action later on),
helmets, swords, lances and a battleaxe.
Two men draw a four-wheeled cart laden
with helmets, a large quantity of spears (or
lances) and a huge barrel of wine. Another
man carries a bundle on his shoulder.

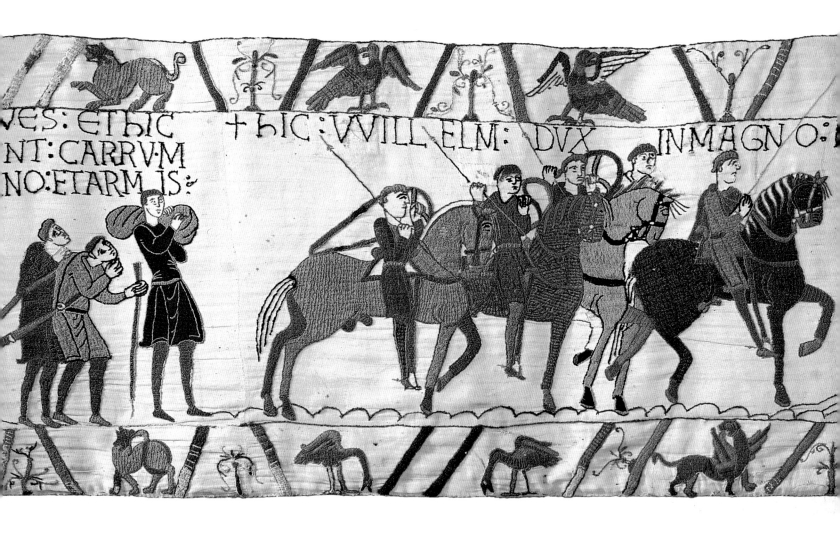

+ hIC : VVILLELM : DVX IN MAGNO : NAVIGIO : MARE
TRANSIVIT ET VENIT AD PEVENESÆ :–

Here Duke William crossed the sea in a great ship and came to Pevensey.

Horsemen make their way to the ships, which immediately set sail. In reality, the crossing was by no means so straightforward a business as the Tapestry makes out. According to the written sources, the invasion fleet assembled on 10 August 1066 and then waited a long time for a favourable wind, before finally sailing along the coast on 12 September and dropping anchor off the mouth of the Somme.

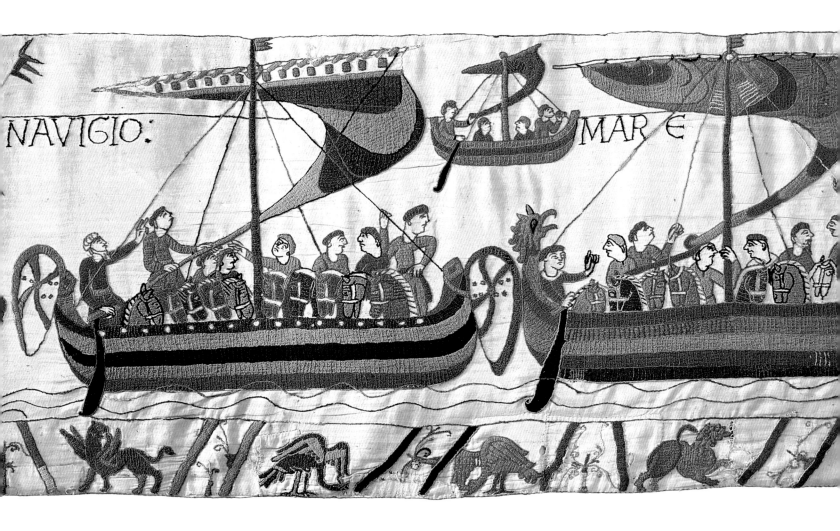

NAVIGIO: MARE

After another delay of two weeks, the ships crossed the Channel on the night of 27/28 September. The bulk of the army was Norman, though Bretons, Flemings, Frenchmen and Italians also took part. The 'great ship' is the Norman flagship, the *Mora*, with a wooden human figure mounted on her stern post.

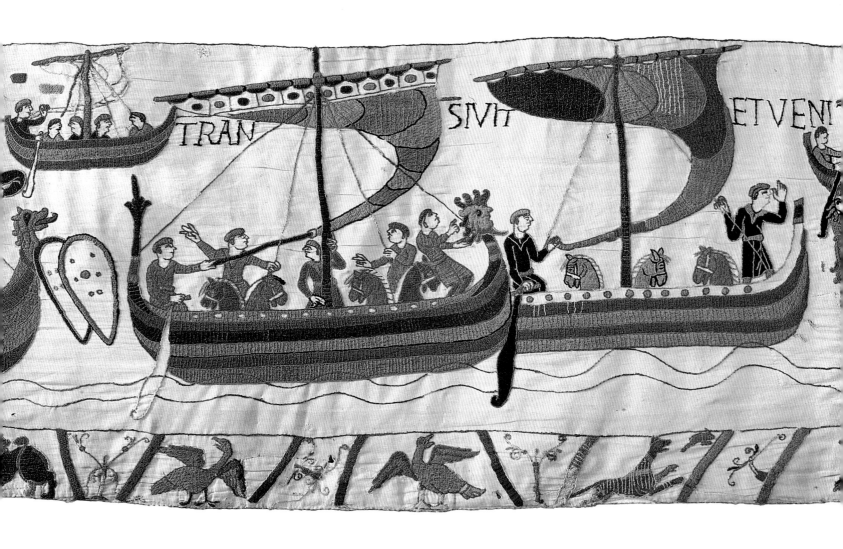

TRAN SIVIT ETVENI

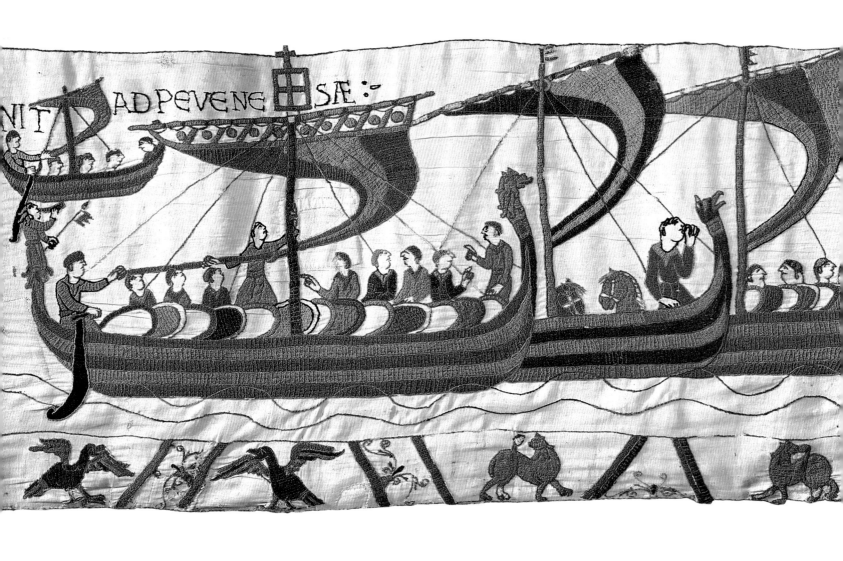

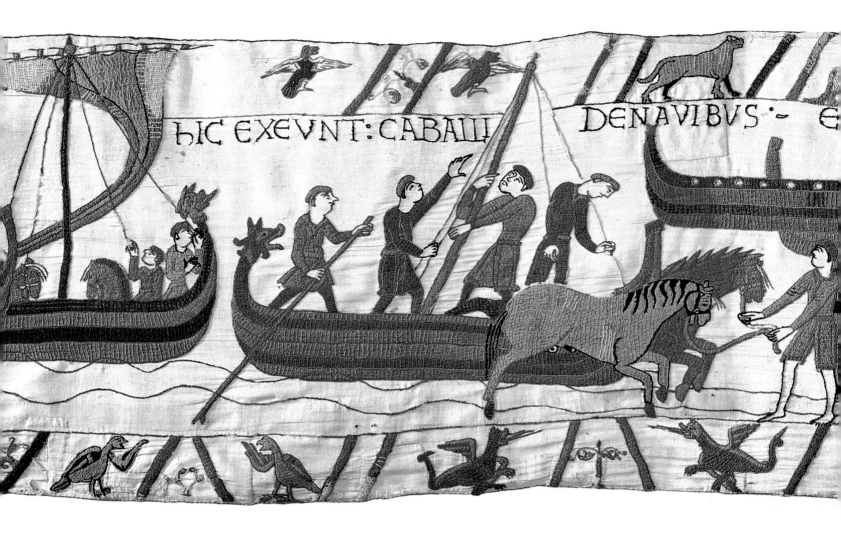

hIC EXEVNT : CABALLI DE NAVIBVS :—

hIC EXEVNT : CABALLI DE NAVIBVS :—

Here the horses leave the ships.

The fleet made landfall in Pevensey Bay, where the gently sloping sand made it easy to beach the ships. There, too, the horses could be landed without difficulty.

The Tapestry shows them jumping the low gunwale, as the crew unsteps the mast.

CABALLI DE NAVIBVS ·— ET HIC: MI LITES: FESTINA

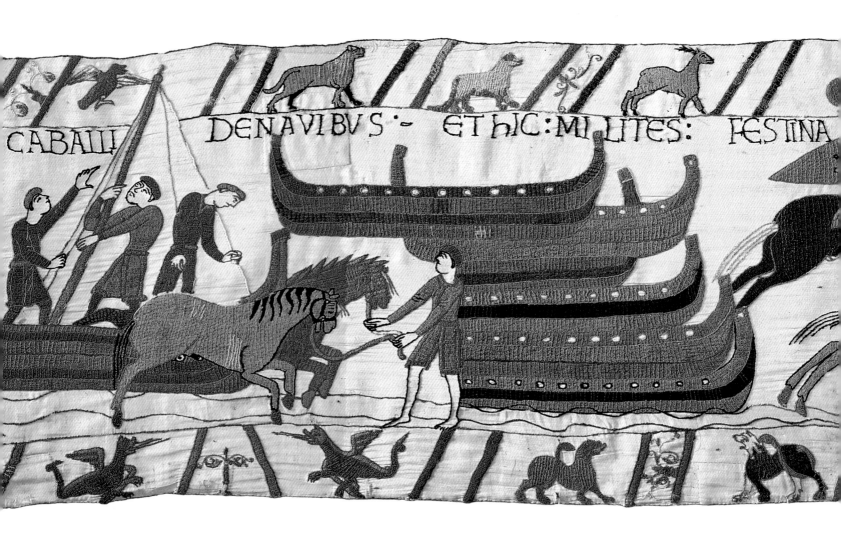

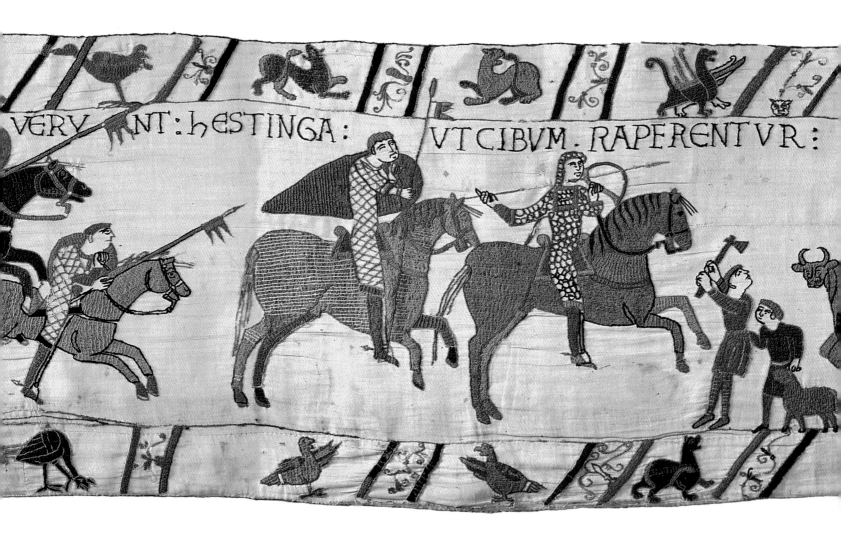

...VERV[N]T : hESTINGA : VT CIBVM . RAPERENTVR :

ET hIC : MILITES : FESTINAVERVNT : hESTINGA : VT
CIBVM . RAPERENTVR ⫶ HIC : EST : VVADARD :
hIC : COQVI / TVR : CARO / ET hIC : MINISTRAVERVNT /
MINISTRI

And here troops have hurried to Hastings to seize food. Here is Wadard.
Here meat is cooked, and here the servants have served it.

A foraging party has returned from
Hastings with livestock. Two men
slaughter a sheep; near them is an ox.
Head-high, a soldier holds what may be a
coiled rope. Another carries a pig across
his shoulders. The knight with the
Norman name of Wadard may well be the
Wadard who was a tenant of Odo's, but
there is no proof of this. He must have
been a well-known figure at the time
when the Tapestry was made.

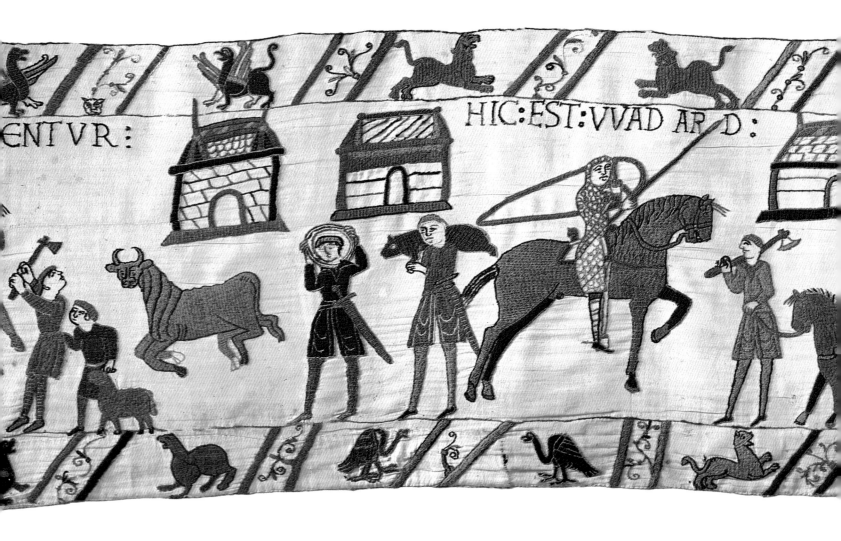

ENTVR :

HIC : EST : VVAD AR D :

The man with the axe, in front of Wadard, is leading a pony. This is a pack animal, as the form of the saddle harness reveals. To the right – beneath a rack of spitted fowl – two men are boiling meat in a great cauldron. The bearded figure may be a baker: in his right hand he holds a long pair of tongs, with which he removes bread or cakes from the oven and places them on a tray. Next, spits of cooked meat are carried to table.

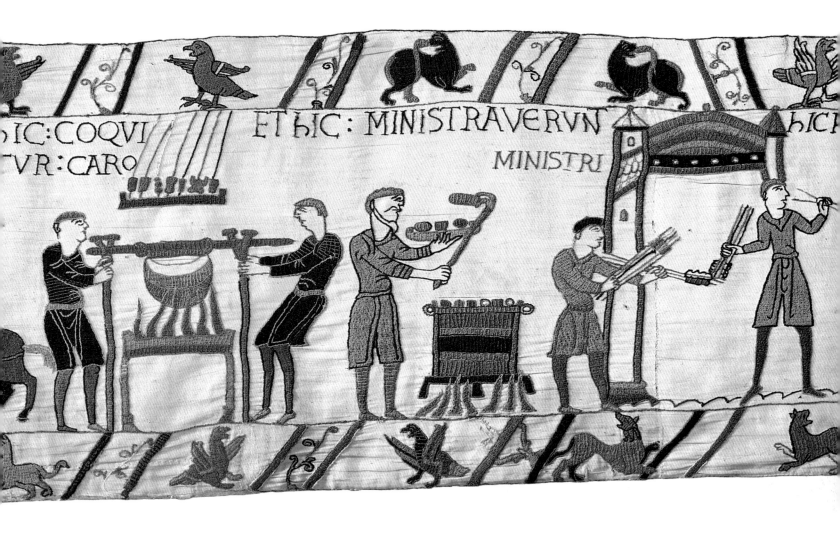

ᴐIC:COQVI ET hIC: MINISTRAVERVN· hIC·

ᴠR:CARO MINISTRI

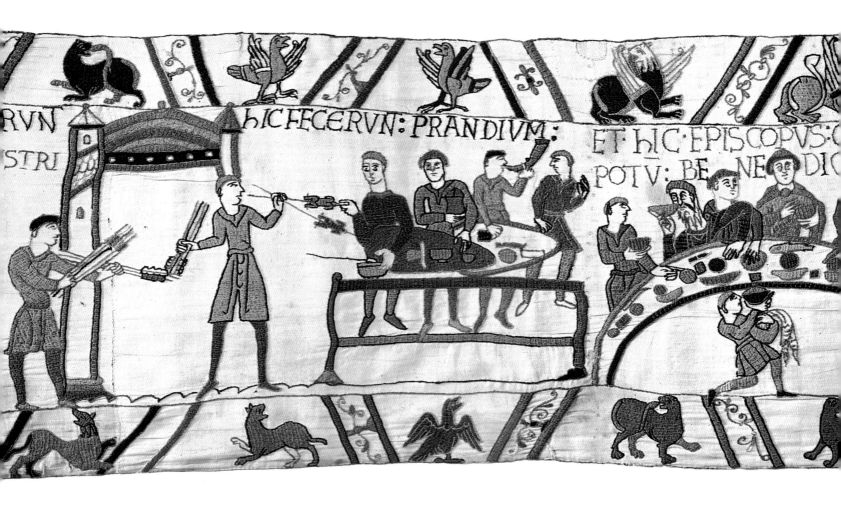

hIC FECERVNT : PRANDIVM : ET · hIC · EPISCOPVS :
CIBV̄ : ET : / POTV̄ [cibum et potum] : BENEDICIT ·

Here they held a feast; and here the Bishop blesses the food and drink.

The improvised sideboard consists of a
wooden framework with shields laid on
top. A servant sounds a horn to announce
that the feast in the Norman camp is
ready. The diners – among them Bishop
Odo, who imparts his blessing in the
centre – are seated at a semicircular table
laden with a variety of comestibles, dishes
and a small crock. Clearly, knives are the
only eating implements. (One member of
the distinguished company whom we
would very much like to identify is the
elderly diner with the long beard.) In the
foreground a servant half-kneels as he
presents a bowl and a large napkin (for
hand-washing?).

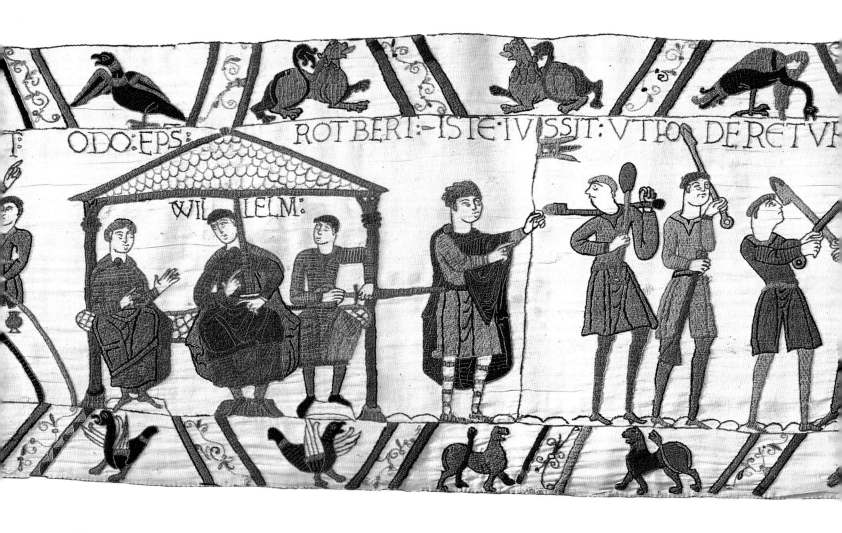

ODO : EP̄S [episcopus] : / WILLELM : / ROTBERT :– ISTE ·
IVSSIT : VT FODERETVR : CASTELLVM : AT [ad] · HESTENGA
CEASTRA

Bishop Odo; William; Robert. This man ordered a fortification to be dug at Hastings.

After the feast William holds a council of war with his two half-brothers, Odo and Robert of Mortain (with sword), who sit on either side of him. A commander, holding his lance with its pennant in one hand, gives the order to throw up earthen ramparts with timber shoring.

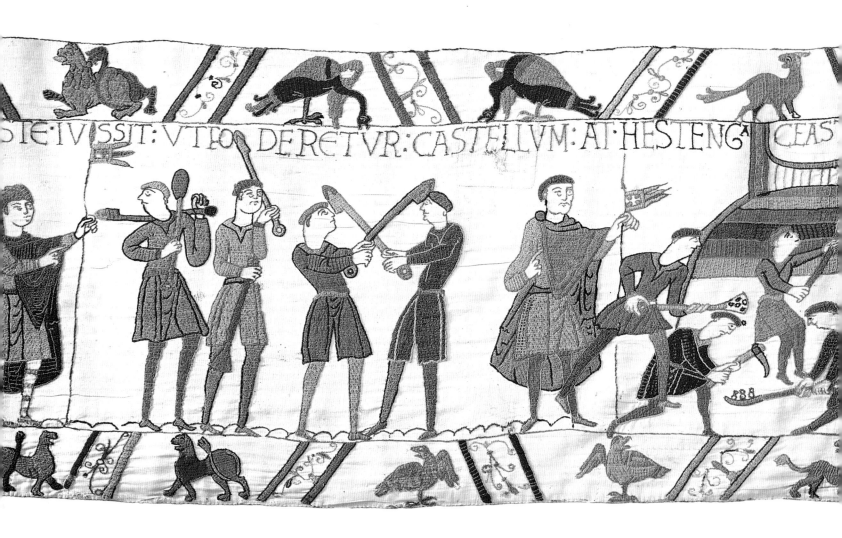

At this point a quarrel seems to break
out, and two men hit each other on the
head with their spades. Another officer
oversees the digging. One workman
wields a mattock; three men pile up earth
and stones; a fourth digs with a spade.

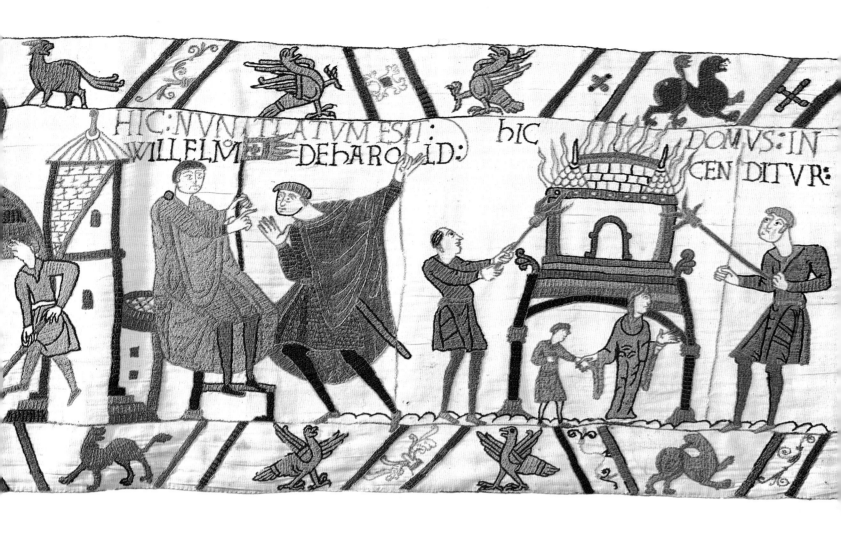

HIC : NVNTIATVM EST : / WILLELM̊ [Willelmo] DE hAROLD : / hIC DOMVS : IN / CENDITVR :

Here William receives news of Harold. Here a house is burned.

William receives intelligence of Harold's preparations. A woman with her child leaves a house as two men set it on fire. The stylized architecture to the right, with a town or castle gate standing open, may well stand for the captured town of Hastings.

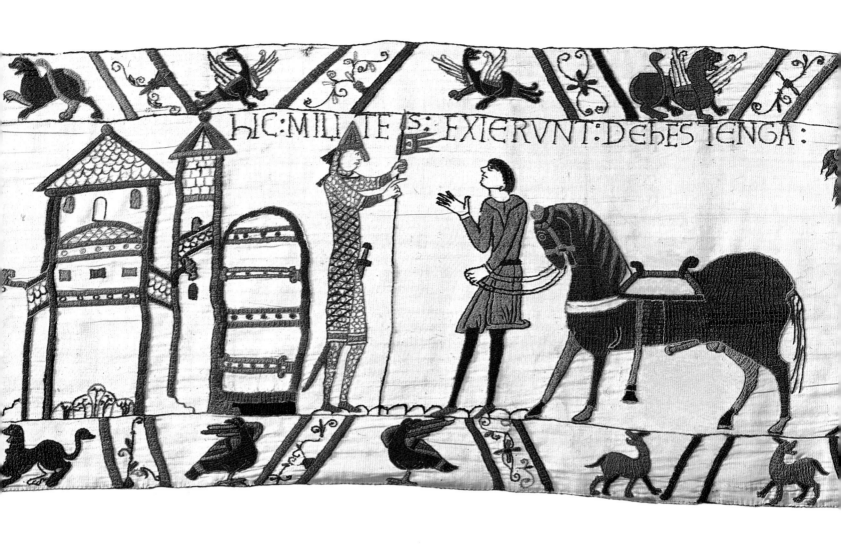

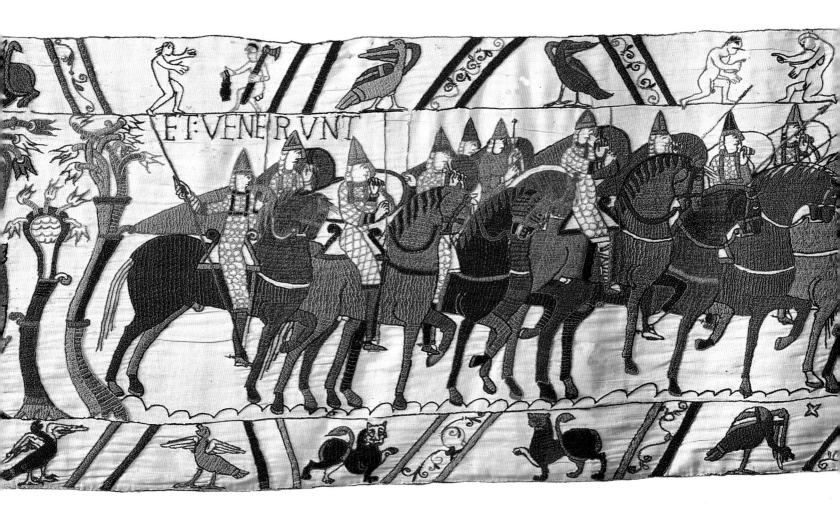

hIC : MILITES : EXIERVNT : DE hESTENGA : ET :
VENERVNT AD PRELIVM : CONTRA : hAROLDVM ·
REGE ⋮ HIC : VVILLELM : DVX INTERROGAT : VITAL :
SI VIDISSET EXERCI / TV̄ [exercitum] / HAROLDI

Here the troops set out from Hastings and advanced to do battle against King Harold.
Here Duke William asks Vital whether he has seen Harold's army.

The Duke's charger is led forward. William stands before the gates of Hastings in full armour. With the exception of one knight, who appears later (the one who may have been called Eustatius; p.161) the Duke is the only figure to wear mail leggings as well as a mail shirt. The ribbons or flashes at the back of his helmet are identifying marks.

Three trees mark the change of scene. The Norman army moved forward on the morning of Saturday, 14 October. The serried ranks of the cavalry break into a gallop with William (again) at their head, holding a mace. In the border above are two little naked couples, oblivious to the impending drama.

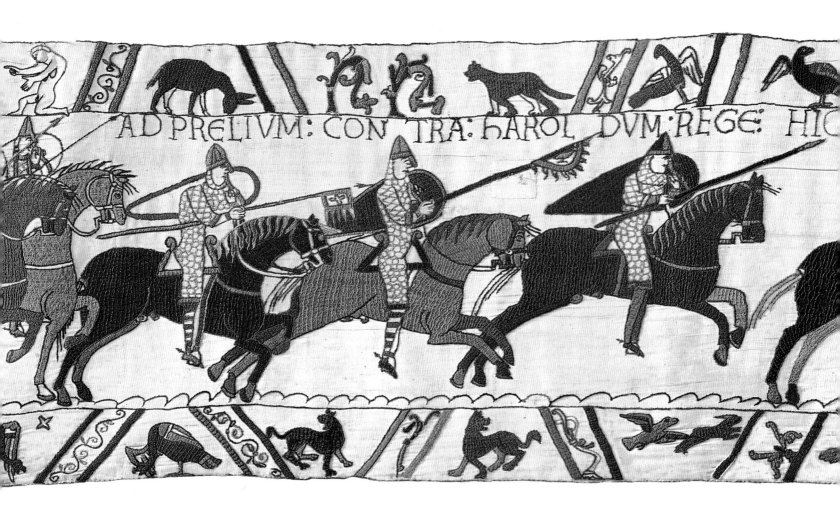

AD PRELIVM: CON TRA: HAROL DVM: REGE: HIC

William asks Vital (who is possibly, like Wadard, a vassal of Odo's) about the position of the English army; two mounted Norman scouts observe the enemy from a hilltop.

146

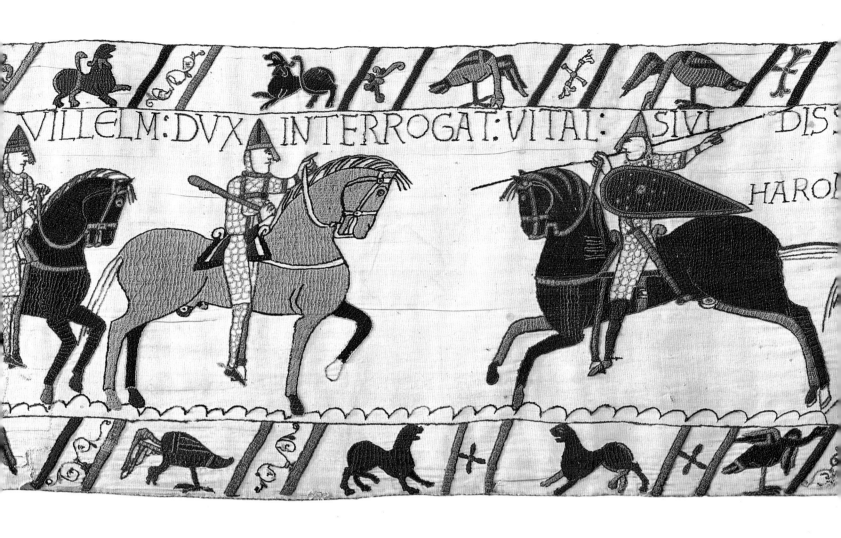

VILLELM:DVX INTERROGAT:VITAL: SIVI DIS
HAROL

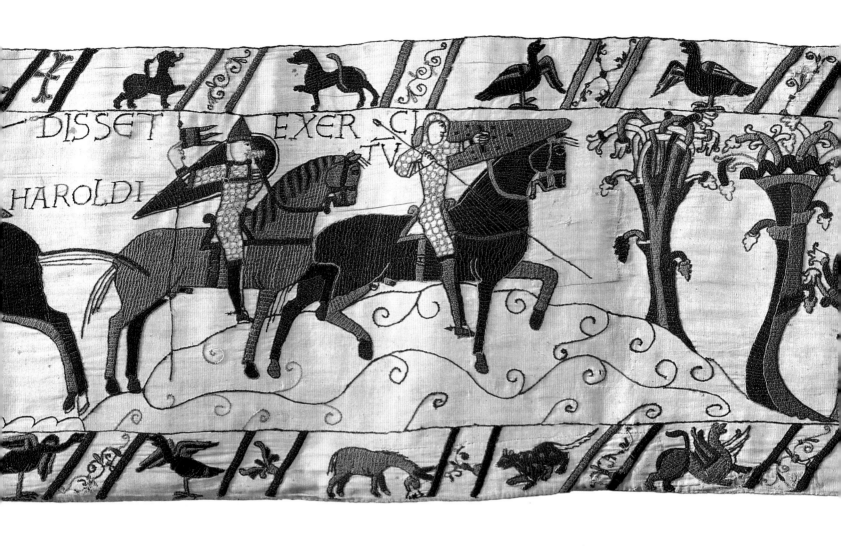

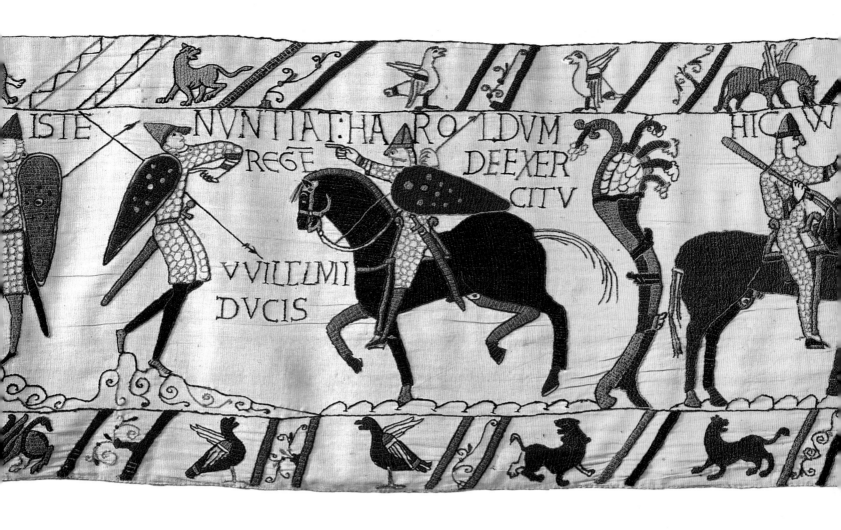

ISTE NVNTIAT : HAROLDVM / REGE [regem]
DE EXER / CITV / VVILELMI / DVCIS

This man gives King Harold news of Duke William's army.

Harold has sent out scouts of his own. One of them peers through the trees on the hill; another, facing Harold, points back towards the Normans.

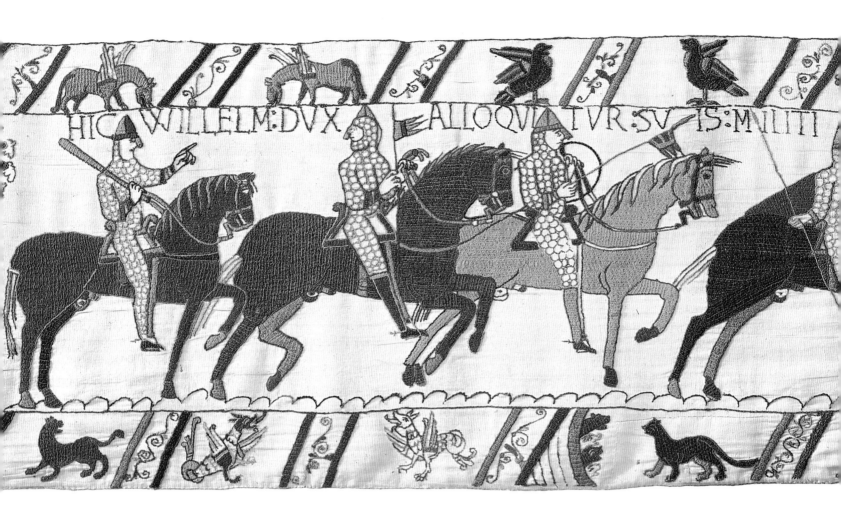

HIC WILLELM:DVX ⊢ALLOQVITVR:SV IS:MILITI

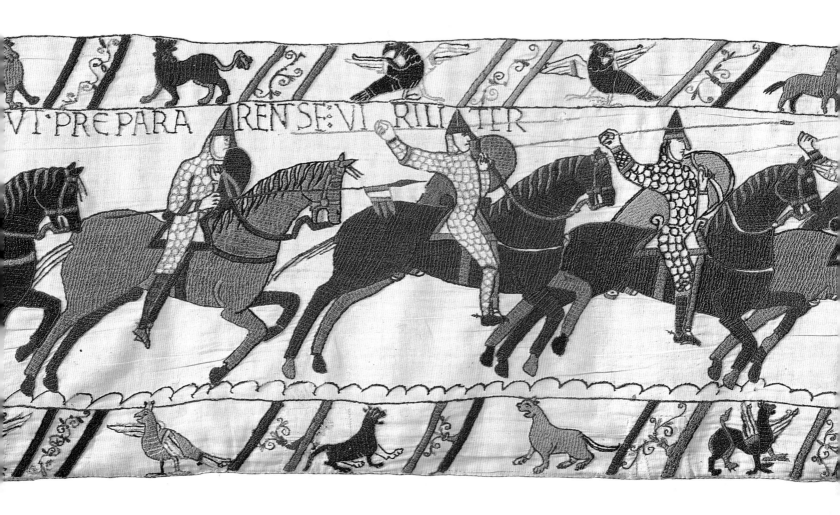

HIC WILLELM : DVX ALLOQVITVR : SVIS : MILITIBVS :
VT · PREPARARENT SE ⦂ VIRILITER ET SAPIENTER : AD
PRELIVM : CONTRA : ANGLORVM EXERCITV̄ [exercitum] :

*Here Duke William exhorts his troops to prepare themselves manfully
and wisely for the battle against the army of the English.*

After William's speech the battle begins.
In the midst of the Norman cavalry a
party of archers advances (p. 152 f.). The
Tapestry shows the Anglo-Saxons form-
ing a shield-wall and repulsing a cavalry
attack on two sides (p. 154 f.). We thus see

Harold's troops for the first time; they
are armed and armoured in the same way
as their opponents, but they fight only on
foot. The lower border now fills with
casualties.

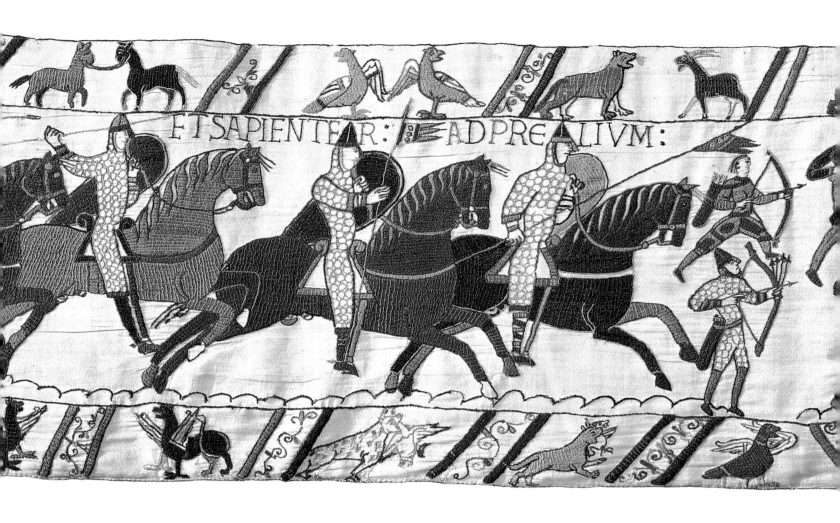

ETSAPIENTER: ADPREALIVM:

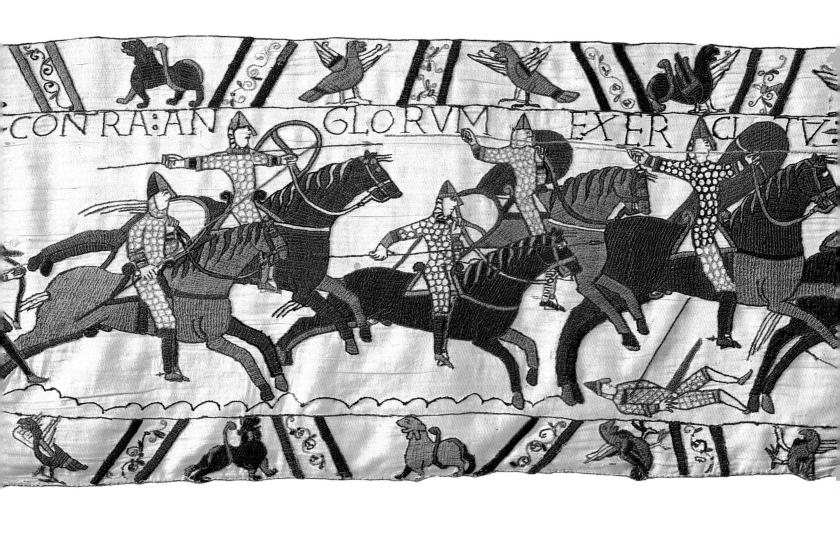

...CON RA:AN GLORVM EXER ACI TV:

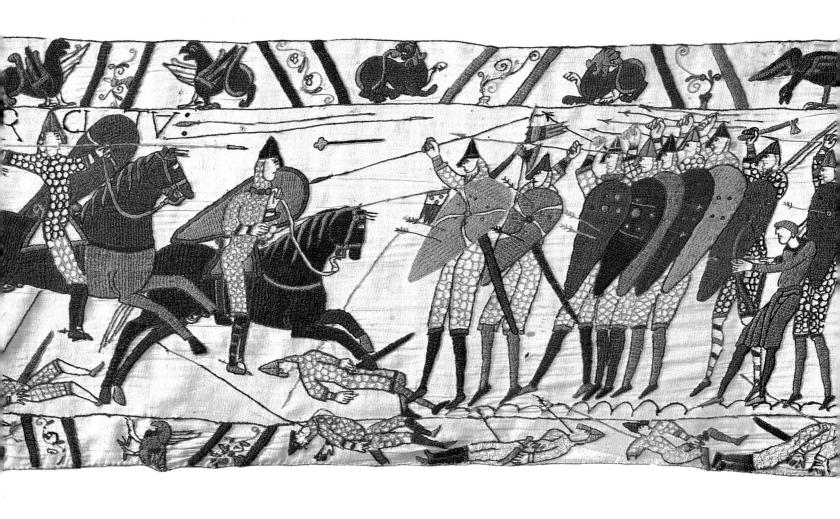

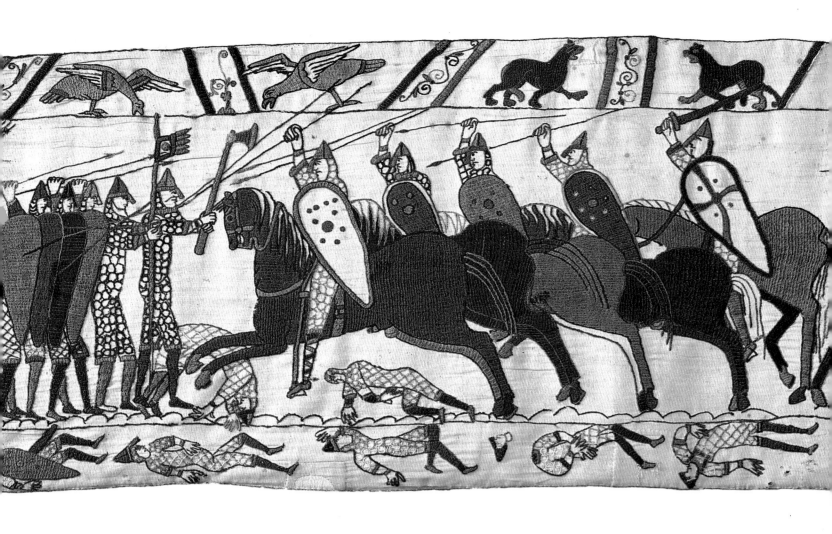

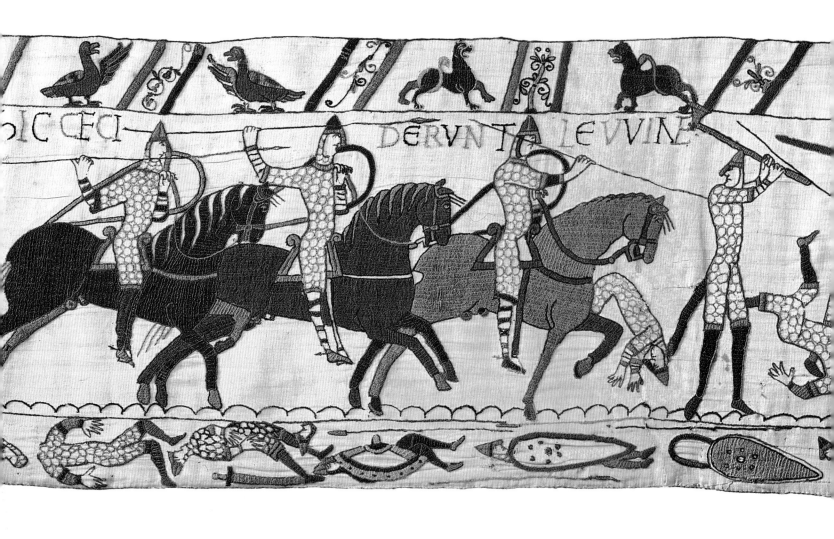

SIC CECI DERVNT LEVVINE

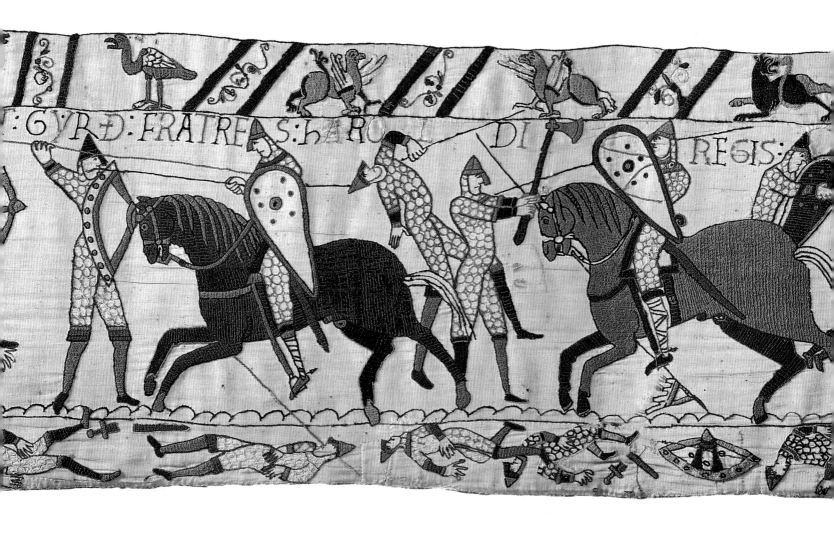

hIC CECIDERVNT LEVVINE ET : GŸRÐ : FRATRES :
hAROLDI REGIS :

Here fell Leofwine and Gyrth, King Harold's brothers.

The Tapestry presents the course of the battle in abbreviated form. William's army made a number of charges, over a span of eight hours, before their ultimate victory. After the deaths of Harold's two brothers, the battle rages on.

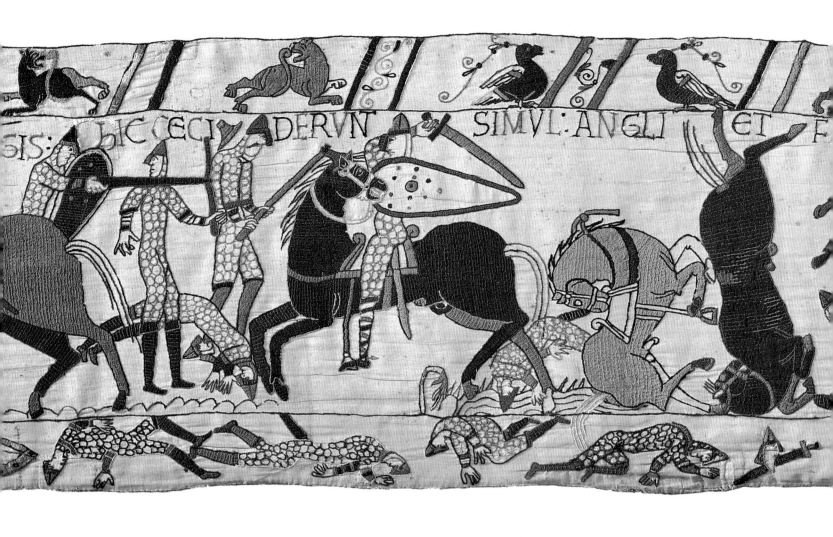

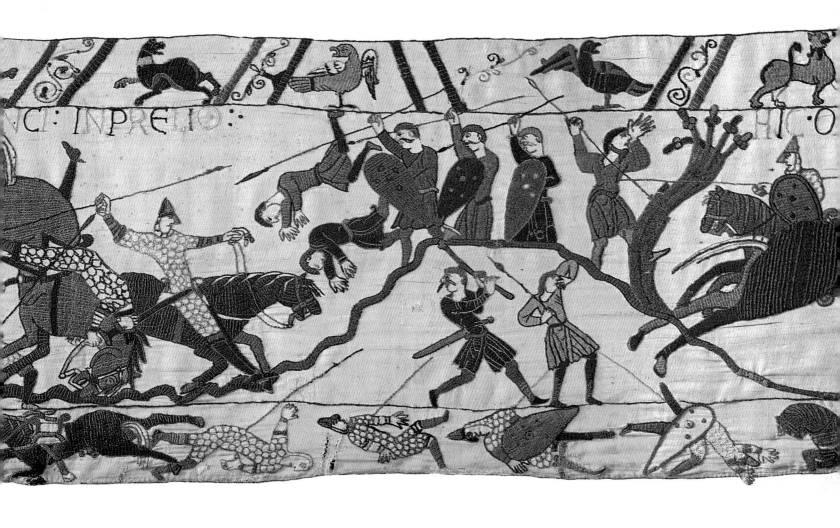

hIC CECIDERVNT SIMVL : ANGLI ET FRANCI :
IN PRELIO :–

Here, at the same time, both English and French fell in battle.

There are casualties on both sides. Horses
plunge and somersault in the mêlée.
Under cavalry attack, some Anglo-Saxons
make a stand on a hill; two of them
tumble down the slope.

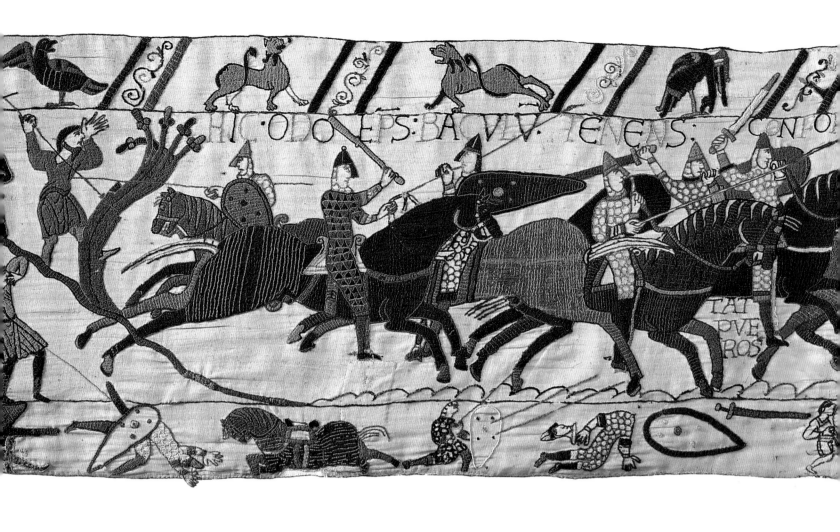

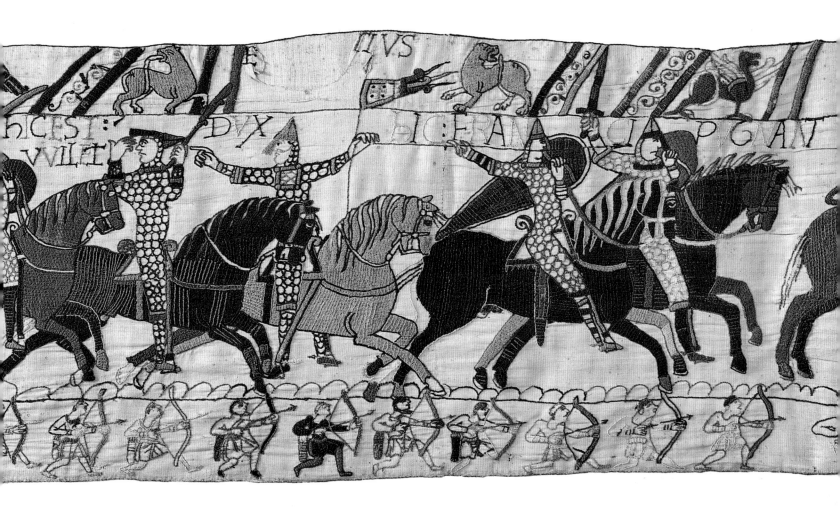

HIC · ODO EPS [episcopus] : BACVLV [baculum] · TENENS :
CONFOR :– / TAT / PVE / ROS
hIC EST :– DVX / VVILEL [Wilelmus] / E… ГIVS [Eustatius?]

Here Bishop Odo, holding his stick, cheers on the youths. Here is Duke William.
E…tius.

In reality, this scene took place at the
start of the battle. The Breton auxiliaries
fell back in disarray and panic broke out;
the rumour spread that William had been
killed. This is why Odo is seen bravely
rallying the PVEROS, presumably
junior horsemen. William tips back his
helmet to show his face. The man riding
ahead of the Duke is possibly Count
Eustace of Boulogne (only part of the
name has been preserved). A long line of
archers in the lower margin accompanies
the renewed cavalry charge.

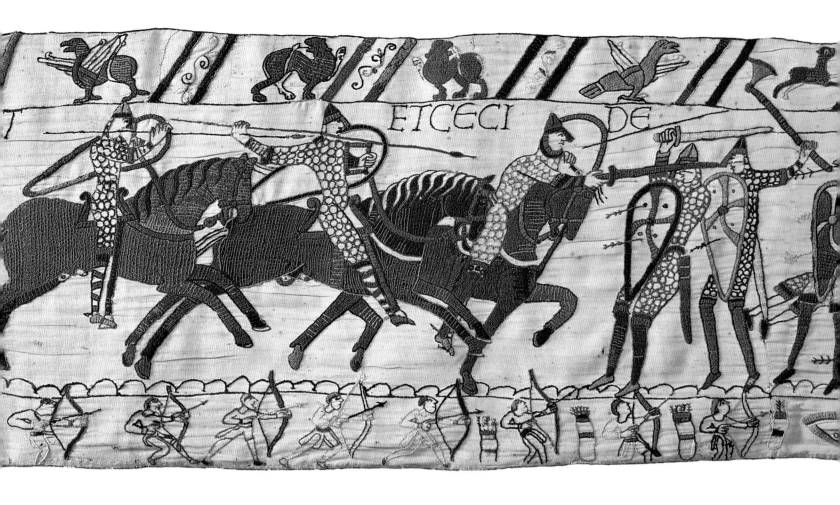

hIC : FRANCI PVGNANT ET CECIDERVNT QVI ERANT :
CVM hAROLDO :– hIC hAROLD :– REX :– INTERFEC / TVS :
EST ET FVGA : VERTERVNT ANGLI

Here the French do battle, and those who were with Harold fell.
Here King Harold was slain, and the English fled.

This cavalry charge leads to a final, bloody, hand-to-hand combat, in which Normans kill Anglo-Saxons. It is now a matter of controversy whether the standing figure who has been struck in the head by an arrow (to the right of the standard-bearer) is Harold or not. What is certain is that the falling figure beneath the words INTERFECTVS EST does represent Harold. With his death, all resistance collapses and the English flee before the Norman cavalry. In the lower border the dead are stripped of their mail shirts.

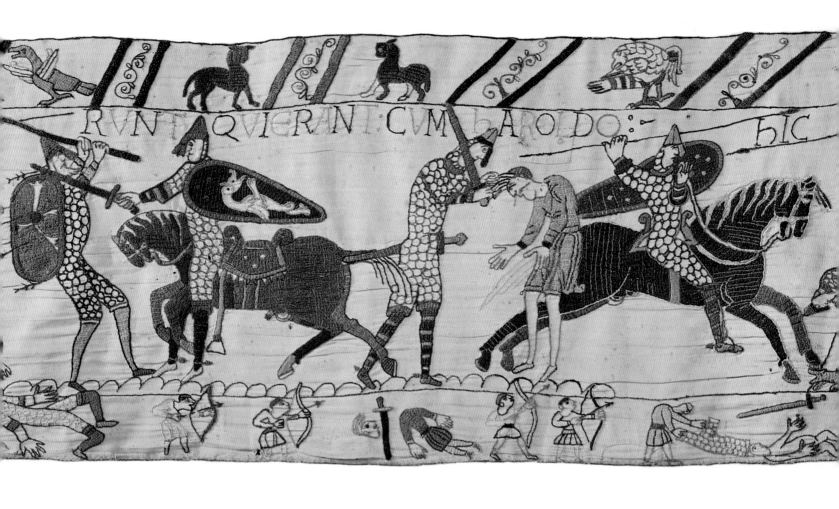

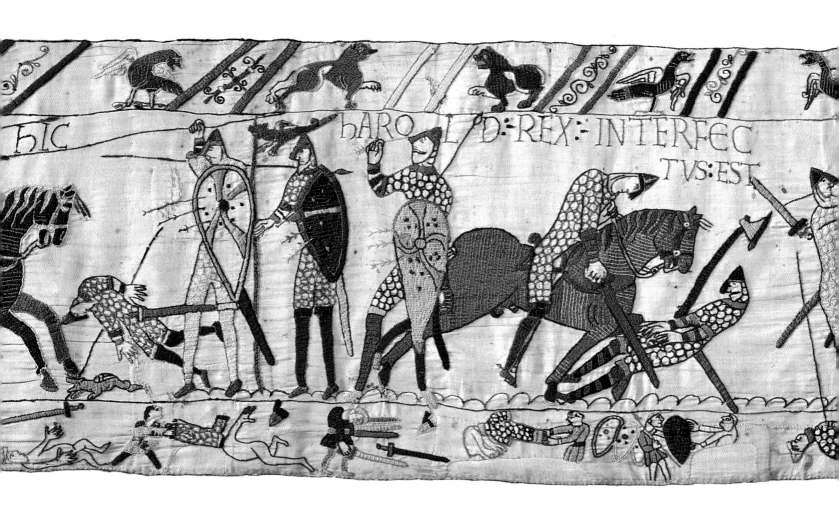

HIC HAROLD REX INTERFECTUS EST

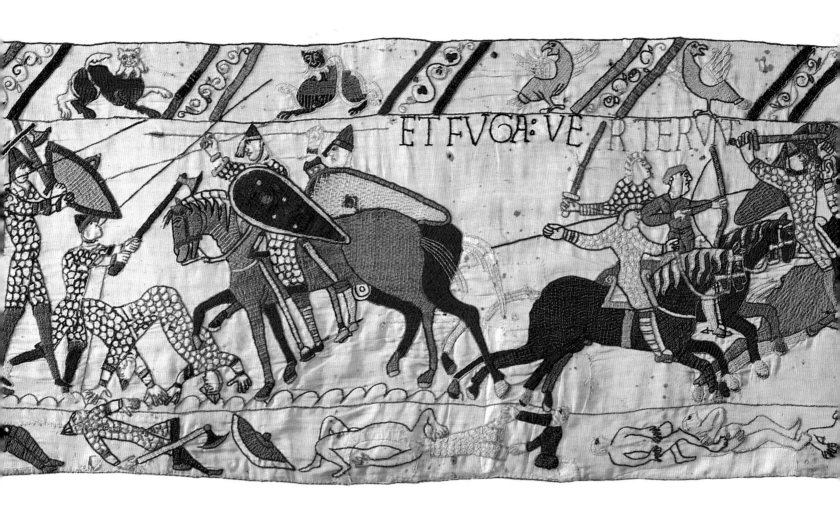

ET FVGA:VE[R]TER[VN]...

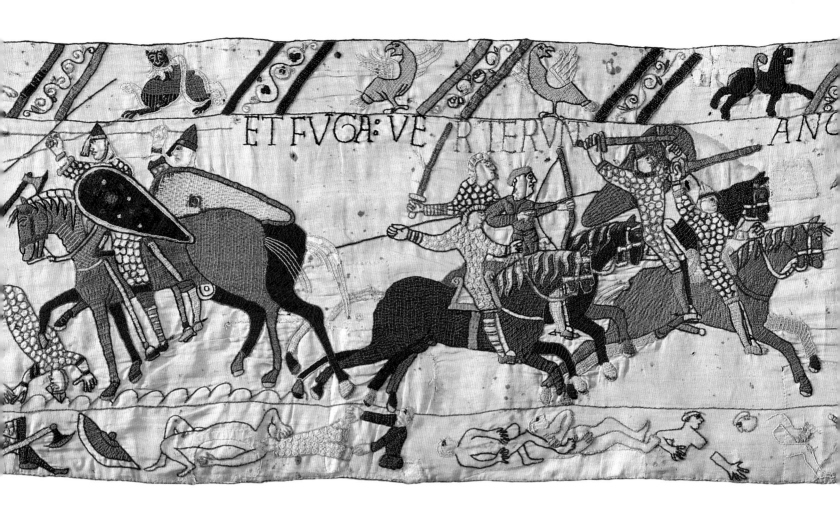

ET FVGA VE RTERVT ANG

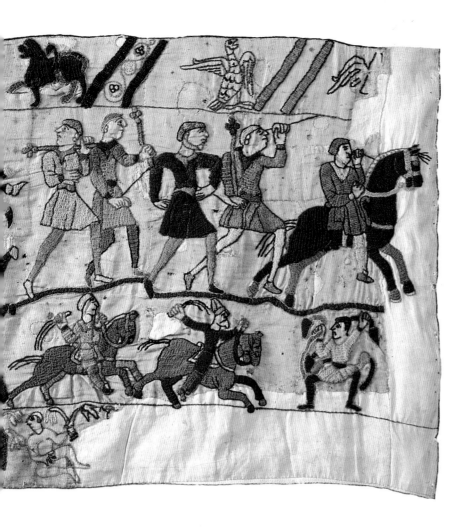

The last scene, to the right of the tree, was extensively restored in the nineteenth century; and here the Tapestry breaks off. It is possible that – just as the narrative began with the image of Edward the Confessor enthroned in majesty – it ended with the final triumph of the Norman Duke, his coronation as King William I.

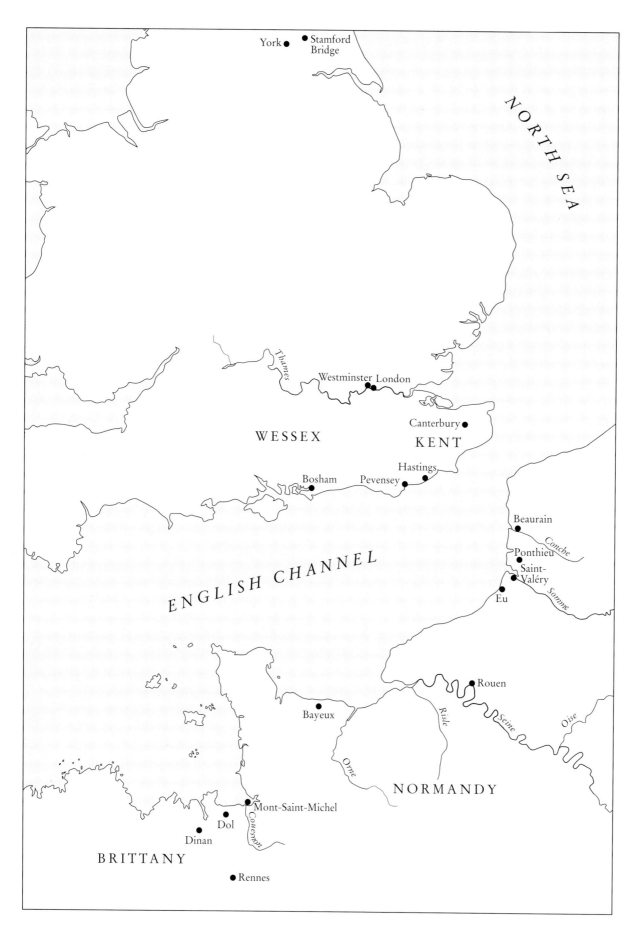

York ●　● Stamford Bridge

NORTH SEA

Thames

Westminster London ●

Canterbury ●

WESSEX　KENT

Hastings
Bosham ●　Pevensey ●

ENGLISH CHANNEL

Beaurain ●

Conche

Ponthieu ●
Saint-Valéry ●
Eu ●

Somme

Rouen ●

Risle

Seine

Oise

Bayeux ●

Orne

NORMANDY

Mont-Saint-Michel ●

Couesnon

Dol ●
Dinan ●

BRITTANY

Rennes ●

Chronology

1005 Birth of the future King Edward the Confessor, and of Lanfranc, the leading Norman theologian.

1027/28 Birth of William. He is the illegitimate son of Robert I and Herleve, a tanner's daughter from Falaise. She later marries Herluin of Conteville and bears him two sons, Odo and Robert.

1035 Death of Robert I; William becomes Duke of Normandy.

1042 Edward returns to England from exile in Normandy and becomes King. Lanfranc moves to Rouen, the capital of Normandy.

1045 Lanfranc becomes Prior of Bec. King Edward marries Edith, daughter of Godwine, Earl of Wessex.

1050 William nominates his half-brother Odo of Conteville as Bishop of Bayeux. The Duke marries Matilda, daughter of Baldwin, Count of Flanders.

1051 Robert, former Abbot of Jumièges and, since 1044, Bishop of London, becomes Archbishop of Canterbury; Pope Leo IX invests him with the pallium.

1052 Earl Godwine, banished by King Edward, returns to England in arms, and many Normans are expelled. Bishop Stigand of Winchester allies himself with Godwine and becomes Archbishop of Canterbury (1052-1070).

1053 Death of Godwine. His eldest son, Harold, becomes Earl of Wessex.

1057 After consolidating his power in a succession of campaigns, William defeats the King of France.

1064 Harold travels to Normandy; William conducts a war against Conan II, Duke of Brittany (reigned 1040-1066).

1066 Lanfranc becomes Abbot of Saint-Etienne, Caen. Edward dies on 5 January; Harold makes himself King of England.
On 14 October William's invading army wins the Battle of Hastings; Harold and his sons are killed. On 25 December William is crowned King of England in Westminster Abbey.

1067 Odo, Bishop of Bayeux and now also Earl of Kent, rules for a time as William's deputy.

1070 Lanfranc becomes Archbishop of Canterbury.

1077 Consecration of the new cathedral at Bayeux.

1082 William has Odo arrested and imprisoned.

1087 Death of William. Odo is freed; shortly afterwards, he rebels against the new King of England, William's son, William Rufus. As a rebel, he forfeits his lands and is banished.

1089 Death of Lanfranc.

1097 Death of Odo in Palermo/Sicily.

Index of Names

Photographic Acknowledgments

The Bayeux Tapestry is reproduced in colour
(pp. 1-16, 91-167) by kind permission of the
Centre Guillaume le Conquérant, Bayeux. Sources
of the black and white illustrations are as follows:

H. J. Adamski, *Die Christussäule im Dom zu Hildesheim*
(Hildesheim: Bernward Verlag, 1990) (photo
Hermann Wehmeyer) 73

J. J. G. Alexander, *Norman Illumination at Mont-Saint-
Michel, 966-1100* (Oxford: Clarendon Press,
1970) 75, 83

Bayerische Staatsbibliothek, Munich 6, 7, 11, 13, 15,
16, 18, 21, 22, 24, 33, 34, 38, 40, 41, 46, 50, 58, 61,
62, 71, 74, 77, 84, 85

J. Beckwith, *The Art of Constantinople* (London and
New York: Phaidon, 1961) 70

Bildarchiv zur Buchmalerei, Universität des
Saarlandes, Saarbrücken 45

T. S. R. Boase, *English Romanesque Illumination*
(Oxford: Bodleian Library, 1951) 78

British Museum, London 67

Byzance et la France médiévale (Paris: Bibliothèque
Nationale, 1958) 44

H. Focillon, *Peintures romanes des églises de France*
(Paris: Paul Hartmann Editeur, 1950) 51, 72

P. G. Foote and D. M. Wilson, *The Viking Achievement*
(London: Sidwick & Jackson, 1980) 37, 56

Editions Gaud, Moisenay-le-PETIT 47

W. Grape 26, 63, 64

H. Grape-Albers, *Spätantike Bilder aus der Welt
des Arztes* (Wiesbaden: Guido Pressler Verlag,
1977) 19

E. G. Grimme, 'Der Aachener Domschatz',
Aachener Kunstblätter (1972) (Düsseldorf: Verlag
L. Schwann, 1972) (photo Ann Münchow) 10

R. Hamann, *Kunst und Askese* (Worms: Wernersche
Verlagsgesellschaft, 1987) 4, 12

D. Kahn, ed., *The Romanesque Frieze and its Spectator*
(London: Harvey Miller, 1992) 27, 30

C. M. Kauffmann, *Romanesque Manuscripts 1066-1190*
(London: Harvey Miller, 1975) 23, 39, 42, 43,
48, 49, 76, 79

L. Musset, *Romanische Normandie (West)* (Würzburg:
Echter-Verlag, 1989) 57

F. Mütherich and J. E. Gaehde, *Karolingische Buch-
malerei* (Munich: Prestel-Verlag, 1979) 60, 69

Ornamenta Ecclesiae, exh. cat. (Cologne: Schnütgen-
Museum, 1985) 3, 68

H. Roth, ed., *Zum Problem der Deutung
frühmittelalterlicher Bildinhalte* (Sigmaringen:
Jan Thorbecke Verlag, 1986) 14

W. Rudolph, *Das Schiff als Zeichen* (Bremerhaven:
Deutsches Schiffahrtsmuseum, 1987) 17, 20

P. H. Sawyer, *The Age of the Vikings* (London:
Edward Arnold, 1971) 25, 66

F. Stenton, ed., *Der Wandteppich von Bayeux*
(Cologne and London: Phaidon, 1957) 1, 29, 52, 59

H. Swarzenski, *Monuments of Romanesque Art*
(London: Faber and Faber, 1974) 8, 53, 82

E. Temple, *Anglo-Saxon Manuscripts 900-1066*
(London: Harvey Miller, 1976) 31, 32, 35, 36

F. Unterkircher, *Tiere – Glaube – Aberglaube*
(Graz: Akademische Druck- und Verlagsanstalt,
1986) 28

Les Vikings… Les Scandinaves et l'Europe 800-1200,
exh. cat. (Paris: AFAA, Association Française
d'Action Artistique, 1992) 55, 65

K. Weitzmann, *Spätantike und frühchristliche Buchmalerei*
(Munich: Prestel-Verlag, 1977) 9

F. Wormald, *Decorated Initials in English MSS. from
A. D. 900 to 1100* (Oxford: Society of Antiquaries
of London, 1945) 54

Y. Załuska, *L'Enluminure et le scriptorium de Cîteaux
au XIIᵉ siècle* (Cîteaux: Commentarii cistercienses,
1989) 2, 5

Zeitschrift für Kunstgeschichte (1973) (Munich and
Berlin: Deutscher Kunstverlag, 1973) 86

© 1994 Prestel-Verlag, Munich and New York

Translated from the German by David Britt

Prestel-Verlag
16 West 22nd Street, New York, NY 10010, USA
Tel. (212) 627 8199; Fax (212) 627 9866
Mandlstrasse 26 · D-80802 Munich, Germany
Tel. (89) 381 7090; Fax (89) 38 17 09 35

Distributed in Continental Europe by Prestel-Verlag
Verlegerdienst München GmbH & Co. KG
Gutenbergstrasse 1, D-82205 Gilching, Germany
Tel. (8105) 388 117, Fax (8105) 388 100

Distributed in the USA and Canada on behalf of Prestel by te Neues Publishing Company,
16 West 22nd Street, New York, NY 10010, USA
Tel. (212) 627 9090; Fax (212) 627 9511

Distributed in Japan on behalf of Prestel by YOHAN Western Publications
Distribution Agency, 14-9 Okubo 3-chomo, Shinjuku-ku, J-Tokyo 169
Tel. (3) 32 08 01 81; Fax (3) 32 09 02 88

Distributed in the United Kingdom, Ireland and all remaining countries on behalf of Prestel by
Thames & Hudson Ltd, 30-34 Bloomsbury Street, London, WC1B 3QP, England
Tel. (71) 636 5488; Fax (71) 636 1659

Typeset by Reinhard Amann, Aichstetten
(typeface: Monotype Centaur)
Offset lithography by H. Bruch, Munich (colour),
and Eurocrom 4, Villorba (black and white)
Printed by Peradruck GmbH, Gräfelfing nr. Munich
Bound by Ludwig Auer GmbH, Donauwörth

Printed in Germany

ISBN 3-7913-1365-7 (English edition)
ISBN 3-7913-1336-3 (German edition)
ISBN 3-7913-1577-3 (French edition)

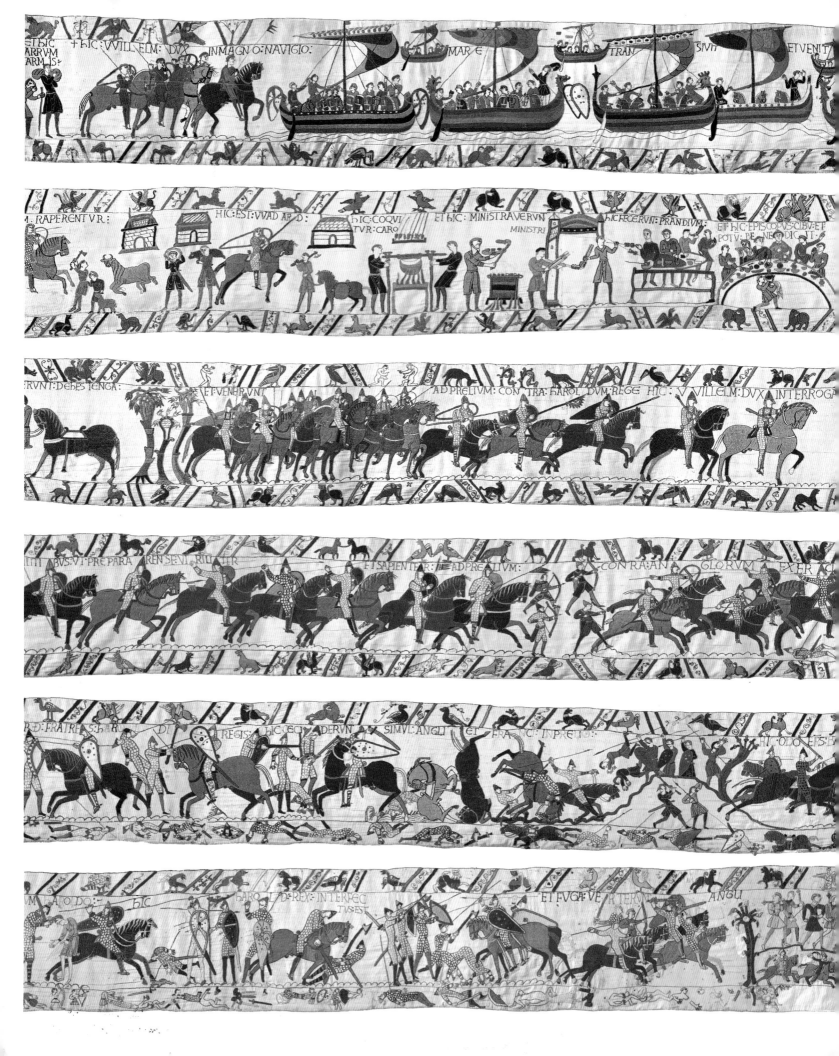

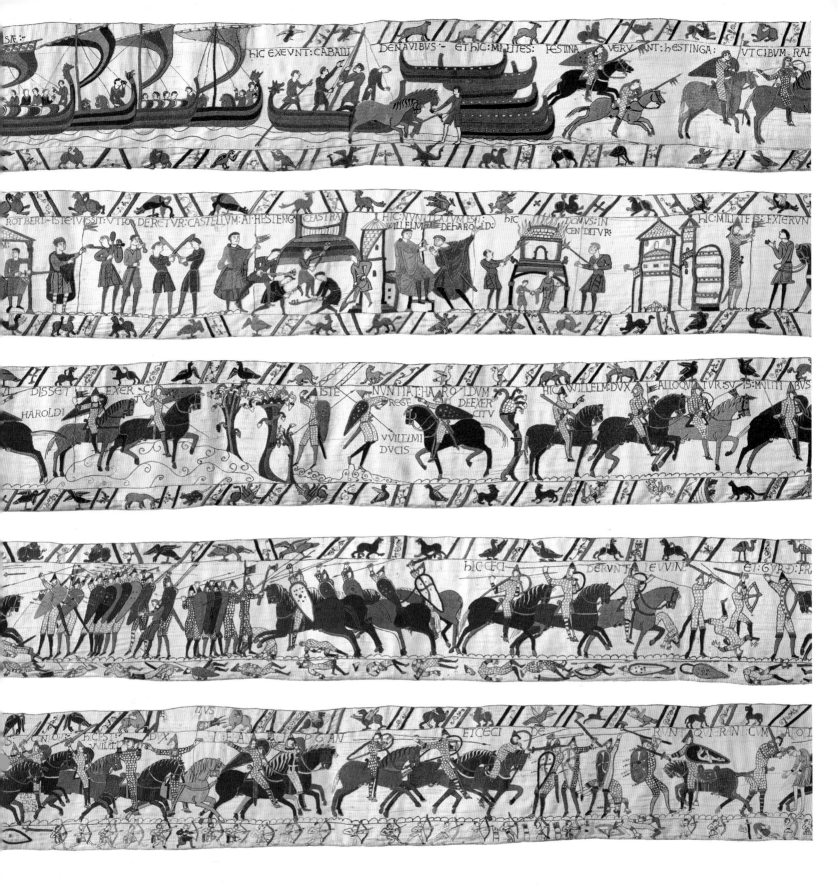

11·21·97, Midwest, 29.95, 69132